The Modern Moves West

The Arts and Intellectual Life in Modern America

Casey Nelson Blake, Series Editor

Volumes in the series explore questions at the intersection of the history of expressive culture and the history of ideas in modern America. The series is meant as a bold intervention in two fields of cultural inquiry. It challenges scholars in American studies and cultural studies to move beyond sociological categories of analysis to consider the ideas that have informed and given form to artistic expression—whether architecture and the visual arts or music, dance, theater, and literature. The series also expands the domain of intellectual history by examining how artistic works, and aesthetic experience more generally, participate in the discussion of truth and value, civic purpose and personal meaning that have engaged scholars since the late nineteenth century.

Advisory Board: Richard Cándida Smith, Steven Conn, Lynn Garafola, Charles McGovern, Angela L. Miller, David M. Scobey, and Penny M. Von Eschen

The Modern Moves West

California Artists and Democratic Culture
in the Twentieth Century

Richard Cándida Smith

PENN

University of Pennsylvania Press

Philadelphia

Published by
University of Pennsylvania Press
Philadelphia, Pennsylvania 19104-4112

Printed in the United States of America on acid-free paper
10 9 8 7 6 5 4 3 2 1

Library of Congress Cataloging-in-Publication Data

Cándida Smith, Richard.
 The modern moves west : California artists and democratic culture in the twentieth century / Richard Cándida Smith.
 p. cm.— (The arts and intellectual life in modern America)
 Includes bibliographical references and index.
 ISBN 978-0-8122-4188-4 (alk. paper)
 1. Art, American—California—20th century. 2. Art and society—California—History—20th century. I. Title.
 N6530.C2C36 2009
 700.9794'0904—dc22 2009018802

In Memory,
Eric Monkkonen

Contents

Illustrations

Introduction
Dilemmas of Professional Culture

The art world [is] such a funny place because it['s] like a big bal-
loon: You push real hard and it's flexible and elastic and resilient; so
you push and push and push, and all of a sudden it goes—schwoo. It
takes you inside, and you can't get out.
—Edward Kienholz

We are told that the art produced in the Bay Area is of nationwide
importance and interest. Sometimes we are even told that it has
international import. We, of course, think that it is all important just
because it is ours.
—Fred Martin, circa 1960

In a passionate, often angry article published in 1963 in *Artforum,* a new
journal dedicated to critical discussion of West Coast art, painter Fred
Martin expressed his outrage at the conception of art history embodied
in recent exhibition programs at the San Francisco Museum of Art, the
nation's oldest modern art museum west of Manhattan.[1] He viewed the
priorities of the museum's new director, George Culler, as fundamen-
tally hostile to the concerns motivating most contemporary work in the
San Francisco Bay Area. Juxtaposing two recent shows at the museum,
"Art of the Bay Area" and "Art of Brazil," Martin questioned the muse-
um's assumption that modern artists in all parts of the world could be
interesting only to the degree that they worked on problems highlighted
in Paris before 1940 or in New York afterward. The museum's staff had
reinforced a division of the world into peripheries and centers. The
work of the Brazilian painters selected for the show fit comfortably into
metropolitan ideas of the tropics. The companion show revealed that a
similar process was well under way with California art, whose lively local
art scenes had only recently captured the attention of New York galleries
and museums. The museum favored work, Martin thought, that repack-

aged trends already established in New York but with flourishes that provided references to sun, surf, deserts, mountains, suburban sprawl, or bohemian rebellion, icons that distilled East Coast conceptions of life on the West Coast. The two shows demonstrated that Bay Area and Brazilian art had been made provincial. Provincial art was "the voice of the Western world," Martin observed, actually present in the work exhibited, "talking about what its own voice sounds like to it" (48).

The curatorial perspective, Martin insisted, denied the citizens of Brazil, or for that matter the residents of the Bay Area, their own intrinsic interests, activities, and forms of self-exploration consonant with their unique histories. Modern art had therefore become a vehicle for dissociating people from their world, from their experiences, from the "sheer sensuous perceiving of the Bay Area as a place" (47). To develop original work with concerns and problematics distinct from those affirmed in the center was to enter a zone of frustration and failure. Works from the provinces that refused to make their starting point ideas that were already dominant in the center appeared confused, parochial, provincial, eccentric.

Martin's argument took for granted that modern art in California had an independent history, grounded in the historical and natural peculiarities of the state. That the major regional museum no longer supported continued development of problems and approaches that had been particularly important to artists working in the state during the previous half century was puzzling to him, for it meant that the museum's leadership assumed that their most important public consisted of curators and critics in New York rather than people interested in art from their own communities. Martin concluded that regional artists would have to search for other venues to reach the broader publics they hoped might respond to their work. A living culture required continuous collaboration between artists and a public that was not afraid to speak back, a public that had rejected the passive, receptive relationship to exhibited work expected from admissions-paying museum audiences. If they failed, modern art would die.

Martin's argument improvised on core beliefs underlying the emergence and development of modern art in the nineteenth and twentieth centuries. Like sexuality, creative imagination was a natural force embedded within the body. A vision of "modern art" as an ongoing conversation between equals sharing their "sensuous experiences" of necessity challenged the establishment of fixed collective norms. The truths artists could bring to the surface were felt physically in the experience of the work they created. The more powerful the work, the more it could transform how its public looked at the world around them and bring them to understand the transience of contemporary social arrange-

ments. Even if his interests were only indirectly political, his faith in the power of art to reveal truths convention had long obscured allowed Martin to make several telling observations about the relationship of art to structures of power in U.S. society and the negative effects of U.S. cultural power upon other societies in the world. The questions he raised others soon extended with even greater vehemence to long-standing inequalities within California's art communities as artists who were female, gay, or from communities of color insisted that their work was essential for the people of the United States to grasp how race, gender, and sexuality had shaped the lives of everyone in the country.

In a previous book, I explored the role of modernist aesthetic ideas in California in providing a discursive resource for criticizing mid-twentieth-century U.S. society.[2] Poets and artists provided a range of images that influenced discussions of the cold war, the Indochina wars, the environment, sexual politics, capital punishment, racism, and poverty. In this study, I return to the politics of modern art as it developed within California to focus on a different question: how a growing "arts community" developed a professionalized identity along with institutional structures that could set priorities and efficiently manage arts training, production, exhibition, and publicity. *Politics* in this context is understood as an unending contest within institutions and organizations over how best to ensure the resources needed to support a wide range of activities, only some of which artists do.

Every arts organization makes determinations about what questions it views as most important for contemporary practice, which approaches provide the most interesting departures, and consequently which artists and movements it promotes at any given moment. In peripheral locations like California in the mid-twentieth century where resources were often exceptionally limited, choices frequently generated protests against the inherent limitations of the criteria used, a challenge that intensified as artists, curators, and critics from marginalized social groups worked to break the barriers preventing their full participation in the profession. Even if a goal of modern art practice has been to provide critical examinations of contemporary experience, the conditions of institutional reproduction pointed in contrary directions. An alternative history of modern art might therefore focus on the successive contests to force recognition for new bodies of work whose absence called into question the very legitimacy of art as a distinctive form of knowledge.

The growth of art as a force able to influence the public has depended on the consolidation of defined knowledge practices into well-organized, hierarchical institutions with the power to determine what issues are most important to explore and whose work best defines the

advances made in any field. Martin Heidegger suggested that the modern era commenced with a concern to test received traditions against accurate representation of the observed world.[3] A rigorous intellectual discipline with standards for evaluating claims, assigning worth to a contribution, and fixing "truth" had to develop if the images of the world the modern sciences developed were to be trusted as more than fanciful speculation. Yet the quest for truth required freedom as well as discipline if inaccurate first principles were to be exposed as false and replaced with images resting on more substantial truth claims. When Immanuel Kant tried to define what distinguished modern thought, he emphasized the autonomy that investigation had gained: "to use one's own understanding instead of being guided by others."[4] Georg Wilhelm Friedrich Hegel extended this line of thought to declare freedom of subjectivity as the defining feature of the modern world.[5]

During the development through the nineteenth century of what would eventually be called "modern art," artistic practice found its niche as an autonomous form of knowledge by taking subjectivity as the special domain of the arts. The visual arts shifted from representation of already established beliefs and values to presenting the "truth" of the world as a trace left on the human spirit.[6] Work as an expression of genuine inner vision must, by definition, be arbitrary, but it also creates an opportunity, if the means of communication are in fact becoming more widely available, for a meeting of experiences, as if in dialogue. At the end of the nineteenth century, aesthetic perspectives on subjective truth paralleled findings emerging from the new science of psychology. William James argued that the study of how consciousness formed required a pluralistic theory of truth. James turned to the etymological roots of consciousness, literally "knowing with," to picture thought operations as relationships between the observer and observed that were fluid and contingent. He noted that "Things are 'with' one another in many ways, but nothing includes everything, or dominates over everything. The word 'and' trails along after every sentence. Something always escapes. . . . However much may be collected, however much may report itself as present at any effective center or action, something else is self-governed and absent and unreduced to unity."[7]

James argued that irreducible pluralism marks the law of consciousness. Not only would different observers see the same thing differently depending on their backgrounds and purposes, but the same observer might well have different perceptions at different times because, at every stage of a thought process, the mind is "a theater of simultaneous possibilities."[8] Without a continuous sharing of a wide range of experiences, any of which are inherently limited in some critical manner no matter how rigorous the process by which they emerged, no truth could emerge

that was sufficiently comprehensive enough to guide human action with certainty that the end results would predictably be what people desired.

In the arts, testing the range of differences in how aspects of the world might be perceived became the object for experimental study. As a result, artists and critics could claim that the work of the artist was actually a form of knowledge, not a technique for representation of images the validity of which was established elsewhere. The form was the content, for the constructive process through which an artwork emerged revealed *thought in action.* Knowledge need not be limited to testable propositions the meaning of which had to be fixed, as required in the sciences and engineering. This breakthrough, a common feature in twentieth-century avant-garde artistic practice, shattered the idea that interpretative communities must involve a set of common meanings codified in a canon of accepted masterpieces. If members of a society in fact had a common standard for looking at the world, there would be no need for them to communicate with each other, as interaction would naturally proceed from full, transcendent communion. Community implies conflict of perspectives, and therefore, community also involves a practical need to reach out and include the experiences of those we do not understand. The arts became a practice in which the exploration of differences in the imagination of the world could be institutionalized.[9]

Arts organizations, whether located in schools, museums, galleries, periodicals, or elsewhere, form an interlocking set of complicated and expensive activities whose practical dynamics at any given time set the terms of what types of work will be deemed most interesting and valuable. Production and dissemination of art require consistency and reproducibility. There will be variations at every step, but predictability and planning predominate over improvisation to define a system that can train students, mount exhibitions, sell work, and reflect on what all the activity might signify. Materials have to be produced on a regularized basis suitable for the object's intended use. Design and production personnel have to be trained in specialized skills. For objects to be produced at an efficient and regular rate timed to satisfy demand, most activities must be standardized to take best advantage of equipment that is often expensive and useful only for limited tasks. These requirements grow even more intense when innovation is a demand of the system since the personnel and the organizations must be able to handle a greater range of possibilities while still meeting the deadlines teaching, exhibition, and publication schedules impose.

Reproducibility is a key feature of what makes an innovation something that holds, something that can be recognized as an innovation worthy of further development.[10] For the individual craftsperson, this is

a question of economic and moral support that provides enough material reward and psychic motivation to keep at it. For each generation struggling to establish their own vision and leadership, reproducibility involves setting forth a defined set of questions that can be worked on over their lifetimes. Viewed from the point of view of reproducibility, an individual work is only one element in a process of forming and developing that gives meaning to every minute of a life focused by an institution. For entrepreneurs within the field, especially, the process, keeping the game in perpetual motion, transcends any single result. Reproducibility of the institution requires its being able to attract resources to be allocated to individuals on a regular, predictable basis and mechanisms for determining who gets those resources and for what projects.

Since producing objects involves the organization of considerable resources, both labor and material, completed artwork presents a history of socially expressed desires that depend upon the mundane requirements of keeping museums, galleries, and public space filled on a regular schedule. More valued objects receive more regular resources, assisting continued production and flow into exhibition. The exclusionary process based on what objects best fit the needs of exhibitors has created a hierarchy of values, which in turn has demanded the investment of literary resources to justify and refine standards. That activity developed into the fields of aesthetics, criticism, and art history, the practitioners of which, however, on understanding the general terms of their own labor can (and frequently do) step back from a primary focus on fine art to consider a broader range of material production.

Effective activity fulfills a continuing flow of deadlines, filling both galleries and printed material with relevant content. Replicable activity requires principles that provide meaning to deeds that are often repetitive. Wlad Godzich has noted, "An institution is first and foremost a guiding idea, the idea of some determined goal to be reached for the common weal. . . . The members of the group are shaped by the guiding idea they seek to implement and the procedures they apply."[11] The principle of reproducibility extends as well to personnel, whose privileges, whatever they might be given particular responsibilities and position, are based on knowledge claims that are simultaneously intellectual and technical.

Their ability to reproduce the validity of their collective expertise is an important factor in the reproduction of social taste. Reception involves a struggle for resources that will determine the ability of particular groups to continue reproducing particular forms and the experiences they foster. Within this framework, the artist is a skilled craftsperson competent in relevant production processes. His or her talent lies in achieving consistent effects that are pleasing and desirable to others, first and fore-

most museum and gallery leadership, collectors, and critics, all of whom must explain why a particular artist's work is worth the effort *they* have invested. As George Kubler put it, "genius" might be better defined as a unity of disposition and situation that allows for group productivity rather than as an innate spiritual or psychological state inherent to a remarkable individual.[12] For a young artist to speak of her career is to speak of a potential in the process of unfolding. When she (or he) becomes a mature artist, her career is bounded by what she has actually produced. A mature career is a sign of the collective recognition she has achieved. To imagine its weight is to determine the value that others, not the painter herself, have found in the work. Professional ego begins with the internalization of the judgment of others. In a field such as art building on a long legacy of practice and theory, the judgment of others who live long after one's death looms as the ultimate arbiter, the only power capable of reversing the decisions of one's contemporaries.

The underlying habitual aspects of production and reception establish relationships of content and form. Meaning is an important element in many art objects, but still only one of several subsystems involved in fabrication. Ideology takes material form only secondarily as explicit ideas. The more important manifestations of social values within art are often unthematized propositions about how to fit experiences together into a structured sense of relationship that has been called a habitus. In the *Philosophical Investigations*, Ludwig Wittgenstein noted that for many, though not all, communicative cases, "the meaning of a word is its use in the language."[13] In constructive activities, such as art, meaning is inseparable from form and crafting and there is no paraphrase possible. Meaning is built into the structure of the object as an object, that is, as something to be sensually experienced, though the ability to exchange objects implies a whole way of living together because the practices of production, distribution, and reception are such that they cannot exist for a single occasion or situation.[14] Objects reveal forms of expression that bid their users to see, to touch, to feel, and to occupy space in specific and replicable ways. The propositions rendered through objects provide an effect considerably different from systems of explanation or intellectual references. When objects are valued, they transform the sensory habits of the body and create ways for responding to the world that can function without being thought about consciously. For professionals to be able to work on a regular basis, they must create a public that is itself as predictable and reproducible as every other component in the process. The subjective repertoire, a "sense" of self (*sense* understood as simultaneously meaning and feeling), that initiated publics seek out safeguards every other organizational element, including the subjective repertoires of artists, curators, and critics.

The problematic of how to organize modern (later "contemporary") arts institutions that can be self-sustaining has been a challenge in every part of the world, although the specifics vary from place to place. California has long been a hub of U.S. and global cultural life, but, curiously, it has also been remarkably provincial and isolated. The state, often proclaimed by its leaders to be as much a "nation" as a political subdivision of the United States,[15] provides an interesting, though certainly not unique, example of a provincial society developing cultural ambitions that include the desire to become a center for the production of art that captures the modern condition. California as a focus for this investigation has the advantage of not being at the center of contemporary art, even if during the twentieth century the state developed into an important site for production and exhibition. It has historically been a province, afflicted with underdeveloped cultural institutions typical for societies colonized initially as resource-extraction zones, where fortunes were made by exporting raw materials to other locations.

And yet it has long been more than that, for the state early developed an exemplary commitment to higher education that proved important to its development as one of the preeminent centers for scientific research and new technology development in the world. An expansive conception of education, together with the location of the motion picture industry in Hollywood in the 1910s, offered the conditions for unusually rapid expansion of the fine arts, at least on the creative side. Institutional support, however, lagged, creating an environment in which artists had to form their own networks to support their ambitions. Artists were often at odds with the state's cultural institutions, and the bitter criticisms found in the historical record were typically aimed at stimulating development. With a history that combines features of both core and periphery, California provides an unusual perspective for studying the relationship of economic development, social opportunity, and cultural expression, a perspective with implications for the future of international cultural exchange. Does the rapid growth of art in California and a modicum of success on the international stage simply mean that the leaders of another metropolitan center have successfully established a place of privilege for themselves within an inherently hierarchical world? Or might the California story exemplify instead a step toward the development of a more egalitarian world in which cultural activity and authority are broadly dispersed in a global network linking communities wherever there are people who want to contribute?

The historical record suggests that the second possibility is utopian rather than realistic. At least as the story has been told to date, modern cultural innovation spread from a handful of centers to the rest of the

world. Chapter 1 therefore precedes developments in California with events in Paris, France, the most important center for new artistic ideas and practices in the nineteenth century. I examine the broader implications of French ideas on modern art through the writings of Hippolyte Taine and Georges Clemenceau. In 1864, Taine helped launch curricular reforms at the École des Beaux Arts, the most prominent art academy in the world at the time. His explanation of "modern" painting proposed that art was an autonomous form of knowledge with distinctive contributions to make to contemporary society. Clemenceau further developed these principles using the work of impressionist master Claude Monet to define how experimental painting expressed the ethos of modern democracy. In Chapter 2, I sketch the movement of these ideas west to the United States. Artists throughout the country, including California, traveled to Paris to get a "scientific" education in modern art. By the beginning of the twentieth century, those ideas were being adapted to the U.S. educational system. If this was a national development, the lack of a centralized art market or art press in the first decades of the twentieth century meant that painting in the United States was still marked by strong regional schools, and the Americanization of modern art followed different paths in different sections of the country. The discussion of what may have been distinctive, though probably not unique, about the California modern tradition hinges around the figure of Sam Rodia (1878–1965), architect and builder of the Watts Towers. For many mid-twentieth-century artists living and working in the state, Rodia was the quintessential California modern artist, a position that this book adopts although for dramatically different reasons. Given that the story of modernism in the Americas is usually told as one of transmission westward, the argument stresses that even if Rodia came to the United States from across the Atlantic, he discovered the principles of modern artistic expression as he engaged the life and values of his new home, a factor not uncommon with other immigrant artists such as Joseph Stella, Knud Merrild, or Willem de Kooning, but indisputable in Rodia's case given his absolute lack of formal art training.

Chapter 3 focuses on two important characteristics of California society as it developed between 1850 and 1950: the state's relatively high number of residents enrolling in colleges and universities and the relatively prominent place that women played in the development of new cultural institutions. Underlying the social experiments of "universal higher education" and new conceptions of proper gender roles were cultural shifts that promoted ambitious ideas about culture and its role in modern society. Chapter 4 explores the implications of the intersection of these developments in the early work of a mid-twentieth-century abstract painter, Jay DeFeo (1929–1989). With ambitious ideas and

unquestioned technical mastery, she developed an austere but spectacular sculptural style that attracted national and international attention. A particularly talented product of the state's commitment to widespread university education, she began her career when the surest form of support for contemporary painters came from artist cooperative galleries, which provided both community and sites for exhibition. The intellectual independence coop galleries provided, however, locked artists into a preprofessional situation and limited how effectively California artists could perform on a national stage. As Chapter 5 argues, this disjunction grew wider with the shift in attitudes and practices associated with the "postmodern." The continuing growth of art programs within higher education however provided a stable alternative path to professionalization. Humanistic education proved better able to support a broader range of work than either local galleries, which were usually short-lived, or the more prestigious system of publicity and commerce centered in the museums and commercial galleries of Manhattan. Indeed the academy has been a foundational pillar of contemporary art as understood today at the beginning of the twenty-first century. The growing dependence of art on higher education is particularly clear in California because the state has been the nation's unquestioned leader in expanding access to universities and colleges.

Chapter 6 discusses the development of the assemblage movement in the state after 1945. Artists after World War II increasingly began to think of artistic practice in terms of constructing objects rather than image composition. In this regard, the example Sam Rodia provided with his towers in Watts proved particularly attractive to many California-based artists, and assemblage art, centered on the use of found objects, either fabricated or natural, was widely practiced in the state from the 1940s to the 1980s as artists developed a newer postmodern understanding of who they were and how their work could contribute to better understanding contemporary life. The styles and subjects of assemblagists were diverse, but critics at the time understood that work in the genre shared a need to comment on life in the United States, to break down boundaries between subject and object, reality and fantasy, life and art, literature and the visual arts. Unlike comparable work in New York, where objects incorporated into art had been selected more for the formal possibilities they offered, assemblage in California was primarily an art with content.

I link this effort to expand expressive potential by expanding the media appropriate to use for the production of art objects to one artist's campaign to go beyond the limitations of contemporary art practice that had developed during a process of professionalization and institutional growth. Chapter 7 reviews the work and ideas of Noah Purifoy (1917–

2004), one of the most influential African American assemblagists to have worked in the state. He served as founding director of the Watts Towers Arts Center, where he used his position to formalize a people- and community-based approach to art that he thought would be more relevant to the needs of the African American community. In the process, he worked to define and refine the values he believed to have been the essence of Sam Rodia's legacy. Purifoy devoted much of his professional life, including eleven years working at the California Arts Council, to establishing an institutional basis that could complement, and as necessary counter, the centering of professional practice in the visual arts in art schools, museums, and commercial galleries. His career was marked by a valiant effort to develop community-based art into a secure institutional niche that could complement both commercial galleries and educational institutions and in the process redirect artists back to the challenge of addressing their work to a larger, uninitiated community, that is to a public that was not necessarily already initiated into the professional practice of art as a knowledge-based discipline.

The ideals that Rodia, DeFeo, and Purifoy articulated and exemplified proved (and remain) compelling to many artists precisely because they provided models for intellectual and moral independence. Each stood somewhat outside the trajectory of institutional realities and thus each in effect offered a critique of how culture was being organized in the state during the twentieth century. Sam Rodia relied on property rights and willpower to reach out to strangers passing by his home with his vision of a reconfigured city that must have seemed wondrous to some and simply weird to many others. Emerging out of the working population, he had no connection to the networks of modern artists who might have supported him, provided that an artist with no formal training could find a common language with those well versed in the traditions they wanted to join. Jay DeFeo entered the professional world twenty years later. She was quickly part of a network, or "community," of artists, friends, and critics, but the ad hoc activities could not provide stable support. To survive, she had to professionalize into the institutions that actually had resources, and she became a teacher in a local college. From that basis, other aspects of her professional career fell into place, and the ambitious ideas that had made her interesting as an emerging artist were contained within a replicable situation. Noah Purifoy entered the professional world twenty years after DeFeo when he committed himself to building a black arts movement. He moved within a large multiracial network of artists, but the institutions he faced had limited room for artists of his background or his concerns. He spent much of his life striving for a more open and pluralized profession with the capacity to sustain a broader variety of participants. Purifoy battled a

form of social production that was alienating to him with alternative ways of working, not with criticism alone, not even primarily with criticism. He understood that there had to be structures available for alternative ideas to provide patterns of reproducibility.

The democratization of cultural legacies inherited from aristocratic societies with well-defined beliefs in the superiority of patrons gifted with good taste and of genius artists miraculously able to articulate humanity's highest ideals has depended upon an uneven but continuous expansion of who is able to express their ideas about the world they have inherited. The struggle to develop a public culture that promotes communication rather than marginalization or division is today an important aspect of much contemporary art. Chapter 8 examines current interests in "borderlands" art and the role that plastic artists in both Californias (U.S. and Mexican) have assumed in dissecting the different cultural meanings surrounding the international border dividing societies that have been closely integrated for more than two centuries. Border art provides an excellent, but in no way unique, example of how intensification of formal techniques strengthened explicitly political statements by artists who felt equally passionate about their craft and about the world in which they lived.

With the border as with other issues, Californians relatively early experienced social realities that later became broadly typical of contemporary life in most wealthy nations: expansion of higher education, broader participation of women in social and cultural life, development of a knowledge-based economy, relatively fluid social mobility accompanied by the continuation of racial hierarchies, broad racial and cultural diversity as a result of global labor migrations. Likewise, the dynamic linking of inclusion and exclusion in the development of the state's cultural life provides an excellent example of unresolved tensions found elsewhere as well. The success of California in overcoming its provincial origins as a site for resource extraction suggests that a model of the world divided between a few cosmopolitan centers surrounded by layers of increasingly backward hinterlands might someday be replaced by one in which talents and resources are widely dispersed across the world in overlapping networks of shared concerns and projects. The outlines of a culture consistent with that possible but still uncertain future might be discerned in the struggles narrated in this book to expand the voices and the visions able to contribute.

Older artists, who can remember the days when schools, museums, and magazines all operated on a smaller, more intimate scale, often speak nostalgically of when art was a "community," when the only people in museum galleries would be other artists and every show felt like a family affair. Institutional growth inevitably has fostered depersonaliza-

tion. It has increased the power in the hands of curators, who demonstrate their professional status as historians and critics through the exhibits they organize. Increased funding and expenses has also increased the power of trustees, typically wealthy patrons with an amateur's love for modern or contemporary art. Trustees often defer to the judgment of directors and curators on specifically art-historical questions, but their personal, occasionally idiosyncratic, enthusiasms for specific artists or types of work remain a factor in what museums exhibit and acquire.

Democratic access and professional standards need not be antagonistic, even if in most local situations their negotiation has been difficult. The more highly developed art organizations are, the better they support both artists and their publics. Well-developed arts institutions have resources to provide artists adequate time for their work. Collective discussion deepens the questions with which artists grapple and provides a more sophisticated theoretical framework for how they pose and execute their work, leading to new efforts that more precisely intervene in the most puzzling and troubling questions of the day, the challenges that irritate most and therefore are deeply in need of imaginative release. By the end of the twentieth century, the plastic arts had become an integral part of intellectual life in the United States, as well as most other countries. Despite more challenging work being presented to the public, attendance at museums focused on modern and contemporary art has grown dramatically.

At the beginning of the 1990s, the San Francisco Museum of Modern Art reported approximately 300,000 annual visitors. In 2004, annual attendance had jumped to nearly 775,000. Membership in the museum increased from 13,000 in 1991 to 57,000 in 2004.[16] The scale of increase is not unusual—comparable growth occurred at similar institutions across the country and around the world. Some contemporary art exhibits draw impressive numbers of visitors, as in 2003 when Olafur Eliasson's *Weather Project*, a series of installations inciting meditation on weather's role in cultural geography in general and on global warming in particular, attracted a "blockbusting" two million people to the Tate Modern in London.[17] Audience surveys done for the San Francisco Museum of Modern Art indicate that their public has a higher than average rate of college education, and growth during the second half of the twentieth century in professional employment requiring advanced degrees partially explains why museum attendance has steadily grown since World War II. So does the expansion of trans- and intercontinental tourism. Undoubtedly, many reasons have been at play, not the least of which has been an increased ability of art organizations to publicize their activities, to ascertain what different publics might be interested in

viewing, and then to employ the staff needed to make a visit comfortable, informative, efficient, and hopefully thought-provoking.

The inclusive and exclusive sides of modern and contemporary art practice have long existed in tension. The issues of whose work is exhibited, what range of content is allowed, and what are acceptable frameworks for discussing new work have a long and contentious history. Those on the outside have had to challenge reigning standards by raising questions about *who* determines what is important about art, *whose* aesthetic becomes normative, and *whose* interests have benefited financially, institutionally, and ideologically from that aesthetic. The introduction of new participants into an institution has not changed these basic questions but it has increased the perspectives included in the debates and made the process of negotiating a range of outcomes both more complicated and potentially more responsive to a broader range of society.

Since economic and aesthetic issues are not separable, the examination in this book continuously moves between art, intellectual, and social history in order to reveal the correlation of overlapping sets of social relations and the subjective horizons they provided for artists responding to the complex set of opportunities and limitations they found as they tried to craft work meaningful to others. The study does not provide a comprehensive account of major figures, movements, and tendencies in modern and contemporary art. The episodes presented allow for a discussion of the historical relation of artists, the institutions that support the practice of art, and the public. Following the course of nearly 150 years, the chapters explore the intellectual and practical conditions shaping the formation of artists' goals for their work; contesting ideas over art as a form of knowledge; the relationship between the expansion of institutional support for visual art and efforts to purify media of extraneous influences; factors promoting the pluralism that has marked artistic practice since the 1970s; the emergence of new media that overturned the supremacy once given to image making as the defining aspect of studio art; and the relationship of manual and performative knowledge at play in the art objects themselves to the cognitive knowledge that governs critical evaluation. An argument about the larger implications of expanding the roles artists and their work have played in modern U.S. life emerges from the juxtaposition of the social, institutional, and subjective domains drawn from a history of mid-twentieth-century cultural shifts, some of which took material form in paintings, assemblage constructions, and performance art; others in the decisions people made about the most intimate aspects of their lives; and still others, perhaps the most important, in developing institutional

structures in higher education, museums, and community-based arts programs.

Each of the levels I treat is distinct if overlapping. Their interrelations are not causative, though it is unlikely that changes in one are without "resonances" (what might sometimes be described as "effects") in other domains. Each change, regardless of domain, can be viewed as "syllables" of social relationships given that no domain is ever experienced in isolation. Syllables are by definition fragments, simple and repeatable and possessing the potential of combining into increasingly complex statements, sometimes so complex that they approach a state of indecipherability. The act of faith is the assertion of a grammar that transforms an isolated event into a "syllable" of visual vocabulary, economic expectations, or family relations; that is, into a fragment of a larger whole that is always imaginary but nonetheless demonstrably real.

How could there be any single history of any phenomenon without in effect isolating one fragment as determinant of the complex? While language grows from structures that facilitate the exchange of meanings, language is also always an ongoing performance in which variations continually emerge. Given that we communicate through relatively limited systems, any given expression has a high likelihood of falling short in conveying what the speaker hopes to communicate. Another variation is tried, an effort to short-circuit the limitations inherent to all forms of expression, whether speech, images, gestures. The plastic arts have remained important because they escape the particular limitations of verbal languages to convey more direct sensory experiences that, if successful, stimulate further efforts to throw off the experience into words that themselves, however deficient or limited, might miraculously bring into focus aspects of contemporary life otherwise stuck in the realm of ineffable feelings.

Chapter One
The Case for Modern Art as a Distinct Form of Knowledge

Hippolyte Taine, "Philosophy of Art" (1864)

The foundations for a newly conceived institution of art developed in France during the second half of the nineteenth century, although observers in other countries quickly absorbed and reinterpreted new ideas and new practices that took root first in Paris. After the innovations of painter Gustave Courbet and poet Charles Baudelaire, overlapping and disparate modern movements increasingly focused on how language, visual images, sound constructions could communicate anything at all—a development that released art from the responsibility of presenting cohesive social myths and shifted creative focus to a more elusive effort of analyzing the psychological and social factors shaping consciousness. The arts developed into autonomous intellectual practices as practitioners explored how the basic building blocks of their media could incite ideas. Students from around the world flooded into French art schools because they provided the most consistent and reliable introduction to a conception of the plastic media as a distinctive source of knowledge about the world. The popular image of modern art has long involved stereotypes of bohemian rebellion against bourgeois society, but on the contrary, modern art emerged as an institution during a long process of teachers, writers, politicians, and artists trying to understand what new culture ought to flow from the advances bourgeois science, industry, and morality had generated. If art were in fact a distinct form of knowledge, education would be absolutely central to its rebirth in modern societies. The artist might have a special role in the creation of what in the twentieth century would ultimately be known as "middle-class culture," but the artist could not be a theoretical speculator. The artist's *manual* labor revealed truths about sensation that critics and philosophers then explained, without reducing the con-

tinuing importance of a direct experience with the objects that artists had created.

In his lectures of 1864 at the École des Beaux Arts, "Philosophy of Art," philosopher and art historian Hippolyte Taine articulated an early, particularly clear, and influential statement on the foundations for modern art as a distinct form of experimental knowledge. Taine assured his audience that the mathematical laws of sensation provided the basis of a truly modern art that the age demanded but which did not yet exist. Practitioners in any medium would break free of both tired convention and novelty for its own sake by discovering the "scales" that would assure them more formalized control over the conditions of experience.[1] I have used the English word "scales" to translate *gamme*, the word he actually used, because he based his discussion first on music before addressing other media. However, *gamme* is a word with broader usage, referring as readily to the painter's palette, the light spectrum, or any organized arrangement of sensations, for which English speakers might use the less technical cognate "gamut." Taine's selection of the word *gamme* served to shift attention from individual signs and the referents they invoked to a process of meaning formation grounded in the systematic relationships linking sensations.

Taine's concept of the scale related to new ideas about language gaining ground in France in the 1860s. The noted linguist Michel Bréal, holder of the chair in comparative grammar at the Collège de France, introduced the concept of value to describe how words in any given statement gained their meaning primarily from association with other words, both those actually used and those conspicuous by their absence. Communication of complex ideas was possible only because every sign had multiple significations. Speakers highlighted some associations over others in order to limit possible interpretations to those values relevant to the exchange of purposes and feelings that motivated their acts of expression. Predication or the assignation of attributes was the fundamental characteristic of language, not signification. Words pointed to possible meanings but they failed to specify anything until they were placed into propositions that stated one's response to the phenomena in question.[2]

For painters, a corollary of Taine's foregrounding of the *gamme* as the nexus of a scientific approach to sensation was a startling reversal of the step-by-step progression from line to volume to color in the construction of a painterly reality. This method had long been taught as the basis of art in French painting schools, including the École des Beaux Arts, where Taine had just become professor of aesthetics and art history at the time of his lectures. Instead of starting with a goal of creating an illusion of mimetic solidity for represented objects, Taine's emphasis

might suggest to artists that they begin by identifying the sensational ranges relevant to their painting, for in that range lay the reason why human vision interpreted some sensory inputs as solid. Careful contrast of highlights and shadows gave way to color modeling based on the construction of a color key that established for any given painting the relationships of the hues used.[3] Whether sensory gamuts in painting reproduced what an artist perceived directly in nature or expressed interpretive states of mind was a question that quickly arose and ultimately divided the postimpressionists from the impressionists.[4] In neither case, if we follow the lead of Taine, is the subjective state distinct from a modern commitment to understanding the processes governing sensation. Indeed for Taine, the problem with the culture of the first part of the nineteenth century had been its narcissistically subjective character. It failed in expressing the nature of the modern age because it separated sensation from reason, response from description, through an emphasis on spectacular effects aimed to stimulate the sentiments.

Georges Clemenceau on Claude Monet (1928)

Taine's argument that modern art was a distinct form of knowledge and thus could perform a sober social role informs the appreciation of impressionist master Claude Monet that Georges Clemenceau published in 1928 during the installation of the *Nymphéas* at the Orangerie two years after the painter's death. Clemenceau had been prime minister of France from 1906 to 1909, when he earned the nickname the "Tiger" for his fierce repression of strikes. In 1917, he returned to lead the nation in its war with Germany with an uncompromising program of total mobilization and sacrifice. He was also a man of letters who was an intimate friend of poets and painters. During the war, Clemenceau ensured that Monet had supplies and materials to continue his work unimpeded, and he even secured train space for transporting Monet's canvases. When the war ended in November 1918, the painter promised to donate two large panels of water lilies to the nation as an act of thanksgiving for France's victory.[5] For Clemenceau the donated paintings assumed a sacred status. They expressed the values that the nation had defended in the war and exhibited in particularly clear form the state of mind that gave modern democratic societies their special character.[6]

Monet's accomplishment, Clemenceau said of his deceased friend, had been to give his fellow citizens a "representation of a state of emotive perception that permitted us to assimilate new aspects of universal energies, allowing an improved comprehension of the world and of ourselves along with it."[7] Monet surpassed "everyday vision" by leaping past

the objects of vision to see the process of vision itself. Clemenceau affirmed the scientific detachment that Monet had made the basis of his life in a famous anecdote that describes the painter's response at seeing his first wife, Camille, lying on her deathbed. Clemenceau reported that Monet told him that as his eyes fixed on her, he began mechanically to examine the new colors that death had brought to her face. His attention focused on the ranges of blues, grays, and yellows he saw emerging. It would be natural to make a final image of the woman he had loved, but the color changes sparked an "organic automatism" deep within him. His reflexes took over and he threw himself into an "unconscious operation" to capture the novel experience before him. Thus, Monet concluded, he was "the beast that turns his millstone."[8]

Monet's self-characterization is not simply pathetic modesty, at least not as Clemenceau will develop his theses on the role of modern art in the republic. From the juxtaposition of brute labor and refined scientific sensibility flows Clemenceau's declaration that Monet had exemplified a new type of "superior man."[9] In the modesty that the anecdote inscribes is the morality of the new era, a morality of sacrifice—extending even to the acceptance of personal limitations that can miraculously be transcended through mastery of one's craft. In search of a knowledge that will liberate productive capacity, one must subordinate personal sorrow into a hierarchy that establishes the superiority of dedication to one's work.

The completed painting *Camille Monet on Her Deathbed* (1879) reduced Camille into an object of Claude's passion for knowledge (Figure 1). The painting enacts with equal force an objectification of the painter into a machine. Monet's eye had become nothing less than the entire man. "Retinal sensibilities" captured all his intelligence and hopes, they took control of his hands. This does not mean that the sorrow he felt had been suppressed. It united with reason and transformed into a higher mental state that Clemenceau called "une ordre sensationnel," a structure governing sensation.[10] Grief and confusion did not vanish, but the powerful feelings the death of his wife unleashed could become tools for looking with greater intensity at the person he had lost.

For Clemenceau, Monet's submission to the ethos of work revealed the play of supreme harmony "in which we find an interpretation of universal correspondences." The emotional vibrations that Monet captured corresponded to the underlying order of the external world.[11] His yoking of emotion to rational curiosity allowed a body of work to appear that helps viewers reorganize their own sensational responses into an emotional state consistent with what modern science had revealed about the structure of the cosmos. His works prepared their viewers to live in harmony with science.

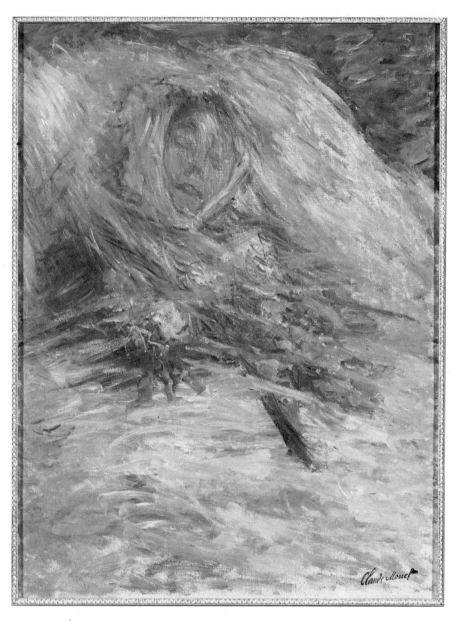

Figure 1. Claude Monet, *Camille Monet on Her Deathbed*. Oil on canvas, 1879. Courtesy of Musée d'Orsay, Paris, and Réunion des Musées Nationaux / Art Resource, New York.

To uneducated sensibilities, the universe appears as a "storm of waves that crash against each other and intensify . . . through the perpetual retreat of lost hopes."[12] Ignorance reinforces despair as humans are whiplashed by the flux of their emotions. Modern art promoted *disponibilité*, another key word in the criticism surrounding the new painting. The word signifies an openness and availability that becomes possible when one strives to disengage from the continuing onrush of immediate feelings. Science is not a dogma that replaces superstition. It puts the mind in a state of readiness by subordinating the flux of emotion to reason and productivity. Intelligence and discipline do not efface but refine and deepen emotion. Personal feelings are heightened through their redirection into a harmony with reason and will. Monet had shocked all those locked in the habits of previous eras, but as far as Clemenceau was concerned his friend had allowed a new personality to emerge that was responsive to the "truth of movement." Those who accepted the message that the nation preserved in the sanctuary it had created for the *Nymphéas* experienced the beauty of form and color as a spiritual liberation from ephemeral emotional states.[13]

Clemenceau's interpretation is speculative and problematic, as he himself recognized. Nothing that Monet said in extant private correspondence or in public statements suggests that he had these intentions.[14] Clemenceau acknowledged that Monet was not a philosopher and that he did not generalize about the import of what he did.[15] Monet had limited his discussion of painting to the technical problems he faced, that is, the most practical questions reduced to the simplest and reproducible craft techniques. If Monet had philosophical insights to convey, as Clemenceau asserted, he did so with his hands in the crafting of objects, the meaning of which was wide open to others to interpret. Monet was indeed the beast at his millstone, mutely performing the labor that made him a superior man, that is to say, a representative citizen of the modern, republican world, whose actions tested the practical implications of his age's ideas.

Monet's refusal of theoretical speculation sets him apart and above other painters.[16] It is precisely his apparent mediocrity as a theoretical thinker that makes him a paragon, the representative man for modern France, the prototype of the accomplished professional whose expertise is not universal but specialized. The grandeur of his accomplishment demonstrates that it is labor and labor alone that establishes what might be called a secular form of grace. Correspondence of self and cosmos is possible. It is known, both analytically and sentimentally, through the fruits of one's sweat and the value they provide to one's fellow citizens. The celebration of Monet as the representative modern man enunciated a central value of a republican liberalism already implicit in Taine, but

which could not become dominant until after 1871 and the foundation of the Third Republic. Nineteenth-century democratic ideology accepted as self-evident that there need be no inherent contradiction between universal law and individuality, provided that science, labor, and a sense of duty were in balance. Democracy is the best possible way of governing society only if individual psychology follows universal laws. What society must ensure if it is to be just and stable is to draw men away from the particular and reinforce the universal aspects of their being. Through a union of science and labor they can transcend the local. Each individual can achieve a discipline that allows for a release of cosmic harmony through his efforts. Democracy as the organization of men's universal attributes would prove through its stunning successes that it was the most perfect form of society.

For Clemenceau, Monet's paintings were practical proof that a balance could be achieved, while the paintings themselves have the virtue of revealing to those appropriately disengaged from ancient prejudices the necessary link between individual, social, and cosmological states. Monet's single-minded focus on his craft and his refusal to philosophize offered convincing proof that it is the average citizen, not the romantic hero, who is the ideal modern man. Knowledge was a functional requirement of democratic organization. In the work that citizens performed for each other, the individual and the universal synchronized in professions that focused interests and activities by establishing a limited set of criteria for what could be useful knowledge. Each person found his (or her) individual realization by accepting and working within those limits.

Clemenceau asserted that sacrifice is the ultimate test of every citizen's integration into the harmonies that govern all natural processes, social as well as cosmological. He quoted Brutus's farewell to his soldiers as they depart for battle: "It is necessary that we *all* go forward to the enemy; I cannot say that we will all return together." Contemporaries reading this knew well that Clemenceau had been an absolutely unforgiving war leader. He assumed leadership of the nation at a point during World War I when it was not clear how much longer France could endure. Hundreds of thousands of casualties had failed to turn back the Germans. Mutinies were spreading along the front, unrest and strikes plagued munitions factories, and defeatist attitudes appeared at the highest levels of government. Clemenceau had long been critical of the army's reliance on machines and bureaucratic organization, which he argued inevitably led to demoralization as long as the opposing sides in the war were in stalemate. In his first address to the nation as war leader, Clemenceau asked France, "Is it through the superiority of our arms that we will attain the final decision?" No, he replied, "what is the most marvelous machine worth if man is not at the lever? We shall conquer

because it is our will to conquer, our will to the very end, whatever may happen." Clemenceau refocused the nation onto a program of total war until victory or defeat and quieted growing popular opposition to the war by prosecuting and imprisoning national leaders who had vacillated.[17] The republican serves the common good with his life, or the republic succumbs to the ever-present dangers of demagoguery, corruption, absolutism, and despotism. War is the ultimate test of the virtue of a republic's citizens, but victory depends upon a taming and organization of individual will into a collective power capable of exacting every sacrifice required to prevail.

Mastery of one's craft also involves sacrifice, and it is Clemenceau's duty to insist that his fellow citizens recognize their obligation to submit and voluntarily accept the limits that societies have ever required of its members. The modern genius does not develop all of his talents. He selects his area of work and subordinates all his faculties and skills, every aspect of his life's conduct, to "incessant labor" in one field and one field alone. He develops an "interpretive intelligence" and a "tension of will" that is honed by the unique challenges of his discipline. Monet, "despite the mediocrity of his cosmic condition," proved himself and "the average man, by virtue of his labor," to be the genuine advanced guard of the modern age precisely because he tended to his work without moralizing and let the products of his labor speak for him.[18]

The Modern Artist as Representative Modern Man

Six decades earlier in 1864, Hippolyte Taine's *Philosophy of Art* posed several incomplete, general propositions about the functions of art in modern societies. Though he called for a modern art, Taine could not describe what it would look like. Over the succeeding twenty years that he served as professor of aesthetics and art history at the École des Beaux Arts, he converted his course lectures into lengthy books on the art of ancient Greece, the Italian Renaissance, and Netherlandish painting. His most famous book on culture was a history of English literature, where he developed his perhaps still widely held if mechanistic position that art was a product of geography, social relationships, and political conditions.[19] When he turned to the art of his own day, his imagination faltered. In "Philosophy of Art," he could do no more than proffer a few general specifications. Modern art would present the nobility of contemporary life. The artist's vision should awaken a sense of moral connection, what he called "le sentiment vrai," which his American translator rendered as "natural feeling."[20]

Two obstacles stood in the way of a "true feeling." These obstacles are really one and the same process with corresponding effects in the life-

cycle of the artist and in the historical development of social taste. In the first phase of his career, an artist "sees things as they are" and studies them "minutely and earnestly."[21] He overcomes blocks built into existing available artistic languages and provides his viewers with a thrill of renewed sensation. But with public acclamation, the artist thinks he thoroughly understands the media he uses. He has developed personal rules in the course of successfully penetrating preexisting rules to reattain the valid experience that preceded their origin. These practical communicative measures become more and more important until the experience transmitted is no longer "true" but "clever." As an artist achieves success, style replaces perception and feeling ("true sentiment"). This is the period of mannerism and decline that every great artist endures after he has developed his own idiom. His interest shifts from sensation to his own system of representation, containing a handful of forms that he uses entirely conventionally.[22]

The same curve appears across generations in the histories of nations. France had achieved the most perfect forms of expression in all of its arts during the reign of Louis XIV following the formation earlier in the seventeenth century of the academies that succeeded in establishing rule books governing every art.[23] Convention readily replaced experience, because as his later book *On Intelligence* argues, thought-through systems of representation provide a supple and predictable set of signs that can effectively guide action provided nothing changes.[24] For the following two centuries, French artists struggled to express themselves honestly in formal languages that increasingly alienated them from nature. Since art, like every science (that is, in Taine's framework, formalization of sensation into an abstracted system of representation), drew its strength from nature, such a state of affairs had to break down. In all previous epochs when convention had dominated, a "great school" emerged that swept away ancient rules with the power of the emotions it unleashed—these revolutions in the representation of sensation would provide the focus for Taine's subsequent writings in cultural history. French culture in the mid-nineteenth century had reached a similar breaking point. A revolution in the arts had to occur that would sweep away conventionalized forms of representation and replace codes of good taste with new standards that assessed art by its ability to provide the public with "true sensations."[25]

Taine's celebration of a revolution in the arts coincided with official policies of his government and was never supportive of the experimental cultural movements already under way in Paris. "Philosophy of Art" served as his inaugural lectures when he assumed his appointment as a professor at the École des Beaux Arts. He joined the school's faculty a year after the ministry of education had revoked the school's charter,

taken direct control of the institution, and initiated a series of reforms in its practices and teaching methods. The decree that instituted these reforms specifically attacked the classicism that the school had long promoted. Instead of offering restatements of established truisms, art, the decree's authors stated, should be geared to the practical tasks of society. Instead of aiming at developing genius, the curriculum should provide basic instruction in techniques that anyone could learn with profit. In the course of this upheaval, Taine's predecessor, Eugène-Emmanuel Viollet-le-Duc, was dismissed, and the minister of education personally chose Taine to take his place. Taine's use of the word *gamme* to highlight what he considered distinctive about a modern approach to art pointed to simplified, mathematically based languages of design that would make the arts more serviceable for an industrializing society.[26]

Taine's series of lectures on the scientific basis of art was part of a larger official effort to transform the practice of art and make it more "modern," a word that Taine used frequently but refrained from defining until the very conclusion of his book. His emphasis on such aspects of sensation as the *gamme* underscored the arbitrary conventionality of academic rules by opposing to them another convention based on a positive conception of science. His explication made clear that he did not think that the new art would simply be a photographic or stenographic reproduction of possible experiences. The totality of experience is chaotic, he noted, which is why society needs artists: they provide a shared conceptual framework for experience. That framework ought to be based on direct observation of the world and ought to transmit to the public greater understanding of the forces shaping social action. Responsibility to living society rather than to a dead heritage would guide the choices a modern artist made.

The artist presents only a "portion" of the object of his knowledge: "the relationships and mutual dependence of parts."[27] Recognition of these relationships and the structures or *gammes* upon which they rest provided a commonly shared practical experience that unified a nation. An effective aesthetic representation clarifies the "essential condition of being in the object," that is, the quality from which all other, or at least most other, qualities are derived.[28] The successful work of art provides a sensation that feels fresh, the logic of which is revealed through the inscription of value (contrast with possible pairs), organized in a systematic hierarchy, the *gamme* that makes sensible ("le sentiment vrai") the priority of causal factors in an experience. Hierarchy tells one what to do, value explains why, and sensation establishes the validity of an interpretation.

This schematic system corresponds to the fundamental schema of nineteenth-century psychology in both the French- and English-

speaking worlds, a framework that Taine reproduced without dissent in his subsequent book *On Intelligence*. The human mind has three overarching faculties: sensation, reason, and will. All three need to be aligned for effective interaction with the world. "Freedom" (*volonté* in the French original, a word that elides with will or agency) is dependent upon the ability of the mind to draw logical conclusions from its experiences. Should any one of the three faculties become too prominent, effective action becomes increasingly impossible.

In Taine's terms, the power that classical representational systems had achieved stifled a fresh experience of the world and hence froze the will in its ability to interact with the continuous challenges that sprang forth in a world under constant evolutionary development. Everything that stood outside modes governing experience appeared unreal, no matter how palpable. This stimulated an unhealthy fascination with fantasy, which was simply a suppressed reality reasserting itself as ghostly apparitions; or, equally pernicious, the quest to refresh experience led to an excessive attention to the will, as if the blockage derived from an imbalance of sensation and rational framework could be overcome through impulsive action or emotional discharge. Taine thus characterized the world in which he lived as under the spell of Faust and the "insatiable and sad" Werther. Taine repudiated equally the dead hand of academic classicism with its blind respect for the glories of the *ancien régime* and the subjective excesses that had emerged in response. The literature and art that the first part of the nineteenth century had produced had been effusive reactions against control rather than a rethinking of standards appropriate to an era that had gained the benefits of science and industry.[29]

Taine's observations on Goethe's two most famous heroes appear as the book outlines the essential character of art, that single attribute that governs all aspects of its production, distribution, and reception. Art in all times and all places serves, Taine claimed, to align sensation, reason, and will in forms that exemplify the "representative character" or ideal personality each society develops to express its most salient values.[30] The artist brings forward the sounds, the forms, the colors that make this personage sensible and an object for imitation. The alignment of inclinations and faculties is clear and reinforces through the power of recognition of an ideal self what a man's aspirations ought to be and how he ought to behave naturally to be in harmony with the structures of his place and time.

In Greece, this ideal was found in the naked youth exuding physical and mental alertness. In the Middle Ages, the representative man appeared in the contrasting forms of the ecstatic monk and the amorous knight. In the perfection of Louis XIV's day that still hung over mid-

nineteenth-century France, the ideal took shape as a courtier attuned to the minutest variations of expression, honor, and policy. Imitation Fausts and Werthers presented their publics decayed forms of earlier ideals. Romantic artists had failed to comprehend the modern mind emerging all around them.

The three attributes that Taine argued characterized the ideal modern man corresponded to the then-scientific conception of the three fundamental mental faculties:

1. In the modern man, sensation was governed by positive science; this led to a more profound investigation of and accounting for the facts of experience, promoting daily discoveries and an infinite growth of experience.
2. The modern man was a worker disciplined by reason; submission to scientific method led to increased productivity, as well as the spread of communication and transport.
3. The will of the modern man was directed by a sense of personal limitation that inculcated a rational and humane approach to political life that protected talent, favored order, and succored the feeble and poor.

In short the modern representative man embodied science, labor, and humanitarian morality. Taine concluded his celebration of the established order with a prediction: this new modern man had finally found a stage for effective deployment of his talents as a result of the revolutions of the late eighteenth and early nineteenth centuries.[31] The second, cultural phase of a broader social revolution had not yet begun, but would as young artists awoke to the new beauties and truths emerging from the triumph of modernity—when the arts worked to propagate a sensibility appropriate for scientifically trained, productive, engaged citizens who knew how to subordinate their sensations and emotions to an ethos governed by labor.[32]

Clemenceau's apotheosis of the stolidly middle-class hero Claude Monet was a continuation of Taine's charge to artists to create a genuinely "modern" painting and effected a reconciliation of official and avant-garde art. Taine had no intention of promoting the trajectory of cultural experimentation that flowed through the impressionists and postimpressionists into the modern art movements of the next century. Nonetheless, his prescriptions established criteria for what modern art should do as well as the character traits of the ideal modern citizen. Clemenceau found in Monet a figure who fit those specifications, with the added twist that the ideal representative modern man was the artist himself, provided he was no self-dramatizing bohemian.

Monet's movement from self-taught painter to ideal modern man was not a sudden development. As the son of a common grocer Monet proved how effectively the revolutionary era had unleashed the creativity of the common people. In the 1870s, Monet's paintings of the contemporary urban scene attracted buyers with images of the spectacular new life the bourgeois revolution was bringing forth. At the end of the decade, however, his work fell out of favor as critics complained that he failed to present an idealized reality toward which people could strive. His sales falling, Monet left Paris to live more economically in the countryside. His interest shifted from representation of richly detailed contemporary scenes to capturing light and color, in effect to revealing the basic conditions of visibility. Monet developed a new working method that allowed him to work on several canvases simultaneously. He could record his initial observations and then draw out the fuller implications of his impressions. He had entered into what Taine defined as the mature phase of an artist's career: he standardized a language that could convey a predictable, semantic understanding of the world with the power to realign sensations so they were open to the modern world as Taine imagined it. His personal achievement provided a model for the work and attitude of a fully professionalized artist, whose basic activities, being based on an experimental method, contributed to an autonomous, self-governing institution of knowledge. The pleasures to be derived from engaging the work were becoming inseparable from the intellectual tasks the work undertook.

Critics drawn to Monet in the 1880s used two words in particular to characterize what set him apart from other painters, either academic or experimental. *Instantanéité* (of the instant, the moment) and *enveloppe* (envelope or covering) defined Monet through his ability to make accessible for contemplation the overall spectral qualities bathing a scene usually only for very brief periods of time.[33] Octave Mirbeau's catalogue essay for Monet's 1889 exhibition at the Georges Petit's gallery defined *l'instantanéité* as a method for identifying the light scales that allowed one to make sense of a scene. The values that constituted the scale of a scene were "seeded here and there." They changed so frequently that one was seldom aware of the role they played in determining one's emotional reaction. Monet's careful observation and selection allowed him to fix the values he found "in their exact form" so that an otherwise "fleeting" design might become available to all for observation. Monet understood, Mirbeau assured his readers, that in order to arrive at an interpretation of nature that was at once both more exact and more emotionally moving, one had to pierce the passing effects of time and make visible an underlying movement of harmonic values. Nature's

actions have powerful effects on the human soul, but they appear mysterious to those who have not learned how to perceive in the "instant."[34]

In *Les Débâcles*, a set of paintings capturing the devastating floods along the Seine during the winter of 1880, Monet vanquished terror as an inevitable response to natural disaster by concentrating on the shapes and colors presented to him in the raging river. The question what is the form of disaster? tames the emotional tides that danger releases and directs the troubled soul to the peace that generates an effective response. Likewise, Clemenceau asked, "What is peace?" and replied that it never meant the absence of conflict. Peace sprang from an ability to confront nature's capricious actions with the conviction that humans are after all conscious and capable of intelligent replies to disaster.[35]

Taine had identified modernity with careful observation of contemporary life refined by knowledge of the mathematical laws of sensation. His lectures directed painters to apply their formidable technical skills to a presentation of the world they saw around them. In so doing he reinforced the power of anecdote and sentiment in academic painting. Modern art would look something like the Italian and Dutch masterworks he had praised in his historical studies, only with contemporary clothing and machinery.

The impressionists pointed to another conception of modernity, one that was cognitive and revelatory of the lasting, underlying processes at play in sensation. Monet's practice remained grounded in Taine's conception of the modern because it united careful observation with a scientific conception of sensation. He could satisfy Taine's specifications of "modern art" more effectively than the reformed academy because his work demonstrated that there was no need for reproduction of what everybody lived with. What the public needed in order to become themselves "modern" was retraining in how to see what surrounded them. Reportage of the everyday scene reproduced the confusing emotions that the phenomenal had triggered. Vision, Clemenceau noted, was perpetually flowing from one impression to the next. Monet's paintings were invaluable because they transformed "the unseizable relays of Infinity" into forms that could be thought so that "the emotion of nature and its interpretation will be what it ought to be."[36]

Within the framework unfolding in nineteenth-century France, painterly craft was no longer to be seen as a set of valuable techniques for representing society's values and beliefs in pictorial form, that is, as a practice in service of others. Nor was the modern simply a question of expanded stylistic choices. Painting had new possibilities as an autonomous form of knowledge, with each painter striving to expand the potential of the medium to expand, and not simply express, human experience. The question remained open whether art was a record of

personal responses to the world, which might be exploratory and thus looking forward or looking back to articulate already existing ideas, or a developing technique with power to reveal truths about the external world that would otherwise be invisible. The tension between these two poles would continue for another century as new theories of art were closely linked to theories of how the mind works. Even if an artwork were simply an individual response to the world, that others could share that response and evaluate it was evidence that, as with democracy, universal laws governing the relationship of sensation, thought, and feelings must be at work.

Like every profession, modern art was developing into an enclosed, special environment that fostered development of a particular set of skills by positing a theoretical basis to the practice. Innovations in concept and technique occurred that would previously have been impossible or unthinkable. In fully developed professions, practical work flourishes because ideas develop in speculative games that can appear ridiculous if not incomprehensible to people outside the field. The so-called separation of art and society that accompanied the emergence of the modern arts movements might better be understood as a figure indicating the increasing division of social organization into knowledge-based institutions, into the professions that claim to deal with fundamental laws governing the human or natural condition. Professions provided the bridge synchronizing the individual with the universal in the field of work. If modernity were to result in progress, harmony was the enduring goal, the result of real knowledge being extracted from but then prevailing over the flux of experience.[37]

Chapter Two
Modern Art in a Provincial Nation

"Should Our Young Men Study in Paris?"

The linkage of painting with modern conceptions of knowledge found a particularly positive reception in the United States after the Civil War. Taine's *Philosophy of Art*, published in English in New York City shortly after the original French volume appeared, went through several editions, unusual, if not extraordinary, for a book of its nature. For decades following the Civil War, U.S. collectors, flush with fortunes made through industrialization and the developing mass consumer market, were particularly taken with modern French painting. They assembled the most impressive collections outside France, and U.S. museums remain the homes of many of the most important impressionist and postimpressionist works. American collectors strongly supported avant-garde culture in France, often to a greater degree than art patrons in Europe. Between 1885 and 1905, the three most important avant-garde galleries, Durand-Ruel, Vollard, and Bernheim-Jeune, each made over 50 percent of their total sales in their New York offices. In a letter written in 1896 to Henri-Edmond Cross, Paul Signac described a disturbing visit to his studio by prospective American buyers. They were uncommunicative to the point of rudeness. Signac could not figure out exactly what it was his visitors wanted. However, they surprised him by going straight to the paintings that Signac himself valued most highly. They bought his work, and their patronage left him free to pursue his individuality (as he put it). Signac urged Cross to get to know the Americans, for they had a deeper appreciation for modern painting than their French counterparts. Indeed, without American involvement, the history of French painting would likely have been very different.[1]

The appeal of nineteenth-century French experimental painting to Americans, unabated to this day, likely had deeper foundations than an association of the modern with a spectacle of consumption that T. J.

Clark has demonstrated to be an important aspect of what made the painting popular.[2] The pleasures of the bar, the dance hall, the circus, or the vacation spot provided subject matter for many lively works, but the quietude essential to much of the work, particularly that of Monet, probably the most admired French painter in the United States before Cézanne, points to a conception inseparably ideological and metaphysical that adds dignity to the valences surrounding consumption—and sets aside a special place of honor for those self-governed men who do their job and accept the personal limitations essential for continued material and moral progress.[3] The pleasures of modern entertainment are inseparable from the capabilities for productive excess inherent to modern social relations, but leisure stands as a point of conflict within a modern self-image that predicates the right to enjoy wealth upon hard work, self-control, and sacrifice. Monet's paintings of different light conditions playing over his own gardens, the haystacks of Normandy, the town of Le Havre, or the tourist attractions of London and Venice provided austere images that, however sensually delicious, linked creative imagination to a rigorous process of investigation.[4]

French culture presented a model for scientific and intellectual precision that Americans believed was unequaled, particularly when it came to unsentimental examination of the human body and spirit. In the nineteenth century, Americans had traveled to France to study in two areas in particular, medicine and the fine arts, with the latter growing in importance after the Civil War. Until the 1840s, young Americans interested in painting went to England to study. In the 1840s and 1850s, student interest shifted to Munich, Leipzig, and Italy. During the 1850s, France increasingly became the preferred site for advanced study. By the 1860s, French conceptions of art were so influential that being able to establish oneself as a painter in the United States without having studied in Paris and won at least one prize was unlikely. Particularly after the reform of the École des Beaux-Arts in 1863 and 1864, Americans believed that French schools had developed the most scientific, modern approach to the art of painting. American artists had to master those techniques and be recognized by acknowledged French authorities if they were to be accepted within the United States, where businessmen, their wives and daughters, and professionals in other fields had to make the most important decisions about their communities' cultural life. Community leaders seldom had formal training in either art or art appreciation, so that validation of an American artist from French experts made his or her evaluation at home easier and ostensibly more objective.

In 1880, according to Department of State estimates cited in a manual published by the Boston Arts Students Association, approximately

10,000 Americans were living in Paris, of whom 9,000 were enrolled in art schools.[5] Since the end of the Civil War, the same manual reported, approximately 3,000 Americans went over to France every year to study art. The art colony in Paris provided the most consistent, direct contact Americans had with France during the last thirty-five years of the nineteenth century. American art students came from all parts of the country and from all social groups. They included women as well as men; African Americans and Native Americans as well as whites; and talented young people from the laboring classes.[6] In 1882, for example, E. Boyd Smith, at the age of twenty-two, sailed from Boston to Paris to study at the Académie Julian, an epicenter of postimpressionist experimentation.[7] Since the age of fourteen, Smith had worked as an apprentice at Riverside Press, a lithography shop in Boston, one of the best in the country. He had been a hard worker and he had demonstrated clear talent. His employer, a Mr. Armstrong, offered to pay for two years of study in Paris, where Smith might win a prize and return home to set up a studio in Boston.

Shortly after arriving, Smith went to the Palais Luxembourg and saw a collection of "modern masters." Overwhelmed, he admitted the work surpassed anything he had imagined possible for its translation of the ideal into forms that he considered palpably real and sensual, without ever losing their purely intellectual qualities. The work confirmed for him that modern painting put on a fully scientific basis would soon surpass the glories of the old masters.[8] He wanted to master the smooth technique of his teachers without losing the ruggedness that he thought marked the best of American painting. The French masters could make one feel the reality of the ideal by translating the interior world into striking sensual forms. The price of their victory, however, was a loss of the "rugged sexual force" still visible in the physiognomy of Americans or in the wilderness beyond town and country. French painting could teach him how to present physical sensation with the utmost clarity, but he hoped to avoid the danger of submerging passion and sincerity within an intellectualized schema. Many of his remarks in his journal reflect his project to think through the conditions that might allow painting to convey the raw transforming power of nature he believed still visible daily in American society.

Smith decided that the interest the French government placed on supporting art was the single major cause for the exceptional quality of the work. He wondered how government support could be reconciled with popular democracy, for he also believed that government control over the arts was the single major cause of the dissolution of passion into acceptable conventions. Discovering the collection of prehistoric art at a museum in the nearby town of St.-Germain-en-Laye, Smith observed

that the power of French art must also spring from an understanding that art was "one of the most ancient if not the most ancient sciences." The most emotional moment of his stay, however, happened when he saw lithography plates he had himself made in Boston displayed at the Conservatoire des Arts et Métiers and described in the exhibition literature as among the finest examples of the new industrial arts being produced anywhere in the world.

Smith did well in school and returned home in 1884 at the end of two years of study with two first prizes for historical paintings he had done on the conquest of the American west—meaning upstate New York. His exhibitions in Boston received glowing reviews, but the number of artists working in the city had doubled since the beginning of the decade. There was no room for another Paris-trained artist armed with his diplomas and prizes. Smith and a young friend from Armstrong's lithography shop decided to go west where they could apply their talent and Smith's Paris prizes in virgin territory. After arriving in each town, Smith rented space in storefronts to display a painting and his Paris prizes; they found lists of the recently deceased and drummed up business for oil paintings based on photographs. They also did wedding and baby pictures. After nearly a year of itinerant life, the two young men arrived in Kansas City, Missouri.

Over the preceding decade, Kansas City's population had increased from 30,000 to 175,000. Paved sidewalks and electric streetcar lines had just been introduced when Smith arrived, part of the self-proclaimed campaign that the city fathers had embarked upon to make the railroad and shipping junction of the nation's cattle industry the "Paris of the Great Plains." That goal also required having art. Because of Smith's years in Paris, local business leaders hired him to be the first director of the Kansas City Art Institute. The *Kansas City Times* wrote that in appearance Smith was "a typical Frenchman" (the line drawing the newspaper ran with the article shows him with a moustache and goatee and sporting a floppy bow tie on his neck collar) and "if untiring and thorough work is any credit to a painter then he certainly deserves it."[9] The article continued that the museum was already comparable to collections in the eastern United States and in Europe. An amazing claim, but the principal treasures of museums (at least in the United States) were still plaster casts of ancient works, copies of the Parthenon statuary in the British Museum, the *Venus de Milo* from the Louvre, the *Discus Thrower* from the Vatican, the *Apollo Belvedere*, and the *Venus de Medici*. There were also plaster casts of works by Donatello and Michelangelo and other "modern" sculptors. New reproductive machinery and modern transportation meant that any city in the world could have a quality collection representing the masterpieces that constituted the heritage of Western

civilization. The casts were, for all practical purposes, indistinguishable as forms from the originals. The materials had not suffered the ravages of time, and the objects conveyed with greater clarity the intention of the sculptor and a sense of how the work must have looked when it had first been displayed.

In addition, the museum opened with a gallery of autotypes that reproduced the principal works of the most famous old master painters—Michelangelo, Raphael, Leonardo, Titian, Rubens—as well as more modern painters such as Gainsborough, Reynolds, David, Boucher, and Gros. Smith set aside one gallery in the art institute to show contemporary paintings. The philanthropic citizens who had organized the association began, under Smith's advice, to purchase paintings for an expanding permanent collection of work produced in the west. The first painting acquired was Albert Bierstadt's *Indian Summer in Upper California*. The newspaper was quite clear on this account: for Kansas City to become the business center of the Great Plains, the town had to become the art center of the region. Smith had been hired to help the city develop a thriving painting community equal to that of any other city in the nation.

Should our young men study in Paris? an anonymous writer asked in *The Arena* magazine in 1895. The author, a young woman from the United States studying painting at an unnamed school in France, understood that painters, like all professionals, needed to base their work on the most up-to-date knowledge. What the author wanted to know, however, was why the United States had not yet developed its own art schools every bit as good as those in Paris. Why had she no choice but to wrench herself away from home? Almost every teacher in every art school in the United States had studied in France. Their success as painters and as teachers put them in an excellent position to synthesize an approach to art that integrated American experience with the European legacy that Americans had inherited. John Twachtman and Robert Henri teaching in New York, Alice Kellogg Tyler in Chicago, Arthur Mayhew and Xavier Martínez in San Francisco were all equally in a position to define a distinctively American approach to art that would be universal, that is, based on scientific principles, but also responsive to the special qualities of national life.

The nationalization of American art that took place in the first half of the twentieth century did not involve a repudiation of French models. Many students continued to travel to Paris to study, but it was no longer a requirement for a successful career. The growth of schools across the United States provided stable income for artists as teachers, while the expanding commercial mass media offered additional income possibilities and, more important for securing recognition of the role art might

play in national life, a platform for reaching others with the idea that art could do much more than illustration. Museums and galleries oriented toward contemporary art, however, were still few and far between. Artists typically assembled together in associations that sponsored art fairs and exhibitions. Their ad hoc organizations promoted competition and discussion, but, aware of the importance of the work still done in France, they watched and reported on new art trends in Paris, while debating how to combine French "skill" with a supposed U.S. "ruggedness." The 1913 Armory Show in New York City provided a broader American public with its first opportunity to see firsthand a range of cubist, fauve, and futurist art from Europe, work that went beyond nineteenth-century experimental painting in no longer having the goal of presenting a recognizable scene. The organizers never imagined U.S. painters should imitate the new European schools, but they certainly needed more regular exposure to the new ideas expressed in the work.

Two years later, another, even bigger exhibition of contemporary art came to San Francisco for the Panama-Pacific International Exposition. As in New York, the cubist and futurist works in the exhibition elicited quick and ready reaction, much of it ridicule, while others saw new ways to think about the functions of art. Lorser Feitelson, later in life a pioneer in color-field painting in Los Angeles, saw the Armory Show as a teenager and came away excited by the idea of an art that so powerfully represented psychological processes. He determined he was going to Paris to study art, a goal fulfilled after World War I. He returned to the United States in the mid-1920s to settle in California, where he worked and taught for a half century.[10] Clay Spohn, who saw the San Francisco show also as a teenager, developed a new understanding of abstract painting as a form of invention. It was an understanding that appealed to him, for his brother was an inventor. Modern art was a way of aligning artistic practice with Thomas Edison, a lesson Spohn brought to his students at the California School of Fine Arts during the explosion of interest in contemporary painting following World War II.[11]

The Modern Moves West

In San Francisco, annual modern art shows followed the closing of the exposition. In 1916 the Modern Art Society of Los Angeles formed to sponsor exhibitions and promote public understanding of the new art. There was a desire to declare oneself up-to-date and contemporary, and "modern" captured that sense. Two decades earlier, in the 1890s, the word "new" had summarized hopes and fears about changes occurring in many aspects of life: the New Woman, the New Drama, the New Spirit, the New Negro.[12] By the 1910s, the word "modern" replaced "new,"

borrowed from twenty years of European discussions. Significantly, the new term referenced earlier seventeenth- and eighteenth-century debates between the Ancients and Moderns and pointed to the Janus-faced aspect of modernism as a particular way of locating contemporary change in time. If "new" pointed resolutely to the future and "contemporary" emphasized the immediate now, "modern" foregrounded continuity with the past while asserting the novelty of the present. The modern did not repeal or reject tradition but attempted a reincorporation and reinterpretation of older values into the expansive and expanding understanding of the world scientific investigations had revealed.

In the United States, for the first quarter of the century, "modern" was often more or less equivalent to "progressive." The organizers of the second annual exhibition of the Los Angeles Modern Art Society advised its members to ignore the scoffer who found it "easier to conform to the established standards than to keep his mind open to the results of modern experiment. . . . Being in the minority, the progressives must make up by sheer force what they lack in numbers. Happily the necessary force is usually coincident with the progressive mind, and Art does progress despite the weight of reactionary disapproval."[13]

After 1925, the word "modern," while retaining its general sense of contemporary and up-to-date, increasingly included the connotation of "individualistic." The modern person followed his or her personal quest, investigated his or her inner vision, refused to be judged by others. Thus to newspaper critics in San Francisco and Los Angeles, modern art became something difficult to comprehend, at best slightly bemusing in its lack of clarity, at worst to be linked with the collapse of family values associated with "modern love." The art page of the *Hollywood Citizen News* for 21 March 1934, juxtaposed its review of the Los Angeles Contemporary Art Association exhibition with an article describing the tragedy that resulted from two Pasadena couples deciding to enter into a "modern love" association. One of the wives no longer could tolerate the mate swapping and killed her husband before committing suicide.

The "modern," in this context, be it in the arts or in love, was no longer something genuinely American, but a foreign import from Europe that undermined the social glue powering the rise of the United States as the wealthiest, most powerful nation in the world. And yet what nation could be more modern than the United States? The association of "modern" with progress stressed the positive accomplishments that society had made with increased scientific knowledge and technical organization. Americans were not bound by unsupported tradition, but maintained a healthy respect for values that were part of their heritage. They subordinated individual desires to collective values and increas-

ingly found that large-scale organizations were more effective than a single person working alone, however talented or gifted with vision he or she might be. The progressive era was marked by the growth of institutions, particularly colleges and universities, that aimed to provide Americans with the skills to live in the modern world. It was a middle-class movement, one that spoke directly to the group to which artists and their patrons both belonged, even if institutional support for the arts remained elusive.

California was one of the strongest centers of progressive thought in the United States, and it should not be surprising that the aesthetic modernism that developed on the West Coast was influenced by the belief that humanity advanced both spiritually and materially through the resolution of practical problems. In California, as well, given how rapidly a new society had come into being in the aftermath of the Gold Rush of 1848 and 1849, the ties of the past were matters of heart and imagination. The blank slate of a conquered land facilitated dreams that Venice or Florence or Athens could be recreated, only bigger and better. In assessing the spread of "modernism" into provincial societies such as California, we need to confront the semantic muddle of the term itself. David Hollinger compared talking about modernism to walking through a room of multisided mirrors, each reflecting light differently, so as to prevent a clear view of any object in the room.[14] Conclusions about modernism depend on how we identify the most significant markers, a task complicated enough when we are dealing with the major modernist creative figures, but nearly impossible when attention shifts to developments on the periphery. For however talented California writers, artists, and architects were in the first six decades of the twentieth century, none played a critical role in shaping either national or international conceptions of modern arts movements. Those like the architect Irving Gill, whose early twentieth-century experiments in poured concrete with elegantly sparse planar façades have achieved retrospective importance, did so only late in life, if not after they had died.

Painters in the Society of Six, an informal group working in the San Francisco Bay Area at the beginning of the twentieth century, developed a thick impasto technique combined with intensely vibrant colors for their paintings of the local landscape, a combination that predated parallel textural experiments elsewhere and that would have considerable influence on subsequent painters within the state.[15] At the same time, ceramists like Beatrice Wood and painters like Rex Slinkard and Mabel Alvarez, influenced by Theosophical teachings, explored shimmering patinas in an effort to reveal an underlying spiritual realm hidden within the experience of light. These experiments pursued a question that has

been central to much of the art produced in the state through the twentieth century: how is a mind formed through the interpretation of mark, form, and line?[16] That these developments had minimal influence elsewhere led to their overall importance being discounted, confirming that California, despite its wealth and influence, has not been exempt from a general rule that the regional is typically labeled as derivative even when relative isolation sparks unusual innovations.

Putting the fine arts to the side for the moment, were we to count the Hollywood motion picture industry as quintessentially modernist, then Los Angeles played as central a role in the development of modernist culture as Paris or New York. Were we to go one step further and say that the modern research university is central to modernist culture, then the University of California, Berkeley, crowning a coordinated statewide system of learning stretching from kindergarten to doctoral programs, was equally at the center of a new public culture that took shape through the first two-thirds of the twentieth century. California's approach to education provided a particularly important model that influenced educational policy in the rest of the nation, and the influence extended into many other countries.

David Joseph Singal, following this line of thought, defined modernism as a set of cultural values that expressed popular admiration for "the vitality and inventiveness of technological progress while decrying the dehumanization it appears to bring in its wake."[17] Continuous discoveries in the sciences overthrew traditional belief structures and undermined the epistemological certainty they had given everyday life. In compensation, modernist pioneers extolled experience over knowledge: learning through doing provided a more secure key to a rapidly changing environment than mastering the archives of human learning. In Singal's view, popular commercial entertainment was of greater importance in spreading these new values than elite experimentalism, which was often a rearguard effort to reconcile the new outlook with an outmoded humanist tradition.[18]

Despite superficial contradictions, a focus on changing cultural values expressed in more popular-oriented media can be combined with an aesthetic-centered approach privileging experiments with the foundations of form and expression. The image of modernism as a broad-based middle-class culture working on multiple levels suspends the awkward isolation of fine arts experimentalists and helps explain why elitist concerns diffused so quickly and thoroughly into the broader culture. An integrated approach also underscores the poignancy of the struggles of the aesthetic avant-gardes. Modernist attitudes never triumphed completely or unconditionally. Residual beliefs in, and yearnings for, absolute knowledge and absolute values welled up continually to challenge

new assumptions that privileged practice, experience, and variety of perspectives.

Common to both approaches is a view of modernism as a response to the scientific method. For many at the beginning of the twentieth century, the most distinctive feature of the modern age was the rapid, apparently unending expansion of knowledge from scientific investigation. Millennia-old beliefs crumbled; new theories multiplied. The universe science revealed—its cosmological structure, the chemical and atomic building blocks of matter and energy, the earth's long history, the evolution of biological species, and subconscious forces structuring human psychology—was one that had been invisible; it had simply not existed for most men and women.

Even if the modern era was one of revolutionary change, when long-held beliefs were overturned and the social, cultural, and intellectual structures from which most people drew their identities weakened, it was also a time when scientific discoveries seemed like a return to original truths that had been obscured by superstition and ignorance. Skepticism did not necessarily lead to cynicism, since positivist scientific methodology relied on a faith that all experience sprang from unchanging universals. God does not play dice with the universe, Albert Einstein said, convinced that the basic laws patterning natural phenomena were uncoverable through an accumulative process of hypothesis and controlled experiment.[19]

This pervasive faith in what Raymond Williams called the "modern absolute," in which particular historical practices assume the aura of eternal universal validity, entered the arts as the basis for a poetics of the scientific method.[20] The goal of nineteenth-century artists to use their craft to provide knowledge of the external world did not disappear, but it proved elusive. The desire to emulate men of learning provided artists and poets with an unstable but nonetheless fruitful goal of transforming aesthetic creation into a form of research on the means of communication. Ezra Pound proposed that poets uncover the rules governing the relation between connotation and denotation in language and use this knowledge to apply standards of machine efficiency to their work.[21] His college friend William Carlos Williams likewise described a poem as a "machine made of words," a phrase that parallels Corbusier's famous dictum that houses were machines for living in.[22]

This relation between artistic products and machinery seems far-fetched, but the attitude reflected an optimism, particularly pervasive in the United States, that knowledge ought to lead to practical know-how. But first, artists had to treat their work as basic research into the components of aesthetic expression and reception, a continuation and intensification of earlier goals. Artists had to isolate and specify the effects of

shape, line, color, texture, perspective—of each individual element at play in the languages particular to the various media—in experiments that isolated the elements of perception. They needed to examine the possibilities for recombining these elementals to define more precisely the process of cognition and the translation of sensory experiences into ideas and emotions. Having uncovered laws governing experience, artists could bring forth work that surpassed representation of what already existed by actually creating experiences never before known to humanity and impossible to duplicate in any other human endeavor.

This model of the arts as an analogue to scientific investigation conforms to the conscious goals of several prominent modernist painters and critics in California. Stanton Macdonald-Wright, who moved to Los Angeles in 1918, led his students through a series of exercises that focused on the process of vision more than the craft of painting. He told his students that once they had mastered the nuances of his theories of color harmony, they could produce specific sensations for the spectator.[23] In 1935 the art critic Arthur Millier explicitly defined modern art as a poetics of scientific method when he defended the work of the postsurrealists, a group of six painters in Los Angeles and San Francisco whose work focused on the processes of cognitive association. "The characteristic creations of our time are completed in the brain before an ounce of construction material is mined," Millier began. "Ours is the age of pre-calculations so exact that their objectifications seem miraculous." To express the dominant facts of the twentieth century, art must parallel science's "precision of theory and method. It must be as precise as the intricately calculated balance of a steel bridge, as absolute in the relationship of its parts as the elements of a chemical compound." The experimental method applied to the arts would reveal the workings of the mind, a claim that Millier made without any hesitation or the slightest qualification for the postsurrealists. Yet he hesitated to erase all distinctions between imagination and rationality. "The artist need not be an engineer," he conceded. "But he must create poems for an engineering age."[24]

Another particularly clear expression of a scientistic view of art came from the Austrian surrealist dissident painter Wolfgang von Paalen, who settled in San Francisco after World War II to become one of the leaders of the short-lived Dynaton movement. The modern movements in the arts, Paalen wrote in 1942, during the first year of his exile to the Western Hemisphere, had spent half a century struggling toward an "esthetic science." The roots of such a science were present in the artistic production of archaic and non-Western societies, but traditional European ideals of order and beauty had blocked true experimentation and con-

tinued to hinder the development of modern art by focusing experiments on superficial forms of spectacle.

Paalen noted that the sculptors of the indigenous peoples of the Pacific Northwest spoke of their work as "right" or "wrong" rather than as "beautiful" or "ugly." Such a conception, he argued, showed that art had originated as a form of problem solving that trained the mind to approach all types of problems with a vision uncluttered by preconceptions. Art, science, and religion were "inseparably interwoven with the growth and development of human intelligence."[25] In the classical European tradition, this original function of art had given way to representing decoratively the worldviews of elites. Artists who continued to work in defined representational traditions helped to maintain a decaying system of social differentiation and prestige. The end of that system and the beginnings of a more inclusive, democratic society would free artists to return to their unique and truly creative functions.

According to Paalen, the artist, as a creative person, had an ethical obligation to expand the ways open to other citizens to examine and test the world:

The true value of the image, through which artistic activity is connected with human development, lies in its capacity to *project* a new realization which does *not* have to be referred for its meaning to an object already existing. . . . The true value of the artistic image does not depend upon its capacity to *represent*, but upon its capacity to *prefigure*, i.e., upon its capacity to express potentially a *new order* of things. In order to distinguish between reactionary and revolutionary painting, it is enough to distinguish between what I shall call the *representative image* and the *prefigurative image.*[26]

Paalen defined the "representative image" as a realistic one that claimed to give the only significant truth of what was presented. If artists approached their subjects with clear hierarchies of values, they would produce dull work, which, however masterly its technique, would ultimately be of little use to their fellow citizens. The "prefigurative image," even if ostensibly realist, never represents what exists, "but potentially anticipates some features of what will exist . . . spontaneously answered by hints related to the most crucial preoccupation of the times."[27]

As a surrealist, Paalen groped toward a view of art as a science of the unconscious and the preconscious, but this scientistic, rationalist model of modernism does not conform with the romantic, largely literary view that came to dominate the discussion of modernism after 1945. The modernist canon has privileged D. H. Lawrence's irrational union with the cosmos, T. S. Eliot's defense of an imagined Christian humanist tradition, or Martin Heidegger's claim that Western philosophy took a disastrous turn with Plato's identification of subjective consciousness

with rational thought. This version of modernism denied that scientific procedure could provide any meaningful system of values. Investigation might lead to useful facts, but science was a set of technical practices. Its utilitarian ethos led to more precise results, but science offered no morally meaningful interpretive scheme for determining what people should do with new information. This form of cultural modernism corresponds to a defense of premodern, prescientific "wisdom traditions" occurring in reaction as enthusiasm for the scientific method entered a new field. The interpretation of modernism that gained greater importance after World War II might be better called "antimodernism," the term T. Jackson Lears applied to Henry Adams and other late nineteenth-century skeptics of modern life.[28]

The antimodernists, whose views have been overrepresented in discussions of modernism, criticized science for artificially dividing the world into the knower and the known, the subject and the object. Antiscientific modernists believed that the reintegration of the self into the world would dispel the horror of scientific "progress." A vision of the world was always a vision of oneself, so that humans defined their individual values, fundamental characteristics, and fate in the process of describing and therefore creating the world in which they lived.

This subject-subject view of artistic creation permeated the experimentation of the fauves, the expressionists, the surrealists, and the work of Mondrian and Klee, as well as the abstract expressionist revolution of the 1940s. The same works that creators and critical proponents easily described as investigations into the laws governing visual communication also were lauded for the autonomous worlds of pure subjectivity they revealed.

Individual creators, critics, and publics often combined a scientific model of the creative process with antiscientific assumptions about the uniqueness of each individual subject. There was no rigid dichotomy available to the protagonists of modern art, nor could there be, except in highly theorized or polemical contexts. Otherwise the practical constraints of work kept pressing artists between the Scylla and Charybdis of "art as a distinct way of knowing the world" and "art as a site of disciplined free will." Professionalism required artists to develop an attention to method they claimed was as precise as that of scientists. Yet ultimately artists and scientists "know" their worlds in very different ways. A poetics of the scientific method had to come into conflict with the factors that make art a distinct human practice.

Mabel Alvarez, a young California painter, struggled with the tension between scientific and antiscientific views of art after she became a founding member of the Los Angeles Modern Art Society in 1916. She believed that rigorous investigation of the effects of color could help

demonstrate the actuality of "harmony." The world *appeared* to be in strife and to consist of opposites. She was convinced, however, that under the temporary forms of social custom was a basic order, which, if brought into daily life, would help orient people to work for moral and cultural progress. Alvarez hoped that by exploring the effects of color, her paintings could provoke viewers to see the order that surrounded them. "I want to take all this beauty," she confided to her diary in 1918, "and pour it out on canvas with such radiance that all who are lost in the darkness may feel the wonder and lift to it."[29]

In remarks similar, though less systematic, to those propounded soon after by the Bauhaus in Germany, Alvarez noted that painting first entered into people's daily lives as a decorative art. By helping to structure perceptual outlooks, paintings could reorient their viewers' relation to the world. In a diary entry from 1919, Alvarez noted that she and her sister had spent an evening discussing how to implement the principles of harmony the painter studied: "Perfect Harmony would be Heaven but we decided we would have as much as possible in everything around us and in whatever we thot [*sic*] and said and did. Carmen decided to change the Disorder in her little room to Harmony, and that when we wash and put away the dishes in the kitchen we are bringing Order and Harmony out of Disorder."[30]

Moved by a memorial exhibition of Rex Slinkard's work in mid-1919, Alvarez wrote of her fellow experimental painter, who had died prematurely, that his work was "all emotion—a dream world of the spirit— Nothing of the material physical world. Strange and lovely color and compositions and subjects. He worked entirely from within and said lovely things that were all his own."[31] In Alvarez's attempt to come to grips with the sources of abstract painting, two ideas clashed: modern art sprang from inner vision and therefore was entirely individual in its form of expression, but as the work became more personal it revealed patterns of perception and cognition that correspond to universal laws working on every level of reality.

This dichotomy between the personal and the universal engaged and frustrated artists, whose work was supposed to reveal the fundamental synchronization of the two. However "experimental" they were, their work was only an imaginative re-creation of the investigatory method, not an actual scientific procedure.[32] The finished works presented viewers with irreducible, unique experiences. A successful work of art was entirely unpredictable, no matter how logical it seemed. Artists, themselves caught between the practical requirements of crafting work and the theoretical model they followed, frequently questioned the path they had chosen. Alvarez complained one evening after returning from a class with Macdonald-Wright, "I have always doubted that pure

abstractions in color would be very successful judging from the way the 'moderns' have tried it. We are told we should get certain sensations from them but we don't."[33]

Modern artists could imitate the ideal of the scientist-engineer, but only by surrendering subjective freedom without gaining the objective increments of knowledge that had become the source of scientific authority. The poetics of the scientific method combined opposites in a desire to discover in personal vision the necessity of universal law. Modernist goals were elusive because two contradictory ideas of power collided to leave only the tragic ashes of an aspiration. For a time, the explosion generated significant work, but eventually artists had to confront the specific nature of their power as artists. To say that a poem or a painting or a house was a machine enunciated a desire to appropriate the powers of technology and science on which contemporary social hierarchy seemed to rest. Modernism from the subjective point of view was then fundamentally a statement of desire rather than of method or epistemology. Modernists grappled with science and technology as they struggled to join those who mastered the world and thereby to gain a place of respect within it.

Sam Rodia and the Watts Towers

To explore how this aspect of the modern movement in California played itself out in unexpected locations, I want to turn away from those who received formal training in the fine arts and examine the seminal work of assemblage art in California, a work that has often been associated with folk or "outsider" art rather than with the subsequent modernist and postmodern art it inspired. By rethinking Sabato/Sam Rodia's Watts Towers (Figure 2) in South-Central Los Angeles as a distinctively Californian expression of modern art, I hope to identify the unique contribution of California modern arts movements in terms that do not require continually defining the periphery solely in its relationship to a largely imaginary cosmopolitan center that never includes its margins.

Sabato Rodia was born, most likely in 1878, in Ribottoli, Italy, a peasant community twenty miles east of Naples. He immigrated to the United States at the age of fourteen and settled in central Pennsylvania, where his older brother was a coal miner. In his late teens Rodia moved to the West Coast, working over the years as an itinerant laborer in rock quarries and logging and railroad camps, and as a construction worker and tile setter. As an adult, he was known by his American nickname of Sam (he was also referred to as Simon Rodia). His neighbors in Watts recalled him speaking Spanish fluently. He himself said that he had trav-

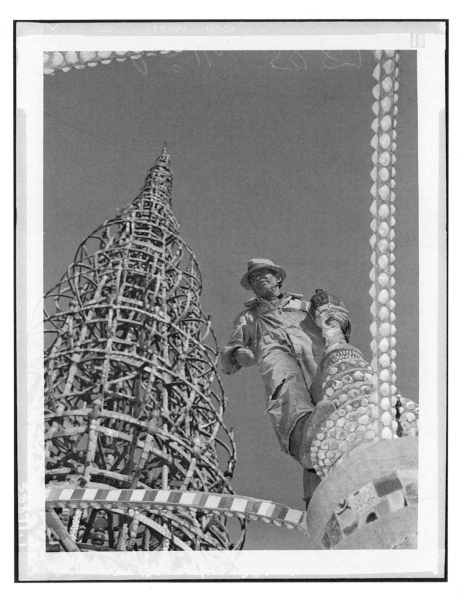

Figure 2. Simon (Sam) Rodia and his Watts Towers, *Los Angeles Daily News*, ca. 1953. Courtesy of *Los Angeles Times* Photographic Archive, Department of Special Collections, Charles E. Young Research Library, UCLA. ©Regents of the University of California.

eled throughout the Americas, going as far south as Buenos Aires before returning to California.

In 1921 Rodia, estranged from his wife and children, purchased a large triangular lot in the working-class community of Watts, some eight miles south of downtown Los Angeles. He immediately began to work on a large assemblage structure that he called Nuestro Pueblo, Spanish for "our town." He first built scalloped masonry walls and then constructed seven towers, the tallest nearly one hundred feet high, out of steel rods and reinforced cement (Figure 3). At the base of the triangle, nearest his house, he put the most parklike elements of his project: a gazebo-arbor, fountains, birdbaths, and benches. At the narrowest point of the lot, Rodia built a galleon that he called Marco Polo's Ship. He decorated his structures with mosaics made from tile shards, broken dishes, seashells, and pieces of bottles. The walls are covered with impressions of hands, work tools, automobile parts, corncobs, wheat stalks, and various types of fruit. He incised his initials into the wet cement, as well as recurrent heart and rosette shapes (Figures 4 and 5).[34]

He told William Hale, who did a documentary film on the towers in 1952, "I was going to do something big, and I did."[35] His goal was to leave a monument: "You have to be good good or bad bad to be remembered."[36] His heroes were Copernicus, Galileo, and Columbus. He felt scientists were truly the greatest heroes for they had changed the world more profoundly than any other group. He also told interviewers that he had started working on his project to keep himself busy after he quit drinking.

Rodia used artistic production to create a place of respect for himself, something he could do only through the exercise of imaginative freedom, for in his aspect as a laborer in an industrial society his individuality had little significance. Art gave him a way to establish his presence in the contemporary world. His project allowed him to change the world by claiming the right to narrate, and thus interpret, his own experiences and traditions to as many people as possible who might pay attention. That his unusual triangular lot bordered the most heavily used commuter railroad in the county, linking downtown Los Angeles with the port city of Long Beach, is evidence that attracting attention was part of his original plan.

Rather than use his property to build a picturesque reproduction of his Italian homeland, he created an abstract environment that required reflection to make sense. His work may echo the ceremonial towers of wood and ribbon used for the annual Festa dei Gigli (Festival of the Lilies), celebrating San Gennaro, the patron saint of his birthplace, but Rodia's forms, colors, and techniques are unique. Not a single element in the composition corresponds to traditional Italian folk art forms.

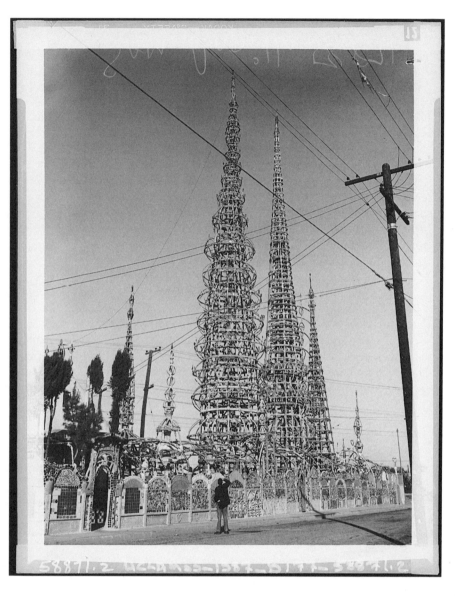

Figure 3. Sam Rodia, Watts Towers, Los Angeles, *Los Angeles Daily News*, ca. 1953. Courtesy of *Los Angeles Times* Photographic Archive, Department of Special Collections, Charles E. Young Research Library, UCLA. ©Regents of the University of California.

Figure 4. Sam Rodia, impressions of tools, Watts Towers (detail), Watts, California. Photograph by Tom Koester, courtesy of Los Angeles Department of Cultural Affairs.

Rather than nostalgically re-create memories from his early childhood, he refracted them through complex images reflecting on the rapidly changing world of the laboring immigrant.

Rodia's use of the assemblage form was key to the effect of linking past, present, and future. In assemblage, the artist uses found or constructed objects as basic materials, putting them together so that they retain some of their original identity.[37] Peter Bürger has argued that assemblage and montage are the fundamental principles of modern art: "The 'fitted' work calls attention to the fact that it is made up of reality fragments; it breaks through the appearance of totality."[38] Two corollaries follow from Bürger's argument: first, the insertion of "reality fragments" into a work of art destroys its unity and any possibility of illusion. The viewers' perceptions of the piece constantly shift between what they know the artist created and objects they understand that the artist found somewhere out in the world. A sense of the work's totality emerges through the enjoyment of contradictory details rather than through

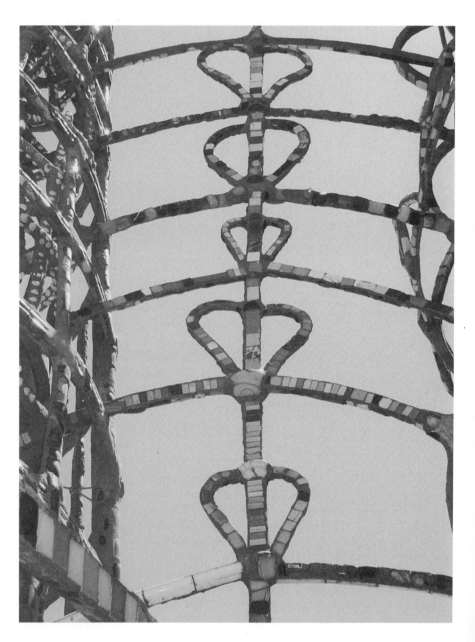

Figure 5. Sam Rodia, Heart Bridge, Watts Towers (detail), Watts, California. Photograph by Tom Koester, courtesy of Los Angeles Department of Cultural Affairs.

appreciation of a preconceived pattern. Second, the authority of the artist's vision is undermined because the viewer sees more clearly the "constructed," arbitrary nature of the completed piece. The artist cannot claim to represent nature or to have created an alternative world that exists in a realm distinct from the society that links the designer with his or her audience. Greater emphasis on the subjectivity of the artist, his or her personal response to that society, compensates for the loss of the authority gained by creating a supposedly autonomous universe. The work of art is clearly an interpretation of a reality external to both creator and spectator. The aesthetic effect comes as an emotional and intellectual response to the contradictions of existence (be they individual, social, or metaphysical), rather than as a reconciliation of those contradictions in the artificial unity of the "organic" work of art.[39]

Modernist works reveal the fictional nature of representational aesthetic strategies. Nuestro Pueblo is not a town, but a set of materially embodied ideas about living in industrial, urban America. Representational work helped establish a cognitive reality for members of a society by reifying its ideologies into sensory experiences that seemed lawfully necessary. Modernist work, on the other hand, helped clarify that the essential act in asserting individual autonomy in a complex society was advancing an interpretation of the apparent facts of one's life, which begin to appear more complex and ambiguous. Every image demands further investigation and creation of new images.[40]

Rodia's composition is a true "constructed" work because he intended the basic materials to remain visible for what they are—steel, cement, broken bottles, broken tiles, corncobs, dishes, silverware, and so forth—and the forms, while suggestive, do not insist upon a single, preferred reading (Figure 6): the towers, for example, can be viewed simultaneously as church spires, skyscrapers, gazebo-arbor, and so forth. Rodia's own ambivalence about the specific content of individual sections of the work is indicated by the multiplicity of names and descriptions he used over the years with various interviewers.

Ernesto De Martino, a cultural historian who studied the transformation of the southern Italian peasantry from the beginning of the nineteenth century to the middle of the twentieth, noted that when the working classes modernize, they do not throw away their traditional culture and replace it lock, stock, and barrel with the "scientific" values of the commercial and intellectual elite. The crisis of the modern world, he argued, lies in the unresolved conflict between two distinct but interlocked modernizing worldviews, one based on power, wealth, and the monopoly of scientific knowledge, the other located in the subordinate world of work, poverty, and poor education.[41]

Modernization in both cases involves (but is not limited to) remaking

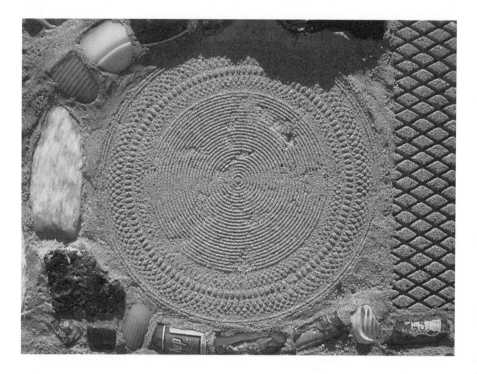

Figure 6. Sam Rodia, Watts Towers (detail), Watts, California. Photograph by Tom Koester, courtesy of Los Angeles Department of Cultural Affairs.

earlier cultural forms into values, beliefs, and customs consistent with the facts of machinery and the increased power of the leaders of human societies. Neither was free of fear of what the future would bring, but both popular and elite cultures wanted the benefits that increased knowledge of the world provides. The elite looked back on twenty-five hundred years of art, literature, and philosophy to invent a tradition that made the contemporary world seem an inevitable, progressive culmination of the march of history itself. Popular culture looked back to folk arts and crafts, to ritualistic religion and magic.[42] Modern art or literature could come from either culture, but the traditions referenced were different, as were the social claims of the creative work.

Could modern societies synthesize these traditions to create a popular culture that could be a source of rationalities and judgment? That question is at the center of democratic aspirations. An affirmative answer is implicit in all inclusive ideas of modern life, but its practical application has been difficult, even for those whose work rested on advanced univer-

sity training. The process of inclusion involves a reworking of both elite and popular traditions (and everything in between emerging in the new mass media) to establish a basis for participation rather than mere presence.

We can see Nuestro Pueblo as a magical act that appropriates the powers of the modern city for Rodia and his neighbors by imitating the urban environment and transforming it into more spiritualized forms. De Martino argued that the magical process of imitation had a function more profound than the naïve belief that power resides in form: "Imitation directed to an end configures itself as an additional ideological 'superimposition'" that coexists with ideological conceptions of the dominant classes.[43] Arguments over the efficacy of magic have overlooked the primary function of magical practices such as astrology in popular culture: to provide a space for ideas reflecting the integrity and self-interest of the lower classes.

Rodia's towers question and refigure the ideology of the modern city so that it can become an imaginative home for all its residents, not just those with money. For most of the thirty-three years he lived in Watts, Rodia encouraged his neighbors to visit and use his project. Weddings and baptisms were celebrated under the towers; as festive as these uses might be, the setting nonetheless offered no escape from urban reality. Nuestro Pueblo confronts its visitors with images of the jumble of urban life: the forms speak interchangeably of buildings, parks, the industrial world, agriculture, and pure purposeless beauty.

What we know about the prices of real estate we find confirmed mythically: Nuestro Pueblo could have been created only in Watts, long among the poorest communities of Los Angeles, yet also a section of town where many of the residents own their own homes. In building the towers, Rodia redeemed not only his own humanity but also that of others like him, the poorly paid, seldom recognized working people who pass their lives in places like Watts. He proved that creativity does not depend on social privilege.

An ambition to build something like Nuestro Pueblo develops only when working people can accumulate a modest amount of property and can count on leisure time to plan and execute the project. Democratic values must have spread through society so it is neither ridiculous nor dangerously presumptuous for a poor man to plan, as Rodia did, on doing "something big." Yet at the same time, social stratification based on wealth must be so all-encompassing that poor people might feel the need to assert their egos against the forces controlling the larger environment by building a micro-environment that challenges the magic of money without incurring the penalties for social rebellion.

By describing Rodia's labors in mythic rather than protoprofessional

terms—critics have noted how Rodia worked spontaneously on the towers, almost like a beaver or a spider, without a documented plan—we avoid considering his project as an action directed toward an end—the affirmative aspect of magic. Nuestro Pueblo may well work as a mythic imitation of a metropolis, but it is also a psychological and social statement that affirms through its very grandeur that a human built this. To deny that statement in favor of the timeless beauty of the myth is to deny Rodia his humanity and to make him an aimless wanderer on the edges of our society, of it but not to be integrated into it. It is in this sense that De Martino defined the magical act as a constant attempt to declare one's humanity so as to achieve a recognizable place in the world: "In reality, the problem of magic is not one of 'understanding' or of 'modifying' the world, but above all of guaranteeing a world in which a being can become present." Magic is a form for asserting the "transcendental unity of self-consciousness"[44] in the face of a world based on social fragmentation, competition, and hierarchy that renders competition inevitably unequal.

But in modern societies, the tools and conditions for self-expression become more powerful and are in effect democratized. Due to his lack of formal training and his status outside the guild that education consolidates, Rodia was isolated from modern artists of his own generation. The younger artists of the 1950s and 1960s who saved the Watts Towers when the city of Los Angeles proposed to tear them down understood his isolation as typical of the region rather than unusual. His activity demonstrated the first principle of being a professional artist in a world with undeveloped support institutions: if you're going to be an artist, you just have to *do* it. By building his piece alongside a heavily used commuter railroad line, he guaranteed that thousands of people saw what he was doing daily and that eventually local newspapers would write about him and his work. The problem of establishing his presence as a person contributing to his society paralleled that of every artist, even those securely within the guild. His strategy had its counterparts around the state in artist societies, independent galleries, and events that would gain some publicity. The Watts Towers countered indifference with passionate action.

Modernism from below implies a moving from the depths to the surface. The fertile netherworld below might involve the lower strata of society, as educational opportunities opened up for men and women who might otherwise never have explored their artistic capabilities, much less imagine that the arts might offer them a profession. It could mean a movement upward from those on the sidelines of classical humanist education. The same movement might come from the depths

of the soul to form a cry of the psyche. A desire to be included must mean an aesthetic philosophy at once inclusive and resentful.

An aesthetics of magic and an aesthetics of scientism were two phases of the same phenomenon, as the modernist fascination with the tarot, Kabbalah, I Ching, Tao, and mythology attests. The widespread appeal that Carl Jung and Joseph Campbell had for mid-twentieth-century artists grew from the ability of these two authors to legitimize their interest in the mystical in scholarly terms, indeed claiming that the mystical provided the foundation for an up-to-date psychological science. For most people both science and magic work in unknown, mysterious ways but provide cognitive maps; their prestige is based on their apparent power to predict results. The working methodology of scientific procedure is so different from aesthetic process that the effort of modern artists to appropriate the powers of science functioned as a form of magic, deployed to seize power by narratively redefining the artist's place and function in society. Modernist exploration in the visual arts re-created in a new framework the powers of the modern era, but the effort left unspecified the practical contributions artists hoped to offer their fellow citizens.

For all the powers that science demonstrated throughout the nineteenth century and continued to demonstrate with even greater effectiveness through the twentieth, there is a fundamental contradiction in the growth of science and engineering as social forces, a split that tends to produce a fragmentation of identity and a virtual schizophrenia. In the area of practical contribution to social life, the individual voluntarily becomes the slave of the requirements of the system of purposive rational action. Desired results flow by following predetermined procedures. Yet the expanded powers of science and technology provided increasing numbers of people with the means to pursue their fantasies unhampered by the inefficiencies of pretechnological organization and distribution. Desire in the area of consumption could find more direct satisfaction. Nathaniel Hawthorne, in an extraordinarily perceptive phrase, recognized an interiorizing aspect to the machine age in 1851 when he had a character in *The House of Seven Gables* make the at-first astonishing claim that trains "spiritualize travel!" Railroads, he explained, "give us wings; they annihilate the toil and dust of pilgrimage. . . . Why should [any person] make himself a prisoner for life in brick, and stone, and old worm-eaten timber, when he may just as easily dwell, in one sense, nowhere."[45]

Science and the machine age expanded and problematized the question of freedom. The Declaration of Independence and the U.S. Constitution enshrined the classical idea that freedom devolved from the ability of freeholding individuals to participate in political decisions

affecting their communities; this idea was now transformed into an existential question: how might inhabitants of a structured society achieve practical goals and also explore the possibilities inherent in personal fantasies? The scientific method offered no help in answering this question, but religion and humanism did, even though their answers had developed in societies with more rigid limitations on the potential of human action.

The dangers that scientific knowledge posed for humanity became inescapable for Europeans in 1914 with the outbreak and intensification of World War I. Rational organization in the service of equally brutal autocrats and democrats led to the largest bloodbath the continent had ever suffered. The frenetic enthusiasm of the futurists and the cheerfully optimistic experiments of the cubists and fauves did not survive the war. After 1918 new European avant-gardes, such as the surrealists and expressionists, looked for alternatives to rationality to vent their fears that the continued primacy of "reasonable men" would lead to even greater horrors. Americans retreated into isolation and, despite persistent problems of racial segregation and widespread poverty, maintained the hope that the liberation of individual creativity would lead to a better world. The Depression of the 1930s undermined that confidence, but Americans did not truly confront the ambiguities of progress until 1945, when the bloodguilt of Hiroshima and Nagasaki and the revelation of the Holocaust reiterated the lesson that technology served evil as readily as good. As in Europe twenty-five years earlier, the shock of war opened the gates to a mistrust of rationality. In the changed postwar environment a new vital role for the arts appeared. Art stood, not as an icon for the necessity of personal vision, but as a process that symbolized the freedom of the unique and the irrational. This transformation required little stylistic change, simply a realignment of interpretive value. Instead of casting investigations of visual experience as cognitive experiments, artists found in their work proof of an interior reality that persisted despite external conditions.

Perry Anderson has argued that the critical synthesis of avant-garde cultural movements into a unity marked by the term modern*ism* occurred only after 1945, when the basic impetus of those movements was already moribund. He concluded that modernism as a concept involves an inherent sense of nostalgia for a classic age one has missed.[46] The word "modernism" entered the culture of the post–World War II era as a ghost that haunts those who have followed because it speaks of a classic age of creativity, one equal to the Renaissance in the scope, vitality, and fluidity of the work produced. The greatness of this work springs from the determination of men and women in this period to come to grips with the challenge of science and create a place for them-

selves in a new world ceaselessly flowing into being. Modernism has been an elusive, muddled concept because it could have no set meaning. The responses to simultaneous expansion of knowledge and imagination varied across time, place, and social position.

As Rodia's work suggests, the challenges inherent to modern life in California initially developed along different lines from much of the rest of the world. Its isolation, its relative prosperity, and the ascendancy of middle-class democracy fostered widespread faith, perhaps objectively an illusion but nonetheless powerful in its subjective consequences, that a new world culture was in the process of emerging there. It would be a culture that synthesized a broad variety of cultural traditions, and it would be a culture developed by both men and women. It would be a culture where the ideal of creating something new while building on the achievements of their heritage would take roots and guide the cultural activity of the future.

World War II hastened the state's transformation from a provincial society into a metropolitan center. Cold war military spending secured prosperity, and the state's population boom created a new middle class, most of them migrants to the state, many of them young men and women from lower-income backgrounds who benefited from the new opportunities modern society seemed to provide. Freed from limiting if identity-giving geographic, family, and class roots, many during the postwar boom had to create their own lives in a complex world that was often indifferent, if not openly hostile or derisive. The ultimate universal that the arts in California proposed was the ability of each individual to define the meaning of his or her own existence in the relative isolation a new society provided, an isolation that involved perhaps a callous indifference.

Isolated from, but not ignorant of, the main developments of world culture, California's modern artists and poets provided a model for a creative synthesis that could lead to a new contemporary culture transcending modernism. The California modern movements had been so removed geographically, if not in time, from the social problematics of European modernism that men and women surveying European cultural debates in the 1920s and 1930s had already constituted modernism as a whole for themselves. The painter Lorser Feitelson declared himself both surrealist and futurist, even though he knew that the two movements were antagonistic, in order to create for himself what he considered the essence of the modern approach to art. The critic Lawrence Hart "deconstructed" the work of Eliot, Pound, and the French surrealists into a theory of poetry he called activism. We can view these experiments as evidence of a provincial pseudosurrealism irrelevant to the "main line" of avant-garde thought, but such a judgment would naïvely

accept the modernist assumption that art was in fact the source of universal, ahistorical truths.

The work California's moderns created often spoke wistfully of dreams to proclaim individuality while accepting the reality that every life was finite and always unfolding within a powerful social organization. In 1947, after winning first prize in the annual Los Angeles County Museum art show, Helen Lundeberg received a letter from an admirer, who wrote that she saw in Lundeberg's paintings "a sense of humility as well as awe before the majesty of things. There is also, or so it seems to me, an acceptance of the solitariness of the individual in your work. . . . A togetherness between two people is an impossibility, and where it seems nevertheless to exist—it robs either one or both of his fullest freedom of development but once the realization is accepted that even between the closest of human beings infinite distances continue to exist, a wonderful living side by side can grow up."[47]

The powers that created the modern world augmented and diminished the individual. The poetics of the experimental method ebbed into a celebration of what the lone individual felt. Elegy often marks the transitional work produced at the end of high modernism, for freedom was achieved by giving up faith in a technological utopia. When modernism passed, the scientific method and engineering remained firmly at the heart of the contemporary world, so firmly that the public needed a counterweight. The artist in the post–World War II period then could shed the costume of scientific investigator uncovering universal law and appear as the figure defending desire, imagination, and irrationality in a world reshaped to fit the needs of the institutions empowered by scientific productivity. That new opportunity, however, conflicted with the fact that schools remained the most stable source of support available to modern artists, and the artist as educator had to be a person of definable skills, debatable principles, and measurable accomplishment.

Chapter Three
Modern Art and California's Progressive Legacies

The Expansion of Higher Education

For the first sixty years of the twentieth century, California's political culture committed the state's resources to building a public education system second to none, culminating in state-funded college and university programs intended to make quality liberal arts and professional instruction accessible to the state's residents. California raced far ahead of the rest of the nation in college enrollments. By 1930, 24 percent of young adults in California attended a university or college, more than twice the national rate. College attendance continued to climb faster in the state than anywhere else in the world, and in 1960, the year California's Master Plan for Higher Education systematized sixty years of decisions, 55 percent of adults between the ages of eighteen and twenty-one were enrolled in an accredited institution of higher education.[1]

John Aubrey Douglass, the author of the most detailed study of higher education policy making in California, identified three goals adopted early in the twentieth century that were distinctive for the time. First, *every* high school graduate should be able to continue his or her education; second, public rather than private universities were needed to meet the goal; third, as public agencies, state universities and colleges were best positioned to link research and teaching to the social and economic needs of the state.[2] Through prosperity and depression, the state government continued allocating massive amounts of money to constructing a system of public universities and community colleges that were inexpensive, accessible, and overall of high quality. It was a remarkably successful social experiment that contributed to the state's preeminence in the sciences, new technologies, and post–World War II defense and aerospace industries. The coordinated system of "universal higher education" was

inseparable from California's development into an important hub within the global economy.

The state of California's determination to expand access to higher education created new opportunities for the visual arts as well. The question of whether studio art practice really belonged in a research university quickly arose after the Department of Art at the University of California, Berkeley, was founded in 1923, at a time when only a few colleges and universities had formal academic programs in studio art.[3] Before the founding of the department, the university had offered courses in freehand and mechanical drawing in the architecture and engineering schools. In its initial phases, art practice on campus was either a recreational elective or a technical course in skills useful for illustration of machinery or geological strata. Even after the department was formed, the campus's Academic Senate, responsible for maintaining the integrity and quality of academic programs, remained skeptical whether art education should be offered at all at a university. For the first fifteen years of its existence, the department struggled through an identity crisis as internal divisions and external doubts undermined the ability of the faculty to develop a coherent curriculum.

Resolution of the department's problems began in 1938 when the campus administration appointed Stephen C. Pepper, a professor in the philosophy department whose specialty focused on the epistemological foundations of aesthetic criticism, chair of the art department. Pepper wholeheartedly endorsed Professor Worth Ryder's proposal for a "balanced art program in higher education." Ryder's program emphasized a rigorous analytic approach to studio practice that gave students practical skills for the rendering of line, shape, tonality, and color, but these technical skills were to be imbued with modern critical theory and a comprehensive survey of art history. With Pepper's backing, Ryder wound up hiring the majority of the studio art faculty and securing tenure for junior professors such as Margaret Peterson who shared a modern perspective on the intellectual functions of art.[4]

Ryder's approach to visual learning addressed demands from other departments—faculty from the science departments most insistently—that art training provide measurable practical skills, but he did so while affirming that since modern art was a form of knowledge, studio art could be a credible field of research and not simply a set of techniques. Ryder's approach loosely derived from Hans Hofmann, who had taught summer session courses at Berkeley in 1930 and 1931. Hofmann had been a mentor for several of the faculty, who had studied with him in Germany. His international reputation provided an effective validation for the reforms that Ryder and Pepper presented to skeptical colleagues.

Developing a grammar of visual structure was a central tenet of the Hofmann method as elaborated at the University of California.

By the mid-1940s, the Berkeley art department had become nationally recognized for its model of art education. The department competed for top ranking in art programs with the departments at the University of Iowa, led by art historian Professor William Longman, and at Yale University, where Josef Albers had founded a program modeled loosely after the Bauhaus. The three most important university-based art programs were very different, but the philosophies at each school were equally at odds with the turn toward abstract expressionism and pure imaginative form coming at the very moment to dominate the most adventurous New York art galleries.[5]

To gain a sense of what students learned at Berkeley, we can turn to Worth Ryder's lectures for his Art 2A course from the spring 1946 term, the foundation class required of all majors. Ryder began by informing the class that although he was a modernist, he insisted that the approach to abstraction had to be made through first learning how to render the objective world with a basic vocabulary of design and composition elements. Students went through a progression of eight graded exercises that trained them to think about mark, form, and line as the basic building blocks which they combined to make a statement.[6]

For the initial exercises, students worked from a still life in the studio classroom. They divided sheets of notebook paper into four sections and in each square arranged a group of abstract shapes they synthesized from the still life. The first group had to be horizontal in orientation, followed by a second group of vertical shapes, and a third group in which vertical and horizontal shapes overlapped. Ryder limited his students to the use of line only as they started out. Having abstracted the still life in three highly artificial exercises, students were then to arrange a composition with the shapes they had developed. The objective he stated was "Practice in visualizing significant shapes and arranging or composing them in a particular format."

Further exercises introduced students to texture, shade, volume, and scale. They then went outside on campus to repeat the same set of exercises by taking details from the exterior environment, such as a "trunk of palm tree, vines on masonry wall, small round leaves found on a hedge, bushes, stems, and branches, tree branches without leaves, tree leaves, a variety of trees and leaves." Having abstracted what they saw into flat, two-dimensional figures, they were then to compose a series of designs with and without overlapping of the shapes. The stated objective was "Practice in isolating form shapes in landscape and in grasping their color character and texture patterns. Also to compose in planimetric space."

Ryder set up his classes to arrive at what he hoped would be an inescapable conclusion: in turning to but not attempting to copy nature, artists could explore objects formed in a universally shared, because biologically based, perceptual process, which subsequently structured into culturally and psychologically meaningful patterns.[7] Art training was to free apprentice artists by broadening their understanding of what made the visible intelligible. At a time when surrealism was a powerful force on many American writers and painters, Ryder insisted that his students not represent their fantasies but look at the immediately visible world and compare their responses and interpretations.

For Ryder, the founding father of modern art was Paul Cézanne, the only recent painter truly comparable in importance and value to the old masters. "Through him we know again what a spatial conception is; what picture structure is; what form is; what color is; etc. Through him we know that to change the color of a body is to corrupt the structure. His work proves absolutely, *that the art of painting is not any longer the art of imitating an object with lines and colors, but provides us with a plastic conscience for our instinct*" (Ryder's emphasis).[8] The curriculum diminished the importance of the impressionists and Cézanne's contemporaries van Gogh and Gauguin, two artists whose popularity derived from the substitution of purely subjective impression for a coolly objective exploration of visual thinking. The worlds they created were lively and colorful but lacked spatial structure. Ryder and his colleagues praised the cubists for their structural precision, but deplored the weakness of their painting technique. The department's faculty vehemently attacked the surrealists for their emphasis on startling subjective material. Abstract expressionism was seldom discussed in class, and when it was, the department's conclusion was that the new painting coming out of New York was superficial and shoddy. In short, the department gave their students an eccentric history of modern art antithetical to the most important trends in U.S. painting in the middle of the twentieth century.

Ryder told his students, "A thought is nothing until it is a *formed* thought. . . . Form creation in the space arts has to do with the sense of sight and the motor senses, with visual and kinesthetic sensations. My job as teacher . . . is to help you to restore contact with these sensations, to assist you to see clearer and to see more."[9] When students thought they were faithfully reproducing a scene, he would demonstrate that they simply mimicked a favorite style and inevitably did so sentimentally rather than intelligently. To break away from style, they had to retrain their vision to be analytic. They had to see the basic forms that were the foundations of all styles, be they idealist, naturalistic, surrealist, or totally abstract. "*The living of an experience* [*is*] *the process of form creation*," he insisted. The result was self-knowledge carefully gained through study

and practice, fitting well into a relatively conventional humanist project maintained in the democratic university as a place where the entirety of human knowledge is made available for reflection to all who momentarily stand apart from the everyday world.[10]

Margaret Peterson was one of the most popular and influential of the teachers at Berkeley. Peterson taught at Berkeley from 1929 to 1950, when she resigned her faculty appointment to protest the university regents' cold-war-era loyalty oath.[11] Peterson was an imposing personality, and she provided an example for women of how to survive as a professional in a male-defined environment. Striding into class with red and white polka dot high heels, a hot pink blouse with a plunging neckline, and a tailored skirt, she was an elegantly feminine presence who was also ambitious and intellectual. She was concerned that students develop the right attitude to the challenge of being a creative thinker. The only book she assigned her students was a biography of Marie Curie so they could understand the general laws of creative thought and the sacrifice required to discover the hidden truths of existence.[12]

Peterson followed the Ryder curriculum in setting up a series of mandatory exercises, in her case intended to deepen students' understanding of primary colors and their relation to each other. Exercises explored how variations in hue, value, and saturation transformed the sensational effects of placing colored objects into a differently colored field. Her lectures built from these practical experiments to present her thinking on the transmutation of pure sensation into meaning.[13]

Peterson emphasized that modern art provided a controllable imitation of sacred experience. Modern artists should aim to reveal the sources of awe that people felt before various aspects of their environment and make it possible to reflect upon and hence control the factors that stimulated these responses. Gaining control over the relation of idea, emotion, and belief was the nub and the essence of the modern creative process. When studying art traditions, be they Native American, Byzantine, or European, students need not attempt to learn the inner meaning cultures assigned to forms. Like Wolfgang von Paalen, Clyfford Still, Mark Rothko, or Adolph Gottlieb, Peterson took particular interest in the art of Pacific Northwest Coast Native Americans. Her most successful paintings worked with visual forms borrowed from this tradition, and like other U.S. modernists of her era inspired by Native American culture, she divorced the forms from the specific myths they embodied. The painter worked, she thought, to isolate the ultimate source of the emotional effects archaic symbols evoked by establishing the logical relationships that brought form into being. That accomplished, a painter had revealed for all to see the rhetorical structures within which societies encased the experience of form.

The pedagogical method at Berkeley was "stodgy," conceded Jay DeFeo, who studied at the school from 1946 to 1951. Several of her fellow students, among them Fred Martin, Pat Adams, Sam Francis, Robert Colescott, and Sonya Rapoport, also looked back on their education with a mixture of ongoing rebellion and grudging respect. The department had ignored all contemporary developments in art except to deprecate them, and students went out into the world unfamiliar with the problems that galleries, museums, and art journals considered current. Nonetheless, the department's graduates defended their training. Berkeley had taught them to think about visual structure in a systematic way, to understand the vocabulary and the grammars that allowed painting to communicate. Berkeley had taught them, as well, how to imagine occupying a position within a tradition of painting that extended from the ancient caves at Lascaux to the present, and then to relate European traditions to parallel developments in Asia, Africa, and the Americas.[14]

DeFeo for one believed that she was part of a historical sequence of painters whose work had separated art from the ideological and theological functions that had defined its development until the modern era. During the sixteen months that she lived in Europe after earning her master's degree, DeFeo's records of her trip indicate that studying prehistoric cave art had higher priority for her than looking at contemporary painting in France, Italy, or England. She brought home many photographs of cave art, as well as of medieval wall paintings. Her selection indicates a particular interest in work where the central image was only partially distinguishable from the background field. She also developed what would be a lifelong interest in Italian Renaissance techniques for creating measured images where lighting effects were more important to the design of the work than color. She stated numerous times, however, that the paintings she saw were less important for her subsequent work than the austere but also changing spatial relationships she discovered in the medieval and Renaissance urban environment as she bicycled around Florence and other communities in Tuscany.

Like others of her generation she was convinced that abstraction provided the best opportunity for exploring the principles of visual structure. Modern art had become an autonomous intellectual function that revealed in "mark, form, and line" aspects of psychological reality that would otherwise be invisible. That art could tell stories was unquestionable, as was its ability to present interpretations of the world in which people lived. What was still to be discovered was how and why the physical material that went into a painting, a drawing, a photograph, or a sculpture could incite ideas. In DeFeo's case, art was to induce people into a reality distinct from what they experienced on an everyday basis but which even if it came from the world of imagination was every bit as

tangible and sensual. The "new reality" she hoped her painting would reveal existed only in the mind, but it was nonetheless true. This was the miracle that she had learned modern art could manifest.[15]

Only a handful of the Berkeley art department's graduates achieved international reputations. Students from the program, however, took faculty positions in new art departments springing up all across the United States during the explosion of college-level education after 1950. The program was not successful in preparing students either for the commercial gallery scene rapidly developing in Manhattan or for the lively polemics unfolding in national art magazines. Their training, however, did effectively prepare artists to take their place in the research university and the liberal arts college, ultimately a more secure, stable foundation for art practice in the United States as it continued to grow in scale and scope.

Women in the Profession

Margaret Peterson's ability to imbue many of the most important of California postwar painters with her philosophical and technical perspectives is indicative of another aspect of the state's progressive if provincial cultural life in the first half of the twentieth century. Women had achieved a modicum of professional success in painting and sculpture, building on a long history of participation in the arts. Susan Landauer has noted that the institution of new arts organizations in nineteenth-century California coincided with emerging middle-class ideas on the special role women had in culture and education. Women were admitted to California's first art academy when it opened in 1874. Indeed women were a majority of the students of the first class at the school. It was the first school in the nation to allow women to work from the live nude, a practice prohibited not only in Philadelphia and New York but in Paris as well until the end of the century. Landauer also notes local claims that the world's first exhibition dedicated to the work of women artists took place in San Francisco in 1885; local newspapers ballyhooed the show as a sign of the state's path-breaking role in world culture. At the 1893 World's Columbian Exposition at Chicago, half the artists selected for the California art gallery were women. No other state had anywhere near that level of female participation in their art exhibits, and indeed California was the only state to have its own art pavilion, suggesting how important art was to the conception state leaders shared that California was the site for a new world culture.[16]

In addition to teaching, women occupied curatorial roles in galleries and museums, and their ranks eventually included two of the most important museum professionals in the Bay Area: the founding director

of the San Francisco Museum of Modern Art, Grace McCann Morley, who held the position from 1935 until her resignation in 1958, and Jermayne MacAgy, the adventurous curator of modern art at the Legion of Honor during the 1940s. Women who achieved success formed a network extending far beyond universities and museums. Women artists were more likely to work as teachers in primary and secondary schools. Jay DeFeo's high school art teacher Lena Wiltz Emery, active in the San José Modern Art Society, identified DeFeo as a potentially talented artist and instilled in her both confidence and conviction that an art career need not be considered frivolous. Emery continued to give advice to DeFeo for many years after she graduated from high school. In one letter to DeFeo, Emery remonstrated with her for spending too much time socializing and not enough time at the canvas. Only art has the power to transform an ordinary human being into a god, she wrote her protegée in language echoing Peterson's convictions.[17]

A parallel story took place in Stockton, California, where Ruth McElhaney, who taught children's art classes at the Haggin Museum and organized local art fairs, identified Pat Adams, DeFeo's friend and classmate at Berkeley, as another young girl with exceptional potential. McElhaney developed Adams's skills and then shepherded her into Berkeley.[18] An informal network of women in the arts provided the extra help that young female artists needed to develop self-confidence. Women modernists like Peterson insisted that art transcended gender though society did not. Peterson refused to exhibit in women-only shows because she felt the selection criteria generally lacked rigor. She made life rough for sorority girls who took her classes to develop social instead of professional skills. Older women had a responsibility to provide tough-minded role models for how to be a progressive, modern artist.

That responsibility included claiming the right to define modern art despite the marginal position occupied as women and as Californians. Women modernists in California acted as if they were innovators synthesizing a cosmopolitan understanding of contemporary global culture, indeed perhaps doing so better than male colleagues and competitors in other parts of the nation.[19] The struggle over the nature of art curricula was of immediate relevance to them, for modern art as a rigorous form of inquiry established their credentials as serious, autonomous intellectuals.

Women taught at almost all the state's college-level art programs, but the University of California, Los Angeles (UCLA) art department was unusual in its having been founded and led by women for its first thirty years, an accidental result of UCLA having developed out of the Los Angeles Normal School, a teacher-training institution. In her oral history, Annita Delano, on the faculty at UCLA from 1920 until her retire-

ment in 1961, discussed the rebellion that the UCLA art department led against conceptions of art that the state board of education mandated be taught to primary and secondary school teachers. Teacher training in art at that time was based on methods developed by Arthur Wesley Dow, specialist in art education at Teachers College, Columbia University.[20]

As Delano put it, Dow provided teachers with six "oversimplified" concepts: proportion, symmetry, rhythm, subordination, opposition, and transition. The Dow method was appropriate, in her words, "to help people in their houses and, say, with textile design and so on, design was the big word . . . and these principles helped you there." Approaching the epistemological bases of art in language that echoed Hippolyte Taine's earlier arguments, Delano argued that the Dow method was pedagogically inappropriate because it squelched the creative, constructive roles of intelligence, imagination, and experience. *Modern* art started with line, space, color, light—that is, experience in need of structure—but the Dow method started with a priori principles that transformed sensation into predictable, pleasing patterns.[21]

Delano added that the Dow method was personally obnoxious to her because the educational system presumed that women had a good sense of design but lacked genuine imagination. She was useful for training the masses in basic principles of visual literacy, but for nothing more ambitious. Modern art provided an alternative role model and alternative practices. But within the demands of progressive public education aiming to raise the practical intelligence of the citizenry, Delano could not simply pose an ethic of individual creativity, as her nonacademic male counterparts might. She defended her position within a professional academic environment using arguments similar to those that Worth Ryder developed at Berkeley, but going one step further by insisting that modern art was vital for *any* research into the relation of perception and cognition.[22] Delano deepened her abilities as a university-based art teacher by studying John Dewey's theories of learning. She spent a sabbatical year at the Barnes Foundation working with Albert Barnes, a collector and theorist of modern art, and another sabbatical touring Europe and visiting with the modern masters. Matisse gave her his palette, which became a study object for her students. She made annual visits to New Mexico and Arizona to study Navaho, Hopi, Zuñi, Pueblo, and Apache cultural forms.[23]

There was no question that women entered the art world on any basis of equality. Women painters faced more clearly the brutal fact that few artists, male or female, achieved the fullness of their ideal. This could heighten competition between women painters who legitimately worried that only a limited number of women could be found interesting at any given time. In the early 1960s, a rumor circulated that Sonia Gech-

toff on hearing that DeFeo was to be included in a group show at the Museum of Modern Art contacted the curator to insist angrily that DeFeo had stolen all her ideas from Gechtoff. The papers of Dorothy Miller, the curator supposedly contacted at the Museum of Modern Art, do not include any record confirming that the contact did in fact occur, but the story appeared credible to those in this circle of acquaintances.[24]

Limitation, however, could also encourage a sense of responsibility to help others. DeFeo's high school art teacher regularly wrote her former student insisting that DeFeo overcome her hesitancy to ask for help, whether it was advice or money. Art had been the way in which Emery discovered the reality of love as a universal force. Her assistance to DeFeo was her way of keeping that force alive in a world hostile to any form of creativity.[25] DeFeo's stepmother, once a ballet dancer, acknowledged that she had never been able to fulfill her own dreams, but she felt the successes of her stepdaughter as a vicarious triumph that allowed her to celebrate her own creative impulses.[26]

Mid-Twentieth-Century Ambitions

At San José High School, DeFeo belonged to a campus clique known as the Quad Girls, so called because they controlled the benches in the center of the school's quad. Much of what DeFeo's high school friends had to say about their expectations as young people and the life choices they made as they matured indeed reveal dramatic shifts in personal expectations that many in their generation at other schools across the state must also have experienced, shifts that themselves may be marked in one form in the creative choices an artist like DeFeo made in her creative work.

Every single one of the Quad Girls I talked to went to college, typically Berkeley or San José State University, as nearby private Stanford University was not an option for children whose parents were either working people or the proprietors of small businesses. Every one developed a professional career—in education, in public administration, in health care, in real estate or business. The Quad Girls grew up, they told me without exception, expecting to be self-sufficient economically and able to contribute something of value to society. Their parents conveyed this to them, and so did their teachers. Male classmates reported that they too had expected that the women they married would be competent, independent people. Both men and women understood that the options open to them were far greater than their parents had known. There was a common worry appended to the accounts of their own youth, that their grandchildren faced a world that was shrinking and that life was much more difficult for them than it had been for the previ-

ous two generations. Looking back on the insouciant optimism of their youth, a common refrain was, "We were all so naïve!"

This handful of personal accounts was elicited solely because the individuals had been high school friends with a person who subsequently achieved a degree of prominence. Otherwise, their stories would be invisible, not even a fragment, in the history told of the cultural revolutions unfolding in the United States after World War II. Perhaps their account is tangential to the most important art-historical questions, but multiply this limited group by high schools across California and an image of another kind of cultural revolution takes form. As the state's commitment to expanded public higher education rippled throughout the population and combined with the yearnings of many parents for their children to have a better, freer life, even students from racial and ethnic groups occupying low-status rungs in the state's social hierarchy found encouragement for rather than dismissal of their ambitions. In a pattern similar to the role of women in the modern arts movements, the expansion of educational opportunity in no way presumed that opportunities were in fact ever to be equal, fair, or for everybody. Yet the conditions for mobilizing individual initiative were in place and intrinsic to the state's political consensus in the mid-twentieth century. DeFeo's generation was the first to grow up in California with the expectation that going to college was a normal, indeed expected, part of life. Whether university training was to produce an enlightened citizenry or a more highly skilled workforce was an open-ended question. In addition to the expansion of job opportunities in fields that paid well, the experiment had profound implications for what the state's residents imagined they might—or should—do with their lives.

DeFeo's goal was to be a painter, and her high school friends reported that they expected her to succeed. Through the years, she invited these friends to her shows, and they often went. She usually had lunch with each of them at least once a year. Self-described as "conventional," they nonetheless took it for granted that good contemporary art would have to be abstract. Representational art was simply "corny." They spoke of taking the train to San Francisco while they were in high school or college to visit the modern art museum, which they liked better than the city's two other museums with their old masters. Many of them associated their preference for abstract painting with their *love* for jazz.

These young women were raised in a relatively permissive environment. Boys and girls went off for unchaperoned weekend excursions to the Santa Cruz, a nearby beach resort, and their parents encouraged them to get out and have fun.[27] These were innocent times when parents expected that their children would behave sensibly. Sex was a legitimate, intense part of life, but its most intimate pleasures were to be deferred.

Though perhaps not for too long. All married shortly before or after graduating from college, all started families in their early twenties. DeFeo's first marriage at the age of twenty-five was indeed the last in her cohort. Her decision not to have children was unusual but not surprising to her friends. Her closest friend thought DeFeo's choice was responsible. When DeFeo was teaching she was painting, her friend continued, when DeFeo was with somebody she was painting, she was always working on a painting, and a child could not grow up always being second to a painting, the friend thought.

As the group continued to see each other past college, the main topics of discussion over the years were not surprisingly men, family demands, jobs, and health—topics that typically had become sources of pain and torment, not of joy. Fully 50 percent of the women in the group divorced their first husbands, DeFeo among them. In each account, however, whether young love led to divorce or not, marital difficulties had involved reconciling contradictory expectations that both men and women shared. On the one hand, wives were to be self-reliant, independent women *and* on the other hand, dedicated, efficient homemakers. Among this group, in every case, the solution reinforced the importance of women having careers, of women being able to take care of themselves and their children if they had to.

Since DeFeo was an artist, her high school friends turned to her for fashion advice. Indeed through the 1950s she supported herself by making clothes and jewelry, the latter providing objects of study for later work.[28] The Quad Girls remained an important part of DeFeo's life until her death. She and her friends were linked by a common struggle to realize a personal excellence that family and school had assured them would be theirs. The goal of expanding access to higher education that the state acted on by investing millions of dollars for decade after decade provided the necessary condition that helps explain the priorities this one group of friends set for their individual lives. Excellence through education motivated their search for new ways of living together—as men and women, as Americans of different races and ethnicities, as productive members of a modern, cosmopolitan society. To the degree that California was in advance of the rest of the country and indeed the rest of the world in broadening access to university-level education and making advanced training and careers a commonplace cultural goal, the cultural shifts in the state that each generation has fostered decade by decade have significance for understanding developments that became widespread elsewhere later. The personal, political, and economic contradictions were worked out in the lives of Californians who struggled to reconcile big ideals with a whole host of customs and conventions, many of which they honored and even liked.

DeFeo relied on both a network of women modernist painters and a group of high school classmates to help find answers to the contradictions of being at one and the same time the objects and the authors of a grand social experiment. DeFeo's story underscores the lack of substance in the mythic dichotomy of conformist versus bohemian that so often structures writing and art exhibits on the postwar United States—there were the beats in North Beach or other bohemian enclaves and then there was suburbia where everybody lived according to the norms shown in television situation comedies.[29] Cultural change according to this picture came from innovations by individuals who were fundamentally outcasts, atypical of a society limited by conformity and fear.

Rather than being separated, the supposedly two worlds were intimately connected through the variety of personal connections people maintained with each other. As with DeFeo and her high school classmates, ideals and ambitions fostered by an ambitious program to transform society with more broadly accessible education also linked people pursuing diverse practical goals. Changes in the arts after World War II went in tandem with changes in who was educated and how they went about their everyday lives. Further, cultural change resulted from excluded groups—be they artists within the university, women painters, or students from working-class urban high schools—taking advantage of opportunities to insert themselves into new places. Postwar art reflected the anxieties of an uncertain, dangerous world, whose leaders possessed the technology to annihilate all life on earth. Postwar culture also expressed ambitious ideas about the ability of individuals to transform themselves and everything they touched. Those dizzying visions of an expansive self were fueled by loving parents who encouraged their children to take it for granted that happiness could be theirs, by teachers at all school levels who motivated their best students to be ambitious, and by a committed program to build new institutions for the development of "human capital."

Art teachers at Berkeley provided their students with a set of values that were increasingly old-fashioned: knowledge is the basis of values and living right. Beauty is everywhere, but only those with educated eyes will see it; the responsibility of the humanistically trained artist is to help others see the hidden potential surrounding them. The creative process is a basic, perhaps the most basic, life force. Creativity is essential to problem solving and the discovery of Truth. The values propounded helped establish art as a discipline worthy to be included within the University of California.

Most Berkeley students resisted these corny, genteel lessons for they understood that their teachers stood apart from everything lively in contemporary art. Nonetheless, the lessons offered could not be shrugged

off completely for they provided ample justification for an ambitious artist working in the provinces, an artist who could enjoy a full, productive life but was unlikely to find financial security from the sale of his or her work. Myths of the avant-garde and of the *poète maudit* muddied the picture, for the images they evoked insisted that "bourgeois" society rejected rather than nurtured serious artists. As anomalies, they could ascribe their desire to be artists to innate genius rather than decades of investment in institutions that could indeed become places that identified, promoted, and sustained talent. The structures provided often appeared as constraints threatening creative inspiration that needed to be resisted.

Clark Kerr, chancellor of the Berkeley campus from 1952 to 1958 and then president of the University of California system from 1958 to 1967, called the combination of demographic expansion with increasingly more radical ideas of human liberation a "shock wave" that rolled across the state.[30] The state's politicians and increasingly the public were not prepared for the breadth of change that occurred. Kerr's conception of the university's role in modern society, articulated in his book *The Uses of the University*, tried to provide a vision of how higher education might contribute to a more dynamic society while containing the disruptive effects of continuing change.[31] The grand social experiment unleashed by the idea of "universal higher education" generated a backlash contributing to the election of Ronald Reagan as governor in 1966. Early in his administration, Reagan fired Kerr in a symbolic gesture that asserted the growing conservatism of U.S. society and a desire to restrain the social transformations connected to the idea that every person should explore his or her personal interests and talents. The state university system entered a lengthy period of lean years, while public education in the state began its dramatic decline, aggravated by the tax revolt of 1978. In the new dispensation, personal security had greater value than opportunity, possibly resulting in an overall decline in both.

The findings presented here do not conform with interpretations of the post–World War II United States as conservative, subsequently followed by an opening up of society during the 1960s. The juxtaposition of institutional and subjective domains suggests on the contrary that between 1945 and 1965, U.S. society had entered a dynamic phase testing open-ended social experiments resting on faith in both individual potential and large-scale social organizations (which might be private for-profit, private nonprofit, government agencies, or some hybrid). Belief in a can-do, problem-solving approach supported ambitious individual and national projects, supported indeed widespread overreaching that encountered its limits in the brutal debacle of the Indochina wars.[32] The relative decline in public education over the last third of the

twentieth century, matched by the increased prestige of private schools, is one institutional correlate of the social conservatism of the United States since the 1960s that promotes fear of any but the narrowest of personal ambitions. A subjective correlate would be a growing pessimism over the possibilities of what either individuals or the nation can successfully accomplish, a negative cast that ought to be puzzling given the immense wealth and resources of U.S. society. An optimistic belief in the power of action had fed the struggle for change that in the 1960s resulted in the passage of civil and voting rights legislation, the emergence of second-wave feminism, a new environmental consciousness, and the determination of groups like the gay and lesbian movements to claim the right to participate in society as equals.

What once appeared to be the dawning of a new social contract in retrospect seems more like the crest of progressive reforms launched much earlier in the century, yielding results that few had expected and which some powerful groups did not want. On a subjective level, the costs of mid-century progressive ideals were high. A generation shaped by a vision of an open-ended future was scarred by the dilemmas lurking within the terrifying efforts of parents and teachers to inspire them with simple affirmative words, "You can do anything you really want! Just try as hard as you can! You can be everything you really want! Don't ever feel you must limit your dreams!"

DeFeo's mother, for example, developed a local reputation for folk art creations—largely artificial flowers like chrysanthemums made from Chore Girl scrub sponges or snapdragons made with Cream of Wheat, pretzels, and pecans molded onto wire. Mary DeFeo (later Murphy) expressed to a newspaper reporter thoughts on love and beauty that she may have imparted to her daughter while Jay DeFeo was growing up: "With beauty you don't have to go according to any book. This is no mathematical problem—you can stretch a thing or narrow it down—no one can say it's right or wrong. Beauty is universal—lines, colors, positions—all give rise to ideas for creating even more beauty."[33]

The reporter noted that "Mrs. Murphy finds people, as well as kitchen items and food products, 'full of overlooked potential.' Her arrangements are quite often brought on by some sentimental song, the sky, a memory, or a person." The writer then quoted DeFeo's mother again, "There's beauty inside everyone—it should come out. When it does, it brings out the good in them. Rebellious people have it too. They just haven't found a way to release it in a way that will create 'positive' instead of 'negative'" outcomes. Mary began making art while she was running a boarding home for women students attending San José State College. "Many girls," she explained, "were majoring in education, taking Public Education Art courses. They'd always be working on some

projects or asking for ideas. I told them, 'You don't have to go by the book to make beauty,' and I set out to prove it. We got together and came up with our own art, using what we had—things from the kitchen."

As an adult, DeFeo dismissed her mother's artistic talent. She thought it had no relevance whatsoever to her own career as a professional. Her first inspiration to be an artist in her view came instead from Lena Emery, her high school art teacher. Emery pointed toward art as a distinct intellectual discipline, one in which modern women would seize their place as equal contributors. Her mother practiced art as a form of therapy. Turning everyday objects into emblems of beauty aided in the task of adjusting to a world changing in unpredictable ways. Mary DeFeo had learned that progress was supposed to lead to happiness. A modern person had an obligation to strive for a positive attitude. She had learned that craft was a field where she had some talent, and its practice affirmed the values she held dear even in the face of the often insurmountable, difficult personal circumstances she had faced as a single mother trying to do the best for her child.

DeFeo's closest friend from high school confided that DeFeo was often sad, frequently upset about the inability of things to connect in her life. The friend went on to say that for most of the Quad Girls, despite all the accomplishments, there had been a lot of disconnect as well and a sense of failure that none of them could explain. Somebody had convinced them, she said, that they could do anything. They had done a lot, but always with guilt for not having been able to do more, of not having done as much as they were told they could. DeFeo's paintings still moved her because seeing them hanging on the wall of a museum, she faced an accomplishment that was tangible. She felt a pride of connection, and thought back over the years to the many ways she and DeFeo had helped each other. But she also saw the paintings as embodying in material form all the *loss* that had been dogging her for years. She stopped in the interview and apologized for being unclear. She was certain she could never explain what she meant. She did know that when she went to see DeFeo's most famous painting, *The Rose*, restored and on display in a touring exhibition that the Whitney Museum of American Art had organized, the pride her friend's painting inspired gave way to darker, more contradictory fears that would not stop whirling within her.

Chapter Four
From an Era of Grand Ambitions

An Emergent Painter's Project Unfolds

As a prominent figure in California's countercultural movements of the 1950s and 1960s, Jay DeFeo has often been associated with, at times celebrated for, a supposed Dionysian irrationality that in fact had little to do with the deeply intellectualized project that guided the development of her painting, works on paper, and photography. She shared a widespread faith of her generation of artists that the validity of painting as a discipline lay in its ability to reveal truths she thought were independent of any immediate social context. Her goal was to bring to the surface underlying realities structuring how sensations turned into ideas and beliefs. In her paintings in particular, she sought to combine opposing visual states into a unified field that freed the thinking subject to see the codes structuring how she perceived the world. Her interest in the principles of visual structure at play in experience developed during her training as a student in the art department at the University of California, Berkeley.

In 1953, when DeFeo returned home from nearly sixteen months studying and working in Europe, the twenty-four-year-old artist threw herself into the rapidly growing art community developing in California's major cities after World War II. She had a part-time teaching position at the California College of Arts and Crafts. She hoped for a full-time appointment at one of the local schools, but her arrest for shoplifting at an art supplies store sharply limited her opportunities. In any event, while teaching jobs were opening up quickly as schools expanded, the number of young people entering the arts profession was growing at an even faster rate. The continuing weakness of institutional support for contemporary art allowed young artists in the 1950s a high degree of freedom to explore their personal interests and to set their own standards for what was particularly interesting. They formed a community

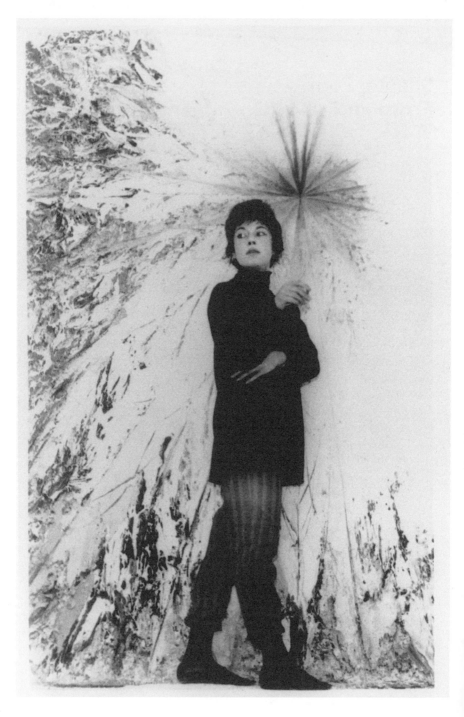

Figure 7. Jay DeFeo in front of an early version of *The Rose*. Photograph by Marty Sacco, *San Francisco Examiner*, 6 December 1961. Courtesy of the Bancroft Library, University of California, Berkeley.

that improvised opportunities for exhibition and discussion. From 1955 to 1965, DeFeo was at the center of San Francisco's emerging counter-culture. She was the secretary-treasurer of the Six Gallery, the most successful of the coop art galleries, perhaps best known internationally for a poetry reading there in 1955 when Allen Ginsberg gave his first public reading of "Howl." DeFeo's husband, Wally Hedrick, also a painter, was the gallery's director. Their home was the gathering place for the many artists, poets, musicians, and alternative filmmakers living in or passing through northern California during the heyday of the "beat era."

DeFeo produced a body of work during this period that remains highly regarded for its ability to have the painting image grow out of her sculptural manipulation of paint as a material substance. Critics at the time spoke of her as among the very best of the emergent generation, and her work was published in several mass-circulation magazines, most prominently in *Look* magazine in December 1962, when DeFeo's still-in-progress *The Rose* (Figures 7 and 10) was highlighted in an article signed by President Kennedy on important new trends in American visual culture. In 1956, DeFeo completed her first large-scale canvas, *Origin*, some eight feet tall and six feet wide (Figure 8). With sculptural application of the paint integral to the design, *Origin* pointed to the body of work that followed over the next ten years. Fred Martin provided a hint as to a source for *Origin*'s title when, explaining the work in a 1956 show of landscapes and still lifes, he noted, "It was from the hunger to understand the origins of life, to represent them in clear, primitive (as beginning, as first) forms, that the paintings were made . . . simple views of the lands of heart's desire made from the dust and stone and sky and sea and light."[1]

Martin's comments spoke to the ambitions of young painters at the time, touching on a desire that a genuine practice of art could "restore" humanity's understanding of the basic laws governing all natural phenomena, themes that nearly a century earlier Hippolyte Taine had identified as the core of an art consistent with modern progress. Art in this context was at once a social product and a natural instinct that can be repressed but never erased. Art was an essential link, along with sex, returning humanity to the rhythms of life and death, of emergence, decline, decay, and rebirth found in every expression of the universe.

DeFeo described *Origin* and two subsequent paintings, *The Veronica* and *The Rose*, as a triptych exploring "floral form" across a decade.[2] Flowers had been a subject of previous still lifes she had done, but when speaking of *Origin*, *The Veronica*, and *The Rose*, she probably did not mean "flowers" in any literal botanical sense. *Origin* and its two successors might better be said to model floral form as an archetypal process of growth—of form*ing* as a process—for which flowers provide one exam-

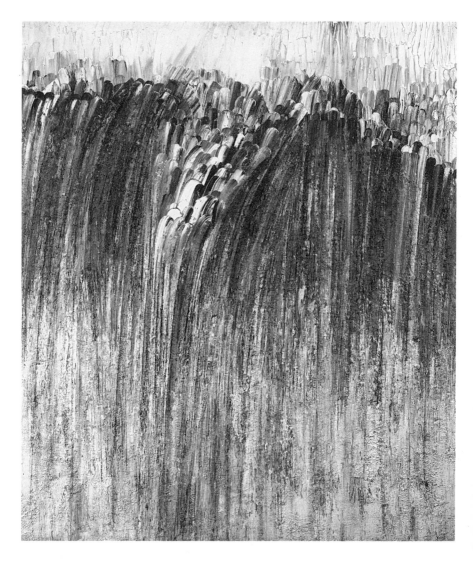

Figure 8. Jay DeFeo, *Origin.* Oil on canvas, 1956. University of California, Berkeley, Art Museum, photograph by Benjamin Blackwell. ©2008 Estate of Jay DeFeo/Artists Rights Society (ARS), New York.

ple. DeFeo's reference when she spoke of "floral form" was more likely to alchemy, particularly as presented in the work of Swiss psychoanalyst Carl Jung, an important influence on DeFeo and many other creative figures of the post–World War II years.[3] Jung argued that alchemical rituals had been symbolic representations of the progress of the self toward a higher level of integration. They provided a set of archetypal images that allowed the mind to perceive that the principles governing its own growth conformed with the structure of the universe. As we shall see later in this chapter, the distinction made in alchemy and other Gnostic traditions between floral and crystal forms is an essential element in at least two of DeFeo's large paintings, *The Rose* and *The Jewel*, both started in the late 1950s and completed in the 1960s.

Woven around the story of her unfolding projects are four sets of ideas that almost certainly engaged her and her immediate circle: new ideas about surface and image found in European abstract painting after World War II; the work of Carl Jung on symbols as primary organs of the human psyche; mystic religious traditions that provided artists with symbolic systems that could be treated abstractly, that is, as raw material for the exploration of psychological development; and the only recently translated work of the German existential philosopher Martin Heidegger on poetry as a form of revelation. Even though there is strong circumstantial evidence for her interest in how these different ideas were relevant to her developing conception of painting, what DeFeo thought must be known primarily through the physical objects she created. She herself said little about the intellectual context of her work other than to repeat that her paintings were not about formal exploration of paint as a means of expression or composition. She referred to her project as "literary" and "philosophical" without specifying precisely what she meant. She did not need to because her paintings were never intended to be illustrations of ideas she had read or discussed. They were practical explorations whose power, if they were successful, had to come from the revelation the experience of the painting provided. In any event, as an independent thinker, she was not "influenced" by other thinkers' ideas except as she made them work for her own ends. If she responded to Jung or Heidegger it was with her hands. In this she was a worthy successor to Claude Monet as Clemenceau had portrayed him. The object must take the place of selected quotations from interviews or artist statements, because whatever odd comments she may have made on one subject or another, painting and drawing were the media in which she engaged in disciplined, serious reflection. In the process, the physical status of the work assumed increasing importance until the image became inseparable from the manipulation of paint as a material substance.

The technique developed in *Origin* required extensive use of the palette knife (or a comparable instrument) as a sculptural tool. Forming in *Origin* is revealed through columns of paint rising upward out of a formless bottom. The process of shaping each column was arduous. Each stroke had to be of identical width, as well as having consistently thin ridges separating them. Using a device for measuring perspective, she had to calibrate the degree to which each column should slope if the columns' movement upward was to appear in unison. She spoke of each column requiring a full day to complete as she stretched the upward motion to three or more feet until the form defied the limitations conventionally imposed on a single stroke. The process could not take any longer than a day because the paint had to remain wet while she shaped it. If she made a mistake, if the paint dried before she completed the form, or if she did not like how any given column fit into the emerging composition, DeFeo had to scrape it back and start over.[4]

Origin sets up contrary expectations that underscore the illusionary and fragile character of art. The strokes in the painting build upward, culminating with carefully rounded caps. One can clearly see the artist's effort to extend each stroke toward the top of the frame, but the rising movement coexists with a countervailing motion downward where the forms break down in the tense textural effects of the lower quarter of the work. The image forms but then falls apart. The shaping of the paint as a viscous substance capable of being molded while it is still wet substitutes for the use of line drawing to provide definition.

The new approach developing in the large paintings initiated by *Origin* was austere and demanding. Measurement and precision of application characterized the work, not improvisation. Given the difficulty of completing the rays that constitute both field and image, *Origin* is a tour-de-force and was the first DeFeo painting to be singled out for critical admiration. Alfred Frankenstein, writing in the *San Francisco Chronicle* about a group show at the Dilexi Gallery, noted that the exhibition "contains one painting which is an event in itself—the huge canvas called *Origin*, by J. De Feo. It is a gray-and-white abstraction composed of immensely powerful vertical strokes, pressing, tense and busting with vitality at their start and growing with volcanic energy as they descend. . . . Walt Whitman would have been the first to approve what Miss De Feo says here."[5]

L'Art Informel

The physical effects DeFeo sought are consistent with approaches to abstraction that she likely saw during her sixteen months in Europe from September 1951 to January 1953. In Paris, she met Sam Francis, a

classmate from Berkeley with whom she had had a brief romance. Given that he was a friend of Jean-Paul Riopelle and the circle of painters surrounding him, it is possible that Francis introduced her to the work of painters identified with *tâchisme, l'art brut,* and *l'art informel.* DeFeo wrote home that she had seen an exhibit of paintings by Nicholas de Staël, whose color and surface quality she found exciting.[6] In the fall of 1951, there was an important show of work by Jean Fautrier, a major figure in postwar French abstraction. Since the 1920s, Fautrier had been working with heavy brush strokes to create open-form landscapes that could also be read entirely as abstractions. His use of objects, sometimes visible, often submerged into the paint, created unusual textures that were integral to his images. The rough, crackling surfaces that he achieved, often inches thick in places but ultrathin in other parts of the canvas, form a body of work strikingly similar to the approach to surface that DeFeo developed after she returned home. Fautrier's work also explicitly evoked prehistoric cave art, an important topic for DeFeo's European studies.[7]

Fautrier was a seminal figure for the many post–World War II European painters who regularly combined paint with burlap, sand, plaster, wire, plastic, resin, and metal sheets to build a painting's surface into a molded physical presence. Jean Dubuffet was already well known in the United States. Antoni Tàpies from Spain and Luciano Fontana and Alberto Burri out of Italy were attracting attention for the physicality of the canvases they made. Like DeFeo, these artists incorporated sculptural elements into their paintings, which often worked more as palpable objects than as compositions of colors into images. Building up and often violating the painting surface created works whose power came from the tension between its physical presence and the illusions of spatial depth that tortured picture planes could still produce.[8]

Younger painters in Paris in the early 1950s were determined to go beyond cubism and surrealism, the two approaches that had been dominant prior to the war. Michel Tapié, a painter who was the chief propagandist for *l'art informel* (art without form), wrote in 1952 of the importance of returning to dada and exploring the implications of that movement more fully. After World War I dada had destroyed the power of language. New painting after World War II had the mission of destroying the power of form. "Life has become totally estranged from form," he declared, "expressiveness is no longer compatible with it." Painters through exploration of the physical possibilities of their medium were to treat form with indifference, indeed contempt. The placing of marks on a picture plane had become a "transcendental calligraphy" that clarified that signs were fully arbitrary even if powerfully creating the worlds in which humans lived.[9] Form was allowed to dissolve in a fluid shape-

lessness (*l'informe*) that would provoke viewers to draw upon their own imagination to complete what was missing. In so doing, they would tap into the deeper roots of the psyche and explore the bases of their responses to the world. If a work moved people, their responses were proof that the painter had succeeded in revealing the reality of "pure imagination" hidden beneath the conventional symbolic systems that structured everyday life. The painting became evidence of a higher reality the mind could intuit through its sense impressions but seldom grasped firmly in the fleeting movement of thought. The contemporary painter would have achieved what Hippolyte Taine had described as the core function of modern art—to liberate the senses from conventional systems of representation and to reveal a "true sensation" of the world. The goal was to challenge the senses and provoke a shock of such intensity that everyone responding to their feelings would have to rethink their ideas about the experience of the contemporary world.

From Image to "Thing"

The Veronica (1957) like *Origin* utilized the effect of layering extended lines of paint next to each other to create an image of form bursting onto the canvas from a hidden opening off the right side of this nearly ten-and-a-half-foot-foot-tall painting. The title of *The Veronica* refers to a move in bullfighting. The flame-like patterning of a ruddy form taking shape against the dark background might speak to the flurry of confused emotions that witnessing a bullfight with its ritual sacrifice of a bull might provoke.[10] The image may be suggesting spurts of blood from a severed artery of a bull or, equally plausibly, the blood of Christ imprinted on Saint Veronica's veil, the episode from the Passion that inspired the name for the move in the bullfight when the matador dangles the cape as if it were a veil.[11]

As a visual experience, *The Veronica* is an experiment into the orchestration of brush strokes, strongly shaped and modeled with the palette knife, to create a fiery feeling of form flashing into the space of the canvas and fluttering upward. A slight ridge effect in both *Origin* and *The Veronica* bounding the edges of the brush stroke provides a value that contrasts with the forward movement of the stroke itself. As in *Origin*, the shaping of the paint provides definition rather than line drawing. This use of sculptural line provided an effect that DeFeo later pushed to its extreme in shaping the craggy rays of *The Rose*. In earlier works, the formed brushwork separates from the ground to create a distinguishable pattern, transforming the textural qualities inherent to paint into image.

In *The Annunciation* (Figure 9), also done in 1957, DeFeo continued working with layered streams of brush strokes, while taking up one of

Figure 9. Jay DeFeo, *The Annunciation*. Oil on canvas, 1957–1959. Gift of Lannan Foundation, 1997.139, The Art Institute of Chicago. ©2008 Estate of Jay DeFeo/ Artists Rights Society (ARS), New York.

the most sacred subjects in the European painting tradition. Her interpretation presents an abstractly rendered torso ripping apart with powerful explosive energy. The central aperture from which the mutilation emanates is defined by a small diamond of four neatly layered stripes of white, black, and red. The composition grows from this austere, painterly center. Energetic brush strokes rise upward in long, delicate, carefully shaped lines that suggest both flames and the sprouting of wings reminiscent of the Nike of Samothrace. The image, emerging and shredding at one and the same time, evokes both angelic presence with its message of divine intervention in human life and the maternal womb as the matrix manifesting the mystery of creation. The left side of *The Annunciation* contains impressive impasto work. The introduction of color highlights among the blacks helps bring attention to the shredding of the matrix as form emerges. The tear, however, is also an emergence, in this case of a semiformed torso. The two processes, tear and emergence, are simultaneous and possibly synonymous. A generalization of the image might be: dematerialization is always also rematerialization.

"This kind of winged vision," she wrote J. Patrick Lannan, a Chicago businessman who bought the painting in 1959, "promises some realization of all that is good in this existence, and more specifically it is a promise to me of the realization of certain powers creatively—and when I say that, I make some association between the words creative and spiritual or divine. It doesn't have to do with any specific religion at all. It is only a symbol."[12]

According to Carl Jung, symbols were psychic organs that the human race had developed over the millennia to restore wholeness to the self. To face a symbol that generated a powerful emotional response was to face an articulation of humanity's most basic and most universal desires, which even though they sprang from a deep substratum of collective feeling were felt as intensely and immediately personal. The basic elements of the visual arts—line, shape, color—captured the meanings of one's desires in forms that were neither arbitrary nor idiosyncratic. In the development of the psyche, for example, Jung taught that the color white expressed a yearning for the "mirrorlike wisdom" that accompanied reintegration of the psyche into nature. Red symbolized the power to make discriminations between qualities, while green grew from needs to act expansively and leap over the barriers the perception of difference could erect. Rotating, mandala figures were images of an integrating self. Wisdom comes as an illumination, literally as a burst of white light, Jung observed, not as the product of argument. When the inevitable process of interpretation took over "what happens afterward is an ever-deepening descent into illusion and obscuration."[13]

A corresponding problem then might well be how to balance the work DeFeo did, the physical choices she made and executed, with the temptation of allegory that her titles invite. The title of *The Annunciation* suggests that the central figure of the painting is an angelic form. The title as well insists on the miracle of conception as a theme of the painting, or in allegorical terms, the materialization of spirit. The central figure's hips and leg stumps imply a pubis. Wings flame from the torso, but the tear replaces head and shoulders. A line of sight moves from the edge of the left "wing" across to the tear, the aperture, the "belly," to the "belly button," down to the "pubis," and then to the right "leg stump." This line of shapes forms the main axis of the painting. The central diamond aperture from which long palette knife strokes emerge, a cluster of dark paint patches, a "hip," and the "tail" form the secondary axis.

Painting sparks the imagination with a physical experience that must be verbalized on some level to be retained, but a physical object is not definable by the interpretive possibilities it can inspire. The material reality of a painting never disappears. Brush strokes of different qualities, pigments of different qualities, suggest a variety of shapes but never cease to be a viscous material applied to a flat surface before it dries. For paint to tell even the simplest story, much less aspire to be a revelation of divine truth, the viewer first must dematerialize pigment, stroke, texture into mark, form, and line, and then reconstruct these sensations into an image that generates stories. DeFeo was crystal clear on this point: painting is a set of manual techniques that provide evidence of intelligence at *work*.

The techniques that DeFeo developed seem to respond to the definition of *technê* that Martin Heidegger gave in discussing what made a work of art distinct from the work that went into making tools and equipment: "The word *techne* denotes . . . a mode of knowing. To know means to have seen, in the widest sense of seeing, which means to apprehend what is present, as such. . . . *Techne,* as knowledge experienced in the Greek manner, is a bringing forth of beings in that it *brings forth* present beings as such beings *out of* concealedness and specifically *into* the uncon- cealedness of their appearance."[14] Art reveals that technique is not about the making of tools or solving problems, but allowing relationships that humanity has with the totality of being to reemerge from the forgetfulness, the carelessness, inherent to practical everyday routines.

Did DeFeo know the writings of Heidegger on art? Nearly fifty years later, Wally Hedrick, married to her from 1954 to 1969, recalled joking discussions among their circle of friends about what Heidegger's heavy phrases could possibly mean.[15] Their friend Fred Martin regularly quoted or cited Heidegger in his frequent writing on the goals of mid- century abstract art in California. While DeFeo copied quotes from the

French philosopher Gaston Bachelard in her diaries, there are no indications of her having attempted to work through Heidegger's more difficult writing.

Nonetheless, DeFeo's large paintings from the 1950s and early 1960s seem readily to provide an analog to Heidegger's vision of *earth* as "the serving bearer, blossoming and fruiting, spreading out in rock and water, rising up into plant and animal." From this outpouring comes a nearness with things that can nourish as well as things that can destroy. It is the awareness of things as presences to be encountered with the open-ended possibilities encompassing both opportunity and danger that art reawakens. In the process, humans recall that the representations they have created of the world are phantoms, even if often useful for particular purposes. "Reawakening" means to return from a shadow *world* where ego has forgotten how to respond to the conditions of being, how even to recognize being. To rematerialize the divine, *earth* must resume its struggle with the *world* as image factory.[16]

If Jung provided a template for understanding the roles artists, supposedly working with universal archetypes, could play in promoting a much more broadly transformative, integrative understanding of the self, Heidegger, on the other hand, could deflect artists away from the traps of narcissistic fascination with their own subjectivity. His writings inspired a vision of authentic art as a "song of the void," capturing the wonder and the danger "of that which is coming ever to be." Art allowed men and women to remember that their intentions did not control the earth, even if they created enclaves ("worlds") for themselves. Modern societies had become increasingly dangerous, in this view, because they alienated humanity from natural processes in which they were always intimately embedded and turned individuals into "solitary actor[s] in a cosmos composed commonly only of objects," that is, things known only to the degree that they served human purposes.[17] Art, in this existentialist interpretation, battled against the inequalities of contemporary society by forcing the honest viewer literally to feel the modern relationship of subject and object to be at odds with a cosmic view of the human condition. Heidegger described poets (given the prominence of Vincent van Gogh in his argument, understood to include visual artists) as initiators of a conversation with the "gods," that is to say, with the most fundamental forces of life and death.[18] Every society tried to prevent further change by memorializing the achievements of earlier poets, by enshrining them within literary canons and within the walls of museums. With terms echoing Taine's earlier arguments, the challenge for a genuinely modern, contemporary art was to overcome the ossification latent within every tradition and to "establish"

once again a relationship between humanity and the mysterious structures connecting every aspect of the cosmos.

Yet "revelation" is not knowledge, at least not in the positive sense that either Taine or Clemenceau meant, nor even Worth Ryder, DeFeo's earnest teacher from Berkeley. DeFeo's paintings and drawings reached out to touch the soul gazing on her work in order for that individual to become aware that the objects so important to one's daily life were also "things," with origins and purposes completely independent of anything human beings might desire of them.[19] As DeFeo's friend the poet Robert Duncan insisted, what made art different from everyday language was the reopening of subject-subject communication in a world overly focused on functional objectives. Citing a famous passage from William James's *Principles of Psychology*, Duncan noted that the total world which *is* is beyond counting for it consists of realities *plus* fancies and illusions. Hence the problem for intelligence was not how to see, for there was no inherently correct vision. Meaning finding is not necessarily an arrival at predetermined truths, that is, a solution to a problem. One worked through sensations that were inevitably linked to emotional states and associated fancies to create codes that arranged sensory relationships into forms that conveyed an assessment that was simultaneously rational and emotional. Those codes were places for the "I" to exist: "Within the world of absolute reality . . . there are the worlds of abstract reality, of relative and practical reality, of ideal relations, and there is the supernatural world."[20]

The poet, Duncan concluded, was the person who sought a mode of expression capable of conveying the various levels of feeling and thought in ways that would allow their linkages to remain practical and thus provide the recipient of the poet's work a more adequate sense of the "complete" that would also allow each person to determine the relative relation of each subworld to the others with which it coexisted. "Poems are events . . . of our consciousness of *making* a universe of feeling in language," Duncan concluded.[21] Works of art create the relationalities that provide meaning to relationships. They do not capture preexisting structures forming experience because there are no universal codes, much less a universal experience. All action and process proceed as part of a larger algebra. As Duncan put it in one of his best known poems, written at the same time as DeFeo's experiments in painting: "as if it were a given property of the mind / that certain bounds hold against chaos, / / that is a place of first permission."[22] An understanding of communication as a process of mutual constitution between two subjects went well past the goals that had guided modern art, hence the work of the 1950s was already "postmodern," even if the significance of the shifts under way was not yet recognized as a rupture.

Tackling the Problem of Surface

DeFeo used paint in all its materiality to transform perception of simple forms into ideas about forming as the inherent aspect of all being. As Tapié and others had argued, how far the flow of ideas emerging from an encounter with an art object might go was not the concern of the artist. The chain of associations an experience ignites nonetheless is part and parcel of a work of art, a logical extension of the forming process the work dramatizes, a chain that remained alive because the abstract nature of the work resisted precise programmatic interpretation. A wide variety of readings might even be a mark of success for a poem precisely because the work has stimulated the meaning-finding capacities of others to come out of hiding.

Unless you are in New York and digging so deeply into painterliness that meaning effects are distractions. In which case, anything that DeFeo or her associates did would increasingly appear to be a distraction to the real business of art. You would be waiting for Frank Stella or Sol LeWitt to emerge from the tears structuring modern art. You would crave work that blocked association and forced the viewer to confront the matrix for visual intelligence without engaging in any deductions of "meaning." You might wish that artists would understand that they were in no situation to reveal universal truths. They could, however, give people pleasure with the work they created.

But in the middle to late 1950s, that direction, while already germinating, was not yet the cutting edge of contemporary art. With her earnest, provincial education in the arts and humanities, DeFeo looked back to legacies she inherited and accepted them as worthwhile. DeFeo shared the "syllables" of her visual vocabulary as well as her interest in exploring spatial illusion with most other mid-century abstractionists.[23] *The Annunciation* invokes one of western civilization's most important mysteries but breaks it down ultimately to return the viewer to the sheer materiality of paint as an indispensable source of truth about divine presence. Idea is allowed to float upward from a carefully designed image, but then rematerializes in the orchestration of painting materiel, or as Heidegger put it: the occupying of the "Open" of truth "must set itself back into the heavy weight of stone, the dumb hardness of wood, the dark glow of colors."[24] In this way, she worked much like a poet who, by forcing a field of sensation into the limited repetitious forms of language, allows for reflection and not simply response. Complex cognitions that related experience to a personal and social history provided a mental world superimposed upon the purely physical.

The elongated ridge and the aperture can be equated with the phallus and the vagina, but DeFeo's commitment to the underlying common

origin of forms undermines a reading that accepts sexual projection as the foundation of experience. She deployed her vocabulary of opening, tear, emergence, and ridged rays as variations of each other. They transform into each other in the imagination as the mind shifts its point of view from one angle to another, or from one painting to another. This power of the imagination is the spin-wheel that alternately synthesizes and analyzes form into a variety of phenomenal manifestations. If extension forms and opening forms arc two views of the same phenomenon, the field that allows for their experience is the necessary foundation for sexual difference. Part of the emotional power of images based on the simplest of forms lies in the way in which they express sexual relations as well as the mysteries of the sublime. Forms used to perceive the exterior world bring humans constantly back to cosmic structures, forcing them into the openness of death and sexual reproduction as the most immediate, but not the only, forming processes working within each human life.

Two powerful panels from 1958, *The Wise Virgin* and *The Foolish Virgin,* began a process of synthesizing her use of the syllables of visual vocabulary into forms that exude a stony tangibility, even as the process of opening up eats away the surface. These forms are fully identifiable, though the juxtaposition of shapes and textures is surreal. In *The Wise Virgin,* DeFeo created an illusion of a paint-flecked wall with a fissure cracking open the surface as a flower pushes forward to emerge. In its paired work, the aperture has caved in, the flower sinks back. Entropy prevails, and the tear in the wall is all that is left. The tearing process is no longer a messenger of a future order but the sign of decay and collapse. The images seem to reveal the protection that the earth provides to forms as well as the inevitability of decay leading to rebirth.

The Eyes, a massive, eight-foot-by-four-foot graphite drawing done in 1956 and 1957, was also untypical of DeFeo's work at this time, although the extraordinarily long but carefully crafted pencil lines are analogous to, and perhaps were even more difficult to execute than, the elongated rays of paint found in *Origin, The Veronica,* and *The Annunciation.* DeFeo herself was convinced that the drawing was a vital part of the project she had begun.[25] Because of its literal content and its literary inspiration, *The Eyes* has the value of articulating the allegorical program underlying the cycle of abstract paintings created during the decade separating *Origin* from DeFeo's last touches to *The Rose* in 1966.

The title of the drawing and its theme derive from a poem by Philip Lamantia that includes the line "I have eyes only for heaven." For once, the transcendental subject looking onto the world presents herself in a DeFeo work with untypical, indeed inescapable, clarity. Given that the act of looking upon the world brings both viewer and its visions into

being, the viewer as a subjective intelligence is a flash erupting into the studio or the gallery, much as the "growth forms" of *Origin, The Veronica,* or *The Annunciation* burst onto the canvas. The work of art looks upon and discovers within the viewer the same mysteries that the viewer will puzzle about in DeFeo's work. The work of art is not there to stimulate new experience but to make open to knowledge what is already within but usually ignored.[26]

The literary allusions found in several of DeFeo's most important works from the 1950s help identify her allegorical intentions, but the massive paintings that conclude the cycle of work she began in 1956 create their illusions by pulling back into more abstract forms. The effervescent qualities of *Origin, The Annunciation,* and *The Veronica* harden into the thick materiality of *The Jewel, Incision,* and *The Rose,* even though DeFeo still worked within a streamlined, even limited vocabulary of visual formation. Her statement about the spiritual nature of the forming process intensified with the use of paint to create thick, heavy, inescapably material worlds that DeFeo acknowledged in 1961 "as a combination of painting and sculpture." She continued, "It is not my intention to be first a sculptor and subsequently a painter, adorning the three-dimensional form in a painterly manner. To realize satisfaction in this effort I must cope with the problems of both sculpture and painting as we have understood them in the past, and attempt to solve the new problems that emerge out of the dependency of one upon the other in my work."[27]

Alchemical Forming: "The Rose" and "The Jewel"

In 1958, when she was twenty-nine years old, DeFeo began work on a large canvas that she initially called *The Death Rose.* Though it had two companion paintings, *The Jewel* and *Incision,* this single work dominated, then defined, her ambitions as an emerging painter, and finally became the signature work of her career. She stopped work on other projects in 1961, and the increasingly sculptural painting occupied all of her energy until 1966. By then, the massive work weighed nearly two thousand pounds and was known simply as *The Rose* (Figure 10). She had not "finished" the painting when she stopped working on it, but she no longer had a studio large enough to hold the piece. Perhaps equally as important, she lacked the physical and emotional strength to keep going.

The central image of *The Rose* combines three simple forms: ridges separate as they emerge from a central aperture to compose a radiating figure. In the earliest versions of the painting, the rays extended to the canvas edge and suppressed the field plane altogether. In the so-called baroque phase of the work, DeFeo terminated the rays with curves that

Figure 10. Jay DeFeo, *The Rose.* Oil on canvas, 1958–1966. Whitney Museum of American Art, New York. ©2008 Estate of Jay DeFeo/Artists Rights Society (ARS), New York.

transformed the ridges into petals lying against an enhanced and promi-
nent field of swirling paint. She was dissatisfied with the surrounding
field from which the figure emerged and by mid-1959, she once again
extended the rays to the very edge of the canvas. She also decided to
expand the size of the canvas. She lifted the first canvas off its stretcher
bars and glued the heavily paint-laden fabric onto a much larger canvas
that filled the front window of her studio.

In this intermediate version, retitled *The White Rose*, aperture clearly
transforms into its dialectical antithesis, emergence. Exploration of
entropy and decay was put aside to give fuller expression to the explosive
character of forming as an eruption of light into the world. The image
is still part of a world of flux, change, therefore ultimately of death and
decay, but the painting in this incarnation focused on the transforming
power of creative energy.

As she continued reworking the image, she reduced the extent of the
rays and restored their relation to a ground, reintroducing a field of
chaos into the upper portion of the canvas. The most active use of paint-
erly texture comes in an intermediate half circle immediately above the
radial form and its brilliant center. This zone of transition between the
center and the undefined mottled blacks in the uppermost portion of
the painting was one of two opposing sets of contrasts DeFeo used to
establish a sensation of emergence and transformation. The second con-
trast comes from the bulging outward in the bottom half of the work. In
the lower half, she kept the rays extended to the canvas edge. Her exten-
sion forms were developing into increasingly massive sculpted blocks
formed from years of accreted paint. The weight of the work moves
downward, and the rays themselves are riven by deep, craggy fissures
that mirror the collapsing image of *The Foolish Virgin*. Weight adds a sen-
sation of pulsation onto radiality, while incomplete formation of the rays
reinforces an overall sense of amorphous field acquiring structure.[28] By
exploiting paint as a material substance, DeFeo refocused the painting
to present the struggle of an emergent figure imposing order upon
nothingness.

DeFeo's continual reworking of the painting contributed to the sheer
mass of *The Rose*. By 1966, the accumulating paint extended at times up
to a foot or more off the canvas surface.[29] DeFeo primarily used house
paint for *The Rose*, which she slopped on with large brushes. The next
morning she chipped away at the accumulated hardening paint with
trowels that she also used to shape the rays, much as she had used pal-
ette knives to form the ridges of *Origin* and *The Veronica*. As with her ear-
lier paintings, she had to measure and shape the rays precisely if they
were to form a single image.

She spoke of submerging various physical substances, primarily sand,

beads, wire, and string, into the paint in order to change the quality of the surface. Her friends recall these efforts as well, but X-ray studies of the painting show that there are no solid objects hidden inside the painting. A parallel puzzle surrounds the type of paint she used. Receipts from the period indicate she bought massive quantities of lead-based paint. The health and dental problems she developed in the 1960s were consistent with lead poisoning. Nonetheless, analysis of the painting when it was restored in the 1990s indicate minimal lead content in the painting in its final form.[30]

A probable but nonetheless inconclusive explanation for these discrepancies can be found in DeFeo's work method. She continually scraped back the painting as she worked. The amount chipped away was so extensive that paint chips piled up over a foot thick in her studio. It became difficult to walk on the floor and she sprinkled wood chips over the paint chips instead of sweeping the debris away.[31] DeFeo continued applying the paint so thickly that for many years, the massive work remained viscous and mobile, quivering when approached, a quality that contributed to a sensation that the painting was a living entity.

While she worked on *The Rose*, two other sculptural paintings occupied her attention: *The Jewel* and *Incision*. *The Jewel* shares with *The Rose* the exploration of radial ridges emanating from a central point. In *The Jewel*, DeFeo narrowed the width of the frame, squeezing radial energy into an oblong, vertically defined form. The compression of the shape led to a more accentuated movement of the ridges outward and a central space that bulged from the canvas toward the viewer. The chromatic range in *The Jewel* was based on red instead of the off-whites and grays of *The Rose*. By extending the horizontal axis of *The Rose*, DeFeo made one of several choices that opened the possibility of movement into the aperture and an illusion of an opening into an alternative space. Viewed together, *The Jewel* and *The Rose* provide a controlled experiment testing how size, width, hue, tonality, and the value difference distinguishing convex and concave form affected the experience of ridge, aperture, and radiality.

Like the earlier panels *The Foolish Virgin* and *The Wise Virgin*, these two paintings can be thought of as images of growth and emergence on the one hand and decay on the other. *The Death Rose* initially was more clearly a painting about sinking back into the ground, into the swirl of possibility, while *The Jewel* portrayed emergence into realized, crystalline form. *The Death Rose* needed to convey a sense of a space lurking on the other side of the canvas, for there had to be a place into which organic matter disappeared before its rebirth. *The Jewel*, on the other hand, points to a state that has escaped cycles and simply steadily grows. In a letter to J. Patrick Lannan, a collector interested in acquiring *The Death*

Rose, DeFeo wrote that *The Jewel* was "a kind of life symbol—in color and stated visually so that all the weight and space comes forward . . . in *Deathrose* [spelling in source] everything recedes."[32] The distinction DeFeo identified led to *The Rose* becoming the more dynamic and difficult of the two paintings, for it required creating and maintaining an illusion of an imaginary space hovering on the other side of the picture plane.

Before the experience there was the work, and before the work was the glimmer of an idea. The titles DeFeo chose for her paintings do not provide a program for work that was always also an improvised reshaping of viscous substances into intelligible forms, but titles nonetheless are clues to the social and intellectual context inspiring her. At Christmas 1958, one of DeFeo's neighbors in the Fillmore Street building jotted down a poem, not for publication, but as a gift to a loved one who also lived in the building. In the poem, the author says s/he wants to be like a jewel and not like a flower. Jewels were a better sign of enduring love because they were eternal, always there to provide solace, company, enlightenment.[33] These were not DeFeo's words, but we can infer a reference to a project already under way in the building, to paintings well known to the person addressed, probably viewed more than once by the intimates of this close-knit circle, to paintings that they were already discussing and interpreting. In this possible response to a cycle of paintings that DeFeo had just started, the jewel is the object of value because it will last. The floral form is already dying by the time it appears, underscoring the values implicit in DeFeo's original title *The Death Rose*.

Since DeFeo did not explain her titles, any reconstruction of their meaning and what they imply about the program for her larger project must be speculative. Nonetheless, the titles of the works, particularly the pairing of *The Jewel* and *The Rose*, seem strongly to reflect, in however impressionistic a way, important symbols in Vajrayana Buddhism. The jewel in that religious tradition serves as a symbol for the soul that has liberated itself from desire. It can be associated with rubies, and thus mystic realization was often represented with a ruddy color, as in DeFeo's painting. The liberated soul that has grasped onto the jewel that the gods and the boddhisattvas offer has recovered its true reality as a hard, eternal force. According to Jung, ruddy hues symbolized the ability to pierce appearances to discern qualitative distinctions. The black rose, on the other hand, is a symbol of earthly passion, attractive but displaying in its color and form the inevitability of death. The pairing illustrates eternity and entropy as the forces structuring the soul's relationships with all the objects it encounters, though DeFeo's vision of the jewel is clearly one with white cracks breaking the surface, raising the question whether *her* jewel was still in formation or ominously moving into a new phase of decomposition.[34]

Including *Incision* as part of a triptych adds another piece of evidence supporting the conjecture that Vajrayana Buddhism informed the titles of *The Jewel* and *The Death Rose*. The jewel offered by the higher beings allows the soul to cut into the material realities it so values and see that they are illusions, constructed by the tricks of a mind deluding itself. The embedding of string and other materials into the surface of *Incision* might be a way of dramatizing the composite, improvised character of all nonspiritual entities. The central panel of *Incision* includes the outline of an unfinished heart,[35] otherwise the painting evades direct imagery and can be seen as a field painting exploring the effects of texture and modulation of tonalities. The chaos of its structure, however, allegorically re-creates the structures of unformed matter waiting as a reservoir for the things yet to be created.

Consider next the respective symbols of the rose and the stone in alchemy. Carl Jung in *Psychology and Alchemy*, published in English in 1953, identified and discussed at length the meanings associated with roses and jewels in alchemical practice. The "noble rose," for example, describes an alchemical process that begins by depositing rotting matter and feces in the bottom of a vessel. A series of steps follow that seek to prepare the decomposing mess by skimming off the ooze that continues to form on the surface. At the right moment, the alchemist pours a drop of red wine into the vessel, then two more drops. Light emerges from the center, pushing its way out from the muck. With each additional drop a form called a rose but looking like no earthly rose emerges from the center, revealing as it grows, in the words of one sixteenth-century manuscript: "How God created all things in six days. . . . By this you will see clearly the secrets of God, that are at present hidden from you as a child. . . . You will see what manner of body Adam and Eve had before and after the Fall, what the serpent was, what the tree . . . where and what Paradise is, and in what bodies the righteous shall be resurrected."[36]

The noble rose quickly decomposes back into matter and shit. It cannot last because the image is literally nothing—just a tantalizing vision of things most humans are not yet prepared spiritually to absorb. To achieve that state, one must purify one's soul into a jewel that is incorruptible and liberated from the meat and the shit that is the body. The rose is a vision, but it is nothing. The jewel is something that endures past all the oscillations of creations and all the play of desire.

An experiment contrasting eternity and entropy developed a life of its own and escaped the original schema. *The Jewel* came to its current state relatively quickly, as did *Incision*, but *The Rose* resisted the original plan. *The Rose* metamorphosed from an evocation of life in the grip of death to explorations of forms of emergence bursting into the world to an

ambitious effort to capture in fixed form the mystery of creation with all its powerful contradictions. Over the eight years DeFeo worked on *The Rose*, she struggled to find the right balance of the simple elements with which she was working. The paintings themselves remain fragments of the ideal DeFeo intuited but could never fully realize. In DeFeo's 1950s paintings, there is an exaltation of the expressive capacity of the fragment, found again and again in a determination to wring all their evocative potential from circular focus, lines and ridges, the brush stroke, a single color.

Her method rested on a conception of "visual vocabulary" or the "syllables" of graphic form, but it would be a mistake to think of these formulations as implying a linguistic or semiotic understanding of visual experience. The syllables she used to construct a complex experience rested on units of experience, not on signifiers or referents. The individual syllables point to nothing else. A red circle, a yellow line, a bright aperture, a ray with an elevated ridge that can catch light are nothing more. DeFeo's syllables function much as Stella described his work: "What you see is what you see."[37] Ludwig Wittgenstein, one of the twentieth century's most important investigators of language acts, stated categorically in his theorizing of the relation of language to sensation, "What *can* be shown *cannot* be said."[38] A picture, even if entirely schematic, presented something "identical" to the source: "The proposition communicates to us a state of affairs, therefore it must be *essentially* connected with the state of affairs."[39]

When DeFeo composed the syllables into an image, however, something greater resulted, a physical experience, with its possibilities for ideas—be they references to alchemy, mandalas, the crucifix, or eruption from an imaginary space on the other side of the canvas. None of the ideas that a painting might suggest could or should substitute for the physical experience of the image, which remained connected to a raw reality that language could not capture. The problem was that whatever that raw reality was that could be experienced did not become usable until it could be converted into words, into an account that inevitably slipped away from the original confrontation. What could be learned from a painting could be summarized in interpretations of various levels of sophistication, but their value was always contingent on a return to the raw physical experience and the continuing flow of ideas that organized sensation generated, ideas that could shatter "convention" if embedded in and nourished by feeling. The new insights paintings could spark would occur only if the ideas associated with the object remained provisional, if they decayed, throwing the viewer back to confront once again an image resisting interpretation.

The "literary" statement a phenomenological experience of *The Rose*

suggested might be summarized as "Here, before you eyes, is the mystery of creation made sensible and present. Behold and wonder!" But at the same time, the sheer mass and physicality of the painting, its assembled, *painterly* qualities, also said unequivocally, "This is paint on canvas. This is not the mystery of creation. It is only a fabricated object." Like Jung's description of the "noble rose" in alchemy, the image the painting throws forward quickly decomposes back into formless matter without changing in any way.[40] The vision of something beyond that the image provokes vanishes almost as soon as it is felt because it is the product of a receptive mind at work. An object reappears as a viewer falls from sensuous experience back into the systems of representation that govern ordinary perception. The object becomes once again a massive block of dried paint, something ugly and crass. Within the alchemical tradition the painting references, the mystical image must quickly turn back into worthless decaying matter.

The viewer of the painting has moved through an experience that is transcendental and banal at the same time, through a process that dramatizes one view of the "human condition" as a conflict of capabilities (the disciplined imagination returning to the embrace of the earth?) with actualities (social constraints fortifying the world's institutional grip?). The image is a tantalizing vision of brute facts of existence that few people are prepared or want to face. The tragic hardness of DeFeo's image separates it completely from anything "New Age," despite her interest in things mystical and cosmological. The impossibility of separating idealized ambitions from the often brutal disappointments of everyday life was woven deeply into the paintings she struggled to make.

Chapter Five
Becoming Postmodern

The Postmodern Turn as Youth Rebellion

On a theoretical level, the postmodern turn after 1960 involved intensive critiques of systems of representation, subjectivity, and the formation of identity. These discussions, largely based in philosophy and the humanities disciplines, came from a broad range of theoretical and methodological perspectives. At no point has there been a unified "postmodern" vision, much less theory.[1] A common, though not universal, aspect of the philosophical turn was a critical reexamination of the category of the subject, that is, of a consciousness theorized as coming into being through efforts to turn the chaos of sensation into meaningful ideas. Questioning subjectivity in particular challenged assertions that art could break through social clichés to stimulate a radical reawakening of experience. Indeed, as new ideas entered into the world of visual art, critics like Hal Foster called for artists to reveal how the "aesthetic" plunged viewers into a "symbolic totality," locking them into "a world at once (inter)subjective, concrete, and universal" but demonstrably false.[2]

The body came to be understood as a cultural artifact rather than a locus of universal forces expressed in biological processes. People responded to visual, tactile, and aural stimuli in historically situated patterns that aligned the experience of social position with understandings of natural order. Art production could contribute to the criticism of the subject by showing the different types of subject created through the merger of ideas and sensations, by demonstrating how social categories constituted a sense of identity and individuality with a grammar dictating how a given subject experienced and understood other aspects of reality. Contemporary art often revealed how subjects are simultaneously raced, engendered, and sexualized. The idea of a hidden God, a universal subject to which the deep soul of any given person is "always already" connected, was an obfuscation to be attacked and rendered harmless.

For artists like DeFeo, trained in the principles of modern art, the new developments posed particular challenges that were primarily practical rather than theoretical. The postmodern turn of the mid-twentieth century was as much institutional as philosophical. New ideas that would later be called "postmodern" required choices about which media to work in and the relationship of "content" to craft, about when and where to exhibit, how to contextualize one's work, or how to earn enough money to have time to continue one's work, in short about how to situate one's project within an institutional world that after 1945 was growing rapidly and dispensing considerably expanded resources.

DeFeo and her husband, painter Wally Hedrick, were at the epicenter of what has been called the "San Francisco Renaissance" of the 1950s. Hedrick had grown up in southern California. Long before he had any ambitions to be an artist, he had drawn surfboards and hot rods, much as DeFeo had drawn fashion illustrations as a child. After being drafted and serving in the army during the Korean War, he used his GI Bill veterans benefits to enroll in the California School of Fine Arts, the art school on the West Coast with the reputation for being at the cutting edge of contemporary art. Hedrick had committed himself to being an artist, but he maintained an ironic detachment from a profession that seemed a little pretentious to a young man of his modest social background and limited education. Hedrick's hero was Marcel Duchamp, whose nonchalant independence from all movements and styles expressed Hedrick's own desire to be an autonomous, freethinking explorer.

Although Hedrick's paintings in the 1950s often have both strongly marked brushwork and a thick, agitated use of paint, exploring the textural possibilities of a painting's surface held little interest for him, nor was he interested in experiments in structure derived from the cubists. As he absorbed his art history, he thought his painting should reflect his provincial American heritage. His *Virgin and Child* from 1958 (Figure 11) presents one of the most common scenes in Italian Renaissance painting. He used gold leaf and colors to mimic decorative styles of the Quattrocento, but he drew his two figures in a graphic style reminiscent of the comic books he loved to read as an adolescent. He claimed a profound sense of affinity with the "old lampooning cartoonists" who ridiculed "the pomposity of those who turn their works into idols and myths and accept them without exercising normal human critical faculties on the sensitivity of emotion and perception."[3] To underscore his distance from classic European painting, he used East Asian Buddhist imagery to develop his two figures. The painting worked well for him because he had overturned the classics with an approach that synthesized popular U.S. culture, advertising design techniques, and classical Asian art in a work that looked like a comic book parody of a Renaissance masterpiece.[4]

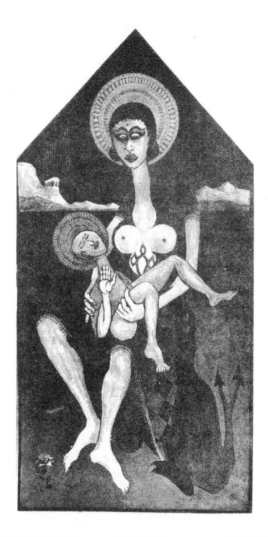

Figure 11. Wally Hedrick, *Virgin and Child*. Oil on canvas, 1958. Courtesy of the Estate of Wally Hedrick.

In strong contrast to the paintings DeFeo was doing at the time, Hedrick's works reveled in their artificiality. The images in his paintings, he claimed, had no particular importance. They reflected, he insisted, only the accidents of his own mental processes. In his artist statement for a show at the California School of Fine Arts in 1956, Hedrick observed that his paintings mean something only because mind has no choice but to impose meaning on the world it encounters. The game of

art is to create situations that allow viewers to reveal who *they* are as people through the necessity of finding a meaning comfortable to them. One of his favorite pieces was rigging the toilet in his and DeFeo's home so that whenever somebody sat down on it the lights dimmed and music, usually jazz, filled the flat. A brass fanfare accompanied flushing.[5] Painting was easy to transport and exhibit and therefore a practical means for reaching the public, but the most important art, Hedrick argued, had to be an art of everyday life that would highlight the absurdity of desires for the sublime, an attitude he defined as imagining that we can be better people than we actually are. "Self-delusion haunts all the days of our lives," he noted in the artist statement for the 1956 exhibit.[6] Hedrick concluded his statement with the dictum, "in painting, it is not what you paint that is important, it is what you paint out that counts."[7]

That was a sentiment with which DeFeo concurred, but with the twist that by cutting back she hoped to reveal more, a surplus that might be a bridge to a universal reality. In a joint interview for the *San Francisco Examiner*, "comely, dark haired Jay De Feo, a painter of drips, and her bearded husband, instructor Wally Hedrick" sparred over the significance of drips in modern painting:

Hedrick: The drips really don't have to be there. It's often bad craftsmanship.

Jay: But the drips may be necessary to the painting. In mine they are.

Hedrick: Still, a lot of contemporary painting is not finished.

Jay: There's nothing arbitrary about a particular drip. I have it to the point where I can say I control every inch of this canvas visually and psychologically.

Hedrick: Jay has been working on one canvas for three years now.

Jay: It's not necessarily true that spending a lot of time will give substance to the idea, although lots of times a painter could spend longer to think through a concept.

Hedrick: It's not just time. It takes getting to know it, like making a good whisky is a matter of distilling and aging.

Jay: Wally's the kind who will go into his studio and in three days will have a painting finished. But in between these three day periods he may not pick up a painting for months.

Hedrick: Sometimes I read more than I paint, so maybe I'm not a painter. I would rather not be called a painter or sculptor but an artist.[8]

If Hedrick preferred exploring the ironies underlying the relation of language and feeling, DeFeo working with the syllables of visual lan-

guage hoped to reveal the reality of experiences that language could not contain, perhaps could not even entertain until painting showed the way. Hedrick's work opened up to critical examination the processes by which viewers reconstructed images into meaningful experiences. DeFeo delved deeper into the mysteries of how forms could carry any content whatsoever.[9] Certainly the direction of art theory and practice since the 1950s supported the conceptual positions Hedrick advocated while reacting against the invocation of the sublime so central to DeFeo's work. Despite their apparent aesthetic differences, they respected each other as artists. Hedrick's comments on DeFeo's drips are not a criticism. He admired her technical skill and her ambition. The union that Wally and Jay achieved might be thought of as a marriage of irony and awe. Each held on to an attitude that allowed shaping a productive relationship to the world and to their career, but there was also a need for the missing element the other so conveniently embodied. The challenge both faced was how to reach a public capable of understanding that their work was neither decoration nor illustration, but an independent form of intellectual work.

The Six Gallery, 1953–1957

In the early 1950s, young artists in the Bay Area could exhibit in the San Francisco Art Association's two annual street fairs, as well as in art fairs in several of the surrounding towns. Art fairs were huge events with hundreds of artists working in a hodgepodge of styles setting up booths to display and sell their work directly to the public. An original painting would sell for two to three hundred dollars, and often for considerably less. Several local bars, bookstores, and framing shops offered exhibition space on their walls and an opportunity, again, to sell directly to the public. San Francisco had no galleries focused on contemporary experimental work, though several department stores in the city had small galleries for local work. Artists who took advantage of these exhibition possibilities reached a broader range of the public than regular museum goers, but they lacked venues, other than occasional shows in local museums, where their art could stand on its own.

In 1953, Robert Duncan, a poet recently graduated from Berkeley, and his lover, the artist Jess Collins, rented an auto-repair shop in San Francisco and converted the space into a gallery and theater for presentation of their own work and those of other young creative people they admired. They named their place the King Ubu Gallery, indicating their debt to French bohemia and their desire to offer work that would shock rather please the general public. The space, however, required more time than either was prepared to give. Duncan transferred the gallery

over to Hedrick and five other young students at the California School of Fine Arts. They renamed the space the Six Gallery after the six principals. They had no expectations that the gallery would sell their work or make any income over and above expenses. They wanted a place where young artists controlled how they presented their work and could discuss what they were doing without having to compromise. The Six Gallery followed the model of cooperative artist-run galleries in New York. Cooperative galleries in Manhattan featured unknown, younger artists, who if successful gained representation at uptown, commercial galleries. At the same time, the coop galleries' ability to jump-start careers made them extremely divisive, the center of what Mark Rothko termed New York's "art intrigues."[10]

The founders of the Six Gallery hoped to avoid the destructive effects of art politics by emphasizing group solidarity. They decreed that exhibits would change monthly. While the gallery did mount single-artist shows, the organizers preferred group shows. Over one hundred people quickly became associates of the gallery, each paying the two dollars a month that entitled them to curate a show. The gallery followed the democratic model of the street fairs, but with a more manageable number of works presented and with the focus clearly on the new generation emerging in the Bay Area. Hedrick was the first director, and DeFeo served as secretary, collecting dues and sending out news about the gallery. "In this little community," Hedrick later said, "we didn't have to have art teachers. It sounds egotistical, but we were our own teachers and we taught each other. We were so close to one another it was as if I could have called them my surrogate parents."[11] In another interview, Hedrick recalled that "it was a time, at least in my life, in my personal life and in my work, when I felt like I was in control and out-of-control simultaneously and it was a lot of fun. A hell of a lot of fun."[12]

In October 1954, the Six opened with a group show featuring fourteen artists plus calligraphic poems by Jack Spicer, history and literature professor at the art school. Alfred Frankenstein, art critic for the *San Francisco Chronicle*, commented that "what I saw there was neither grievous in taste nor grievous in tone, but it was not too incredibly exciting." Frankenstein singled out Hedrick's pieces as "particularly handsome," and he hoped the new gallery would do more to serve its members by allowing them to develop clear individual profiles.[13]

In addition to monthly art exhibitions, the gallery hosted regular poetry readings, underground film screenings, and performances by jazz and avant-garde musicians, including Dave Brubeck and Harry Partch. Probably the most famous event at the Six Gallery was the poetry reading on October 7, 1955, during which Allen Ginsberg gave his first public reading of an early version of "Howl," one of the masterpieces of

beat-generation literature. Exhibitions, readings, and concerts were often excuses for parties, which then could turn into art actions. At one opening, three artists destroyed a piano with a blow torch, hammers, saws, and sledgehammers. One of the performers cut himself with an axe. The audience, thinking this was part of the show, cheered as his blood flowed onto the wrecked piano.[14] At another party, punch was served with dry ice floating in it. The steam wreaths rising from the bowl were another form of magical, ephemeral art. But it was also an object lesson in the dangers of fantasy. Those who drank the punch were rushing outside to puke in the gutter.[15]

The group valued the ephemerality imposed on them by poverty. All of the gallery's opening announcements were on mimeographed postcards, few of which have survived. Wally Hedrick observed with a laugh that neither he nor his colleagues had ever thought of documenting Six Gallery activities: "I was more interested in doing it than documenting it. . . . If I'd gotten hung up with tape recorders and cameras it would have never gotten done because it was so impromptu."[16]

The most successful show at the Six was Fred Martin's exhibition of several hundred postcard-sized paintings in 1957, each selling for a nickel or a dime. The income from the sales was used to buy more wine for the opening-night party.[17] Much of the activity at the Six was ephemeral, and to that degree the gallery was a place for having a good time and exercising one's animal spirits.[18] Even exhibitions that might have been mounted primarily with a comic spirit could well be making a serious point. Martin's show of micropaintings, for example, took aim at the conception, prevalent throughout the United States, that the seriousness of a painting somehow was connected to an ambitious size and scale. Even with a deliberately ironic attitude toward the institution of art as it had developed, the shows took the creative process itself seriously. Some of the work presented was indeed important and worth repeated examination. There was art created quickly for the moment, provoking reactions that would be retained only in the mind, and that was good too. Then there were pieces that articulated a longer-term ambition and deserved to join the tradition of masterpieces that the group mocked and respected at the same time.

Jazz juxtaposed to the ever-present Jungian ideas about art and symbols provided a language for recognizing a performance that deserved repetition, for identifying the eternal always present in the fleeting moment. Hedrick said, "I think of myself as a great improviser. I grew up with jazz, even though I never did it professionally. Jazz is jazz, and it has to do with the moment, not any long-term getting to heaven or any of that. It has to do with right now, and either you make it or you don't."[19]

Funk was a term Six Gallery artists used to describe what they found particularly connected to inner psychic truth. In jazz, funk was a form of hard bop that emphasized improvisation emerging out of an artist's ability to eliminate the distinction between consciousness, meaning theory and planning, and the material, that is, the tune with its melodic, harmonic, and rhythmic potential.[20] "To be really funky," Hedrick elaborated, "you have to be . . . non-aware of the fact that you're funky." Artists who intellectualized *while* creating could not be funky since their rationality stood in the way of directly expressing an instantaneous inner vision: "to be really funky, a person has to be controlled by the materials."[21] Truly funky music could not be rehearsed or preserved in any form of written score. The sound emerged and took everyone, performer and audience alike, by surprise. Its existence was ephemeral, and the sounds that had emerged would never be heard again, at least not in any live performance. The truth of the moment lived on in the memories of those lucky enough to experience a particularly brilliant improvisation.

The Assemblage Movement: Drawn to the Poetry of Found Objects

In the visual arts, *funk* suggested the use of rough and dirty materials, along with lack of concern for a fine surface. The term covered the deliberately distorted, often cracked ceramics of Peter Voulkos, Paul Soldner, and John Mason; the plaster sculpture of Manuel Neri; or DeFeo's *The Rose*. As in jazz, the term primarily indicated a mental framework in which immediate response to the performative possibilities of materials took precedence over theory. For DeFeo, funk meant "a very close relationship to the use of materials and my relationship to the process of painting."[22] In the visual arts funk became closely associated with the use of found objects and the assemblage tradition. For artists, this association had less to do with the shabby nature of the throwaway materials incorporated into a painting, sculpture, or "combine" (to use Robert Rauschenberg's term for the medium) than with the way in which the detritus of everyday life could be reworked into a revelation of an essence that transcended contemporary society.

Although artists in the pre–World War I European avant-gardes produced works that incorporated already existing objects into their graphic or sculptural work, the word *assemblage* came into use only after 1953 when French artist Jean Dubuffet coined the term to describe a series of collages he made from butterfly wings and cut paper. Eight years later in 1961, William Seitz adopted the word into English when he curated the "Art of Assemblage" exhibition at the Museum of Mod-

ern Art in New York. Seitz defined assemblage as art that was "predomi-
nantly *assembled* rather than painted, drawn, modeled, or carved" and
which was constructed at least in part from "preformed natural or man-
ufactured materials, objects, or fragments not intended as art mate-
rials."[23]

Renewed interest in assemblage art coincided with the emergence of
the postwar "affluent society." These were years when progress seemed
to have been confused with the availability of consumer goods. Art based
in the *object* rather than the *image* better captured the intense relation to
things that constituted much of life in the United States. Assemblage was
an effective and timely expressive form for provoking new responses to
the objects surrounding a person in his or her everyday existence in U.S.
society.[24] Mixed media work remains an important step in the long proc-
ess by which artwork transformed from statements and representations
into objects that sometimes strove for thingness (in the Heideggerian
sense). In California during the 1950s, mixed media assemblage proved
a compelling form for younger artists, particularly painters.[25] Found
objects provided new opportunities to explore how texture and gesture
could replace or complement painted or drawn imagery. Richard Die-
benkorn, for example, turned to quick experiments in both collage and
assemblage when he had difficulties establishing a "surface" in his
abstract paintings: "If you're not getting it in paint, and you start putting
[objects] on paper, and you're successful there, the next time you work
in paint you're influenced by your success the day before."[26] Edward
Kienholz, in contrast, definitively turned away from paint on canvas to
constructing objects and tableaux. Initially, his motivation, or so he
explained, was simply that in the mid-1950s, when he was starting out,
he was too poor to afford oil paints, turpentine, brushes, canvas, gesso,
or the other materials often required to achieve the surface effects he
liked: "that's why I used plywood and housepaint. It's amazing. . . . [The
city] throws away an incredible amount of value every day. . . . From
automobiles to desks, to clothes, to paint, to—you know, half-bags of
concrete that are hardened up. . . . And if you're living on the edge of
the economy like that, all that waste filters through your awareness and
you take what you want."[27] Kienholz initially used the objects he col-
lected on weekly scavenger trips to make wall hangings, but the pieces
quickly expanded in all three directions, even though his inspiration
remained painting rather than sculpture, or even bas-reliefs. The open-
ing up of the two-dimensional plane allowed him to achieve and accen-
tuate the sense of drama that he identified as the most interesting legacy
of the European painting tradition.[28] Modern society's profusion of
detritus that artists could recycle convinced Kienholz that museums
were obsolete. He wondered if everything in museums ought not to be

documented holographically and then destroyed: "I mean, why keep it? Why burden society with the incredible amount of shit that is collected and stored and moved and insured?"[29]

Hedrick liked working with junk because he found it an accurate and offensive symbol of an American society in love with waste and war. In 1956, he began making sculptures from broken radio and television sets, refrigerators, and washing machines he found in junkyards. He painted over the surfaces with thick layers of impasto and gesso whose brushwork was reminiscent of action painting. He was particularly pleased when he could fix an abandoned appliance sufficiently that at least a part of it would work and he could turn his assemblages into moving sculptures. The professional art world, he argued, smothered the discovery of beauty in everyday life, and therefore his obligation was to assault the institution of art so people would stop looking to museums and galleries as the repositories of beauty when the nation needed to face its history with a brutal frankness.[30]

The increasing use of assemblage in California to articulate a biting social critique was problematic to the many painters who were focused on exploring new possibilities for surface, texture, patina. Realizing that the medium had developed in a manner that was inherently philosophical and political, Diebenkorn decided to stop his experiments with assemblage. The use of found objects had "lost its formal base and went in with another thing that San Francisco art has always been famous for, its kind of funkiness. . . . And it became extreme. . . . To establish the surface wasn't enough. You had to put tar paper, or feathers, or wood, or anything on the surface after a while."[31] Through the 1950s, DeFeo made a number of assemblages as well as creating paintings where she inserted objects into the picture surface, including dried flowers in at least one work. The surviving works in this vein have a crudity that was possibly uncomfortable for an artist who aimed to reconcile the funky and the elegant. Her assemblage contribution to the San Francisco Art Association's 1956 print and drawing exhibition at the San Francisco Museum of Art generated a minor scandal. DeFeo had entered a cross that was ten feet high and eight feet wide. "It was made from white butcher paper stretched on a cross-shaped frame," Fred Martin recalled while examining the difficulty serious artists in San Francisco had finding viewers with sufficient sophistication to see the work before them.

The center area was painted messily black. Toward the center of this streaky black was pinned a four pointed, clumsy looking black papier maché star. At the center of the star was a large yellow glass jewel. . . . The work immediately became a storm center while newspaper critics denounced it and Art Lovers wrote dirty words on it. The Museum finally removed it from the exhibition with the explanation that the burden of inscriptions placed on it by visitors had made

it an obscene object. No one was able to deny, at least, that it was an object, and that in it the cross was made manifest and real. Perhaps one didn't care for the manifestation or felt that the reality was excessive, but, until officialdom found a way to protect itself, the cross was for a time a thing in that Museum.[32]

Martin's conception of the "thing" was drawn from the existentialist philosophy of Martin Heidegger, who wrote that a thing, unlike an object, is not for use but instead insists upon a response.[33]

DeFeo's increasing use of sculpted paint may reflect the influence of assemblage and the lessons found objects offered for rethinking what painting could become. With *The Rose, Incision,* and *The Jewel,* she was experimenting with "assembled paintings," where manual manipulation of her materials led to the forming of an image the surface textures of which might reflect her insertion of objects such as beads or string. The nature of a painting as an object was brought to the forefront, and the working process, the form*ing* so central to her project, was established as the performance of an artist. In the words of Norman Bryson, in this new approach to painting is an implied revolution in the concept of art waiting to find its fuller ramifications: "The work of production is constantly displayed in the wake of its traces . . . the body of labour is on constant display, just as it is judged in terms which, in the West, would apply only to a *performing* art."[34]

From Emergent to Mid-Career

As its members grew older, the generation of San Francisco artists coming of age in the 1950s was rupturing the formal and methodological distinctions that had been important for the classification of media for several centuries. Modern artists had from time to time experimented with breaking down the barriers between media, but the generation of the 1950s, not only in California, had made breaking those barriers an important step in their own formation. They violated the dictates of critics such as Clement Greenberg who defined modern art as the purification of every medium of every extraneous influence. Given the prominence of Greenberg at the time and his purported power over galleries and museums, to reject the purity of each medium could appear as an existential act, springing from the deepest creative urges in work that made the artist a potential outlaw.[35]

That tradition and youth, professional ambition and aesthetic aspirations, group solidarity and individuation appeared to be in conflict led to expressions of self that were contradictory as Americans in general tried to balance what appeared as opposing, but equally valid, demands. For artists and poets, the persistence of contradiction led to enthusiastic, but also anxious and often incoherent, experimentation in aesthetic

form and also in what would come to be termed some derisively "lifestyle." The conflicts they faced were part of coming of age *as an artist* in the 1950s. Each artist faced a crisis of conscience and career, as he or she struggled to balance loyalty to private vision with the responsibilities, obligations, and dangers of operating in a professional world. These conflicting demands helped define the inner life of bohemia on the West Coast between 1950 and 1965. In an age divided over the relative values of conformity and the pursuit of individual excellence, artists' personal dramas enacted for the public an effort to gain control over social forces through the rejection of worldly opportunities and the validation of the prime importance of personal ideals. Their private dilemmas became part of the public spectacle, in which the arts provided a symbol for both the dangers and the positive values of individualism.

But the young avant-garde in San Francisco was not as isolated as its members sometimes liked to portray themselves. With Gurdon Woods's appointment in 1954 as director of the California School of Fine Arts and its subsequent rebirth as the San Francisco Art Institute, the school where Hedrick worked as a teacher and administrator established the reigning modern art orthodoxy in the San Francisco Bay Area. The local form of abstract expressionism and its figurative offshoots, as well as work made from found objects, dominated museum exhibitions of contemporary art well into the mid-1960s, long after hard-edge abstraction and pop art had swept the rest of the United States. By the end of the 1950s, the work of Hedrick, DeFeo, and their friends was on exhibit almost at any time either at the San Francisco Museum of Art or at the newly opened crop of contemporary art galleries. They had joined, perhaps in their own minds "revolutionizing," the local art establishment. The San Francisco renaissance, as it has been called,[36] was in large part the product of a youth movement in rebellion against the provincial isolation of their home. As interest grew in what these young men and women were accomplishing, ideals of authenticity and freedom butted against newly emerging *professional* ambitions.[37]

The Six Gallery closed in December 1957. Beverly Pabst, the gallery's secretary at the time, sent out a letter that month to the membership announcing the closure. She summarized the accomplishments of the Six as "During the last four years the gallery has been a very valuable impetus to many individuals and groups concerned not only with painting, but with music, dance, experimental photography and sound, and poetry. It has afforded all of us the space and freedom to experiment not usually offered by other galleries or the museums. As such the gallery has always been open to resounding defeats as well as moments of excitement and inspiration. Both kinds of experience were valuable . . .

to any individual or group of individuals vitally concerned with creative activity and human growth."[38]

James Newman's Dilexi Gallery, Dmitri Gracchis's Spatsa Gallery, and William Jahrmarkt's Batman Gallery quickly filled the gap left by the Six. These privately owned spaces were only nominally commercial. They made no money, nor did their owners expect that the ventures had any purpose other than bringing together under one roof a variety of work that spoke to the gallery owner's personal interests. It was the same situation in Los Angeles where the newly opened Ferus, Dwan, Nelson, Sander, and Stuart galleries featured the work of younger, more adventurous artists from across the state. Young entrepreneurs ran each of these new galleries. The directors brought highly personal creative visions to the work of curating. In presenting the public the work of artists they considered most interesting, they were presenting not only objects but a quality of mind, a personality in which thought and action had found some kind of unity. Critic Alfred Frankenstein's call for greater attention to the "individual profile" of artists had become the order of the day. Profit was not yet a realistic goal, but as the 1950s concluded, the generation of artists approaching their thirtieth birthdays began defining professional personas and looking forward to reaching publics outside the region.

"Sixteen Americans," 1959

In December 1959, the "Sixteen Americans" exhibition opened at the Museum of Modern Art in New York City, a show that in retrospect, given the artists invited to appear in it, seems to have predicted with remarkable accuracy the ruptures about to tear apart modern art in the United States. Since 1941, the show's curator, Dorothy Miller, had organized exhibitions every two or three years with a limited number of younger artists whose work she felt best revealed interesting new trends in U.S. art. Each artist had his or her own small gallery, gaining the ability to present a body of work instead of the usual one, two, or three pieces per artist typical of group shows. Several, though not many, of the younger artists Miller showcased over the years went on to prominence.

Typically, neither Miller nor the Museum of Modern Art had been at the forefront of exhibiting new developments in the visual arts. Miller's 1952 "Twelve Americans" show gave the museum's blessing to abstract expressionism nine years after the movement had burst into public attention in 1943 with gallery exhibitions in New York and the first museum exhibitions of the nascent movement in Chicago and San Francisco. By 1959, art journals were discussing abstract expressionism as a historical moment that had passed. Its masters still produced important

work (and would continue to do so), but younger artists clearly had moved in new directions. There was as yet no critical consensus about what would fill the void. Miller's "Sixteen Americans" show was her effort to assess where hope for the post–abstract expressionist future might lie. Her selection involved a broad range of styles, but given that she included Jasper Johns, Ellsworth Kelly, Louise Nevelson, Robert Rauschenberg, and Frank Stella in the exhibit, Miller proved unusually successful in predicting the contours of U.S. art in the decade to come.

Miller invited DeFeo and Hedrick into the show as well after a tour of artists' studios on the West Coast. Miller asked to include *The Death Rose* in the show, which she had seen in progress, but DeFeo, certain that she could not finish the painting in time, declined.[39] DeFeo was represented instead by *Origin* and *The Veronica*, as well as three large abstract charcoal and graphite drawings. Hedrick had nine oil paintings in the show. Curiously, DeFeo and Hedrick decided not to attend the opening of "Sixteen Americans." They gave the air tickets that the museum had sent them to friends who needed to get back east. Over the years, Hedrick and DeFeo gave various reasons for a seemingly peculiar response to a great career opportunity, with Hedrick consistently insisting that they were both very busy at the time and they were not sure how important the exhibit would actually be.[40]

When put in the context of the critical reception the show garnered after it opened, Hedrick's assessment of the "Sixteen Americans" exhibition as an event of uncertain worth seems less quixotic or foolish and instead pragmatically realistic. A black-and-white reproduction of a Hedrick painting was published along with the review of the show in the *New York Times* by Stuart Preston. In and of itself, the critic's choice of Hedrick's work was a nice piece of publicity for the painter, but neither the work nor Hedrick's name was otherwise mentioned in the body of the review. Preston's response to Miller's show was starkly negative. He appreciated her "selecting so many genuinely independent talents," but he then devoted the lion's share of his review to a fierce condemnation of Frank Stella, Jasper Johns, and Robert Rauschenberg.[41] Four days later in a second article on the show, Preston briefly praised three of the artists included, among them Ellsworth Kelly, before proceeding to pan Frank Stella as one of the show's "weak spots."[42]

John Canaday, the senior art reviewer for the *New York Times*, sent Miller a personal letter condemning the show, explaining why he refused to review the exhibit himself. "For my money," he told her, "these are the sixteen artists most slated for oblivion." In two articles published in 1960, he cited Miller's show as prime evidence that contemporary art was in deep conceptual trouble. Like Preston, he singled out Stella, Johns, and Rauschenberg for special condemnation. Canaday

bemoaned the conceptual turn demonstrated in the show. The new trend revealed through the exhibition diminished the importance of any individual painting, which had become little more than a variation on an underlying idea, "variations that must be seen as an ensemble if they are to be effective individually." His final judgment was that contemporary art had required continuous interpretation because it was no longer possible to experience a single work without having access to the ideas motivating it. Painting had become an "adjunct to words," a process, he complained, that meant that successful contemporary artists were dependent on their work stimulating "verbal acrobatics" among curators and critics rather than on the skill to make ideas appear in the course of a powerful sensory experience. Frank Stella's work was "disastrous" as painting. It purposely offered nothing to the senses, but it was exciting to talk about and therefore pointed to the future of art.[43]

In none of the lively debates surrounding "Sixteen Americans" was DeFeo or Hedrick mentioned other than in listings of the contributing artists. Nor did they figure in reviews of the show in other New York newspapers or in magazines, besides a brief complaint by Sidney Tillim in *Arts* on the ponderous quality of the work Miller had selected, illustrated with a quote from DeFeo's catalogue statement that the critic deemed particularly obnoxious. Tillim complained that "Humor is jettisoned as art becomes messianic."[44] To be fair to the artist, the sentiments of DeFeo's statement, however awkward and naïve, were neither original nor unique. It echoed the language that most artists of her age used when having to explain work they believed had to communicate directly to a viewer through the senses. Artist statements at this time were still pure formality and not a particularly important part of the presentation.

Given responses that ranged from lukewarm to negative—"chaotic but stylish" (Robert M. Coates in the *New Yorker*, overall Coates did not like the show but singled out individual works by Ellsworth Kelly and DeFeo for praise), the artists and their work formed "a sensational average" lacking "a sufficiently personal way of working" (Thomas B. Hess in *Art News*), "unspeakably boring" (Emily Genauer in the *New York Herald Tribune*)—DeFeo's and Hedrick's relative absence from the critical record may have made the show less threatening for them but also left them wondering if anybody had actually looked at their pieces.[45]

Stella, Rauschenberg, and Johns may have been the primary targets of critics precisely because each had passionate defenders who believed that the three young men embodied the future direction of art in the metropolis. Dorothy Miller was reported as liking Stella's work the best of all the artists she selected for the show. Having seen his work in his studio in lower Manhattan, she immediately telephoned Alfred Barr, the

director of the museum, and had him come down to see what Stella was up to, promising him "a special treat." Leo Steinberg, the erudite historian of Renaissance art and a perceptive critic of contemporary painting, also singled out Stella as the single most exciting artist of the show in a lecture Steinberg delivered at the Museum of Modern Art. Miller and Barr had already purchased four major works by Jasper Johns during his 1958 show at the Leo Castelli Gallery. In this case, it was Barr who was so excited by the work that he called Miller to tell her to rush down. The two spent more than an hour discussing which paintings the museum would take from an artist both had already decided was one of the most important emerging artists of the late 1950s.[46]

DeFeo and Hedrick, whose work had developed in another location with its own conversation about the future of painting, were invisible to the show's critics. Nor did young people in the New York art world spend time thinking about the work of the artists in the show from California. Years later discussing her failure to recognize the importance of the two women in the show, the art critic Lucy Lippard recalled noticing the work of DeFeo and Louise Nevelson but even if in retrospect she could see that their work in the show had been "impressive," "the rising stars of Jasper Johns and Robert Rauschenberg" had captured Lippard's attention at the time. She confessed that she "was not yet sophisticated enough to recognize Frank Stella's 'breakthrough.'" Sol LeWitt recalled Stella and Johns as having been of immediate interest to him. He was taken by "the idea of the flat surface and the integrity of the surface" that these two painters maintained. "Abstract expressionism was played out," LeWitt continued. "Pop art was interested in objects. I wasn't interested in objects. I was interested in ideas." His conception of ideas focused on confronting the limitations of what painting as a medium could do, not realities beyond the canvas: "to make color or form recede and proceed in a three-dimensional way." Robert Ryman also appreciated Stella's self-sufficient work that rejected any suggestion of illusion, the pictorial, or a "form" that a painting revealed. Stella's stripe paintings helped Ryman think about surface in a new way and how to get beyond the limitations of color field in the work of Mark Rothko.[47] Both Ryman and LeWitt may have disagreed with Clement Greenberg on almost everything, but they too, although with different strategies, pursued the goal of ridding graphic form of everything extraneous.

Ryman, Lippard, and LeWitt were friends and neighbors, part of an intensely competitive community of young artists and critics living in Manhattan. Art was the passion of their lives, offering an intellectual challenge filled with many puzzles over what painting could and should do. Stella, Johns, and Rauschenberg were stimulating painters in part because they were already figures of debate. Their work signaled the

autonomy of painting as a practice. Equally important, every element in their work sprang from painterly practice and, to the degree that they referenced social, psychological, or cosmological realities outside art, their approach could only have emerged through the pure practice of the plastic arts.

For those working in California, this was a puzzling perspective and not immediately obvious as a breakthrough. Thomas Albright, a participant in San Francisco's avant-garde cultural circles in the 1950s before becoming the art critic for the *San Francisco Chronicle*, looked back two decades later upon the changes overcoming art in the United States at the end of the fifties in order to contrast the objectives of DeFeo and her friends with those of their contemporaries on the East Coast, by then incomparably more famous. Young artists in California in the 1950s, Albright claimed, wanted art to challenge and transform the world. The decision to become an artist reflected an innate critical reaction to an inherently corrupt and ignorant society. At the very least, the work had to complicate how viewers responded to the plethora of images and objects surrounding them by suggesting that the reality of "things" (in the Heideggerian sense) is never limited to what one sees. Most Americans moved through the world blind because social conventions and personal fantasies substituted for investigation of either the sensual or the psychological world. The new art coming out of New York, Albright argued, worked to silence images, to render them harmless by limiting what they say to the conditions of their fabrication: "The common denominator of most avant-garde art of the past two decades has been an increasing *reflexivity*—art whose basic subject is art. . . . A target or a flag in a Jasper Johns—as commentators never tired of telling us—remained a target or flag only ironically, but was essentially a neutralized field of surfaces, textures and forms from which the fangs of reality had been removed. . . . In [the work of California artists], a target or flag or mushroom retained its full potency of associations, and ramified out to form all kinds of others as well; the aim was not to neutralize, but to multiply connections and meanings."[48]

Johns's tamping down of dramatic effect ironically increased the emotional tension of at least one of his paintings, *Target with Plaster Casts* (1955), to such a degree that Barr and Miller decided they dared not buy a work they both found exhilarating (Figure 12). The painting of a bull's-eye target done with meticulous but nonetheless lush gestural brush strokes was topped by nine wooden boxes filled with plaster casts of miniature body parts. The casts included a hand, a foot, a breast, and a face, all done in a blank, emotionless style reminiscent of medical illustration. One of the casts was a miniature replica of male genitals. The representations of body parts were mundanely unremarkable, mere cop-

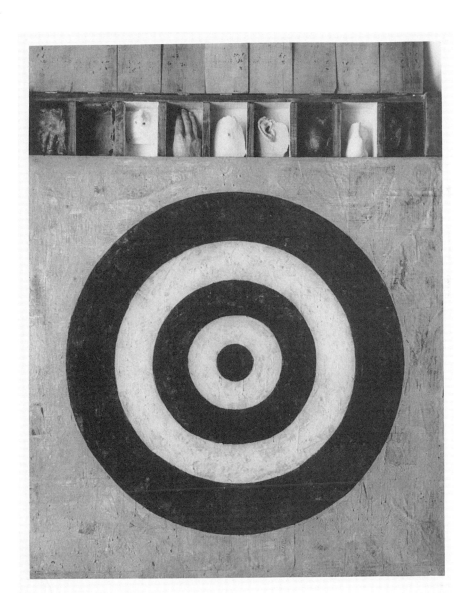

Figure 12. Jasper Johns, *Target with Plaster Casts*. Mixed media, 1955. Private Collection. ©Jasper Johns /Licensed by VAGA, New York. Photograph courtesy Leo Castelli Gallery, New York.

ies of what might be seen in any anatomy class, but by including a penis and scrotum, Johns had made a potentially explosive work out of materials that were otherwise emotionally neutral. In his own words he worked with subject matter that relied on "preformed, conventional, depersonalized, factual, exterior elements," "things the mind already knows."[49] If representation of male genitals was controversial in this case, the cause lay solely in the eye of the beholder.

The male nude has been an honored subject in Western art. Every ambitious painter wanted to present heroic scenes, in which nudity signified the purity of the characters shown. The artist's skill in evoking heroic sentiments constrained the dangers of making male sexuality visible. Johns's work negated all ostensible drama so the piece could not be said to induce "prurient" responses, a key marker in the 1950s of what was "pornographic." The work contains no story line whatsoever nor even any suggestion about how a story might be assembled from the target and nine representations of body parts. The noble ideas that might elevate humanity's carnal side were simply missing. The piece relied on what viewers would bring, and there lay the rub. Enough people would see something smutty and object to its presence in the museum. Barr's rejection of the piece underscored that, at the time Johns constructed the painting, viewers simply could not be trusted. The museum was still under an obligation to provide a noble and uplifting story whenever it ventured into controversial material, much as Picasso's *Guernica* could be represented as a protest against the cruelties of war in general rather than a specific action combating the policies of Franco, Hitler, and Mussolini, fascist leaders who set no boundaries to the damage they were willing to inflict on innocent Spaniards in their effort to overthrow the country's elected liberal republican government.[50]

Stella was the most overtly radical participant in "Sixteen Americans." His four large paintings in "Sixteen Americans" refused all abstract flourishes and rejected any effort to imbue either paint or image with evocative ideas. Stella covered flat black paint with unevenly executed, thin, pale lines etching out a series of identically formatted, rectangular black stripes. His application of the black ground was steady and consistent to avoid any variation across the canvas that might give cause for interpretation. Instead of dramatic impasto technique, Stella achieved a flat, textureless finish that would have done a house painter proud. The histrionic titles he gave his paintings—for example, *Die Fahne Hoch!* ("The Flag High!" the title of a Nazi song), *The Marriage of Reason and Squalor* (Figure 13)—had no apparent relation to Stella's affectless canvases, and indeed the titles might seem designed to mock the high drama surrounding abstract expressionism, *l'art informel*, and West Coast painting, whether abstract or figurative, but they just as easily mock the

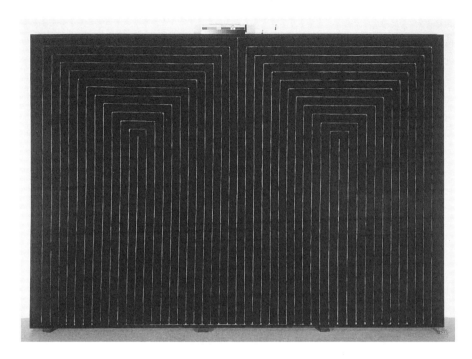

Figure 13. Frank Stella, *The Marriage of Reason and Squalor.* Enamel on canvas, 1959. Museum of Modern Art, New York, Larry Aldrich Foundation Fund. Courtesy of SCALA/ Art Resource, New York. ©2008 Frank Stella/Artists Rights Society (ARS), New York, and the Museum of Modern Art.

French classical painting tradition from Poussin to David that established a standard of high moral purpose for serious painting, a purpose that impressionists like Monet had to reckon with even as they sought to evade its dictates. Generations of painters might have believed that their work revealed moral principles, the principles of a Kantian sense of justice secured in an attitude of good taste, but Stella scoffed at the very idea that paint on surface could be anything other than paint on surface. Contemporary painters who thought that the goals of painting could be redeemed by reworking the moral imperative into an effort to capture the workings of the mind or mysteries of the universe might be working hard but could not escape the fallacies inherent to an idealist vision of painting serving transcendental knowledge.

The short statement accompanying Stella's section of the exhibition catalogue, written by his friend Carl André, declared, "Art excludes the unnecessary. Frank Stella has found it necessary to paint stripes. There is nothing else in his painting. Frank Stella is not interested in expres-

sion or sensitivity. He is interested in the necessities of painting."[51] The transcendental ego was not even under attack in his four paintings in "Sixteen Americans." To believe that painting had anything to do with states of mind was simply self-deception. To imagine that canvas and paint could connect the soul to universal realities was to succumb to outmoded ideas no longer of interest to anyone seriously engaged with art as art.

Perhaps, given the titles of the work in "Sixteen Americans," Stella, who at twenty-three was the youngest artist in the show, linked the faith that art was transcendent to an impossible ambition for perfection, to a desire to be lifted out of the ordinary world of men and women—ambitions and desires that culminated in world war and the murder of millions. That implication of course was an idea independent of the painting as a painting, an effect solely of applying loaded words to objects that were themselves mute and resistant to interpretation. Stella had rejected the romantic abstract expressionists as his forebears and followed the path set out by Ad Reinhardt's monochromatic paintings and the rule of the "six no's": no texture, no brushwork, no drawing, no size or scale, no movement, no subject.[52] When asked what his paintings revealed, Stella responded simply that there was nothing "besides the paint on the canvas" and "what you see is what you see."[53] At a lecture given to students at the Pratt Institute in New York during the "Sixteen Americans" exhibition, Stella described the problems motivating his paintings in the show as the desire to eliminate balance and depth. The solution was to make a painting uniform throughout with a symmetrical image that forced "illusionistic space out of the painting at a constant rate by using a regulated pattern." The method logically had to be to use house painters' tools to achieve the same flat, uniform effect desired for a living room wall.[54]

Hedrick's catalogue statement posed his goals in a dramatically different way that emphasized his belief that painting transported viewers into a heightened sense of reality: "When I paint I must take nothing and make something . . . the main ingredient that is needed is an IDEA. He who has an idea cannot be stopped except by himself. I understand that lots of people don't have ideas." Whatever he paints reveals him as a person engaged with the world for "the things I'm thinking about in my head are still mine (i.e., no one has ever thought of them before)." He encouraged his viewers to engage him as a personality through his work, which he compared with a woman with whom he has made love. Only after desire has found ecstatic release, he concluded, can he know a person or a painting. DeFeo's statement was no less bold even if she limited herself to five short sentences. "Only by chancing the ridiculous, can I hope for the sublime," she began. "Only by discovering that which is

true within myself, can I hope to be understood by others."[55] That "truth" was a cosmic force that lay within each person connecting her to a chain of being, the linkages it was the function of art to reveal.

Stella's paintings in contrast questioned the place of ideas as such in art and the illusion that subjective engagement with a painting revealed an order of truth that might otherwise be invisible. While the implications of his moves for painters like DeFeo with "literary" or "philosophical" ambitions, was clear, his gesture may more likely have responded to the self-censorship that Miller and Barr exercised when they declined Johns's *Target with Plaster Casts*. "How could noble stories redeem pictorial work when paintings are incapable in principle of saying anything?" Stella seemed to be asking those in the art world who still insisted that painting reveal the world in a higher, more ideal aspect and thus could not tolerate the thought of anything as base as human body parts hanging on a museum wall. "Could painting ever be more than illustration?" was a corollary question. Stella refused to answer either question if only because media that *show* things are incapable of *saying* anything.[56]

After the close of "Sixteen Americans," a New York gallery owner representing a number of younger California artists wanted to add DeFeo to his group. He asked her how quickly she might be able to produce enough new paintings for him to launch her. She was reluctant to put *The Rose* aside in order to generate product and discussions ended.[57] Even if unrepresented, DeFeo still enjoyed continued attention, with photographs of the still unfinished and never exhibited *Rose* published in two national magazines. In April 1961, *Holiday* included a photograph of DeFeo working on the painting as an illustration to Kenneth Tynan's article "San Francisco: The Rebels," an impressionistic account of the city's bohemian cultural scene. In December 1962, DeFeo and her work were featured in *Look* magazine in the article signed by President Kennedy on new directions in American art. Both photographs, taken by New York photographer Burt Glinn, treat DeFeo as an ingenue making her debut.

If "the comely, dark haired Jay DeFeo" was presented as a star in the making,[58] there was nonetheless a growing disconnect between her own requirements and those of the institutions interested in marketing her. Her image dominated what readers saw, not a body of work. As a young painter, she was reduced to her personal image, a sexual being who ought to be the object of desire for art lovers. In that story, her paintings were secondary to the youthful personality on display. Given that the artist's image with its illusion of personality was more important than the work, a logical next step would be for artists to incorporate their physical presence into the work, a strategy critical to the work of Carole Schneeman and Cindy Sherman, as younger feminist artists confronted

the practical conditions of the nation's cultural institutions shaping women's participation.[59]

DeFeo, even if already embarked on a performative approach to art, did not have the theoretical framework to perform a feminist response to the role assigned her in the contemporary art world. Her friend Wallace Berman did a more provocative series of photographs of DeFeo and *The Rose* than the pictures Glinn had taken. Berman was no feminist, but his romantic understanding of artists as a saving remnant in a corrupt world provided him a way to see that the sexual stereotyping applied to DeFeo was a diminishment and not effective publicity. In one image, DeFeo stands without clothes in front of her painting. Her arms and legs are extended in a clear echo of Leonardo's celebrated drawing of man against the cosmos. The Hebrew letter *tzaddi*, the symbol in the Kabbalah for the diverse forms that the divine can assume in human life, is superimposed on her chest.[60] In this idealized image of DeFeo, the artist appeared as a manifestation of the force of creative intelligence, present everywhere and in everyone even if, in Berman's view, typically suppressed. In another photograph, Berman presents DeFeo, totally naked, pushing a mop in her kitchen, an image jokingly playing with the expectation that DeFeo, whatever her creative aspirations, could readily take the form of a middle-class housewife if that is what a spectator expected to see in a woman. In a third photograph, Berman displays DeFeo sitting in front of her painting with her legs slightly open. She is naked in this picture as well aside from a string of pearls and black high heels. The association of the central image of *The Rose* with the vagina was obvious to all her contemporaries, though seldom discussed. Berman's staged photograph made explicit what had occurred in more disguised form in pictures taken for the mainstream press. Berman's representation of his friend as a female stereotype was consistent with his conviction that sexuality and poetry were intertwined, corresponding universal forces, both of which had been perverted in modern U.S. society. Berman's advice to his friends, and his own personal practice, was to avoid the spotlight of public attention, to keep away from a devouring world that misunderstood poetry and converted the sublime to kitsch.[61]

"Toughness" in California: The Cool School

In 1965 facing eviction from her home and studio, DeFeo agreed to Walter Hopps's proposition that he bring *The Rose* south to Pasadena, where he directed the Pasadena Art Museum. She could put her finishing touches on the work, and the work was to receive a gala premiere in 1966. Hopps had known DeFeo since 1954. He had included her work in several shows he had curated, and he briefly represented her when

he ran the Ferus Gallery in Los Angeles. In 1961, he became director of the Pasadena Art Museum, a small institution with little money that under Hopps's direction developed a reputation for being the most exciting venue in the United States for contemporary art outside of Manhattan.

The show Hopps promised did not occur as planned. The unveiling of *The Rose* was postponed three years after Hopps suddenly left Pasadena in a disagreement with his museum board over an unrelated matter. He left California, working first in Washington, D.C., at the Corcoran Gallery, and subsequently in Houston at the de Menil Collection. In winter 1969, the Pasadena Art Museum, under new leadership, finally gave *The Rose* its first public exhibition. Los Angeles newspapers noted the exhibition of *The Rose* but no formal reviews appeared. Later in the year, the painting moved to the San Francisco Museum of Art for its first showing in the Bay Area. Thomas Albright's glowing review for the *San Francisco Chronicle* nonetheless called the painting "a glorious anachronism."[62] The art world, he noted, had moved away from an earlier love affair with subjective expression and embraced the cooler detachment of pop art, minimalism, and post-painterly abstraction. The directions that Stella and Johns had predicted in 1959 now dominated critical thinking.

California critics had followed the lead of their New York peers in turning against art that was too physical, too overtly transcendental, or too open with an editorial perspective on modern life. Richard Diebenkorn, Wayne Thiebaud, Robert Irwin, Billy Al Bengston, Larry Bell, Craig Kauffman, and Ed Ruscha were the new stars, and it was not coincidental that the group were all men and for the most part not associated with the beat culture of the 1950s. The work that represented California internationally had bright colors, often sported identifiable references to popular culture, and were frequently made with new materials requiring unusual skills to master. California art increasingly reflected a vision of the state that evoked bright blue skies, booming growth, and especially technological ingenuity. Because of the new materials often used, much of the work produced was difficult to capture in photographs. Instead, images of the artists with their surfboards, their motorcycles, or their girlfriends or otherwise performing the role of the "young rebel" took prominence in posters and magazine articles.[63] As with DeFeo, publicity sexualized younger male artists by rendering them with images coded in their case for tough, masculine coolness, qualities that could then be said to characterize the objects they had fabricated.

Robert Irwin's paintings increasingly eliminated line, form, and every aspect of pictorial representation. He replaced image with an intensely physical experience that challenged what viewers thought they knew

about the laws of perception. Irwin's disk paintings, produced through the 1960s, shared DeFeo's interest in both circularity and perceptual illusion. These large works, however, made with ordinary lacquer, acrylic, and plaster, actually seem to disappear as physical objects when hung on a wall. Instead they offer viewers an intensified play of light and shadow captured on a glimmering surface mysteriously floating off the wall. "Everything [has] both an image and physicality," Irwin declared, "and my interest really lay in this whole thing of physicality, in that the moment a painting took on any kind of image . . . instead of filling up or being more interesting, it did just the opposite for me—it became less interesting. . . . The minute I could recognize it as having any relationship in nature, of any kind, to me the painting went flat." Rejecting image, he wanted pure physicality, which meant rejecting even line, which already carried the seeds of referential implication to realities that were external to art and therefore irrelevant to artists. Viewers should never notice his application of paint, they should never think about the kinds of surfaces he made, and they should never imagine that he had a point of view. The result was a physicality that veered into an ethereal flux of light. Irwin presented himself as a researcher exploring the conditions of perception. Painting provided him with an experimental format if, and only if, he could remove all reference to anything existing, including the very materials from which he constructed his paintings. If an art object were to be a gateway to pure thought, every reference to form itself had to be erased.[64]

Larry Bell's glass cubes, on the other hand, dazzled viewers by focusing their attention on what he could do with his materials. Bell began manufacturing chemically vacuum-coated glass boxes in 1963, using industrial technologies that allowed him to create refined and often mysterious reflections that at times seemed to defy the laws of optics but were inescapably embedded in the hard surfaces of the objects he crafted. His work, Bell insisted, had no content whatsoever other than the skill required to discover never-before-seen physical effects. His cubes communicate nothing but their material splendor. There are no sly references to a history of artists before him working in trompe l'oeil, nor to mystical traditions like Theosophy, deeply rooted in California, where light emanations are viewed as a bridge to extracorporeal realms. Bell rejected all interpretations that went beyond what was immediately visible, including claims that, like Robert Irwin, Bell wanted his surfaces to induct viewers into the mysteries of perception. "Talking about perception," he told an interviewer, "is a lot of cheap talk. . . . If I knew what I was doing . . . I couldn't externalize it any way except through the work."[65]

Billy Al Bengston's paintings took a new direction when he started

applying automotive lacquers to sheet metal or other industrial surfaces with an airbrush. The brightly tinted, highly polished paintings of military insignia, surfboard designs, and other subjects drawn from popular culture leaped out at viewers with a bigger-than-life impact. Yet just as surprising was how Bengston's treatment divorced the symbols he selected from any of the real-world conflict surrounding them. The country was deeply divided by war when his paintings appeared, and other California artists were struggling to express their rage at policies that made no sense to them.[66] Bengston's military insignia have no hint of even subtle editorial commentary. There is not even the slightest implication of a critique of militarism or masculine privilege, in striking contrast to the work Ben Talbert, Edward Kienholz, or Wally Hedrick were doing at the time. One critic commented as she praised Bengston's approach, "His paintings are as real and unromanticized as the bare facts of contemporary life: they repel sentimentality and iconographic interpretation."[67] His paintings were on such a large scale that they magnified well-known images into purely physical objects divorced, perhaps, from their original symbolic functions. Bengston need make no editorial statement, because in his hands, popular icons transformed from assumption-laden images to affectless forms whose emotional power became a puzzle in need of decoding. To say that his project was neutral in a time of controversy and therefore effectively conservative politically would be unfair and, from the point of view of an art world that was professionalizing, not germane to how artists in fact contributed to society.[68]

Any citizen could speak out against war, and should if he or she felt the nation's policy was wrong. A citizen's professional work stood in another realm. A surgeon's skills were not changed by a position taken as a citizen. The idea that an artist's opinion about war and peace was somehow more meaningful than those of any other citizen, or more deeply felt because of the craft they practiced, rested on erroneous assumptions about what artists did, assumptions that had been fundamental to modern art and made Picasso's dove a universal symbol of humanity's desire for peace. In the new, professionalized view of art emerging in the 1960s, only the most disciplined intelligence could work with an object and give it an appearance unlike anything else that had previously existed. The move away from modern art reaffirmed the ambition that Clemenceau had discerned in the work of Monet, an ambition diluted by the resurgence of romantic subjectivity. The truths that artists presented ought not be grand or pretentious. Artists aimed their work to those with the expertise to appreciate something genuinely new that still built upon the long tradition of manual knowledge subsumed under the word "art."

The new California art of the late 1960s and early 1970s was not "otherworldly" even if, as in Irwin's case, in pursuing the mysteries of perception, work rested on philosophical assumptions. Nor was it "abstract" even if not figurative, for shapes and colors themselves, in whatever form they might be composed, were part of the illusion that had to be banished. The work presented spectacular effects, not ideas, and if an effect suggested any particular idea, the power of the work as a pure object collapsed. Viewers might read into the objects an exuberant celebration of technology, appropriate for a region where the post–World War II economy was fueled by military spending, aerospace, and high technology. But one had to *read* any message into these pieces. The works themselves refuse any content beyond their physical presence. This was work that conformed with a vengeance to the new demand for objectivity in art enunciated by Stella's paintings at the "Sixteen Americans" exhibition at the Museum of Modern Art, and thus it was work that could take its place on a national stage without complicating the story of modern and contemporary art in the United States.[69]

Peter Plagens observed that in the early 1970s the leading trend in California's art world was to "get rid of our appetite for all those nasty, dusty, heavy, corny objets d'art, and if we could wean ourselves from such hoary materials as oil paint, bronze and welded steel, to polyester resin, nylon scrim and 'pure' light and space, contemporary art could get us to the next astral plane."[70] In an era when the work of art was dematerializing, *The Rose* was altogether too, too physical, and too overtly cosmological in its ambitions. It was also perhaps too feminine, too focused on subjectivity and self-reflection, on the process of thought and the discovery of relationships, at a time when the California art market had become increasingly geared to the celebration of masculine "toughness." The aesthetic division between California artists, a normal element in a competitive, pluralist society, solidified into a social division that had clear market implications. Larry Bell noted that he and his friends refused to associate with other artists still working in figurative modes: "It was a sort of weird kind of snobbery and there was always this sort of feeling . . . that it was easier to do figurative context or literal context work than it was to make nonfigurative kinds of things, stuff that didn't look like anything else. And the only way that you could really maintain that sort of strict discipline in pursuing that kind of work [nonfigurative] was to not hang around anybody who did it [figurative or literal contexts]."[71] Talking about one's work was a taboo that violated the basic principle that their *work* was a product that either did what it was supposed to, in this case present unusual physical effects, or had failed utterly. Ideas of art making anybody a better or a more enlightened person was part of the "cheap talk" that stood in the way of actually engag-

ing art objects for what they were. In exchange, there was insistence on the right of professionals to receive an economic return for their activity. Bell recalled that when he started working as an artist in the late 1950s, he believed that making art and making a living were "diametrically opposed" to each other. Bengston, in particular, taught him that he had a right to make a living from his work and that the money an artist earned was the only objective way of putting a value on work.[72]

Objects involving unusual technical processes were expensive to produce. To keep working, an artist required a steady capital infusion, either through sales or through commissions. Increasingly, negotiations between artists, art patrons, and institutions such as museums or universities that could provide sites for the display of completed work became a necessary part of the process. The artist's inspiration had to be expressed in sketches and verbal pitches that could stimulate anticipation for what was to come. As art grew autonomous, leaving behind "literary" or "philosophical" purposes to achieve a purity of expression independent of other modes of thought, artists nonetheless entered into social relations binding them to sponsors, whose interests, needs, and confusions affected the final shape of the product. Producing art according to Jasper Johns's self-admonition from 1963 or 1964—"Make something / Find a use for it / and / or / Invent a function / Find an object"[73]—was hardly a formula for practical independence if it required a complicated dance of business negotiations.

In describing the crafting of *Iceberg*, Bell recalled that he had read that an art collector had endowed Brown University with an art center. Bell contacted the collector with a proposal to prepare a piece for the new gallery. The collector asked for a proposal, including sketches, budget, and work plan. After Bell designed a piece for a specific site at Brown, the university declined the donation. The collector was still interested, but he needed a public institution to accept the piece since his funding for *Iceberg* was contingent on being able to take a tax deduction. After several months of continuing discussions with a wide variety of potential recipients, Bell convinced the Massachusetts Institute of Technology to accept the work. Bell modified the design to adjust the work to its final site. At no point in the discussions was the "content" of the piece at issue, yet the "context," both financial and geographical, shaped the final form of the work.[74]

The Postmodern Arrives

The "postmodern," as it first appears, announced a rupture with both the scientistic and humanistic ideals that had driven the development of modern arts movements from the mid-nineteenth century through the

1950s. It took shape in the rejection by younger artists of older ideals that struck them as irrelevant to the facts of their lives. In early artist-run venues like the Six Gallery, the postmodern involved an ironic, laughter-filled rebellion against the pretentiousness of art history, as well as the hypocrisy and commodity-fetishism they believed permeated modern society. Many younger artists wanted to celebrate, albeit with critical distance, the common culture that they shared with most (white) Americans of their generation. DeFeo was no exception to this. While she was working in her paintings to create illusions of rotation around a central aperture, DeFeo constructed several photocollages in the 1950s, in which she pasted cut-outs of pinup girls she had found in magazines as if they were petals of a flower in the process of opening up. Despite DeFeo's insistence that the pinup girls had no meaning for her, the undisguised source material inescapably alluded, with semisurrealist or neodada bravura, to the role sexual desire played in stimulating the imagination.

The ambitions that might be expressed through art became more precise but also often narrowed. If an object presented nothing but its own tangibility, did the public gain a more critical relationship to the possibilities open to them? Might in fact the new objectivity embedded in art promote acceptance of the world as it existed? The intentions of artists themselves varied widely, but, as always, they functioned within an institution that was not of their making, an institution that defined *for them* the terms of success and failure, while defining for the public the standards for evaluating work. Through the 1960s, the drive to secure the autonomy of art production coincided with the expansion of the art market. Art objects defined by an ethos of "what you see is what you see" proved the most valuable commodities, while art objects with extra-art ambitions were shoved to the margins. In California, the process coincided with Los Angeles emerging as the "second city of art" in the United States, with local boosters taking this new cultural stature as proof that the region had come of age, had outgrown its original provincial isolation to arrive as a player on the world stage. Art was brought from the relative freedom of the periphery into the center of cultural life. There was money to be made, and in large quantities. The successful establishment of modern and contemporary art institutions in Los Angeles and San Francisco spread to other towns around the state, with prominent business and social leaders in many communities eager to contribute large sums of money for building campaigns, an expanded and more professionally trained staff, and massive publicity.

The commodification of art, simultaneously alienated from humanistic values, generated countermovements from younger artists in the late 1960s and 1970s. The professional autonomy of art achieved in the

1960s revealed with tremendous clarity how limited and exclusionary art practice had long been. As values of "coolness," "objectivity," "distance," and "toughness" defined U.S. art in a period of expanding galleries, museums, and publications, the space that women artists had carved for themselves in the decades prior to 1960, however limited and confined it had been, actually shrank. The profession of making art, like every profession, had long been a masculine preserve, opened at the margins to women of unusual talent and determination. The relocation of art practice onto a model based on male skilled-craft work wrote women out of the picture. At the same time, professionalization and expansion of museum staff meant that younger men with Ph.D.'s in art history increasingly replaced women curators and directors. Feminist art emerged in the 1960s to challenge new trends in U.S. society that overlay older, more customary ideas of distinctive gender roles with an aggressive celebration of male expertise.[75] Feminist resistance, however, was not a path that DeFeo was ready to take.

She could not negate the history of art she had inherited if she was to stake her position as an artist on a claim of assisting its continuity. DeFeo was not avant-garde, at least not in the sense of wanting to rupture traditions others, like Judy Chicago or Faith Ringgold, experienced as ruthlessly repressive and exclusionary. DeFeo had learned that "modern art" was whatever the next step might be in a long process of expanding the expressive capabilities of humanity. For DeFeo, even if the art world had in fact long been masculinist, the idea of universal truths and the continuing relevance of long-standing traditions had been essential to her own identity as an artist.[76] She could not recognize that her faith in "art" as a transcendental category grew from the conditions shaping women of her generation entering the profession as it existed in the mid-twentieth century United States during a period of expanding public education. In the transcendental framework that guided DeFeo's project, every artist who continued what Heidegger had termed a conversation with the gods was a *modern* artist pushing the limits of his or her expressive abilities, whether that craftsperson was inside the caves of Lascaux, the temples of Ajanta, the towns of Tuscany, or the urban metropolises of the twentieth century.

The tradition her teachers at Berkeley had given her had to be real or she would have no escape from the limitations her society assumed should normally structure the lives of women other than plunging into the free fall of anarchic rebellion. Her assessments were shared by many other men and women in the United States whose ascribed social position blocked their full participation in the advance of human progress. For them to claim a place for themselves in the world of art, a place that might correspond with their vision and talents, they could not think

either that art was going to end or even that art was under threat. Art and culture were always expanding, always open to new contributions. Perhaps only those who had walked away from privilege that family background, education, race, or gender conferred on them could readily imagine that the destruction of so-called Western civilization was desirable and inevitable.

Modern universals and postmodern diversity were two distinct, but not necessarily contradictory, strategies toward the goal of expanding the conversation. The challenge for DeFeo, as for many others, given the rapidly changing dynamics of art practice in the United States was to evade the fashions of the moment and find a niche within the institution the goals and structures of which could better sustain her personal quest. The solution to her personal problem was to secure a tenure-track position in the Department of Art at Mills College, a highly regarded program teaching both undergraduate and graduate students. The professional demands governing promotion within colleges and universities included an obligation to exhibit new work on a regular basis, which discouraged any tendency to linger on a single image. Interactions with students helped her refocus on her values as a painter and develop a more concise way of talking about thinking through paint.[77] The advance after *The Rose* involved a growing understanding that her responses to the world were always in development, moving forward in many variations that over time captured shifts in her thinking and her feelings. She had abandoned the idea that the universe could somehow be materialized in a single painting, or even a series of paintings. Every work, even the most powerful, was a snapshot demanding more work to address the ands, ifs, and buts inherent to consciousness.

Much of her work after 1970 started with formal studies of everyday objects such as jewelry, her camera tripod, swimming goggles, lightbulbs, or the shoe trees in her closet. Usually the object remained recognizable, but she carefully restricted the visual keys that would help a quick identification of her subject. By relying on the mind's capacity to fill in what was missing, she invited the imagination to explore what happened to everyday objects when they entered new, often unusual spatial contexts.[78] The objects with which she started were not unimportant, but her goal, as always, was to give them the "new reality" that could be found only in the practice of art.[79] Providing a "new reality" to the subjects of her artwork liberated swimming goggles, jewelry, or knitting needles from the preconceptions that encaged perception of their forms. Within the Heideggerian terms implicit to her work as an emergent artist, the new reality each drawing, photograph, or painting posed transformed objects with carefully defined uses into things to which one had

to respond if one were to comprehend the world into which one had been thrown.

Critic Thomas Albright thought her new paintings were "battle-grounds on which the sensibilities of two eras [had] locked in desperate combat: the aggressive, awkward forms and rugged surfaces of 1950s Funk versus the hard, crisp shapes and flat, buttoned-down grounds—the clean (or slick) look—of the 1960s." Her new paintings ended the battle between sublime depths and spectacular surface "in an irresolute clinch." The ideas in her paintings that replicated "the mannerisms of Abstract Expressionism" surfaced in "a few ragged spots, erasures, smudges" absorbed into a "geometric regularity" that remained "the antithesis of all that the funky sensibility of the fifties stood for." A desire for "order and tranquility," for a Platonic relationship with existence that affirmed the permanence of all that was real, could not vanquish her fundamental belief that "flux and indeterminacy, the refusal to crystallize" were the most fundamental truths of existence.[80]

Sales of her work grew each year. In 1982, DeFeo received an honorary doctorate from the San Francisco Art Institute. She had grown into an honored senior figure of California art, inevitably referenced in the increasing number of publications on the history of painting and art in the state. Efforts to secure a New York dealer failed, but in the parameters of the local world where she had been born, educated, and lived her whole life, she was an eminence whose global reputation was reaffirmed by the graduate students who applied to the Mills College MFA program to work with her. She was at last a painter whose profession had provided her with a world that could be both stable and productive.

Chapter Six
California Assemblage
Art as Counterhistory

Professional Limits

Ironically, prior to the 1960s, the relative poverty of arts institutions and the paucity of support available allowed for a more transparently democratic arts world, for all suffered to varying degrees from the isolation and lack of resources. Underdevelopment fostered ad hoc community-based improvisations such as the Six Gallery for the sole purpose of asserting *presence*—an assertion paralleling Rodia's Watts Towers. The basic rule had to be, if you have something to say, you just have to say it. That somebody found your work moving was the greatest reward, the validation that choices you had made for your life were meaningful to others. The expectation that financial reward provided a more objective standard for evaluating artists' work was part of a revolution in the relationship that artists had with the rest of society.

Limits on meaningful participation gained intensity as an injustice as professional art institutions grew and were able to support more complex activities. Galleries, museums, and schools have not had the resources, even in their new, relative prosperity, to engage a broad variety of participants coming from all sectors of U.S. society. In the mid-1970s, "earned income," a term referring to ticket sales for museums or sales of artwork by galleries, accounted for only 50 percent of income generated in the visual arts field. The other half came from private and government grants as well as income earned in teaching. The situation in the visual arts stood in sharp contrast to both the performing arts and the publishing business, where "earned income," directly derived from primary activities, accounted for 96 and 98 percent respectively of support. (Were the comparison limited to classical music and dance or to the "small press," the figures might well be more similar to the economic situation in the visual arts.)[1]

Given the often high prices that some contemporary artists receive for their work plus the expenses involved with museums functioning with much larger staff, many with Ph.D.'s or professional expertise that command competitive salaries, the fiscal situation in the visual arts has seemed to be healthier than it actually is. Since the 1970s, private support for museums has grown to cover widening gaps between income and expenditures. Private support primarily has come from individuals, often giving through their personal or family foundations, rather than from corporations. This has increased the dependence of museums on their trustees, with wealthy collectors shaping acquisitions and exhibitions policies toward their personal interests. Curators and museum directors, often with impressive scholarly credentials, can negotiate from positions of expertise with their patrons, an expertise that is essential for museum programs to be credible. Curators have become responsible for educating patrons in contemporary art and steering them to artists they should consider important additions to their personal collections as well as to the museum's holdings. Practicing artists, while potentially able to earn more from the sales of their work than ever before, have little leverage, perhaps less leverage over the disposition of their work than when the Six Gallery was organized in 1953, for in those days, local museums needed to maintain contact with, and curators perhaps had greater interest in, local artists who could provide a steady flow of work for exhibition and discussion.

Teaching has remained the necessary anchor of stability for most artists, although employment in advertising, commercial illustration, motion pictures, or, increasingly, web design has provided alternative sources of income.[2] The economic realities have fostered resentment and more explosive efforts by those on the margins to demand access to a *market* that is usually operating at its limits but is connected to an academic *discursive formation* that debates which new possibilities for artistic expression promise to expand or deepen the scope of artistic experience. Intellectual assessment identifies innovations that can refresh the market by introducing new talent, new media, and new content, allowing for a continuous reframing of the boundary between "modern" (work that has become classic) and "contemporary."[3] If contemporary art has developed as if divided into antagonistic camps, the rage accompanying the proliferation of expressive strategies can be explained by the reintroduction of principles of exclusion based on aesthetic standards into an art world that had developed around an ideal of continuously expanding participation, around practices of informal sharing. Eventually in the avant-garde fantasy, divisions between art and life would be erased as the hidden poet within every man and woman was liberated. Professional standards, ominously claimed to be set in other

places, typically New York City, and collectors' tastes turned art objects into commodities of potentially astronomical value and subverted an ideology of art as a sharing of experiences, which by definition need to be diverse and contrasting if there is to be a rationale for *sharing*.

Assemblage Art as Alternative History

In the preceding chapter, I outlined the triumph in California at the end of the 1960s of what has been called the "fetish finish," work that, although sometimes aligned with pop art, relied on the use of new technologies and materials to achieve pure visual experiences largely divorced from any explicit social content or comment. At the beginning of the decade, however, the assemblage art form had been the new medium that best seemed to define the direction young artists were taking art in California.

The appeal assemblage had for artists was particularly striking given how little interest local museums initially took in the form. Shows were typically informal and brief. Clay Spohn, a painter teaching at the California School of Fine Arts, organized a brief showing of his mixed-media work at the school in 1949. Spohn's "Museum of Unknown or Little Known Objects," a collection of objects Spohn made from scrap metal and unusual objects he had discovered in trash bins, left a deep impression on those who saw it. In 1951, Spohn's friend Hassel Smith put together a show of assemblage works, "Common Art Accumulations," at the Place coffee house in San Francisco. In 1954, assemblages made their first appearance in the annual Los Angeles and Vicinity exhibition. Edward Kienholz exhibited his own assemblages and work by Gordon Wagner at his Now Gallery in 1955 and 1956, while assemblage work appeared frequently at the Six Gallery in San Francisco. In 1957, the Ferus Gallery in Los Angeles opened with a show featuring assemblage works.[4] Gordon Wagner had an early exhibition at a commercial gallery in 1959, but his assemblages were shown in conjunction with his paintings. No records exist to verify his recollection, but Wagner recalled that none of the mixed-media work sold. He relied upon painting sales until 1966, when the first customers appeared who were primarily interested in his assemblage work.[5] Bruce Conner exhibited assemblages at the Spatsa, Dilexi, and Batman galleries in San Francisco and the Stuart-Primus Gallery in Los Angeles. He was the first, and for a long time the only, California assemblagist to have New York representation. In 1959, he began exhibiting at the Charles Alan Gallery in Manhattan. As in Wagner's case, Conner's assemblages initially were exhibited as accessories to his paintings and drawings, but unlike Wagner, Conner's assemblage work sold well, and for the next five years, the primary demand

for his work in New York was for assemblages, suggesting that buyers on the East Coast were more open to new forms of expression than buyers on the West Coast.[6]

Following William Seitz's "Art of Assemblage" exhibition at the Museum of Modern Art in 1961, major exhibitions of assemblage work occurred at California college galleries and in museums. Between 1962 and 1964, *Artforum*, at the time based on the West Coast, published several articles exploring the distinctive qualities of California assemblage. Donald Clark Hodges argued that assemblage was primarily a form of protest art, used to satirize the absurdly wasteful character of American society.[7] Donald Factor agreed that with California assemblage subject matter always had priority over formal concerns, a factor he thought was in sharp contrast to comparable work from New York. Artists in California used found objects to make biting editorial comments on current social and political issues, but these comments were typically driven more by a deep conviction about the spiritual underpinning of reality rather than a defined ideology.[8]

John Coplans, on the other hand, stressed the neodada component of assemblage. He thought that the state's assemblage artists had opened up another front in a battle begun in Europe by the tâchistes and in New York by pop artists. Artists from each of these movements were in contact with each other (which was true), and he believed they shared an indifference to any concept of beauty or to the use of art as a liberating factor in society (on both issues he was clearly wrong about the attitudes of California artists if we go by what the artists themselves have had to say).[9] The following year, Coplans reversed his position, now accepting that California assemblage artists generally worked in processes and with sensibilities completely different from comparable work in New York or Europe, such as Rauschenberg's combines or Arman's accumulations of objects. Coplans concurred that California assemblage art typically expressed an overtly critical relationship to contemporary society. Coplans agreed with Factor that the critique assemblage artists made was primarily focused on the psychological condition of American society.

The confusion over how to interpret California assemblage reflected the mixture of spiritual concerns with social critique found in many artists' approach. Work, even when it addressed topical issues, seldom could be distilled into a simple or direct political statement. California assemblage brushed aside both political and artistic values to focus on the connection of the unhappy internal state of Americans to the nation's many public malaises. Recycling found objects into art denied that the usefulness of things could be limited by the initial purposes for which they were made. New uses always lay dormant. The question was whether one had the imagination to see the potential within every

aspect of being. Gordon Wagner, an aerospace engineer who developed a career as an abstract painter, turned to making objects from the junk he found because it allowed him to think more deeply about the society in which he lived:

You get thinking about that environment of where that came from, and it takes you through a whole association with the past, although you're working in the present. So the now and building something for the future, you kind of go through the past, present, and future at once. The nostalgia of the actual being there and the old civilization, the way it must have been and [how] the people were. You get to imagining these things while you're building, and you're feeling this piece. There's a feeling I can never get from people, but I can get it from objects. . . . Those objects all lived a full life, right? They were thrown out as discards. Nobody wants them anymore. . . . Yet an assemblage artist comes along, he sees these things as actors, you know, and he brings them back, puts them back into play again, gives them a new life, a new way so they can be appreciated.[10]

Redemption was the great overriding myth explored in Wagner's assemblage art: What shall survive of what has already been? Can the human spirit truly be so alienated that mere products could define who a person is? Many other assemblage artists shared the sensibility. The objects artists found and transfigured into art stood metonymically for the men, women, and children who had made, used, and enjoyed them. In American society, not only were objects treated as dispensable, so were most people—a central, recurrent theme that gave urgency to the transformation of junk into art.

By emphasizing the use of discards assemblage artists challenged conventional public attitudes about beauty in art and preferences for sleek, modernist design that were particularly prominent in the 1950s and 1960s. Noah Purifoy's *Breath of Fresh Air* (Figure 14), composed from two joints of stove pipes with part of a tin and tar paper roof mounted on the peak, expressed Purifoy's love of pure form. The parabolic swoop of the lower leg and the pliable molding of the upper portion have the majesty of shapes normally associated with aluminum or some other modern, high-tech material. The piece is ironic to the degree that it demolishes preconceptions that only certain materials can be sleek or that junk must be nostalgic. But the piece, however much it gestured toward formalist sculpture, still had an overtly political edge. Purifoy had collected the objects in the ruins of buildings that had been destroyed during the Watts riots of August 1965. Purifoy challenged the spare ethos of the new L.A. Look by demonstrating that even the humblest materials found in the most distressed circumstances could possess the grace usually associated with modern technology. Yet the assemblage movement simultaneously stressed the ephemeral nature of human

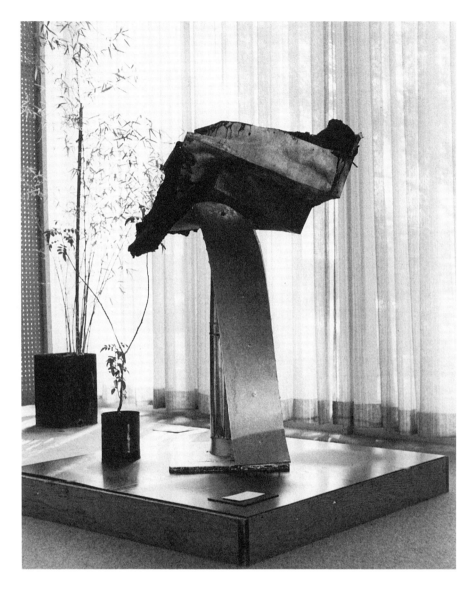

Figure 14. Noah Purifoy, *Breath of Fresh Air*. Mixed-media assemblage sculpture, 1965. Courtesy of the artist and the Noah Purifoy Foundation.

products with a delight in exploring the power of weather and decay to produce new textures, patinas, and colors that were often sensually delightful. Assemblage involved a two-fold rebellion: as artists they protested increasing emphases on elegance in contemporary art criticism; as citizens they questioned the high value placed on efficiency in U.S. culture in the 1950s and 1960s.

Assemblage art begins with the artist insisting that the objects in a piece have at least two immediately visible meanings. They must continue to index their original historical character while signaling the alternative images that the artist's vision has revealed. Objects incorporated into an artwork have many alternative overlapping meanings. The practical exists in relationship to the imaginative, the sorrowful, the humorous, and the spiritual. The revelation contained within an assemblage work holds for any object because each thing surrounding humanity is potential material for the aesthetic imagination, whether put into a work of art or not. The assemblage artist's imaginative freedom bears a reassuring promise: ever-present social limits bind no thing or person. Assemblage presents an object turned into an actor—that is, into a subject capable of responding and reaching out to reconstruct both understanding and use of the world. "What is there" is no longer a given, no longer a "what must be there."[11] Assemblage therefore embodied a relation of self to society that dramatized private value inevitably and ritually triumphing over social determination.

The Costs of Engaging History

Given the critical social vision surrounding the project of reworking contemporary society's throwaways, assemblage art often generated controversy. In 1957, Wallace Berman was arrested and then convicted of violating the state's antiobscenity laws after the Los Angeles Police Department visited an exhibition of his assemblage work at the Ferus Gallery. In 1966, the Los Angeles County Board of Supervisors ordered the Los Angeles County Museum of Art to cancel a show it had scheduled of Edward Kienholz's constructed tableaux, on the grounds that the exhibit contained morally offensive material.[12] In 1962, the American Legion and the Veterans of Foreign Wars picketed the Pasadena Art Museum protesting Walter Hopps's "Directions in Collage" exhibit. Protestors appeared at the Pasadena City Council to criticize the city's allocations to the museum, claiming that those public funds went to support art that possessed, in the eyes of the demonstrators, no sense of beauty or permanence.[13]

While protestors considered every piece in the show, without exception, offensive, they singled out George Herms's *Macks* (Figure 15) as a

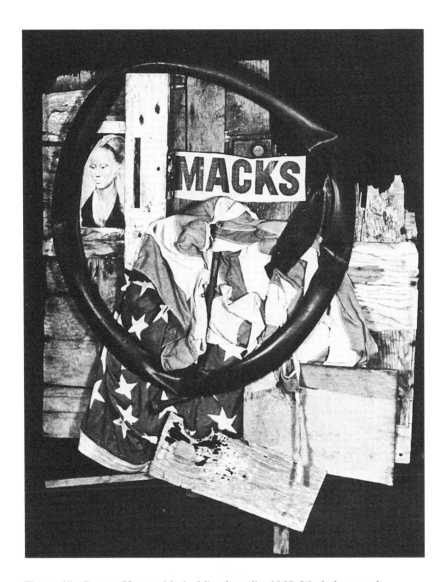

Figure 15. George Herms, *Macks*. Mixed media, 1962. Work destroyed, photograph from George Herms, *The Prometheus Archives: A Retrospective Exhibition of the Works of George Herms* (Newport Beach, Calif.: Newport Harbor Art Museum, 1979); courtesy of the Orange County Museum of Art and reprinted with permission of the artist.

direct insult to patriotic values. Herms constructed the work around a tattered, oil-stained, crumpled American flag he had found in a vacant lot. He placed the flag in a composition containing a deflated bicycle inner tube, a rusty wrench, a reproduction of an old master, and several wood fragments. Herms explained that his intention was to reveal the emotional power the flag could still generate as a symbol even in the condition he had found it in vacant lot. He said that when he happened across this flag he suddenly understood what must have moved Francis Scott Key when the composer of the national anthem saw the flag still flying after the bombardment of Baltimore in 1814. That the U.S. flag could generate a strong emotional response surprised Herms for he despised the militarist and imperialist policies of his government, as well as the environmental devastation unchecked development had brought. Apparently ideals he had imbibed as a child about the nation as an experiment in liberty and responsible self-government were still meaningful to him. He wanted to work with the flag to reclaim the lost, alternative history of the United States. Instead of accepting his alienation as the inevitable, logical development of the country's history, Herms could reclaim patriotism as a value up for contest and lay the basis for a new future in which the country returned to its ideals. It was just as logical and natural to conclude that his political opponents were the aliens within American society, not himself. Herms implied that political conservatives seeking to police the free expression of thought and feeling were the modern-day equivalents of the British laying siege to the "land of liberty." The American Legion rejected Herms's explanation of the piece as far-fetched. The object they saw in the museum was an offensive desecration of the nation's most cherished symbol as well as a violation of legal codes mandating the proper disposal of used flags. After the museum board of trustees refused to remove the piece, vandals broke into the museum at night and ripped the flag out of the work.[14]

By the end of the 1960s assemblage disappeared from commercial galleries and museums, as critical attention on the West Coast shifted to the very different problematics of pop art, postpainterly abstraction, minimalism, and conceptual art. California assemblage lacked "toughness," since the artists could not challenge the forms of semantic enclosure that prevented art from functioning as an autonomous discipline. Even if mixed media relied on the polysemous nature of objects, specific readings, challenging to power and authority, were privileged. Robert Rauschenberg's combines provided a contrasting "tough" use of found objects. Rauschenberg had started incorporating sheets of newspaper into his paintings in 1952, but quickly moved to adding other kinds of rubbish into highly textured works the focus of which oscillated between formal and painterly composition and the allusive nature of the found

materials. As Leo Steinberg described the effect, the thrust of the work only tangentially referenced the overt emotive content of the inserted materials. Instead, the works functioned as snapshots into the connection between painting and thought. "Any flat documentary surface that tabulates information is a relevant analogue of [Rauschenberg's] picture plane," Steinberg explained. The juxtaposition of art and nonart materials "stood for the mind itself . . . [ingesting] incoming unprocessed data to be mapped in an overcharged field." The work could not have a point of view about the subjects the materials, whether paint or found objects, referenced without losing a deeper function as a "flatbed" or "work surface" continually rearranging diverse materials into a wide variety of potential messages that failing to say anything specific threw viewers back into the *process* of thought rather than fixed interpretations, arguments, or demonstrated conclusions.[15]

California-based artists used the medium instead to express highly personal feelings about race relations, the militarization of U.S. society, capital punishment, abortion laws, the displacement of sexual desire into violence and pornography. Critics often responded to Rauschenberg's 1955 work *The Bed* (Figure 16) with disgust because of his use of bedsheets apparently stained with semen, urine, and feces, but they understood the work as an extension of pure painting in which the use of other materials helped deepen the impact of a work through allusions to everyday realities, including the elegant geometric pattern of a blanket. Nonetheless, action painting remained a primary reference for the work since no interpretive framework had been allowed into the composition and the painterly quality of the bed composition was reinforced by hanging vertically on a wall. Given that there was no editorial message present, viewers embedded in an environment that already favored the autonomy of art as a thought process would return to the aesthetic questions raised by the work, which in no way meant that they were unaware of other possible suggestions that the composition, its materials, or its social references implied.[16]

Developing out of a need to editorialize about the nation's situation and developed in private or largely noncommercial showings, the assemblage form in California did not outgrow its preprofessional nature. The political perspectives were often ambiguous, as with Herms's *Macks* (referred to as *Old Glory* in the local press account of the controversy it generated), which no less than Rauschenberg's *The Bed* explored the process by which symbols assumed emotional power. But California assemblagists rejected the depoliticization that accompanied the drive toward professional autonomy. Much of the work in the genre directed viewers towards social controversies, not toward the operations of the mind per se or the place of art practice within the "work place of

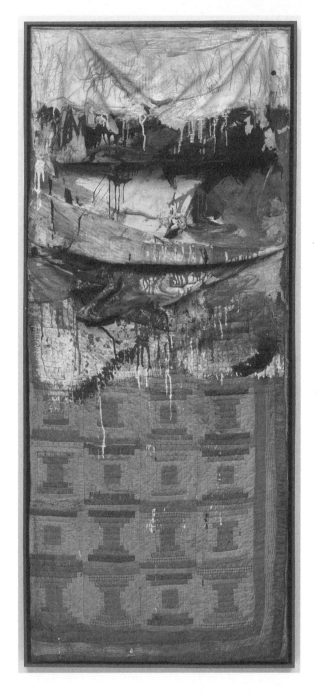

Figure 16. Robert Rauschenberg, *The Bed*. Mixed media, 1955. Museum of
Modern Art, New York, Gift of Leo Castelli in honor of Alfred H. Barr, Jr.
Reprinted with permission from ©Estate of Robert Rauschenberg and Licensed
by VAGA, New York. ©The Museum of Modern Art, New York.

thought."[17] Rauschenberg's projects aroused critical disgust, but not the popular fury that greeted George Herms's *Macks*. The desire to make critical statements about the world in which artists lived and worked regularly led to conflict with unsophisticated fellow citizens who saw disrespect for America if not outright lack of patriotism. Even as controversy harried them, many artists in California did not want assemblage to escape into the formalist world of commercial galleries and art museums. Bruce Conner described assemblage as a "folk art form." The best work he thought he had ever seen he had found in the windows of a dry cleaners in Chinatown, where the owner had organized a combination of old plants, flags, dolls, and decals. When, in 1967, Peter Selz organized the survey of what he called "funk art" at the University Art Museum at Berkeley, Conner told Selz, "Look, you should get to the real people. . . . Don't just do all those people who are with art galleries or who you meet through an art museum or an art critic. Go to these people that don't have any association with that art level at all, in no way at all."[18]

The social critique California assemblagists offered typically displaced attention from political factors onto the difficult relationship individuals might have with sexuality and death. Americans had built a violent, destructive society because they feared the life cycle and could not face their own mortality. Fear of death led to fear of sexuality, which in turn fed fear of uncensored expressions of the life force. Assemblage protested this cycle of denial and sought release in a spiritual rebirth that accepted that mortality was inherent to the divine plan. Gordon Wagner's *Mexican Night Clerk*, for example, juxtaposed objects he found in an American and a Mexican hotel in order to contrast the relative openness with which he imagined Mexican society faced the reality of death with the fear of mortality that he was certain was a central factor in the tragic and repressed quality of life in the United States, as well as in the development of its war machine.[19]

African American Assemblage Artists in Los Angeles

During the 1960s, a group of African American artists emerged in Los Angeles who found the already well-developed assemblage form a valuable tool for rethinking the relationship of their community to the nation at large. Black-owned galleries such as the Brockman in Los Angeles mounted frequent shows of assemblage and installation art.[20] The black assemblage art scene in Los Angeles, like that in the white community, consisted almost entirely of younger men with training in both modern art and traditional male handicrafts. David Hammons, Timothy Washington, Ed Bereal, John Outterbridge, John Riddle, and

Alonzo Davis were among those following the lead of the older Noah
Purifoy in asserting the importance of assemblage art in the creation of
a distinctive African American aesthetic. In an interview, John Outter-
bridge, director of the Watts Towers Arts Center from 1976 to 1993,
expressed his conviction that his work was grounded in the everyday life
of the black community and thus was very different from art found
uptown in mainstream galleries and museums: "I know people in South
Central Los Angeles that look at their front yards as works of art. They've
got the oldest Cadillac in the world stacked up on blocks and they
wouldn't move it for anything. If I could take that front yard and transfer
it to a gallery, it would be a most successful work of art. We [artists] can
only mimic that attitude. The person who relishes that yard, he's the
artist. We're just reacting."[21] Outterbridge continued by arguing that
creative people had to root themselves in the communities from which
they came if they were to maintain their poetic powers. One of the great-
est dangers artists faced was to succumb to art as an apparently autono-
mous institution: "The cultures we grew out of did not produce art.
They were more tangible with life causes and effect. If that cause and
effect was decorative, if it made the face of a spirit show, that wasn't art
so much as breath. That's not saturated with the rigidity of the object,
that ties a string around a concept and doesn't allow it to be anything
other."[22]

This type of argument reinforced the belief that artists could remain
part of the community that had raised and nurtured them; indeed they
could return something important through the work they did. They
were artists because every human had the talent to create, not because
a limited number of individuals possessed a special kind of vision or
technical skill.

If many of their fellow citizens did not realize their full capabilities,
the explanation was that American society was frozen by its fear of death
and hence blind to the creativity that the divine put in each man and
woman. In expanding their own capabilities, the black avant-garde
adopted a view of themselves as fighting for everybody's freedom. By
expressing the possibilities within the individual, they exposed the
absurd limitations imposed by social conventions.[23] The Watts rebellion
of 1965 pushed Outterbridge, working at the time as an assistant for a
motion picture set decorating company, to develop a radically new
approach to the art he created. He wanted to take images associated with
urban blight and make them as positive as possible, without in any way
losing the anger that a person should feel about the human costs of
blight. He gave the example of driving through Watts and seeing chil-
dren dancing in vacant lots filled with broken glass. In the glitter of the
glass underneath the children's feet was a magical image of beauty and

promise that reminded him of the music that had come out of the African American community. The basic materials were humble, but the end result was elegant, sophisticated, emotionally moving, and usually with a strongly pointed political perspective.[24] In the "Containment Series," a body of work created in the late 1960s, objects composed from urban debris linked national symbols back to the brutal historical realities underlying the country's rise to power. In *Traditional Hang-Up* (Figure 17), Outterbridge mounted a strip of faded, stained wood with stars and stripes, evoking the national flag without in any way being a replica, above a grooved piece of wood that reminded him of drawings of slave vessels. Outterbridge placed incised button caps inside the groove to convey the feeling of human beings having been crammed inside while simultaneously evoking a sense of collected skulls. The crucifix form referred to an element of African American folklore in stories he had heard as a child about people meeting the devil at a crossroads, but at the same time, it was an Easter image embedding the suffering of his people within Christ's sacrifice and resurrection.[25]

Aesthetics of Urban Blight (Figure 18) is a series of large metal sculptures from the 1980s constructed with metal panels he found in a junkyard. As he started the series, many of the factories that had once been the backbone of the Los Angeles economy and a source of good-paying jobs for the African American community had closed and were being taken apart. The cast-off industrial materials provided Outterbridge with an opportunity to create a very large-scale reconstruction of an urban environment in tableaux that would emphasize the raw beauty of what had been discarded. He decorated the panels with pieces of rag, remembering his grandmother and her friends making jewelry out of rags, jewelry that also changed color and texture as it aged. In his account of how he started linking the skeletal remains of Los Angeles's moribund industrial culture with the rural south where he had been raised, he described scarecrows made from rags and dried gourds hanging from a crossbar. As the rags and gourds bleached white in the sun, he discovered "another kind of beauty [t]hat's a dynamic piece of sculpture that you never saw in a museum." As far as he could see, the beauty to be discovered within everyday life of African Americans, whether they lived in farming towns or in industrial centers, had been excluded from high culture in the United States, had not even registered as something worth noting. It was "blight," which he called "a lie in the name of progress." As a community-based artist, indeed as an artist whose career was possible because of his ability to work in an institution like the Watts Towers Arts Center, he responded to the lie with work revealing the hidden power of "ordinary things, people and places that stand close by, not readily seen by many and seldom heard."[26]

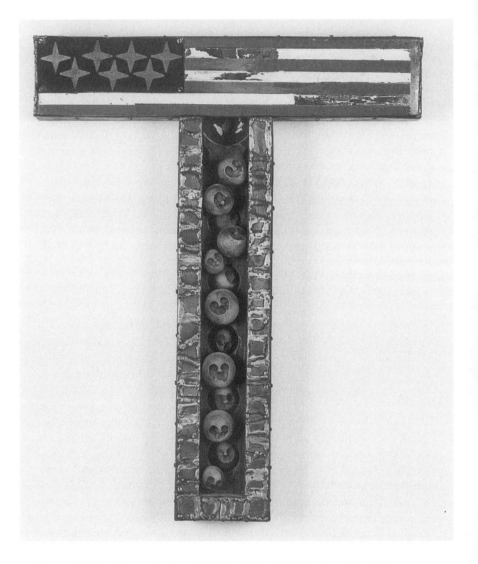

Figure 17. John Outterbridge, *Traditional Hang-Up*. Mixed media, 1969.
Courtesy of the California African American Museum.

Outterbridge's statements on what gallery and museums were willing
to show grow from the social context African American artists of his gen-
eration faced: the absolute lack of institutional support to a degree that
few white artists of the same period comprehended. White-controlled
museums and galleries did not understand black art and did not exhibit

Figure 18. John Outterbridge, *Aesthetics of Urban Blight* (detail). Mixed media, 1987–1988. Courtesy of the California African American Museum.

it, except in circumstances that reinforced its marginality. The first exhibit of African American art at the Los Angeles County Museum of Art, "Los Angeles, 1972: A Panorama of Black Artists," was organized by two African American employees at the museum, Claude Booker, a security guard, and Cecil Fergerson, a preparator. The museum administration placed the show in the basement, in the lobby outside the rental gallery, instead of in one of the regular exhibition halls. The show received no reviews from major newspapers in the city. The museum's decision to place a second exhibition, "Three Graphic Artists: Charles White, David Hammons, and Timothy Washington," in the same space led to the museum being picketed.[27] Second, black-art-oriented galleries and museums were isolated from their local communities; the black press was indifferent, and there were only a handful of collectors.[28] The arts in African-American communities were particularly vulnerable to the vagaries of public funding, which were usually within education/recreation programs or funded by poverty agencies such as the federal

Office for Economic Opportunity. Support for African American creativity came from agencies the purposes of which ostensibly had nothing whatsoever to do with art, a situation that given the growing professionalization and autonomy of art also underscored the marginality of black art in relationship to the existing arts institutions.

Outterbridge and other black artists crossed over to claim the territory of the arts, but not as aliens to be naturalized out of the industrial working class like Andy Warhol and Robert Mapplethorpe were, a professional art identity replacing family and community ties so that they became incidental, and from a purely professional perspective totally extraneous, to practice, message, form, and reception. The African American arts movement emerging in the 1960s during the black power struggles insisted that the existing cultural life of their community was beautiful and could be the basis for a more formal, professional art, one radically different in that it did not hover above *their own people* as threat and insult, but radically extended the horizons of expectation. Perhaps because heterosexuality was taken for granted at the time, many black artists could remain more easily connected to their communities. Warhol and Mapplethorpe could not be queer and still remain part of the working-class Catholic communities that had formed them. They needed the refuge that a professionalized art world provided them, and thus the worlds that they created for themselves developed in a matrix completely separated from ethnic, religious, and family ties that might have given them a relationship to U.S. society independent of their profession.[29]

In this sense, many African American artists continued the task of the avant-garde long after it had waned in western Europe and white North America: to make the continuum between daily life and art a source of formal innovation. But with an important difference: they remained close to their popular roots, in large part because the U.S. system of segregation made escape difficult, unusual, and often dangerous. But there were contradictions within the aesthetics: to convince people in their communities that aspects of their lives are in fact "art" ran against common sense and an underlying philosophy of the artists themselves. The hope embodied in the aesthetics was constantly frustrated by the reality of their problematic relationship with their own community. As Jane Poindexter, interviewed for a project exploring the development of African American poetry in the 1950s and 1960s, recalled, "There was nobody, there was no mother, there was no father who would say, 'God, my son wants to be a poet—isn't that wonderful!' "[30]

In 1966, like Outterbridge responding to the Watts rebellion of the previous year, ceramist and jewelry maker Betye Saar turned to assemblage art to express her reactions to the growing social unrest sweeping

the United States. In doing so, she broke an unspoken gender barrier that had defined assemblage as an art form that men did because they were well versed in the craft traditions of carpentry, stone masonry, machine repair, and all sorts of do-it-yourself gadgetry in general.[31] Other black women artists like Suzanne Jackson, Samella Lewis, and Ruth Waddy were working and exhibiting in California, but their media remained painting and printmaking. In New York, Faith Ringgold had begun to work in quilts, using textile art to make protest statements comparable to the work of assemblage artists. In California Saar and Marie Johnson-Calloway from Oakland were alone in taking up mixed-media construction until a younger generation of women artists picked up the trail they blazed. The visual traditions Saar called upon took in a broader variety of African American popular crafts than those men were likely to know, such as the making of dolls and quilts, or the design of a variety of objects useful for homemaking.

Thus Saar, though like other assemblage artists committed to bringing to the surface the treasures hidden in what the dominant forces in American society had long depreciated, worked with a broader range of popular traditions. Discarded objects needed recuperation, but so did the misunderstood and dismissed cultural heritage that black women had forged over the centuries. Underneath the stereotypes of African people that colonization and exploitation had promoted were men and women full of surprises, not under anyone's control, capable and prepared to defend themselves. That reality was independent of whatever artists did, but in making new types of images, the visual craftsperson could refuse the lie that denied agency to the poor and oppressed. Image and object makers contributed to freedom and justice by identifying a long history of defiant creativity.

Mass culture in the United States had reduced black men into Uncle Bens and Stepin Fetchits, women into Mammies, and children into Sambos, amusing and benign characters seemingly incapable of defending themselves, so trusting and innocent they could not possibly be victims of injustice. In 1998 Saar noted: "I felt these images were important as documentation of how Whites have historically perceived African Americans and how we have been portrayed as caricatures, as objects, as less-than human. These manufactured images and objects often were, in many cases, the only source of how we saw ourselves. The Civil Rights Movement and the murder of Dr. Martin Luther King, Jr., motivated me to use these images in my art. I began to recycle and transform Sambos, Toms, and Mammies in my assemblages."[32] *The Liberation of Aunt Jemima* (Figure 19) was part of a body of work challenging the amusement and comfort the stereotypes had long provided to those who benefited, to whatever degree, from a society based on racial hierarchy.[33] *Sambo's*

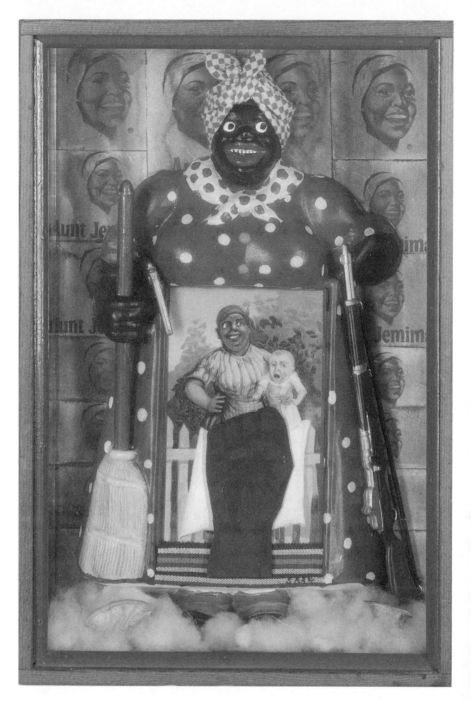

Figure 19. Betye Saar, *The Liberation of Aunt Jemima.* Mixed media, 1972.
University of California, Berkeley, Art Museum photograph by Benjamin
Blackwell.

Banjo, for example, transforms the banjo case into a coffin in which a photograph of a lynch victim hangs above a child's string toy of a dancing Sambo (Figure 20). The innocent dangling figure of the toy reveals the historical parallels between lynching and stereotyping, both acts of violence aimed at destroying a people's self-sovereignty. At the very top of the box, Saar superimposed an automatic rifle on top of a nineteenth-century minstrel image of an African American banjo player. She wanted the rifle to show a "way out," but she was also insisting that even if Americans have learned to see each other through the prism of stereotypes, the person inside endures. The resurrection of that individual as a person with his or her own vision of the future was the necessary first step for resistance.[34] At the time Saar's piece was made, when the deconstruction of stereotypical images was still a novelty, minstrel images called up ideas of an earlier society typically coded as "simpler" even though its gentility rested on murder and other forms of violence, symbolic as well as direct, needed to maintain a rapacious exploitation of other human beings.

The elegant images Saar weaves through much of her mixed media work hover at the brink of nostalgia. Within the larger picture that many of her pieces insist on representing, maintaining that mood is impossible, for nostalgia requires adopting an innocent interpretation of what is presented. Images like Sambo can be nostalgically amusing, pleasurably quaint, only if their full historical content is repressed. Sambo and its kindred figures remain kitsch whenever they evoke earlier times as if those social realities were either uncomplicated or, as has become increasingly more common, relics of a supposedly distant, fading past. The juxtaposition of images in Saar's assemblage asks viewers to reflect on their own interpretive responses to the individual images as an indicator of how much the stereotyping process has made them part of a social structure built on degradation and violence.

Nostalgia cannot be dismissed or merely wished away. Its blinding effects must be confronted and understood as inherent to colonial domination. Liberation rests on a process of thinking through what holds our attention and what we pass over quickly. Saar like most other California-based assemblagists redirected the political message, which in her work is both pointed and explicit, into a zone of spiritual reflection that pointed toward greater reverence for all with whom we share the world. As in *Shield of Quality* (Figure 21), objects and photographs can be appreciated for their beauty without relying on nostalgia if they are recognized as having once been meaningful to people now dead, as clues to complex inner lives that remain in the contemporary world only through discards easily dismissed as "junk."

In one of Saar's earliest assemblages, *Omen* from 1967 (Figure 22),

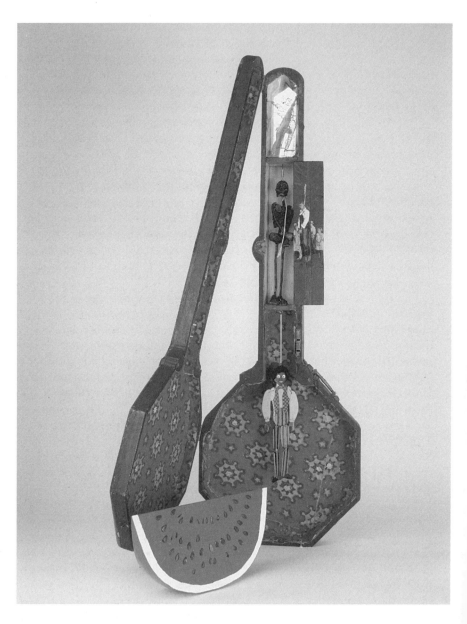

Figure 20. Betye Saar, *Sambo's Banjo*. Mixed media, 1971–1972. Courtesy of the California African American Museum.

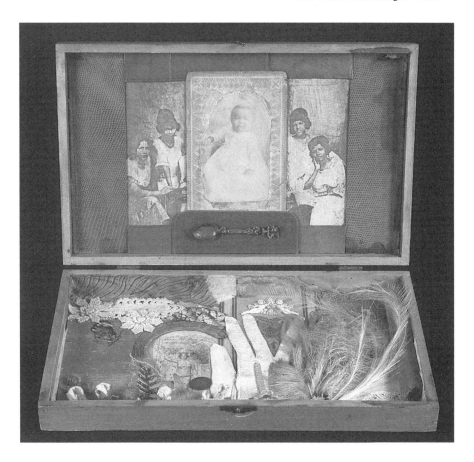

Figure 21. Betye Saar, *Shield of Quality*. Mixed-media assemblage in box, 1974. Purchase 1998 The Members' Fund, Collection of The Newark Museum 98.37; courtesy of Michael Rosenfeld Gallery, LLC, New York. ©Betye Saar.

Saar developed a composition weaving together a vintage photograph of three children, a sheet of broken glass, and canisters of simple organic materials such as bark, moss, and shells juxtaposed with images associated with the zodiac and palm reading. The discarding of family photographs is one of the most chilling reminders of the unremitting march of time. All those who once cared for the people shown have passed away. The people in vintage photographs have lost all living connection to the contemporary world even though their suffering and their joy contributed to what succeeded them. The images in *Omen* combine to suggest an ominous narrative, but the plot, if the piece is to be read as a

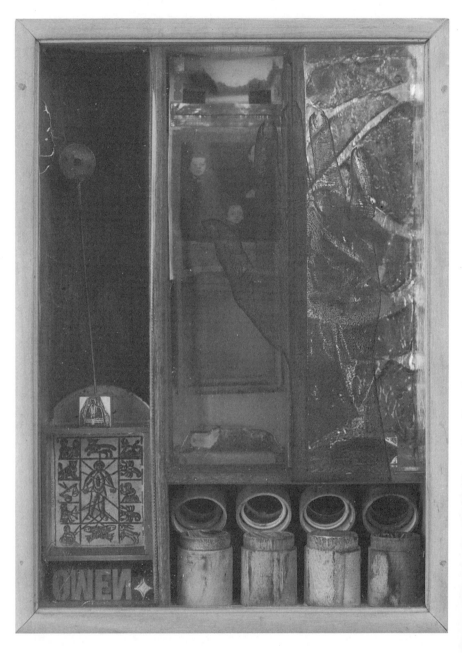

Figure 22. Betye Saar, *Omen*. Mixed media, 1967. Private Collection; courtesy of
Michael Rosenfeld Gallery, LLC, New York.

narrative, remains the responsibility of the viewer. If we want to know our own fate—or perhaps the fate of the three young souls shown in the piece—we need to read all that is closest to us as a zone of mysteries, as something precious that nonetheless could someday be thrown into the trash. That change in attitude would mean transforming referencing into reverencing. It would require no longer taking for granted that what appears is the same as what is. The transformation assemblage artists like Saar sought to provoke was a new way of reacting to the world, a new way of thinking of others, a new way of thinking of the desires coursing through the self, their sources, and the effects they have. The choice of whether to cling to assigned meanings or to become available to the potential within people or things is the core act of the politics that assemblage art proposed.

Saar's work proved appealing, and her work quickly found buyers. She became one of the handful of artists in the state who could survive from the sale of art that she produced. This liberated her from teaching as well as from the jewelry business she had run as a younger woman. The potential conflict between the larger political ambitions she had for her work and the essentially private exchanges between artist, gallery dealer, and collector that characterize the most successful stratum of contemporary art were resolved in her commitment to organizations like the Woman's Building and her readiness to speak out on issues of importance to her as a black woman in the United States.[35]

As with other assemblage artists, no doubt including Robert Rauschenberg, it was and remains impossible to disentangle Saar's artistic, political, or spiritual goals. The depoliticization of art that occurred along with the vogue for abstraction and purification was never complete. Many artists continued to express their responses to the world in which they lived. Feminists and artists of color, seldom included in major shows or written about in mainstream publications, initially benefited little from the professionalization accompanying purification of media. Artists who understood the links between their subordinated status as citizens and as professionals asserted their presence by rudely violating the ban on ideas extraneous to art theory and practice. They had something to say, and they intended to be heard. Efforts to rethink the social possibilities of art helped spark the pluralism of the 1970s, which involved institutional experiments, as well as a much broader range of approaches to relating form and content. The challenge remained to develop alternative foundations for practice that would be secure and replicable, while avoiding the pitfalls of ad hoc organizations.

Chapter Seven
Learning from the Watts Towers

Saving the Watts Towers

While well aware of the precedents that Picasso, Schwitters, Picabia, and others in the pre–World War II European modern arts movements had provided for the use of found objects, artists in California cherished their own indigenous source for assemblage art—Sam Rodia's Watts Towers.[1] As she was growing up, Betye Saar often visited her grandmother, whose home was only a few blocks from Rodia's. Saar spent much of her childhood playing around the Watts Towers while Rodia was still at work building them. She recalled the towers as a "fairy tale palace." Even as a child, she was fascinated by Rodia's use of broken dishes, bottle shards, cracked mirrors, rocks, seashells, corncobs, and rusted tools to decorate the tall spires and masonry walls he had elevated on his lot.[2] Mortared onto the skeletal structure, his commonplace objects that most people would consider garbage struck her as transformed into magical jewels.

Saar's *Spirit Catcher* (1976–1977), a mixed-media assemblage she made after returning home from her first visit to Africa (Figure 23), combined bones, shells, feathers, and other objects she had found into a personal interpretation of shrines and altars she had seen over the years. The original inspiration for the piece came from Tibetan spirit traps, structures for protecting people from wandering evil spirits. The cultural references expanded as she incorporated African and Oceanic imagery, but as she finished the piece, she realized that the form echoed the outlines of the Watts Towers. The connection, though originally unintentional, underscored Saar's conviction that an artist combines images and ideas experienced throughout a lifetime to create something new and synthetic—in effect catching the spirits of people she had encountered and keeping them alive in a new form.[3]

Preservation of the towers was almost accidental. In 1959, two young

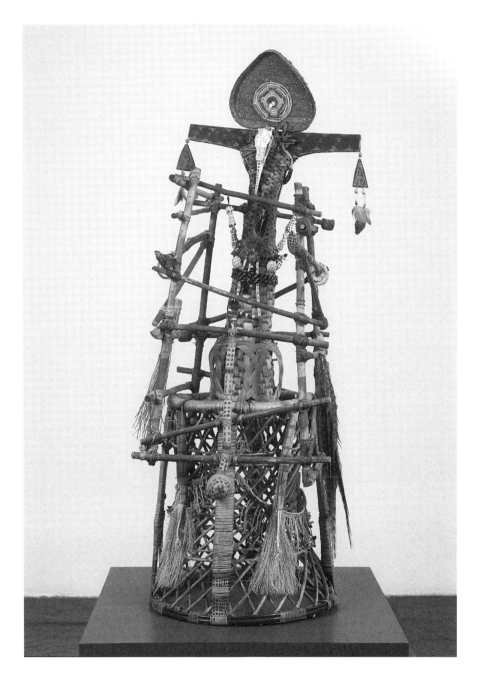

Figure 23. Betye Saar, *Spirit Catcher*. Mixed media, 1976–1977. Private
Collection; courtesy of Michael Rosenfeld Gallery, LLC, New York.

experimental filmmakers, both under the age of twenty-five, went out to Watts after seeing an early film on Rodia's Towers shot by William Hale. When they learned that the city planned to demolish the site as a public safety hazard, they raised three thousand dollars from friends to buy the property and formed, with other enthusiasts, the Committee for Simon Rodia's Towers in Watts.[4] The committee included no major art patrons or representatives from major art institutions, nor were the city's cultural leaders supportive of the effort to turn the towers into a cultural heritage monument. City and state officials, relying on the considered judgment of experts in the arts, doubted that Rodia's site was significant enough to warrant the expense of restoration or maintenance. The California Department of Parks and Recreation studied the project and concluded that it was "a sort of bizarre art form" of such limited popular interest that the state should not acquire or maintain the property for public recreation purposes.[5] Twenty-five years later, after public opinion about the towers had been reversed and the state had committed several million dollars for their rehabilitation, Richard Sherwood, then president of the board of trustees of the Los Angeles County Museum of Art, suggested that a primary reason for the difficulty many had in recognizing the towers as art was their location in Watts, where most people interested in art would be afraid to visit. Had they been in a more affluent white neighborhood, he thought that they would certainly have received the attention they deserved much earlier.[6]

In 1962, the Committee for Simon Rodia's Towers in Watts formed the Watts Towers Arts Center to offer classes and organize exhibits. The committee hoped the new effort would develop community support for their project in a neighborhood that had become overwhelmingly African American in the years following World War II. Difficulties between the committee, organized and led by young whites who all lived in other parts of Los Angeles, and the local community continued until 1964 when the committee hired Noah Purifoy to be the cultural center's first director (Figure 24).

Purifoy, born in 1917, hailed originally from a small farming town outside Selma, Alabama. His parents had been sharecroppers, and his earliest memories were of trailing behind his parents and twelve siblings as the whole family worked hot, humid summer days picking cotton. When he was three years old, the Purifoys moved to Birmingham, then in the midst of a boom as the city became the coal and steel capital of the South. Looking back upon his childhood, Purifoy concluded that the family had been poor, but not "disadvantaged."[7] Both of his parents worked, as did his older brothers and sisters. His parents encouraged him to go to college and plan on a professional career. He studied at Alabama State College, majoring in social work.

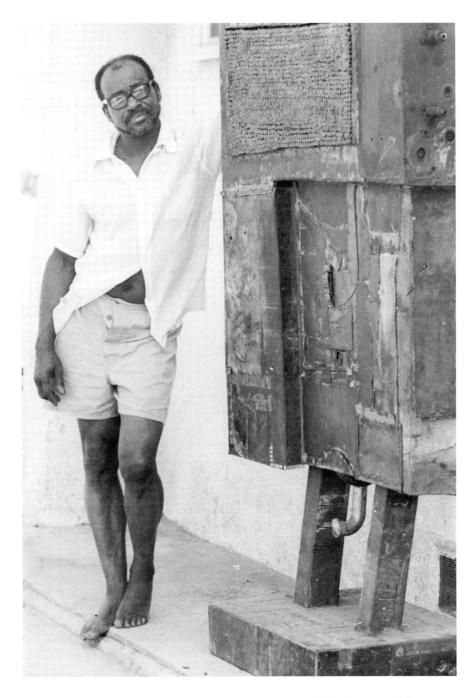

Figure 24. Noah Purifoy at Watts Towers Arts Center, ca. 1965. Courtesy of the
artist and the Noah Purifoy Foundation.

In 1942, after teaching in a high school for several years, Purifoy volunteered for military service and wound up a carpenter's mate first class in the Navy Seabees, assigned to the South Pacific in a unit responsible for providing safe drinking water for newly constructed American military bases on islands recaptured from the Japanese. His military experience taught him that controversy was necessary to bring about change: "We made it known that we were unhappy about the discrimination and the segregation, where we were being managed by intellectually inferior people. I had a degree [from] college when I went into the military, and I was managed by some white cat who hadn't even finished high school. We made it known that we weren't happy with that."[8] Protest led, in this case, to a promotion for Purifoy and to the captain being transferred.

When he returned home after the war, he considered going to graduate school, but he worried that earning a Ph.D. would be a "white thing." As he put it, "I had experienced enough prejudice to not have an affinity for anything related to white society, and education of that ilk was related to white society. . . . I wanted to experience [black life] at the level we lived. I did not want lots of money, or lots of clothes, or anything like that. I wanted to experience what it's like to be poor so I could report it as it was. Which accounts for the media I used to express my feelings about aesthetics."[9]

His use of the term "experience" here reflects years of reading in existential philosophy and Freudian theory. His working-class southern family was poor, but he had not thought about his childhood as "living in poverty." He was aware that certain other people, particularly white people, had more money, as well as privileges that were actively denied him. Yet within the life that his family pursued, these were the conditions from which both joy and anger sprang, both satisfaction and discontent. It was a full life, and on its own terms lacked nothing. To experience this web of relationships as "poor," he had to reach a point where, through education and advancement, he could develop a professional, scientific career and consequently view the lives of his own family as if a stranger.

In the normal course of upward mobility, he would put the conditions of youth behind him and adopt the moods and perspectives that came naturally with a more privileged status. Even this would not involve an "experience" of his childhood as "disadvantaged," for the relationships of his youth would sink deeper and deeper into a past relegated to the unconscious. Past feelings would never leave him, but they would not seem to involve anything useful for his new life. At odd moments, memory would trigger a return of experiences that were otherwise repressed. Sometimes these ghosts would be pleasant, nostalgic reminders, like his recall of the whole family picking cotton, of a way of life that amid all

the deprivation included reinforcement and satisfaction, even a sense of connections that were deeper and superior to the glib accomplishments of professional life. At other times, the return involved a sense of shock at reminders of a past self defined increasingly by a string of humiliations that occurred as he grew into adulthood. Whites of course had wanted to keep him in his place, but equally painful had been encounters with other blacks whose self-esteem seemed to require hurting those around them.

From reading Freud, Purifoy had learned that opposition to efforts to bring elements of the unconscious into consciousness led to the development of neurotic or even psychotic symptoms. The theory of repression describes an unrealized mental process that retains its energy within the psyche, but the individual has no memory of its formative episodes. Freud used repression to link sexual desire with infantile phobias. Instead of seeking an outlet for desire, the libido converts into anxiety, which then dangerously appropriates an aura of sexual excitement. The release of fear and anger becomes a source of unconscious pleasure that the individual constantly seeks, even though it plays havoc with one's life. The urgent demands of sexuality flood into irrational behavior that can become violent, paranoiac, and ultimately self-destructive.[10]

As he read the writings of the German existential philosophers Edmund Husserl and Martin Heidegger, the picture Purifoy developed of processes shaping subjectivity grew more complicated. To experience a condition of life, one had to stand aside from it. To remain in touch with one's life, it had to become a representation.[11] By closely watching the processes by which the mind organized patterns of experiences into symbolic images, a person could overcome some of the most negative aspects of repression. One could bring up from the depths of one's past feelings that everyday life tended to repress. Phenomenological philosophers tended to approach this process of converting feelings into images purely as a question of rational thought guiding the interaction of perception and representation in order to achieve more adequate knowledge. Purifoy thought, however, that the ways in which a person looked at the world were deeply emotional. Blindness grew from a fear of recognizing the effects that others have had in shaping his or her life. To see those effects was often deeply threatening because repressed relationships from the past usually involved feelings of inadequacy and persistent hurt.[12]

Purifoy did decide to go back to school, and he earned a master's degree in social work from Atlanta University. He moved to Cleveland after he finished his military service, joining his family, who had moved north to work in the war industry, and worked for two years at Cuyahoga County Social Services helping the parents of disadvantaged infants and

toddlers get better care for their children. He then worked in a mental health program for teenagers and young adults. In 1950 he moved to Los Angeles, where he joined the staff at Los Angeles County Hospital counseling patients who had problems, typically for religious reasons, accepting any kind of modern medical treatment.

Purifoy was dissatisfied with the state of social work practice. Patients grew dependent on their counselors rather than learning how to work through their problems themselves. Most of the patients assigned to him had a hard time understanding the modern medical institution, and many were resentful of being told what to do. Living in a segregated society that limited what they could do in the public realm, they did not want to surrender the small area of liberty they had in their personal lives. They often responded to their medical situations with rage, which he thought represented years of repressed feelings that were shaped equally by a sense of deep personal failure and anger at an unjust society. Based on the extensive reading he had done, he thought that, at least on a theoretical level, art could help his patients deal with their problems. Art could bring repressed thoughts and feelings to the surface in a form that had distance from the immediate situation.

Art that tapped into patients' experience might be unsettling at times. It could even appear as a form of shock therapy. Both religion and psychology taught that looking into one's heart honestly is a painful experience because a person must acknowledge the power of external forces in shaping the most intimate feelings. Perception is interaction with the environment, which is never passive and always pushes back. Art therefore was fundamentally a way of rethinking relationships.[13] At the level of interior process, the *I* turns out to consist of *you*. Central to repression is a denial of the interaction that makes consciousness, literally "thinking with," possible. To see and to think depended on recognizing what was there in any event: the others from which our entire world, inner and outer equally, was assembled. Art might help those who were open to its messages regain the right to experience love without feeling guilty.

Purifoy stood at a crossroads. He could not test his ideas without learning more about art. In 1952, Purifoy took advantage of his about-to-expire GI Bill educational benefits and enrolled at Chouinard Art Institute in Los Angeles. He was the school's first full-time African American student. The school's founder and director, Mrs. Nelbert Chouinard, had migrated west to California from Alabama years before. She still honored the southern racial code, and she had refused all previous black applicants. Purifoy did not know any of this, but, given that he was already thirty-four years old, he would not have been surprised if the school rejected his application. Reviewing Purifoy's application, however, Mrs. Chouinard recognized that the war had created a new moral

obligation for her. She could not deny any veteran who had risked his life in defense of the nation an opportunity to pursue a new career even if she herself was accustomed to a system of strict racial separation.[14]

Finally applying himself to art, Purifoy discovered that he was most interested in abstract art. His teachers at Chouinard were figurative artists, and the school's strength had been preparing students for careers in commercial art. Nonetheless, faculty and students recognized that serious modern art explored the formal capacities of a medium to communicate sensations and ideas and that the "far-out" experiments of contemporary abstract painters like Jackson Pollock or Franz Kline were already reshaping advertising art, print illustrations, and motion picture design. Purifoy was not interested in commercial art in any event. He did not like to draw, and he was not interested in the human image. Drawing was a waste of time, he felt, because illustration showed what was already perfectly visible and therefore already a thing of the past. He wanted to use art to model reality as something always changing as one moved into the future. "I refused to draw," he said. "I refused to learn to draw. Today, I cannot draw, because I was afraid I'd get stuck with the human image, and I knew it didn't express my basic feeling about nature and about being: that the human is not the essence of being. The human in relationship to the world is the essence of being."[15]

While in art school, Purifoy worked nights operating a shearing machine at a Douglas Aircraft assembly plant. His art training, with an emphasis on design, allowed him to get a better paying job as a window trimmer at the Broadway Department Store, a job he would hold from 1956 to 1964. His home, decorated with paintings and sculptures that he and his friends had created, was open almost every evening for visitors to drop by and talk. He had a large record collection and an expensive hi-fi system that he had built himself. His home became a gathering point for people in the Los Angeles African American community who wanted to talk about the latest foreign movies, jazz concerts, books, or art exhibits. "Here was a place where we could discuss our lives in connection with art, and we could plan for the future," he recalled. "Or we could reexperience the past and plan for the future. So here was a place where I had my most profound spiritual experiences as well as art experiences."[16]

In the constant flow of conversation, the arts, philosophy, psychology, and politics crossed and crisscrossed. Purifoy's home was ground zero for the renaissance in African American art in Los Angeles during the 1960s. Civil rights and black power pushed the artists in new directions, as it did Purifoy after he experienced the Watts rebellion of 1965 firsthand, but the ongoing conversation at Purifoy's home provided the intellectual base for an aesthetic, black-arts response to the political and

social crises of the nation. Younger artists like John Outterbridge, David Hammons, and Nathaniel Bustion received the encouragement they needed to plunge deeper into the creative process. His house was a university in psychology, as John Outterbridge put it,[17] but Purifoy decided that as valuable as Freud's theories were, they presented a problem when applied to a future that was always full of surprises: "Psychology has a tendency to put people in pigeon-holes—categorize them—for your own aggrandizement, your own satisfaction, your own comfort in the world. You put people into this little box and you know all about that little box and what's inside it." One of those boxes had a comforting label on it: "artist." Purifoy's comfort at the time involved living a life by a formula that was still incomplete: "I had a beret. I ate cheese and drank wine, but I wasn't an artist yet."[18]

Noah Purifoy described the changes wrought in the 1960s as a shift in his position from social alienation to acceptance that occurred without his changing as far as he could determine. Prior to 1970, he had stood out in both the white and black worlds as an anomaly by virtue of being a black artist. He arrived at the Watts Towers Arts Center "not being quite colored," Purifoy observed from the reactions of other African Americans to him. "I had a lot of white characteristics."[19] He had led a nonconventional life in terms of both employment and sexuality. Outside of the bohemian circles in which he had lived for the previous ten years since starting art school, he understood that he was not an acceptable person, particularly to those in the community with the deep religious faith of his own family. Spending most of his time with other artists and intellectuals had not seemed a deprivation because bohemia provided an identity that he found preferable to his other options as a single African American male, though his family's lessons that every talented black man or woman had a personal responsibility to do good for the race haunted him.

Learning from the Watts Riots, 1965

Going to the Watts Towers, Purifoy found himself at ground zero of the nation's urban disaster. In August 1965, riots protesting police brutality spread through the community of Watts. Thirty-four people died over five days of armed conflict. Over four thousand people were arrested, and several blocks of the neighborhood's main shopping district burned down. Here was a case in point of American society at large and the African American community in particular turning against itself. He wanted to believe that art could contribute to a healing process. He wanted to show that the profession that had sheltered him from some of the worst aspects of life in the United States could in fact reveal a constructive

method of problem solving with the power to counteract the cycle of repression and violence once again tearing the nation apart.[20] "Art as an escape from the world, that's wrong," he thought. Art should be a confrontation with a *me* that is always in need of improving. "Is what I know applicable to me?" he asked and then continued, "that was the most disturbing thought in my whole life."[21] Art had been an activity that allowed him to lead a bohemian life and to believe that he had contained the damage of the ways American society forced human beings to relate to each other.

Well before the riots, Purifoy had discovered that children enjoyed organizing found objects into compositions. Purifoy took the children on field trips through the neighborhood to pick out junk objects that they found interesting. The children took their ungainly treasures apart and reassembled them into imaginative creations. Sam Rodia's construction provided a daily reminder of how junk could be turned into a monument of impressive beauty. Mysterious qualities of life were bound up with hidden meanings in every object. Assemblage was the perfect expressive form for revealing hidden relationships. Things that people thought they knew perfectly well were reborn as strange and wondrous beings with personalities.[22]

As Purifoy watched the children at work, he reexamined the possibilities of the art experience. The lessons learned at the arts center had little to do with formal characteristics of art objects and had everything to do with the images a person formed of herself and her world—which he already understood were two words for the same thing. As art allowed a person to work with and transform those images, new types of knowledge were acquired, knowledge that could be very powerful: "We believed that an art experience was transferable to other areas of their activity and so forth and that if they could come to the [Watts] Towers and have a good experience, a positive experience, they could take this experience with them wherever they go. It improved their self-image, and this would make a great deal of difference in terms of their ability and capacity to grasp whatever their objectives were, whether it was in school or out of school."[23] He concluded that "Within [each person] there's a creative process going on all the time, and it's merely expressed in an object called art. One's life should also encompass the creative process. We were trying to experiment with how you do that, how you tie the art process in with existence."[24]

By "creative process," Purifoy was thinking about forms of learning involving manual and performative knowledge, activities that usually were not theorized, but in which through processes of trial and error as well as imitation of mentors, an individual develops increasingly more accomplished skills. He or she can formulate goals and a plan of action

that leads to completion. Manual knowledge depends upon habit and the acquisition of particular sets of muscular motions. Manual knowledge is closely connected to "experience," and hence is the site of the most intensely subjective forms of knowing. The knowledge acquired is literally incorporated into the nervous system. As anyone knows who has learned to play a musical instrument, a particular style of dancing or acting, or skills such as auto repair or sewing, body knowledge need not be intellectualized, if by that we mean taught with verbal concepts. Imitation and practice may be the best ways to learn these skills. As a performative rather than logical discipline, manual knowledge has long been highly developed in the fine arts, in which the final product emerged through a process of learning through building, taking apart, and rebuilding.[25]

Artists could fill a gap, he suspected, by taking the strengths that people in the community already possessed, reinforcing them, and then helping them make a leap from manual to conceptual knowledge inherent to art practice as a specific form of manual and performative knowledge. The technique they imparted would not be limited by preconceived understandings because ultimately language remains external to its operations, even if what is done and the know-how that is acquired can be discussed. A completed object served to document a developing thought process that was more important than anything actually made. The realization of projects sharpened perception and stimulated the imagination to explore new goals and intentions that were suddenly understood to be well within the realm of possibility. The knowledge brought forth through a linking of cognitive and technical thought operations became a presence in a person's life, rooted in an experience to which one could continue to return and ponder further implications.[26]

When the Watts rebellion broke out in August 1965, the arts center was only three blocks away from the heaviest fighting. Standing at the back door, Purifoy and his students saw people from "the community making Molotov cocktails and throwing them at the police. They were buying nails and tacks from the hardware store and strewing them on the street to prevent the police from coming into the area. The authorities did not know how to handle the event. It was a unique experience for everybody involved."[27]

After the shooting and burning stopped, Purifoy led a group of students into the community to salvage objects from the rubble. Purifoy invited five other artists with experience in assemblage, including Gordon Wagner and Arthur Secunda, one of the editors of *Artforum*, to work with his students on a show of assemblages constructed from the debris that the arts center community had collected. As a result of a collective

process that seemed to unify all those who participated, Purifoy experienced his first major creative burst.

Purifoy's new work was first shown to the public in 1966 as part of the exhibit "Sixty-six Signs of Neon."[28] The exhibit took its title from the neon signs that had melted into unsettling surrealist-like shapes. Purifoy took the glass drippings he retrieved from burned-out stores, cleaned them off, mounted them, and exhibited them as elegant artworks that were also eyewitnesses to, and products of, the heat of the community's anger. The centerpiece of the exhibit was Purifoy's *Watts Riot* (Figure 25). In 1997, when the piece was shown at the retrospective exhibition that the California African American Museum organized for Purifoy, Christopher Knight, art critic for the *Los Angeles Times*, hailed it as one of the most important works produced in California during the 1960s, one that captured in its very essence the confusing and dangerous currents then ripping the United States apart. In his description of the piece, Knight noted how simple, yet meaningful, were the elements Purifoy had assembled:

a painted and plastered vertical panel, three feet wide and about four feet high, to which bits of charred lumber have been affixed. The slathered colors are muddy, mixed from a glowing rainbow of hues—an improvisation that seems composed from paint remnants scavenged from leftover cans. The scraped plaster is thick, ridged and scarred; the burnt wood applied a visual scaffolding. The panel has the appearance of a fragment of a ruined wall—though you can't quite tell whether you're looking at its front, back or innards. In the smoky blackness near the top, torn letters in low relief spell out the word "signs," while a sooty disk at the lower left bears the circular legend, "Always be careful." This smart assemblage is part remnant of a dwelling, part tattered signboard, patched together from the debris gathered in the wake of the 1965 Watts rebellion. Like a talisman, it exerts a powerful, even mesmerizing pull. Virtually exquisite, the nonetheless battered object appears to have been through fire. Thanks to an artist's knowing intervention, however, it has endured the grueling trial as if annealed, emerging as a beautiful icon.

Knight continued by distinguishing Purifoy's work from other examples of California assemblage. Purifoy did not condemn U.S. society as openly as Edward Kienholz did, nor did the pieces evoke an alternative bohemian world where poetry and dream subdued the forces of social chaos, as in the work of Wallace Berman or George Herms. "Instead, *Watts Riot* recalls the persevering spirit manifested by the old slave song from which James Baldwin had taken the title of *The Fire Next Time*, his searingly brilliant 1963 meditation on American race relations: 'God gave Noah the rainbow sign / No more water, the fire next time!' "[29]

For all the seriousness of the historical events motivating Purifoy's work in the 1960s, he was not afraid of treating his subject matter humorously. A viewer approaching *Sir Watts* might find the humanlike

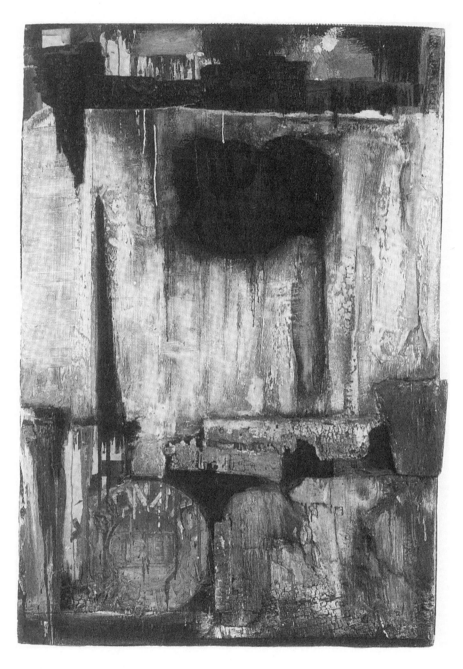

Figure 25. Noah Purifoy, *Watts Riot.* Mixed media, 1965. Courtesy of the
California African American Museum.

figure constructed from drawers, sheet metal, dowels, gears, safety pins, and assorted home items to be comical (Figure 26). Laughter would not be an inappropriate response to the helmet and the rows of pins arranged like military ribbons, mementoes of past campaigns that no one else remembers. The juxtaposition of iconography and materials, however, critiques a laughter that comes only if the objects seem too miserable to be worth the dignity the imagery claims for them. On a closer look one finds genuine handcrafted quality in the carving on the drawers that form the figure's base. Like every person, the figure is so stuffed with objects and images that it cannot contain them and they come pouring out from the heart. The pretensions that first grab a viewer's attention allow the piece to symbolize the contradictions of human aspirations, but only if our perception grows and we recognize the multiple emotional qualities embedded in this figure. Its evocation of the human spirit was one of the factors that made it the most frequently photographically reproduced work of the show when over the next several years, "Sixty-six Signs of Neon" traveled to other cities in the United States and in western Europe.

On What Foundations Could "Community-Based" Art Thrive?

The burst of creativity Purifoy experienced after 1965 led to recognition and an ability to earn his living as an "artist," benefiting from sales to collectors eager to acquire the work of a major representative of new developments in African American art. Curators increasingly requested his work for inclusion in shows surveying contemporary African American art. Purifoy's first one-artist show was held at the Brockman Gallery in Los Angeles in 1970. His treatment of crime, drug addiction, and prostitution as problems that black communities had to address if they were ever to become self-determining made the exhibit controversial, but nonetheless it was widely and largely positively reviewed. Attention to his work and his ideas about the nature of art in its relation to creative process led to lecturing and artist-in-residence appointments at several universities.

Yet at the beginning of the 1970s, Purifoy doubted that working as an artist was an effective way to help the community. He did not see a stable institutional framework working to facilitate artists playing a constructive role in U.S. society. He could make "protest art," and to a degree both critics and the public expected him, as an African American artist, to work primarily in a mode that he personally found inadequate. What was wrong, he thought, was well known, and art that simply repeated what everybody already knew was weak. Despite his success in reaching

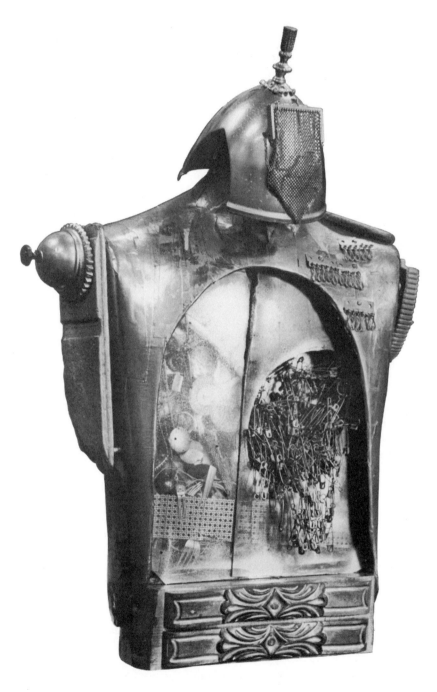

Figure 26. Noah Purifoy, *Sir Watts*. Mixed-media assemblage sculpture, 1967. Photograph by Harry Drinkwater. Courtesy of the artist and the Noah Purifoy Foundation.

out to large numbers of people in different cities around the world, his experiences suggested that art as an institution occupying a definite place in modern society was in fact distinct from, and indeed even antithetical to, the creative process that he believed was inherent to the human condition. Art, he thought, spoke only to relatively small groups of privileged people. In particular the art world, even when it recognized African American artists, still largely excluded most blacks and most poor people from its public. If the knowledge that artists gained was to be made more broadly available, less emphasis had to be placed on the completed work and more on the thought process inherent to the making of art. He argued that

Art is a product of the creative process. You make a picture. It's a mere product. The creative process has all the steps and the guidelines to enable the artist to paint a picture or make art. The creative process answers all the questions regarding what the artist should do to end up with a picture that somebody would find value in. So the error we make is never looking at the creative process, but looking at the *product*, which is art. Now, my theory is that it is not art that's applicable; it is the creative process that's applicable. It has all the guidelines to enable us to apply [it] to any state of being in the world. Where we made our most serious error historically was that nobody chose to evaluate the creative process in terms of its applicability. . . . [Is it] applicable to anything other than the making of art? That's the question I asked myself as I went on this long search to find anybody who would agree with me. . . . Immanuel Kant was a philosopher who dared slightly into the creative—[he has] a chapter on the creative process. It wasn't the creative process at all. It was about beauty as being the essence of being in the world, or something to that effect.[30]

The professional model was wounded from its inception: its boundaries replicated the elitism of U.S. political and economic organization. Art could be a locus for aspirations for free subjectivity, but the life of contemporary artists kept folding back into itself and separating from the social forces that would deepen their vision: "'Art's been crammed down our throats by the elite for all of our lives, for centuries on end. For what reason, I'm not clear on yet, except that art was so mysterious that they wanted to set it aside only for the elite. . . . I wanted to tell the world that this is untrue; that we are blinded by this concept and that therefore no one would try to analyze the creative process—note the word *analyze*—the creative process in terms of it applicability to something else."[31] To pursue that train of thought, he returned to Heidegger and Husserl and their "hints" that "existence itself could be inventive and creative."[32] His career unfolding within pregiven institutional relationships challenged the ideals that had motivated his work.

For Purifoy, assemblage art was a practice that ought to allow people in the community to use the objects surrounding them to explore in plastic form their reactions to the world that they faced. Each artwork

would be only one step in a long process of self-recognition. He noted that Marcel Proust had proposed in *Remembrance of Things Past* that particular images become important to individuals because they lock up past emotions in the random sensory data of a moment. Responses to images require a code of one's history, so that for Proust's narrator, the beach along the Norman coast brought with it the sensations he shared with laughing young girls, a long-stemmed rose had taken the place of the woman he had wanted to dominate but lost, while the madeleine dipped in lime tisane opened up the mysteries of time. Proust's insights impressed Purifoy, but he developed another theory that reversed the novelist's proposition. Images, Purifoy thought, could as easily be responding to dreams of places one had not seen yet but *could* if the imagination were freed from the prisons modern society imposed on each person. Common objects that were important to people transfigured into works of art could serve as signposts to a future society that would be based on liberated consciousness rather than servitude. In Purifoy's conception, assemblage should be much more than a picture of the degradation Americans had suffered. In its most powerful expressions, assemblage provided a map for where the people of America could go if they had the courage of their dreams.[33]

In 1971, Purifoy went to work for the Central City Community Mental Health Center in Los Angeles, where he experimented with art as a form of therapy expanding the communicative possibilities of young children for whom relationships of any sort had been so painful that they had withdrawn in varying degrees from the world. In 1976, his ideas about broadening the functions art practice played in society brought him to the attention of Governor Edmund G. "Jerry" Brown, Jr., who appointed Purifoy to the California Arts Council, a new state agency run by and for working creative people. Only one of the nine founding council members Brown appointed initially was a businessperson and arts patron.[34] Other original council members included the poet Gary Snyder, who served as the first chair; Luis Valdez, director of the Teatro Campesino; and the actor Peter Coyote.

Purifoy served as chair of the committee on education. He convinced Governor Brown to earmark an allocation in the state budget to experiment with a model art-in-education program, California Learning Design, initiated in nine schools across the state. Artists and teachers were paired across different subject areas to develop new ways of presenting the curriculum.[35] The experiment grew into an artist-in-schools program that paid creative artists full-time salaries for working twenty hours a week in schools. The federal National Endowment for the Arts had launched artist-in-school programs in 1966, and most state arts councils had applied for federal funding to start programs for their

states. In these programs, students were taken from school to a neighborhood community center where artists would demonstrate their crafts and students would have a chance to work with the artists in a workshop situation. On occasion, musicians came to schools to perform. The new California program sought to build more intensive, personal connections between an artist and a community. Artists went into one school for a year to collaborate with the school community on how best to include art practice in the educational program. Sometimes the artist initiated new classes, sometimes he or she worked collaboratively with teachers to experiment with how art could enhance the teaching of traditional subject matter, and sometimes the artist ran tutorials for a small number of student-apprentices. Close interpersonal relationships between artists and students were a stated goal of the program, and community groups could renew an individual for up to three years.[36] Summer workshops were started in 1977 to prepare artists for their mission and to help reorient educators to a broader conception of art in the classroom. School districts were pleased with the results of the program, which included measurable improvements in test scores at a time when student achievement around the state was beginning to decline. Applications from districts to participate increased.

The success of the artist-in-schools program led to two additional programs that placed artists in community groups, senior citizens' centers, hospitals, prisons, and other public facilities. Artists in residence performed and displayed their creative work, but the grants stipulated that traditional artist/audience relations were less important than developing interaction that stimulated the creativity of the people with whom the artist worked. The goal of the program was for artists to convey to others the unique way of thinking they had learned through professional practice with demonstrations, lectures, and discussions.[37] Between 150 and 200 artists were placed in communities around the state each year for the next decade in addition to artists placed in the schools program every year.[38] The Arts Council's summary of its art-in-communities programs provided a succinct version of Purifoy's vision:

Whenever artists engage with their material, they initiate a process, consciously or unconsciously, which amounts to basic problem solving techniques. From the first stroke on a blank canvas, relative color values advance, retreat, etc. Each stroke is a step toward a solution, instantly evaluated; accepted, rejected, or adjusted as a process of completing the work. There is a state of mind concomitant with these decisions: attentive, fluid, relaxed and totally absorbed. It synthesizes the apparent opposites of logic and intuition. . . . We maintain that the creative process can be applied to any problem, whether aesthetic or social, and that artists may be the best people around to demonstrate that process, and to create situations in which it can be learned.[39]

A parallel development in the council's new grant priorities was expanding the public participation program, which the council used to increase arts organizations' understanding of the needs of underserved segments of the public. The council funded forty organizations a year. Institutions that accepted these grants could not use the funds to target traditional audiences that attended arts events and performances. Instead they had to experiment with ways to make arts programs interesting to new audiences without diluting artistic quality. The local organization development program funded dance, music, and theater touring programs, small press distribution networks (which staged authors' reading tours), and the development of auxiliary art galleries by museums, all with the goal of dispersing various types of art more broadly. More than five hundred such grants were awarded each year.

Many established arts groups complained that the arts council was hostile to their interests, particularly because the state institution refused to subsidize overhead and administrative salaries for large symphonies, museums, and opera companies. However, the new program proved popular with state legislators, who discovered that their constituents liked the grassroots approach and were willing to write hundreds of letters of support. Indeed, grassroots arts programs generated over five times the number of letters requesting continued support than major institutions were able to develop from their patrons and subscribers. The state legislature regularly increased the council's funding, although after Republican George Deukmejian became governor in 1983, the council found itself working with an increasingly unsympathetic executive branch that while never overtly hostile to the council's philosophy, remained unconvinced of its long-term value and preferred to see arts practice supervised by well-established institutions led by responsible businesspeople.[40]

Public response validated Purifoy's conception that people in the community had lost something valuable as art practices had developed into a modern, professionalized institution. Science had divided into specialized disciplines because that division enhanced the sciences' problem-solving capacities. Art as an institution imitated the organizational frameworks that the sciences had developed. Purifoy was convinced that the autonomy of arts institutions did not increase the quality of work produced, but it did lead to decreased interaction between the public and professional artists. Society at large received little extra benefit from its investment, other perhaps than the construction of more museums. The sciences involved specialized knowledge, but the creative process was present in all people as a natural attribute. Professionalization of the arts diminished the innate capacities of the public by establishing an elite status for artists and their patrons and devaluing the

general urge to respond to existence through creative forms. The public needed alternative art institutions that nurtured the role art played in everyday life.

Purifoy attacked the discrepancy he identified by expanding the teaching functions of artists, the single most important form of financial support for most working artists, to go beyond the professional art school, in the post–World War II era increasingly located as a department within the modern university. "We designed three programs we hoped would touch everybody. . . . Instead of teaching how to draw a picture . . . I wanted the artists to teach step-by-step a process that enables you to become the person you want to be."[41] Participating artists would be selected for enthusiasm for a new vision of their relation to society. The Arts Council's program objectives stated unambiguously

In modern America, following many centuries of cultural specialization, the creative capacity has become the territory of certain highly trained and/or gifted persons who are increasingly drawn into the production of a commodity. The place of this commodity is only narrowly assured, and large numbers of people are now alienated from it. The society itself is bent on a course of growth and consumption which seems to render all other human values—such as beauty— expendable. For sanity and survival, we feel the priorities should be reversed. . . . Highly trained and gifted artists are not a class apart, possessing something that the rest of us lack, but along with all artists great and humble, are bearers of a transmission we all share in, and are teachers to everyone of innate and healing powers of creativity and insight which grant every person in the land their own view into the intricate beauty of the universe.[42]

Eventually, he thought, as more people in various communities developed a close personal connection with people whose lives were dedicated to creativity, they would understand the potential of art to assist in "problem solving" and a broader range of artist-public collaborative projects would naturally emerge as long as the Arts Council was prepared to support innovative endeavors. These projects would allow Americans to explore and discuss questions of racial inequality, war and peace, the expansion of gangs, crime and punishment, substance abuse, or the crisis of the family in terms considerably more sophisticated than the mass media or traditional politics had fostered.[43] The ultimate goal of the council's programs would be to arrive at "a society so deeply dyed with art, craft, and style as to render an Arts Council unnecessary."[44]

During the eleven years he sat on the Council, Purifoy made no art himself. "I was looking," he explained, "for another vehicle to see to what extent one single person can effect change in the large world that we live in. I thought I'd found in the California Arts Council a vehicle through which I could be effective and communicate my ideas. It didn't work in art. At least, it was premature through art. So I thought I had

found my life's work. It was easy for me to give up art and never antici-
pate going back to that, because I could spend the rest of my life trying
to find a means by which one can synthesize the left brain with the right
brain and come up with some kind of profound concept about how peo-
ple learn what they need to know to exist in the world."[45]

Learning from the California Desert

Purifoy's self-imposed exile from the practice of art ended in 1987 when
he retired. He planned on settling back into his home in South Central
Los Angeles and concentrating on his own work as a professional artist
working with galleries and in museums. Instead the owner of the prop-
erty where he had lived for thirty years decided to sell it, and Purifoy
had to move. He tried living in an artist's cooperative in downtown Los
Angeles, but he needed a cheaper place to live and more time to reflect
critically on the issues he had been exploring his entire life.

With considerable trepidation, in August 1989, Purifoy accepted a
friend's invitation to move over a hundred miles east into the desert and
share her lot in Joshua Tree. He set up a mobile home and built a work-
shop for himself. His first response to the terrain was negative: "it just
gives the impression of desolation and sheer poverty."[46] As he lived
there longer, he discovered a rich variety of life surrounding him in
every direction. Hosts of persistently busy animals and a plethora of nat-
ural processes had been completely invisible to him, but they slowly
revealed themselves and forced him to take notice. His response to the
desert provided him with an all-encompassing metaphor for puzzles he
had pondered all his life: what is the relationship of selfishness and
blindness? What are the conditions by which relationships are patterned
into meaningful designs? How can art promote the mutual recognition
that is the necessary condition of knowledge and communication?

In the desert, he began the second creative burst of his career, one
that lasted until his death in 2004. He reconstructed two and a half acres
into an aesthetic experience that systematically revealed his ideas about
the relation of perception to mood, preconceptions, and prior knowl-
edge. Following the model of Rodia, relying solely on willpower and
property rights, Purifoy worked to leave a trace of the ideas he had strug-
gled with his entire professional life. Working as an assemblagist in the
desert proved to be a radically different experience from working in Los
Angeles, where sooner or later everything is thrown away as junk or gar-
bage. In Joshua Tree, everything seemed to be recycled. To find materi-
als, he took part in the weekly swap meets where his neighbors
exchanged belongings they no longer needed or wanted.

Word of mouth spread about his project, and young people stopped

by interested in learning from him. Some provided the heavy manual labor that he needed to complete the increasingly larger-scale projects he designed. People in Joshua Tree and the surrounding communities dropped off their refuse, giving him old refrigerators, broken washing machines, automobile parts, computers, and other electronic equipment that no longer worked. One plumbing contractor donated several dozen toilets that could no longer be installed in California due to changed water-conservation laws. In 1999 a foundation formed to protect what Purifoy had created and to plan for a cultural center that could continue after his death. Artist Ed Ruscha purchased an adjacent lot, which he donated to the foundation. Before his death, Purifoy had ten acres at his disposal. The desert became the blank slate upon which Purifoy wrote his alternative histories.

His first pieces were large stand-alone sculptures with considerable elegance (see Figures 27 and 28). Constructed with shiny metal sheets and decorated with simple building construction materials such as heating duct tubing, Purifoy returned to ideas motivating *Breath of Fresh Air* twenty-five years earlier. He spaced his sculptures around his site, setting them against the different vistas on the property of distant mountains, valleys, and desert flatlands defining the Joshua Tree area. Adding a humorous touch, he connected several of the large standing sculptures with *Kirby Express*, a two hundred-foot-long railroad line made from aluminum tubing for a train constructed from broken vacuum cleaners mounted on bicycle wheels. Another humorous piece, *The City*, consisted of tall, brightly colored skyscrapers rising above the Joshua trees on the property, constructed from dozens of yellow and green lunch trays.

He wanted the harsh high-desert weather with its constant winds, 110-degree-plus heat in the summer, and frequent overnight freezes during the winter to be an integral part of the sculpture park he was developing. He erected a thirty-foot-long, twenty-foot-high scaffolding in which he suspended sheets of brightly colored metal. In this piece, which he titled *Mondrian*, he wanted to start out with a straightforward imitation of one of the constructivist masterpieces of the well-known Dutch modernist. Season after season, wind, rain, and hailstorms were to rearrange the piece. Whenever *Mondrian* lost its formal coherence and no longer could be seen as the product of a dialogue between an art idea and a tough natural environment, Purifoy reconstructed it and the process resumed. A very different piece took shape in a large twenty-foot-square field, where Purifoy pinned down old shoes and clothes that he had collected into a large textile collage. Initially, he wanted the piece to have the rich colors and textures of a Bonnard or Vuillard painting. He expected that over the space of several years, weather and the work of animals would dull the colors and pull the materials back into the soil.

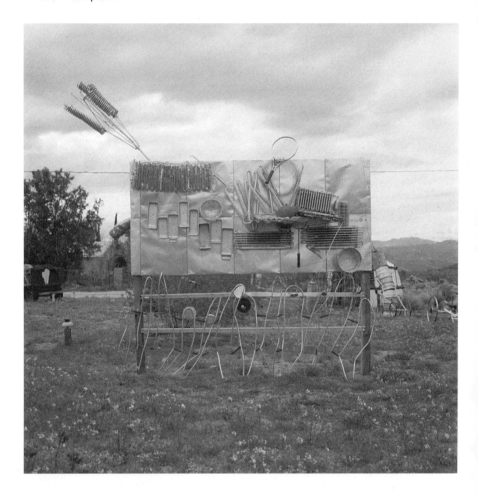

Figure 27. Noah Purifoy, Untitled (*Red Tube*). Mixed-media assemblage sculpture. Noah Purifoy Outdoor Desert Art Museum of Assemblage Sculpture, Joshua Tree, California, 1996. Courtesy of the Noah Purifoy Foundation.

The initial vision was to remain detectable in the juxtaposed shapes etched into the desert sand, but the climate would have enacted a form of art historical transformation. The piece had taken on the look and feel of a 1950s abstract painting by Dubuffet, Fontana, or Burri. But modern art in these conditions collided with the "untamed, undomesticated, aloof, prehistoric landscape" that the English émigré writer Christopher Isherwood had thought defined life in California. "You are perfectly welcome during your short visit," he wrote. "Everything is at your disposal. Only, I must warn you, if things go wrong, don't blame

Figure 28. Noah Purifoy, *Spanish Arch*. Mixed-media assemblage sculpture. Noah Purifoy Outdoor Desert Art Museum of Assemblage Sculpture, Joshua Tree, California, 2000. Courtesy of the Noah Purifoy Foundation.

me. . . . Don't cry to me for safety. There is no home here. There is no security. . . . Understand this fact, and you will be free. Accept it, and you will be happy."[47]

Juxtaposed against the pieces defined by Purifoy's reflections on modern art were other works with more direct social comment. *Voting Booth* presented a row of old shoes standing in three stalls behind drawn curtains. An iconic image of democracy in action is transformed whenever the wind lifts the curtain to reveal a row of toilets in place of voting machines. Nearby is *Aurora Borealis* (Figure 29), an assembly hall built around a printer's plate with the first page of the Declaration of Independence that has been broken in half suspended from the ceiling. A speaker's platform, decorated with the stars and stripes of the national flag, takes up one side of the room. Next to the platform is a fragment of a large store sign that Purifoy had found sporting the words "Today, It's Simple, Convenient." In one corner of the hall, Purifoy added a sunken garden of broken plate-window glass. The wall facing due west is constructed with glass bottles that burst into bright colors as the sun lowers in late afternoon. Outside the assembly hall by the front door is a

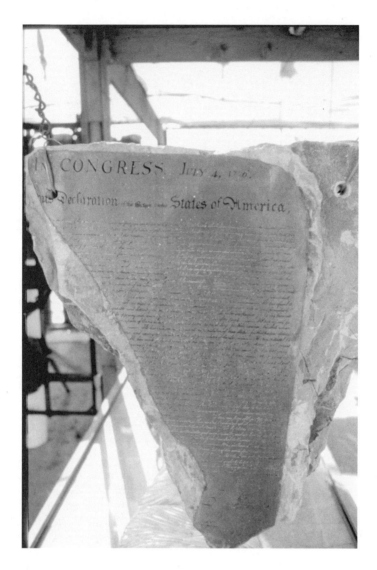

Figure 29. Noah Purifoy, *Aurora Borealis* (detail). Mixed-media assemblage sculpture. Noah Purifoy Outdoor Desert Art Museum of Assemblage Sculpture, Joshua Tree, California, 1999–2001. Courtesy of the Noah Purifoy Foundation.

water fountain labeled "White" placed next to a broken toilet bowl labeled "Colored," a reference to the segregated public facilities of the South when he was growing up. Purifoy denied that the work was "protest art," claiming that he was representing simple historical facts.[48]

A parallel effort to rethink the experience of segregation in the Jim Crow South can be found in *Review 54/Outhouse* (Figure 30), a mixed media construction that Purifoy's friend and successor as director of the Watts Towers Arts Center John Outterbridge constructed in 2003. Jill Moniz, visual art curator at the California African American Museum, described the work as an environmental work allowing viewers to enter into the exclusion that defined life in the United States for so many of its citizens: "Outterbridge constructed an outhouse, a building separate from the main house or big house, for viewers to enter, to sit on the stool, and to read text on the walls, ceiling, and floor. The text comments on the *Brown* v. *Board* case [the 1954 U.S. Supreme Court decision definitely declaring "separate but equal" unconstitutional]. The outhouse itself represents the disparity between those who are outside the power structure versus those who make the rules for everyone else to live by. The wheels on the outhouse are a symbol of mobilization and the potential to move forward."[49]

The attitude moving through the assemblage work that Purifoy constructed in Watts and then twenty years later in Joshua Tree conforms to a special form of knowledge that the mid-twentieth-century Japanese philosopher Tanabe Hajime called "metanoetic," literally a way of knowing that unites all forms of interaction and the specific skills they require. Tanabe used this term to mean that one had learned to look at the world as a place made from mutually responsible relationships. Out of this new type of knowledge sprang a sense of repentance for having confused superficial and deep reality.

The work of reconstructing the meaning of an object so it reveals deeper layers of spiritual meaning and not simply an extension of our wants does not mitigate the fact that the passing away of one manifestation of reality so that others can appear involves pain and usually conflict. Confronting the multiple realities inherent to a developing being is not, therefore, a solution to the problems that beset any given society. It is merely a recognition that existence contains contradictions that must be faced, a sorrowful acknowledgment that may allow a person to face inescapable conflicts with greater equanimity and with a firm goal of lessening suffering to the degree that one can.[50] We might understand assemblage, then, as a form of prayer that one may act with justice in relation to all beings. In undertaking this art form, Purifoy followed in the path of his deeply devout mother, who went through the day constantly praying in a half-loud singsong. Her persistent reaching out to

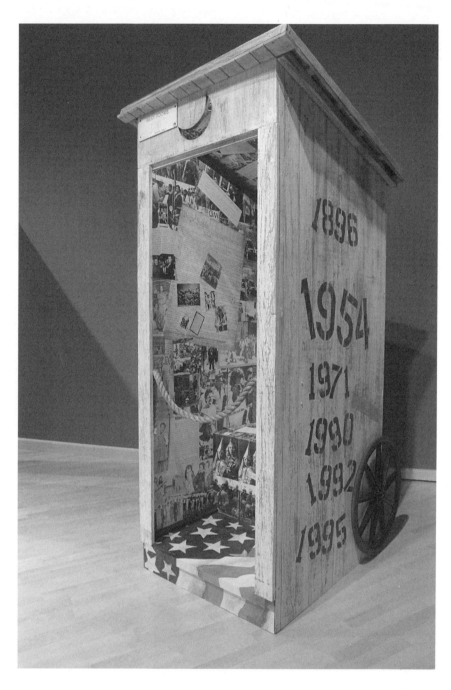

Figure 30. John Outterbridge, *Review/54—Outhouse*. Mixed media, 2004.
Courtesy of the California African American Museum.

God underlay her strong sense of responsibility for those who had been placed in her charge.

Perhaps for these reasons, Purifoy consistently refused the label of "protest artist," although he typically included at least one protest piece in his shows because, he said, curators and critics expected the work of an African American artist to be primarily motivated by anger.[51] Art that manipulates the spiritual weaknesses of its viewers, Purifoy noted, extracts "from the individual what he doesn't intend to give—pathos." The protest artist wants to make his or her viewers feel bad, a goal that Purifoy despised: "When artists begin to use their work to communicate something that they think people ought to be or feel, I think it's an affrontation and I think art loses its real essence based on the creative process."[52]

Like Rodia's Watts Towers, Purifoy's desert sculpture park is both elegant and bewildering in the number of references and in the lushness of the visual imagination. As viewers walk through the site, they face gallows, witches, African warriors, crucifixes, bathtubs, bed frames, PVC pipe, bicycle wheels. Many of the pieces are quickly thrown-together visual jokes, but many others, like the objects he plated with melted lead and then covered with multicolored lumps of splattered metal, are elegantly crafted works that cannot be translated into a simple verbal counterpart. While building the sculpture park, Purifoy also made large hanging wall pieces for sale. This was work done for commercial purposes. He had come to accept that the institutional structures he lived with, however deficient they were in comparison to his ideal, were still the only structures within which he could work. To get the money he needed to continue the desert sculpture park, he needed to sell more portable work. The questions he grappled with, however, remained those that had puzzled him throughout his life. On the series he made from automobile and truck radiators that he took apart and then reassembled as abstractions, he observed,

When you see a radiator, you don't see what's exposed here. You see a rectangular or a square object, with tubes running out of it. That's what you see. When you do art, you see beyond the object. That effort of seeing beyond the object is also present in human relations. You see beyond the individual into what he/she thinks and feels. . . . What's underneath is always, almost, a surprise. To some of us. To me, no. What I'm doing is going back and forth, applying it to the object itself and then transferring it to people. The thing is never applicable to itself as such. . . . But looking at a radiator in a car, how often do we immediately transfer to the absence of knowledge about another human being who strikes us as being problematic, just like a radiator in a car, and want to know his full function, his behavior, in relationship to me or anyone. The relation is peculiar, meaning I don't thoroughly understand my relationship with the human being. But I do thoroughly understand the function of a radiator in a car. Now, why doesn't the function of a radiator in a car stimulate me to want to know, or transfer?[53]

Chapter Eight
Contemporary Art Along the U.S.-Mexican Border

Building an Arts Community in Baja California

The problem of how to expand and deepen the relationship of contemporary artists to a broader public, the problem that Purifoy tried to address through his twelve years on the California Arts Council, continues as an unsolved puzzle sparking a variety of improvised responses. Artist-in-community programs have grown since his retirement, and several foundations have collaborated in an initiative to expand support, financial and organizational, for arts organizations developing alternative ways of working with the public.[1] Experiments can be particularly exciting in communities experiencing the emergence of a locally based art community. As a vibrant art scene developed in Tijuana in the 1990s, many activities occurred in spaces largely independent of government-run museums, where political priorities often set limits on what could be seen or said. The emerging art scene kept apart as well from the Universidad Autónoma de Baja California, which like many provincial Mexican universities, had offered no degree programs in art—until 2004 when the university opened a school of fine arts to provide training and a theoretical base to the region's cultural activities.

Artist-run spaces and training programs developed in the Colonia Federal, a neighborhood running along the border fence to the Pacific Ocean that has recently turned upscale and middle-class with shops and entertainment now competing with ad hoc arts groups for space and attention. Taking over a building fifty feet south of the border, the mixed-media artist Marcos Ramírez ERRE launched Estación Tijuana, an alternative exhibition and training space open to students, many of whom would be ineligible for admission to the university or unable to afford to go. Luis Ituarte, a painter, spends three days a week in Los Angeles as a curator for the Municipal Art Gallery and the rest of the

week at his home in Tijuana, where he has served as president of el Centro Fronterizo de Arte y Cultura (COFAC), founded in 1996 by a group of artists working on both sides of the border. Both Estación Tijuana and COFAC offer instruction, exhibition, and a continuous set of programs with speakers and debates. The Nortec Collective has developed around a web site, with the temporary use of buildings, often without authorization, for concerts, exhibitions, and discussions.[2]

In this vibrant scene, the question remains open whether alternative spaces are preparing the foundations for a broader variety of institutional supports than have been present north of the border, or whether they are the first steps in establishing Tijuana as a mature regional cultural center organized around schools, museums, and galleries. In the latter case, the network will have expanded, but the structural issues concerning how people living together share the broadest of experiences relevant to their situation will remain unaddressed. One hundred miles to the east of Tijuana is another large border city, Mexicali, the capital of the state of Baja California. Mexicali, with nearly one million residents, is home to more people than Athens, Florence, Venice, or Amsterdam had during their golden ages. Unless we hold that the distribution of talent in the human race has shrunk radically in the last several centuries, Mexicali should be as vital an intellectual and aesthetic center as these cities have been. Its ambitious, talented citizens would no longer automatically think of migrating to Mexico City, Los Angeles, New York, or now to Tijuana, developing into the metropolis of the Mexican Northwest.

In both Mexicali and Tijuana, a deepening cultural relationship with Los Angeles, San Diego, and other cities in the U.S. state of California offers the possibility of international recognition, resources, and patronage beyond what had previously been available locally or brought in from Mexico City. At the beginning of the twenty-first century, Los Angeles had become one of the major sites for contemporary art in the world, with well-established museums, galleries, and schools that were likely to become even stronger over time because of the interest of private collectors. From San Francisco to Santa Barbara to Los Angeles to Orange County to San Diego a network of regional activity has developed that extends into Baja California as many in the United States try to use their talents to help rethink how the border has developed. Exchange programs between the two Californias have grown, leading to a series of exhibitions in both countries exploring "borders" and "borderlands" that have gained considerable publicity.[3] Though artists and poets have little to say about the substantive details of immigration law or trade agreements, they have been among the first to explore the intellectual and affective aspects of the new world that politicians and corpo-

rations are busily constructing. Art has provided a place for audiences to experience what it *might* mean to live in a world with less restrictive boundaries. However, as George Yúdice has pointed out, while the benefits to artists, curators, and sponsors are clear, the "return for the local population" on either side of the border remains to be seen. Have the lives of the men and women who work in the maquiladoras improved? Have the conditions Mexican workers within the United States face become more just or responsible?[4] Have public attitudes changed at least in part due to the unusual perspectives artists have brought to debates on both sides of the border?

Yúdice's questions force consideration of the ambiguities surrounding production of contemporary culture. There is no doubt that visual, media, and performing artists have created compelling visions of the various frontiers separating different aspects of contemporary society. They offer unusual experiences growing out of the manipulation of their media that stimulate new ways of thinking. The work has been successful in drawing media publicity, as well as increased investments by governments, private collectors, and public institutions. But has the work succeeded in finding, or creating, a public that would know how it should act given the new understanding gained through engagement with art? The relationship between artists and their publics, actual and potential, remains in question because the public that exists *for* art has been created by arts institutions. The politics underlying that audience relationship points back to the needs for predictability and reproducibility of the arts as a knowledge-based institution, not to questions of public policy. The art public cannot be equated with any particular community, nor with the citizenry at large, much less with "humanity." The loss of the modernist ambition that art reveals truths about the human condition unavailable anywhere else has led to a more realistic assessment of how artists can intervene in contemporary debates, but it is also symptomatic of a conservative trend that reduces the scope within which individuals and organizations work. It indicates a limitation on what can be imagined.

The art public is itself one element that develops as the institution establishes itself and matures. Of course, no overt barriers are placed in the way of broader public participation in arts projects. On the contrary, efforts to expand the public for contemporary art have been a priority for museums and galleries. Many border arts projects strove to escape museums, to go out, take over, and transform heavily used public space specifically to communicate with those who seldom if ever enter a museum. The "in-Site" exhibitions along the San Diego-Tijuana border have been among the most ambitious in trying to change the nature of public discussion of the border separating these two cities while drawing

on a broad, international group of participants who could reformulate the specific issues to highlight broader ramifications. Did this strategy succeed in merging the publics for art and politics in a situation where U.S. government policies were radically transforming the everyday lives of the citizens of both cities?

The In-Site Exhibition Series, 1992–2005

In 1992, while the U.S. government constructed a double wall dividing the major cities along the border, arts and educational institutions in San Diego responded with an exhibition of installation and site-specific art along the border. The work selected was to highlight "the potent and meaningful context" of "two major cities with distinctly different and historically disparate cultures [sharing] a common geography, yet . . . separated by a fiercely fenced international border."[5] After the initial show in 1992, four additional exhibitions along and across the border followed. In 1994 the Centro Cultural de Tijuana partnered with the San Diego Institute of Contemporary Art to plan the second show, with venues added on the Mexican side of the border. The collaboration involved cultural institutions that had developed along dramatically different models. San Diego's largest art museums were locally based with boards of directors drawn from the business and social leadership of the city. Professional standards, grounded in both art historical and museum scholarship, provided a degree of autonomy for the work of the curatorial staff. Funding came from a combination of hotel taxes, government grants, foundation grants, donations from private individuals and major corporations, membership fees, and admission charges.

The Centro Cultural de Tijuana, on the other hand, was an agency of the Mexican federal Ministry of Public Education. Its director and staff were political appointees who served at the discretion of the president, with administrators in Mexico City taking an active role in setting priorities for both programming content and types of community involvement. The Centro Cultural is open to the public free of charge. Its programming mandate has been "to strengthen national identity on the northern Mexican border as well as to promote cultural tourism incoming from the United States."[6] The government has also charged the Centro Cultural to reach out to Mexican-descent communities in Southern California. Its regular programs include exhibits on Mexican history, natural history of the Mexican Northwest, and anthropology and ethnography of the nation's indigenous peoples, as well as art, movies, musical concerts, theater performances, and photography. It has a planetarium and offers introductory courses to the physical and biological sciences, as well as a reading room that provides free access to a large number of

scientific and cultural publications. Contemporary art has been only one part of a broad program addressing educational needs in the greater Tijuana region.

U.S. private sponsors provided the largest share of funding for the in-Site exhibitions. Three Mexican government agencies provided half of Mexico's contribution, with private funding from major Mexican corporations and several important art collectors covering the other half.[7] Private collectors of art in Mexico had established museums for their collections, but, prior to the 1990s, they had seldom funded programming at government-run museums, institutions that based their authority on a claim to speak for and to the Mexican people at large. The in-Site series helped introduce a U.S. model for cultural programming into Mexico. Given high-level involvement from both sides of the border, success for the in-Site exhibits conformed with the highest standards of international contemporary art. This resulted in less prominence for local artists, even those whose careers had long been involved in addressing the issues motivating the in-Site series. The in-Site exhibitions minimized the participation of the Border Arts Workshop/Taller de Arte Fronterizo, a coalition of performance and conceptual artists that had engaged in arts actions on both sides of the border since 1984.[8] Instead, the participants came from all over the world and were names well known within the art world for their inventive and often difficult approaches.

The dozens of artists who have participated often produced work that sought to unsettle conventional ideas about place.[9] In designing *CYM 55296*, for example, installed in 1994 at the Athenaeum Music and Arts Library in San Diego, Hong Kong–born artist Ming Mur-Ray prepared seventy-two translucent panels inscribed with 768 completely invented characters (presenting the viewer with a total of 55,296 unknown statements). Scattered through the library, Ming's freestanding units refigured a familiar environment with unreadable if presumably decipherable text. Occupation of space was, in theory, transformed by a need to absorb and categorize the new context that the panels and their texts had created, much as many everyday practices are changing slowly under the pressure of new international conventions and regulations. If viewers failed to find any code to make the panels comprehensible, Ming's work still had to be circumvented and avoided as library patrons moved from one part of the reading room to another.

For *ReinCarnation Camp*, Fernando Arias, a Colombian artist based in New York City, went into the basements of two buildings adjacent to the border fence, where he constructed gigantic razor blades out of the same material used for the fence. The blades hover over a row of mirrors on which he placed a line of white powder. The physical image referred

to cocaine, synonymous with his native country in the minds of most U.S. residents, while also referring to the increasing identification in political rhetoric of the border as a front in the so-called drug wars. The drive to isolate the United States from the rest of the world had become a guillotine-like threat resting on whatever justifications could be found in current events.

The in-Site exhibitions have drawn criticism that they have extended the conceptual possibilities of "border" and "borderlands" so widely that the complex realities of the actual national frontier are diluted. In her review of the 2000 exhibition for *Art in America*, Leah Ollman wondered,

Scar. Wire. Dam. Wound. The border between the United States and Mexico suffers from metaphor exhaustion. In both art and the mass media, it's always being likened to something else. Such distillation can yield pithy truths, but it's equally likely to deliver something facile, a single note assigned to stand in for the cacophonous whole. . . . If public art exists "to thicken the plot," as Vito Acconci puts it, what is left for it to do when the plot is already as dense as it is here, on the most heavily trafficked international border in the world, where two radically different cultures and economies meet with such abrupt intimacy? How much thicker can it get?[10]

The use of public space along the border fence was the specific theme of the 1997 program. Marcos Ramírez ERRE's *Toy an Horse* (Figure 31) relied on a cultural metaphor well known in both countries to make a direct statement on the contradiction between perceptions and practices related to the U.S.-Mexican border. He constructed a thirty-foot tall, two-headed wooden horse straddling the frontier at San Ysidro, reputedly the most heavily trafficked international crossing in the world. Effecting a clever English-language pun, ERRE called up nativist concerns in the United States that immigration had become a Trojan horse sapping national integrity. ERRE however visually reminded his audience of border crossers, both U.S. and Mexican citizens, that the horse pointed in both directions. If this border symbolized danger, certainly Mexico was as vulnerable as the United States to unwanted changes, probably more so given its weaker economic condition and the relatively greater fragility of its political structures. The piece asked its viewers who else could be the secreted warriors threatening the future of Mexico and the United States but themselves, the fifty thousand tourists, businessmen, shoppers, government officials, and workers who daily crossed the border at San Ysidro. For those like ERRE who live and work on both sides of the national boundary, the frontier is lived with and around in the simple pursuits of everyday life. Even before the terrorist attacks of September 2001, the procedures and protocols imposed on crossing the border into the United States were becoming increasingly complicated,

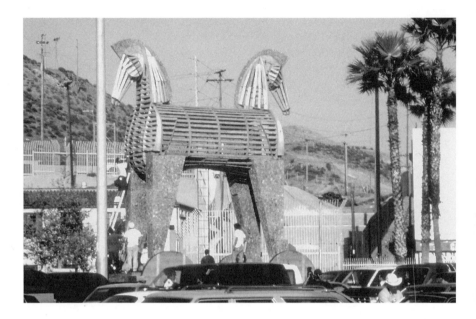

Figure 31. Marcos Ramírez ERRE, *Toy an Horse.* Wood and steel, 1997.
Constructed for in-SITE '97, at the San Ysidro, California / Tijuana, Baja
California border crossing. Courtesy of the artist and Iturralde Gallery, Los
Angeles.

but nothing yet has stopped the thousands of Mexican citizens who every
day legally enter the United States at San Ysidro and places like it stretch-
ing two thousand miles east.

ERRE's joke from 1997 provided a timely reminder that interchange
between any two nations is a living process involving thousands of dis-
crete acts by people with sundry motivations and intentions. Given that
interpretation as a possible reading of the piece, it is necessary nonethe-
less to remember that the work was produced within a particular social
structure that has its own relation to the border. If artists arrive at a tell-
ing formulation about borders, nations, and the mixtures they create,
this is not because they have reproduced observable facts. Imagination
has thrown forth an alternative way of seeing that stands in opposition
to what can be observed, as much as ERRE's *Toy an Horse* stood over the
actual business of crossing the international border. While it was
installed, ERRE's piece in no way changed the process of passing
between the United States and Mexico, though it may have sparked a
variety of interior changes among the hundreds of thousands who
passed it. Society seldom turns to artists, or writers for that matter, for

policy recommendations. Cultural production, to the degree that it attracts attention and seems relevant, offers relief, surcease, incitement, provocation; audiences are drawn to an alternative experience that can reduce complex, often intractable realities to images with the power to put ideas back into play. The concrete political issues surrounding the border transformed within art practice into a metaphor for the ability of artists' work to connect experiences that might otherwise be seen as unique. The actual border challenged artists who lived near it to translate an immediate, personal experience into more generalized statements on the barriers to human beings sharing the meanings they draw from their encounters.

ERRE's frequent participation in the in-Site exhibitions underscores that locally based artists made important contributions to the series. The exposure he gained led to invitations to exhibit elsewhere and commissions for site-specific work such as signage for a freeway outside Harrisburg, Pennsylvania, with the names of cities the United States had bombed over the last two centuries with their distance in miles and kilometers. ERRE was born in Tijuana in 1961 and grew up with family living on both sides of the border. After studying law in Mexico, he earned his living as a construction worker for seventeen years. He moved easily across the frontier to work wherever he could find a job. In the process he learned the construction techniques of the two countries. This formative experience, central to his self-conception as an artist, was the basis for *Walls/Muros* (2002), in which he juxtaposed balloon-frame walls, typical of U.S. home construction, against brick walls, commonly used as the inner core of walls in the construction of Mexican homes. ERRE embedded video screens in the two walls, projecting edited footage he had shot of construction sites on both sides of the border. In both cases, the workers are Mexican, underscoring the contradictory realities of a border that has become increasingly difficult to cross but yet has long been permeable.

Working in the building trades provided the basic skills he needed to construct the large-scale assemblages that have characterized his work. In the 1990s, as ERRE became a leading figure in the growing art world of San Diego–Tijuana, mixed media was one of the primary expressive forms used by contemporary artists. ERRE's work, however, had simply become art, without any of the qualifications applied through most of the twentieth century as critics and museums struggled to deal with assemblage and other media based on constructive rather than visual techniques. Given his ready incorporation into a more capaciously defined professional world, ERRE's sharply critical perspectives on contemporary life in both of his countries have been expressed through the prism of a profession as much concerned with its own history as with

making statements about the contemporary social situation. For his con-
tribution to the 2000 Biennial at the Whitney Museum of American Art,
ERRE constructed *Stripes and Fence Forever—Homage to Jasper Johns,* a large
metal structure with the flags of Mexico and the United States back to
back and constructed from the same materials used for the fence sepa-
rating the two nations in the San Diego–Tijuana metropolitan area. "It
was in the Whitney courtyard," ERRE noted in an interview, "placed
diagonally over a three-by-three-meter patch of dirt contained by four
short walls—two of cinder block, two of brick. The flag cut the dirt lot
in half, an artificial divider over the square. To me, the cinder blocks
represented the U.S. and the bricks represented Mexico. The soil, it's
one and the same and belongs to both."[11]

ERRE did not attend art school, as have most successful artists of his
age in either country. He began his constructions to express his attitudes
toward the contemporary political scene, using materials and skills
readily available to him as a man trained in construction. However,
unlike Rodia, he worked knowing that what he wanted to do had come
within the parameters of contemporary arts institutions. As his work
received a positive reception, he read more in the history of modern
and contemporary art, and he engaged in lengthy conversations with his
peers. The history of art and the history of social conflict have had an
intimate connection in his work. His homage to Jasper Johns is not sim-
ply irony, but an acknowledgment that Johns's deadpan renderings of
national icons had been an important step in their demystification as
symbols.

ERRE's *Hay mitos que envejecen/Aging Myths* (Figure 32) adopts Andy
Warhol's revisioning of contemporary celebrities using silk screen por-
traits appropriated from newspaper photographs of fourteen cultural
icons of the contemporary world. ERRE has formed seven pairs, the top
figure a "legend" who died young—such as Frida Kahlo, John F. Ken-
nedy, John Lennon, Ernesto "Che" Guevara—and continues to loom
over the present as a symbol of lost purity. The bottom figure has a con-
nection to the mythic hero presented above—María Félix, Richard
Nixon, Paul McCartney, Fidel Castro—but having survived to old age
could not escape the consequences of his or her ideals. Public imagina-
tion has linked the name as much to his or her mistakes as to the ideals
that motivated them. The hero who died young inhabits a world of pure
myth, but the counterpart straddles the worlds of myth and history. The
piece is an overt homage to Andy Warhol that borrows his technique for
incorporating popular cultural images into a high-art discursive frame-
work. ERRE developed his own pop culture style that mixes together the
Mexican and U.S. imagery that he grew up with, showing an interactive

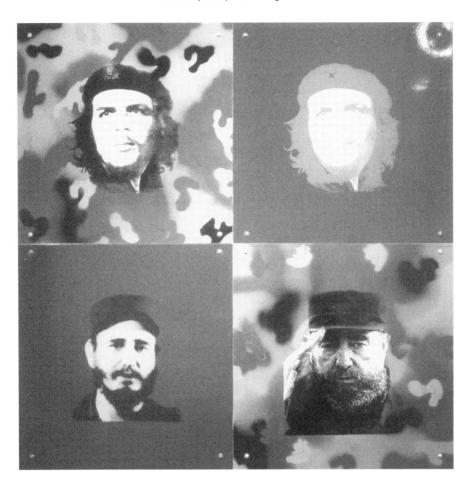

Figure 32. Marcos Ramírez ERRE, *Hay mitos que envejecen/Aging Myths (Che and Fidel)*. Automotive paint and silk screen on aluminum, 1999. Courtesy of the artist and Iturralde Gallery, Los Angeles.

culture that he hopes his public will recognize as richer and more interesting.

ERRE's homage to Warhol was as genuine and as serious as his nod to Johns. Without the liberation from modern-art purity that Warhol's life story and work has come to exemplify, it is hard to imagine how an artist like ERRE would find recognition. Art, meaning the construction of objects, had returned from the philosophical heights to become a form of response to the world based on manual knowledge. The art piece was a performance of the artist's reactions and feelings. It relied on sharing.

The object had no life in and of itself. It was as limited and inexact as any perspective, not the ensnaring of a piece of "absolute reality" within a frame. People engaged a work or it might as well not exist. Instead of a natural law revealed within a frame, art offered a sharing of heightened experience. ERRE's Warhol, as well as his Johns, formed a lineage he constructed for himself as an artist with multiple interests: his life criss-crossing the border, his love of building things, his interest in the technical aspects of image production. The formal art issues might be just as important for who he has become as the history that has made him an effective critic of the position the United States occupies in the world. To separate them would be to deny the practical institutional contexts that allow an artist like ERRE to reach his public.

Art has had a privileged role in cross-border cultural experimentation because most artworks are not dependent on language. They appeal more directly to our sensory capacities to provoke ideas and responses, which we then articulate through conversation and criticism in our respective languages. Literature provides a more difficult challenge for the process of constructing a shared culture across borders. Linguistic communities form exclusive markets. The question of what gets translated and thus shared is governed by a variety of institutions, many commercial, some educational, philanthropic, or governmental. Much, maybe all, of the junk of U.S. culture finds its way into the markets of other nations. Very little of either the popular or the high literary culture of Mexico finds an English-language publisher beyond a handful of masterpieces, particularly those translated in the 1960s and 1970s, when Latin American novels were in vogue. Readers in the United States who are not specialists might know a handful of modern classics of Mexican literature like Mariano Azuela's novel of the 1910 revolution, *Los de abajo* ("The Underdogs"), Carlos Fuentes's novel *La muerte de Artemio Cruz* ("The Death of Artemio Cruz"), or the poems of Octavio Paz. The works of few contemporary writers are available in English. Even the novels of Gustavo Sainz or Elena Poniatowska, to speak of two senior novelists, remain largely untranslated and unknown to the broader reading public in English-speaking America, the same for the works of Paco Ignacio Taibo II, Elena Garro, Carmen Boullosa, or many other names as readily familiar inside Mexico as Philip Roth, Toni Morrison, or Don DeLillo are inside the United States.

Even the regional literature that has developed around the U.S.-Mexican border remains untranslated for the most part. *Tijuanenses* by Federico Campbell has been translated and published by the University of California Press, but not yet *Transpeninsular* or other important works Campbell has written on Baja California. *Espantapájaros* by Gabriel Trujillo Muñoz takes up the conventions of *X-Files* and *Alien* to tell the story

of a secret military plan to genetically engineer raptors into highly intelligent, highly lethal secret weapons. Parts of the novel, particularly its use of the border and the role of indigenous peoples in resolving the dramatic conflict, offer ideas and connections considerably different from what would normally be shown on television or in movies in the United States, but Trujillo Muñoz's approach is fresh, appealing, and consistent with popular taste in both countries. A Hollywood movie based on *Espantapájaros* would be a sign that a new popular culture might be emerging from the closer integration of the Mexican and U.S. societies. Since 1987, Trujillo Muñoz, who teaches at the Universidad Autónoma de Baja California in Mexicali, has worked with Harry Polkinhorn of San Diego State University to issue volumes of writing from and on the border, published under the imprint of Binational Press/ Editorial Binacional, a joint project of their two schools that pursues a goal of allowing citizens in both countries to share and discuss their experiences as neighbors.[12]

In the absence of any shared literary or media culture that could help citizens of the two countries consider the fuller implications of their nations' relationship, the visual arts have carried an extra responsibility to translate ideas and experiences between the two societies. In part, artists are well situated to fulfill this role because the modern arts movements that emerged at the end of the nineteenth century to which they are heirs typically stressed the universal, transnational aspects of creative process. The truth that art revealed about the human condition was valid everywhere. Art helped people translate across the dizzying variety of actual custom and convention to find what they shared as human beings. This faith has been a defining feature of elite art movements since at least the 1870s even as it has been extensively criticized. The truths that artists revealed were particularly valued if, like Claude Monet, they did not proclaim their findings as anything other than work, an extension of disciplined craft, a refined understanding of being "a beast at his millstone." Critics, and later historians, had the freedom to derive the truths from the primary evidence that artists had created. Artists work with their hands, and others interpret. The works remain, while the words flutter in a continuous process of developing a public commensurate with the direction that artists have taken.

Seeking the Ideal, Responsible Public

Because modern arts institutions have long been organized around both national and international axes, the proposition that borders are unique places promoting the formation of hybrid cultures must be modified when applied to the activities of galleries, museums, and other formal

cultural organizations. Whether they are located physically on a national frontier or not, arts institutions seek international exhibitions because they serve the broader educational functions of galleries, museums, and schools defined on a national level. Such programs create images of distinct national cultures as apparent facts, chart an imaginary topography of universal similarities and historical differences, and define a place for the homeland within an imaginary global culture. At the same time, constant international traffic of cultural work supports a continuing value, seen from Claude Monet's time to the present, that art unites what borders and politics keep apart and thus must reveal a deeper, more persistent layer of reality than the ephemeral world of current affairs.

Criticality is a defining feature of contemporary art as a professional endeavor in the United States. A mature culture institutes for itself a defined zone for disengagement, self-reflection, and autocritique. Aesthetic examination can be directed against aesthetic theory itself, the forms that art takes, the epistemology of vision and performance, the commodification of art objects or processes, the structures of symbolic power that are proposed for defining a social entity such as a nation, or as DeFeo and Purifoy proposed, the process by which sensation is transformed into "experience." Within a professionalized art discourse, the use of aesthetic rather than social science theory to discuss political or social phenomena carries no implications about the nature of the realities that theories describe. It locates the discussion as taking place within an established institutional framework that has narrowed the terms of reference so that insights particular to that field can be deepened.

An unusual but perhaps validating response to what artists have had to say about the borders dividing contemporary society took place in 1993 when Daniel Joseph Martínez was commissioned to do a site-specific piece for an exhibition of Chicano art at Cornell University. He was reading the writings of Guy Debord and the situationists on the May 1968 events in France. As he looked over the maps of how students and intellectuals set up barricades around the Sorbonne and effectively took over Paris and brought the whole nation to a halt, the paths around the Cornell campus reminded him of the streets surrounding the Sorbonne. He proposed erecting barriers to block movement around campus. This led to *The Castle Is Burning* (Figure 33), a title taken from graffiti in Paris in 1968, but to many at Cornell an obvious site-specific reference to the castle-like administration building overlooking the campus.[13]

"Privilege is articulated through use of architecture and space," he said later as he described the project.

So I thought I'm just going to mess it up a little bit. I'm going to overlay the exact pattern of barricades in Paris over the Cornell campus. Well, they wouldn't

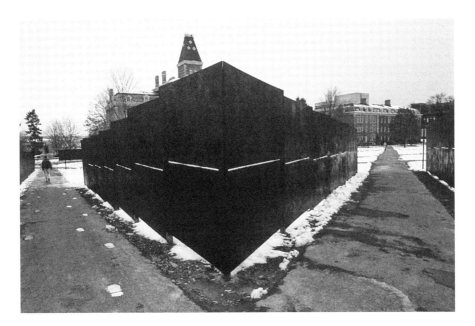

Figure 33. Daniel Joseph Martínez, *The Castle Is Burning.* Mixed media, 1993–1994. Cornell University, Ithaca, NY. Courtesy of the artist.

let me do that. Health and safety reasons. So I took the arts quad and I created a wall across the whole thing. I made a barricade out of "black ice." It was as beautiful as a Reinhardt. But I created a line across the panels. When the snow hit the ground behind the wall, the light hit the snow and bounced up and created a luminescent line across the whole thing. It was my homage to California light and space. The real question is private/public. It was a way for me to create disorder. Maybe people misunderstood me. The panels that made words above started to be destroyed. A lot of negative press.[14]

After he returned to Los Angeles, a group of conservative students announced their intention to destroy it. Four hundred other students, mostly students of color, formed a human chain around the work to defend it. Following a battle between the student groups, there was a student occupation of the administration building. The university's passivity in the face of vandalism directed against a work by an artist of color was symptomatic of the administration's refusal to acknowledge, much less address, long-standing patterns of intimidation against students and faculty of color. Access to higher education meant only being present on campus but not being included. Students demanded hiring of more faculty of color, building library collections in ethnic studies, and chang-

ing the curriculum to address the interests and needs of students of color. Martínez recalled that the president blamed him for the situation rather than looking at how the university's policies created a hostile racial climate at Cornell: "'Individuals like Martínez will be the demise of western civilization.' Wow! Just one little person. It was like the servants taking over the house. You can't have that."[15]

In the end, student demands were met and the president resigned as a result of his failure to manage the confrontation. After 1993, Chicano students at Cornell continued to celebrate the anniversary of the administration building takeover and honor the inspiration they and their predecessors received from *The Castle Is Burning*. "And what is it?" Martínez asked. "Just a little bit of art, a hope, an idea. I laid the plans out. They picked it up, read the plan, and enacted it. A sleeping giant lies at your feet and you don't even know it. An exceptional event, an exceptional moment."[16]

That Martínez's public art projects have consistently generated intense public response, though seldom to this degree, suggests how well his work confronts the languages and images dividing contemporary Americans. He begins with a proposition that whatever is said silences. His task as a poet is to return the absented, not for meaning to be overturned and replaced by nonsense, but precisely in order that the social relationships embedded in local, everyday language situations be revealed with crystalline clarity. He devalues the "real" as a shadow, which means that he must create an art that is "true" because it is not reducible to anything immediate. If we return to the definitions of "modern" art Hippolyte Taine made in 1864, contemporary artists like Martínez continue to work within a paradigm of art as an extension of knowledge, indeed as a form of knowledge that only art practice could reveal. In the course of 150 years, the implicit understanding of art as knowledge has taken on an explicit meaning of providing viewers with sensual experiences that allow them (or, if particularly successful, force them) to rethink intellectual conclusions about the general patterns shaping aspects of their lives.

Contemporary experimental art practice is defined by a goal of creating imaginative space that can transcend immediate social realities, be they national or local. The professional and disciplinary autonomy of arts practices and institutions has been a relative condition enabling artists to reveal to their fellow citizens alternative modes of perception. Autonomy is relative because, even if creative expression is universal, the organization and goals of cultural institutions are not. These are products of national histories with precise contexts shaping the possibilities for practice in any given time and place. Innovative art practice that aims to provide alternative perceptions of social and political realities must

simultaneously critique, negate, and transcend immediate structures for professional practice if imaginative space that counters settled perceptual and cognitive habits is to materialize.

"I like the ephemeral and I like the transitory," Martínez told me shortly after we first sat down to talk about his work. "Some of the most memorable things . . . are small conversations I have with other people."[17] The immediacy of face-to-face conversation invoked calls to mind Walter Benjamin's conception of the storyteller, whose narratives are accompanied by a gestural performance that circumscribes the special space within which narrator and audience become present to each other. What it all means is at the surface, for the storyteller's story conveys an evaluation that must be shared.[18] I think of this transitory, morally charged but imaginative connection as the model for what Martínez means when he speaks of a "third" or imaginatively freed space that he hopes his art reveals.

Working to reveal a "third" space where the absented truths of national, local, and institutional structures become palpably present has ineluctably led him to what at first glance appears to be an iconoclastic or even nihilistic position: "In order to find the next space for us to consider our humanness, we have to smash the idols that preceded us. Smashing them in anticipation of something I don't understand and for something I can't *yet* imagine."[19] With a lineage extending back to Antonin Artaud, Alfred Jarry, and Lautréamont, Martínez invokes an escape from order precisely to escape the arbitrariness and cruelty congealed into a system of taste, logic, and authority, qualities that both his personal experience growing up in the barrios of Los Angeles and his reading of the history of the avant-garde told him had long been used to prevent a fuller range of critical conversation about contemporary life.

The tradition Martínez invokes for himself is clear given the high regard he has for Friedrich Nietzsche's essay *Twilight of the Idols*: "When I read that for the first time, I said that's it! This is imagination of a space that does not yet exist. What we do in our lives is that we exist in quantifiable spaces and we do not let our imaginations function. We're always trying only to recognize what we see and to deal with what is reality in a sort of Cartesian-based world, and why we are so boring is because that is where we situate ourselves."[20] The third space, he insisted, inserts "a discourse into a space where the discourse is not allowed." The gesture, bound to be misunderstood, puts fixed assumptions into play and allows for a resumption of "discussion" that struggles to resolve misunderstandings. A radical experience becomes possible, which if grasped will be understood as the purest form of beauty. Desire for the comfortable and known gives way to a need to confront the artificiality of the world as it is lived in an everyday sense and to transcend the limited imagina-

tion that habitual response allows. "If we give up our imagination, we give up our ability to discern," he said, "we give up our human rights. If we give up our human rights, we become something I can't even describe." Radical beauty invokes a space where a person can discover the imagination of autonomy. Not individuality, but autonomy from all categories of identity, even those that one finds comforting and self-affirming.[21]

The work flowing from an exploration of what such ideas might mean in practice has proven that Martínez's ideas touch on a tangible, actionable realm of contemporary reality. The response to his work has been such that he has developed a reputation as a "wild animal" (in other words, a *fauve*) whose ideas might be well meaning but are suspect and possibly irresponsible.[22] By attempting to live up to the highest standards of the profession that he like DeFeo, Hedrick, Purifoy, and many other artists from popular backgrounds joined virtually by accident, he crossed boundaries protecting the autonomy of arts institutions in the United States as arenas for research. In 1990, the Seattle Arts Commission commissioned Martínez to prepare banners to be hung from poles along the streets of the downtown shopping district. The banners asked a series of simple questions that were in paired proximity: "Do you earn minimum wage" was adjacent to "Do you have a trust fund, savings account, or a credit card"; "Are you hungry" to "Are you a connoisseur with a refined palate. Do you have a wine cellar."[23] The Seattle Business Association and Seattle newspapers insisted that the banners insulted the majority of shoppers, though perhaps the real issue was undermining the thoughtlessness that accompanies shopping frenzies. After several weeks of debate, the banners were removed, but debate continued in Seattle over the nature of art and free speech long after the work had been suppressed.

He highlighted questions of ethnic self-identification for his contribution to the 1993 Biennial at the Whitney Museum of American Art in New York City (Figure 34), when he handed out admissions buttons to patrons that declared, "I can't imagine ever wanting to be white." Mayor Ed Koch wrote an open letter to the director of the museum charging the artist and the Whitney with fomenting racial tension and insulting white patrons. Controversy dogged Martínez once again after he and two associates won a competition to design and build a major, million-dollar public art project for downtown San Francisco. Large signs were to arch over a busy street announcing in bright block lettering, "This Isa Nice Neighborhood," an ironic reference to the well-known fact that the project was part of a program to redevelop a "bad" neighborhood with many residents whose first language was not English. Shortly after Martínez's team won the commission, politicians, developers, and even other

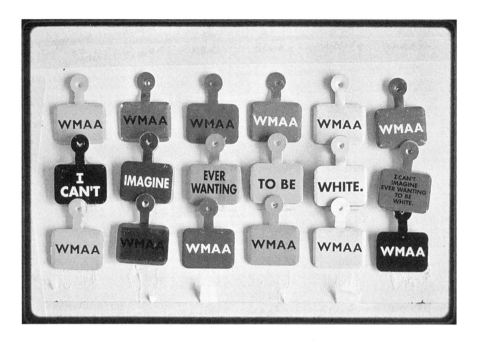

Figure 34. Daniel Joseph Martínez, *Museum Tags: Second Movement (Overture) or Ouverture con Claque—Overture with Hired Audience Members.* Mixed media and performance, 1993. Whitney Biennial, Whitney Museum of American Art, New York. Courtesy of the artist and The Project, New York. Collection of Michael Brenson.

artists began attacking the proposal so fiercely that the Redevelopment Agency reopened public hearings, and then used negative public opinion to justify canceling the already signed contract.

The turmoil surrounding Martínez's projects has exacted a personal toll and contributed to a reputation as a "difficult" artist. His professional position is secured by his position as professor of art at the University of California, Irvine. He is a successful, working artist with an international public precisely because he has succeeded in acting socially as an artist, with no pretension to offer anything to his public other than the constructions that express his responses to the world in which he has had to live. His reputation rests on his role as a public intellectual who can transform local spaces with a professional practice.[24]

Publicly funded arts exhibitions need to satisfy two conflicting demands, "excellence" and "accessibility." Martínez satisfies the first demand, but the questions he raises challenge a comfortable relation-

ship to art. He has tried to export conversations that are relevant and serious among professionals and show why they were relevant to broader publics, including the communities like that from which he originally came. He has showed that art can provoke discussion and debate, but in ways that questioned the need for professional control. This form of border crossing, more than anything else, has been a source of tension between him and the profession to which he belongs.[25]

Despite his ambitions, the meaningful public for Martínez's work has remained professionals, who mediate the ways in which the broader publics hear of what he has done. Even at Cornell, where students of color showed themselves to be the responsible ideal public artists dream of reaching, a responsible public that knew how to act upon the events that art made visible and understandable, they themselves were professionals in training, pondering in an alienating campus environment the existential meaning of the histories of communities of color within the United States. Higher education trains those who will become the leaders of the country (and hence putatively of the globe) in thirty years. To grasp that privilege, students of color have to learn how to convert apparent marginality into strategic assets. Martínez's work provided an important object lesson for the training of new professional cadre who *may* bring into being a world where categories of race *begin* to be less decisive in determining individual fate. In this sense, Martínez has contributed to an ongoing nation-building project that allows the U.S. state to endure and indeed expand because state and civil society become increasingly self-conscious and self-reflective about the conditions of their emergence and consolidation.

Martínez's work functions within a politics of subjectivity, directly addressing how subject position is articulated in different discursive frameworks. His stated goal is negative, to offer a position to his audience by which they can disengage themselves from that which they occupy unself-reflexively. Utopian aspects are part of the mechanism by which thinking can occur about who the *I* is that one has been in contrast to the *I* that one can become. I say the utopian aspects are secondary because the possibility of leaving the institutional framework is not a given, as Purifoy found out. One finds a "family" of similar-hearted comrades within the institution that one occupies. A reevaluation of subjective expectations takes place as prelude to rethinking what the institution should be, what narratives it can offer, and if the resources of the *I* can be expanded and made more central to the enterprise.

Creative Embrace of Limitations

In a variation on the concept of the "third" space, Martínez acknowledged that his work must be done for more than the immediate context:

"One of the things I'm interested in is to create space bubbles where [exceptional people] can solidify into print, into production, a force that will have to be dealt with one hundred years from now looking back. Not the decoration, but what has force, who *on the margins* has the force to sustain themselves."[26] To this end, he and two other artists based in Los Angeles, Glenn Kaino and Tracey Shiffman, opened Deep River, a gallery space and a publishing venture in the Los Angeles artists district that allowed them to connect with others by providing opportunities for more adventuresome shows than artists might have in venues oriented toward sales and self-promotion. Artists who have exhibited at his space have often moved on to commercial galleries, and older artists have presented work that because of scope or novelty required some protection from the limelight before being shown in more conventional spaces. Deep River, like earlier artist-run spaces such as the Six Gallery, was a collaborative experiment to see exactly how much artists could do for themselves outside the parameters of commercial galleries and public museums. Perhaps Martínez's goal was to give his "family" courage to do more than they normally could imagine, for that would be the only way the discipline of art would stay alive and engaged. This required a degree of accepting marginality even within one's own discipline as a strategy for contributing to its highest ideals.

The marginal, and therefore productive, position that artists have found in modern social life brings to mind the seminal essay from 1928 by Robert E. Park, "Human Migration and the Marginal Man."[27] This is one of the first theoretical texts that posits hybridity and border crossing as explanatory factors behind the political and economic power of the United States. Park, the principal figure in the sociology department at the University of Chicago, rebuffed fellow Anglo-Americans who naïvely believed that either religious or racial purity could have been the foundation of the greatness the United States enjoyed. Ten years later in a follow-up essay, he wrote, "Inevitably [the marginal man] becomes, relative to his cultural milieu, the individual with a wider horizon, the keener intelligence, the more detached and rational view-point. The marginal man is always relatively the more civilized human being."[28]

Innovation is the product of those who stand at the margins and are most easily able to move between cultures. In ancient days, Park reminded his readers, they were nomads like Abraham, Isaac, and Jacob. In the twentieth century, the innovators would move between races as well as cultures. They were mulattos and mestizos in the Americas and Eurasians in the old world. Given the racial and ethnic politics of the United States in the 1920s, his argument could have had little immediate practical effect, but he helped prepare the ground for changes decades later. His arguments found a more receptive readership in Latin

America. Park's formulations, combined with Franz Boas's concepts of cultural relativism, provided intellectuals there with an inspiring rationale that challenged stereotypes that the primary impediment to progress in their countries had been the mass of impoverished Indian or mixed-blood peasants. If Park was right, the strongest force for modernization would be found in communities that appeared marginal. They needed access to a technical education that would provide skills for solving their most basic problems themselves.

In the Latin American situation, social theorists like Manuel Gamio found Park's concept of "marginal man" a useful way of conceptualizing the deep social and cultural divides of their nations and placed racial and ethnic divisions within a political and economic system that had fostered starkly differing levels of education and social mobility. The marginal man was the individual who could move between the value systems of his (or her) indigenous roots and the scientific and technological knowledge available from the broader world. His productivity rested in his becoming marginal to both and thus able to cobble together a creative understanding of the world. His imagination worked with the fragments of diverse cultural legacies, both within and without his homeland, to assemble a bricolage of the world that was open to innovation and invention. The marginal man's example augmented the possibilities for others to dissent from the groups that insisted on social solidarity as the basis for either national or local progress.[29]

The dilemma of artists speaking to public policy issues is that the internal logic of poetry as a materialization of a potential, of that which does not yet exist but which might, makes it impossible for them to make strategic, goal-oriented interventions. Others, like the students at Cornell who defended Martínez's *The Castle Is Burning*, must do that, and their engagement can turn the artist's imagination of hegemony overturned into an actuality. In most cases, this will not happen because the "public" that public intellectuals address is a notion rather than a situated group of people with interests to defend and advance. It may not have been chance that Martínez found his ideal audience at Cornell, but it was pure luck that the timing of his exhibition on campus allowed his concerns as an artist interrogating the discursive contradictions of U.S. society to coincide with the increasingly urgent need of students of color at one school to assert their own program for meaningful education.[30]

If there is no single public but only groups of people living and working in local situations, the visions of artists cannot be reducible to a common national experience, or even a common experience shared by women, gays, trade union members, Catholics, or members of a racialized group. Nor can art about borders emerge spontaneously out of the borderlands or the immediate confrontation of two distinct national cul-

tures. Formal expression requires the manipulation of discursive, institutional, and subjective traditions, each lodged in self-replicating organizations, which in professionalized disciplines claim the authority to determine what is and is not meaningful, what is and is not interesting, what is and is not innovative. To understand the imaginative space that artists from the United States, Mexico, and other nations offer as alternatives to a world of regulated borders, one needs to understand the institutional ethos enabling the practices of an artist. If a new "post-border" culture linking the United States and Mexico is to arise, it will require a synthesis of national expressive traditions facilitated through the emergence and consolidation of new arts and educational institutions that operate on both sides of the border.

Artists in Mexicali, like Ramón Tamayo, who taught in the drama and arts programs of the Universidad Autónoma de Baja California (UABC) before his death in 2007, dream that their city can be the home of a renaissance too, a rebirth linking a network of local sites, in exchange and interaction, each developing the rich potential that the imaginations and talents of their populations already possess. At the time Tamayo started working for the university, UABC had no degree-granting programs in the arts. Courses were offered exclusively as electives for personal improvement or recreational diversion and organized in conjunction with student clubs in theater, video, painting, photography, and music. Arts classes were open as well to the broader community as part of the general service the university provides to the citizens of the state, services that include regular arts festivals, concerts, and theater productions. The structure of the arts on campus conveyed a straightforward message that they are for personal enrichment and intellectual development, but they were to be a private rather than a professional interest. This structure, an effect of the state's double dependency on the United States and Mexico City, permitted Tamayo to develop a program that spoke to a much large public than most contemporary artists can reach. He chose to speak to his fellow citizens on the factors that held back the fullest development of their communities.

Mexicali is provincialized whenever its leaders assume that the practical tasks of nation building require the city to develop primarily for maquiladora production. "To include everybody is not a characteristic of contemporary culture," Tamayo decided.[31] That distribution of labor, which then drives the educational process, inevitably directs many residents away from their homes in order to find opportunity, much as he had had to travel to central Mexico to find appropriate training in the visual and performing arts.

The danger for anyone, artist or not, who lives in a provincial environment is an assumption that there are inadequate resources for activities,

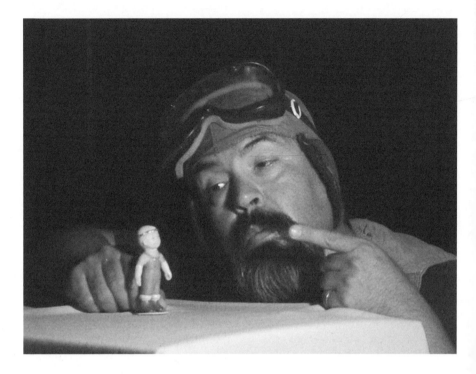

Figure 35. "El planeta del rey," scene from *El Principito*, teatro de mesa/
tabletop theater adaptation by Ramón Tamayo from Antoine De Saint-Exupéry;
performer: Ramón Tamayo; produced by La Bicicleta, 2001. Courtesy of Mónica
González and La Bicicleta, 2001.

which to be done well must be done elsewhere. The challenge is to
escape the self-censorship that accompanies provincialization. "We do
theater," Tamayo said, "but we have no theater, no lights. We accept the
conditions that we have." Shadow puppet theater or *teatro de mesa* (the-
ater performed on a tabletop) allows performance in a variety of limited
conditions, even if there is only one person available to present a play.
The "actors" for his one-performer version of Antoine de Saint-Exup-
éry's *The Little Prince* (*El Principito*, Figure 35) are Lego-like figures and
plastic toy dolls that he bought at the flea market. The performer moves
the figures on top of a portable table while shifting from voice to voice.
As products of commercial culture, the characters are grounded in cul-
tural icons that his audiences can easily identify—in this case Merlin, a
Star Trek figure, and a Ninja warrior who served as the Aviator.

In the theater of what Tamayo called "antispectacle," storytelling is
more important than technical bravura. The goal is to refocus the the-

ater experience onto the immediate presence of other human beings and what they can suggest with vocal and movement gestures: "Every person carries everything needed for theater in and on his own person."[32] If all the resources needed for creativity are always at hand, then "lack of resources" can never be a reason for not creating.[33] His sculpture likewise served dual purposes that mixed art and public service. Like any visual artist, he explored plastic form in a variety of media and then exhibited the completed work at museums and galleries. At the same time, these forms have been redesigned for an experiment conducted by the engineering and architecture faculties at UABC to create controlled microclimates in child care centers. Hooked up with water conduits and placed in relation to shade trees, his sculptures provide space where children can play outside during the summer, when the thermometer is usually above forty degrees Celsius. The project is not expensive, and the planners hope it will offer a prototype for providing schools in low-desert areas throughout Mexico and the Southwest United States with practical play space that is moist and cool.[34]

For Tamayo, theater, sculpture, and architectural projects equally reached out to his fellow citizens to suggest that solutions to their problems may be close at hand and not as expensive as they have been led to believe. Tamayo's strategies for creativity directly confronted the limitations of being part of a nation that is relatively poor and that has long made concentration of wealth and talent the central strategy for national development. He built on alternative traditions within Mexico that have focused instead on strengthening local talent. Following this strategy, the chief resource for progress lies within each human person, and Tamayo's efforts contributed to national welfare to the degree that he succeeded in challenging students, colleagues, and audiences to think more deeply about their marginality as a potential rather than as a liability.

He found a group of enthusiastic students, all of them studying to be agronomists, engineers, chemists, doctors, architects, and lawyers, the careers that the state has determined are most important for future economic growth. Working with Tamayo inculcated an ideal that the local should be valued and protected, that the citizens of Mexicali have the potential to develop things of value for other parts of the world.[35] A few have redirected their careers as Tamayo himself did, shifting from his undergraduate work in sociology to advanced studies in theater in Mexico City and Guanajuato. As a nationalist, he observed, "More than to protect Mexican culture, I want to share it, take it out, and let others enjoy it. . . . If the French know the history of Mexico as well as Mexicans know the history of France, there would be a recognition, a breaking of frontiers, and a shared history would develop. The same with the U.S."[36]

Neither the mounting of plays nor the exhibition of sculpture could, in and of itself, accomplish his broader goals. Tamayo provided another example of insisting on the universality of creativity and its presence even in the most banal of circumstances. It is a model that attracted students from other parts of Mexico and from other nations, who came to Mexicali to study with Tamayo and work in his productions.

Tamayo defined his work with theater form as a practice of antispectacle. The theater practitioner, whether performer or director, relearns the resources that he or she as an individual can master and deploy to a small, intimate audience. She relearns the power of direct personal contact and how that response can reshape what one presents. These are lessons appropriate for a theater of limited budget that fits within a bureaucratically defined goal of providing entertainment to children, senior citizens, and others in the community. It cannot compete with Hollywood or Mexican television. Those remain unchallenged staples of consumer culture. Small theater performances offer an alternative that reminds audiences of the emotional power that *can* come with direct, one-on-one contact with another human being. It offers an experience that commercial media cannot. The public enjoying antispectacle theater learns to see itself anew. This is micropolitics with a vengeance, as the only way it can proceed is by a slow process of percolating through society while reminding people of who they could be and restimulating the pleasures and desires of direct human contact. The practice is sustainable because it conforms to the missions of the Mexican university while providing an outlet for students seeking to participate in cultural life as creators rather than as consumers. To embrace the antispectacle is to accept the inevitability of limitations in any human situation and make one's marginality the basis for exploring and building upon the capacities a community actually possesses.

In a still imaginary future, the location of artists will (perhaps) be secondary to their participation in organizations dedicated to creating a common cultural life transcending the borders that divide humanity both between and within nations. The epistemological claims of modern and contemporary art practice have for more than a hundred years pointed strongly to that goal, but an organizational framework supportive of that goal has largely remained fragmentary and ad hoc. The imagination of a "postborder" world effected in the arts will inevitably be very different from what will be worked out simultaneously in journalism, the mass media, law, business, or politics. The images artists have offered have been critical, and perhaps frustrating to many, because artists do many inventive things but they cannot provide any practical guidance to the tough questions that those working in business and politics will have to answer or suffer the consequences.

The artist as a mediator of human experience falls into the logic of Robert Park's marginal man by providing through creative enterprise a possibility of moving between distinct ways of looking at the world. The conversation that artists try to initiate, with the indirection of media that escape the limits of words, yields often softly stated conclusions about how we in the present *should* act for the future. The ethical confrontation with potential meanings creates a situation where the play of imagination becomes imperative.

This new space does not alter the immediate facts of social relations, but by making present alternative ways of thinking, artists reveal social facts as actually unsettled, fluid, and ultimately suitable for renegotiation. The political work effected by artists has been and will likely remain a temporarily transformed framework for looking at the world. Their practice has not required a specific set of behaviors in response other than moving into that imaginative frame of mind that Daniel Joseph Martínez called "the third space" or Jay DeFeo called "a new reality." They, like every artist discussed in this book, have been "beasts at their millstones" working, in Martínez's words, "to temporarily transform the environment and alter perceptions."[37]

Conclusion
Improvising from the Margins

> How often, when probing what is on the fringes of a given problem, do we discover the most useful keys for dealing with the problem itself.
>
> —Manfredo Tafuri

In the first decades of the twentieth century, the San Francisco Bay Area had only a handful of places regularly showing modern art. At the beginning of 2009, publics with an interest in art had more than 250 possible venues, offering highly diverse programs with distinctive approaches to contemporary art practices.[1] Three new museums were in the planning stage, while both the San Francisco Museum of Modern Art and the Berkeley Art Museum were launching capital campaigns to expand gallery space for special exhibits and more regular display of sizable and growing permanent collections. Similar growth occurred somewhat earlier in Los Angeles, and a long-standing competition between the leaders of the two major metropolitan centers in the state has probably helped spur ambitious projects in the Bay Area. Expansion of art programming is found throughout the state, particularly in the fast-growing cities of San Diego and San José, but also in much smaller towns like Santa Barbara, Sacramento, Monterey, Santa Rosa, and Fresno. Open studio programs operate in every part of the state, as contemporary art has become an element in the tourism economy of the state. County and city governments have been supportive of arts programs, often using hotel taxes and public art set-aside requirements for large-scale commercial developments, to provide a financial base relatively more secure than grants to activity viewed as both economically and culturally significant. Beyond government support, the growth and increased stability of California's cultural institutions have come through impressive dona-

tions of money and time from the state's business and social leadership. Deciding on the right balance of regional and more internationally recognized work has long been a subject for tense debate for all institutions that have made contemporary art a regular part of their programming. At times disputes over how best to balance the variety of responsibilities has sundered boards of trustees with opposing priorities. The experience of the San Francisco Museum of Modern Art suggests that as the stature of an organization grows, programming balance shifts away from local experimentation toward work with recognized international value. Local artists continue to echo Fred Martin's complaint in 1963 that the museum does not give high enough priority to them. However, given the increased prestige that the museum has gained over the past four decades, when its curators do decide to mount an exhibit of a local artist, a broader, more international professional public will take note of the work. At the same time, dozens of other venues have opened that focus on exhibition of different types of local work. Weak to nonexistent institutional infrastructure is no longer one of the many problems artists face as they develop their careers.

The stories in the previous chapters suggest the difficulty of the process by which artists in the state developed a distinctive regional culture that inevitably reflected the ambiguities of their own social position. As important as the growth of museums, schools, and government arts programs has been, the growth of a culture in which contemporary art occupies a valued place is primarily the result of men and women imagining that it would be a good thing, both personally and for others, if they spent their lives practicing art. California cultural life took its particular shape as members of marginalized groups staked their claim to interpret modern life. They saw themselves helping develop a new type of art community that, like the University of California, the state's preeminent cultural institution, could be simultaneously democratic and rigorous.

Sam Rodia proved to be the quintessential California modern artist because he provided an exemplary model for transcending the dual challenge of personal marginality and regional provinciality. He created a work that was original even though the resources available to support his project were virtually nonexistent. Each of his limitations, whether of materials, real estate, finances, or his own education, passed through his creative imagination to become a positive element strengthening his statement. Because he had no fine arts training, preexisting standards of excellence did not constrain him, nor did the widely shared desires in the first half of the twentieth century to translate to the shores of California phantasmagorical images of an idealized Mediterranean heritage. He responded to the messy social conditions of his time with a single site-specific work that he clearly hoped would attract the attention and

approval of others. Rodia provided a model for cultural production no longer defined through a subordinate relationship to imaginary cultural capitals whose distance always marked the inadequacy of one's own immediate situation.[2]

As local arts communities grew rapidly after World War II and evidence of a distinctive regional culture gained the attention of national and international observers, the question still remained of how regional activity connected to what artists in other parts of the world were doing at the same time. If modern art was in fact a global movement aimed at freeing sensation and perception from social conventions, the new culture California artists developed needed to include an imaginary of both present and past, of distant colleagues with whom one's work was in dialogue. This was the challenge that Jay DeFeo, product of an ambitious experiment in public education, undertook. She had to be "funky" because improvisatory use of rough-hewn materials expressed the expansive, if rough-and-tumble, society that had identified her as a woman whose talent ought to be nurtured instead of suppressed. The professional and subjective paths she and her peers followed inevitably were improvised, for there were simply no models to imitate. Her embrace of a "classicizing" approach to composition and work method provided a mental structure within which to think innovatively as well as a relationship to a shared heritage that might help make the model her generation was developing readable to people in other places and times. The connection would be meaningful only to the degree that she could build upon the legacies she had inherited, to the degree that her work made understanding of one's heritage real and relevant for contemporary life. In the process, the large-scale ambitions that marked her work and that of many of her peers provided a basis for becoming full professionals whose intellectual and technical accomplishment ought to be of interest to anyone anywhere in the world.

Like DeFeo, Noah Purifoy worked with both modern and classic aesthetics in mind, but as he struggled to develop the relevance of contemporary art for the African American community, he confronted the question of how publics for art form and then are reproduced. If artists were to work toward the utopian ideal that an emotionally and sensationally intense physical experience can transform, or "refresh," to use Hippolyte Taine's terminology, how people look at their world, their work is important for the broadest possible public. However, given that complex organizations need to manage resources in predictable ways, arts institutions required much more limited publics whose appreciation could predictably sustain both daily operations and a manageable level of growth. The democratic ideals that had made Purifoy a professional artist who imagined his craft probing the contradictions of contempo-

rary life were in conflict with the organizational needs of his occupation. As the institution of art consolidated, modern ideals of art practice as a form of knowledge gave way to postmodern conceptions of art as self-authorizing, self-justifying practices. Purifoy started with an assumption that art practice could, and should, be conceived as a form of research, but results could be applied to a much wider range of social situations than had developed in contemporary museums or university art departments. To escape what he imagined as the golden cage of professionalism, he pursued a strategy of state-funded programs expanding the range of sustainable artist-public relations. His efforts were successful on their own terms but could not overturn the hierarchy that assigned lower worth and hence fewer resources to work produced in community-based situations. He also discovered that he could not be both an arts administrator and an artist. As an administrator, he could create new conditions for the building of contemporary culture, but only as an artist could he actually contribute to that culture.

Efforts on both sides of the U.S.-Mexican border to make art practice an important part of the understanding of border life demonstrate that the configuration of artist-public relations shapes what can be said effectively, who artists reach, and how work is received and interpreted. For practicing contemporary artists, regardless of the specific topics that they address or the methods with which they work, the incomplete, always contingent nature of professional autonomy remains a force driving improvisation and, on occasion, genuine innovation. The experiences of the artists examined in this book remain instructive for the different paths taken as the United States has developed a more diverse and inclusive culture. Questions of access and inclusion remain intensely contentious in part because participation in the professional art world by women or people of color remains the most limited at the most prestigious sites. The persistence of inequalities is particularly evident in one critical marker of success in the contemporary art world, the sales price an artist's work fetches, but their effects can be seen in other indicators of professional recognition such as the prestige of the museum where one exhibits or the ranking of the school where one teaches.[3] Nonetheless, the ability to create work that can reach a broader public and generate comment has widened dramatically. The pace of inclusion quickened after the 1960s, but the process itself goes more deeply into the past, suggesting that long-term trends are inclusive rather than exclusionary even if each step has been the occasion of bitter, often violent confrontation, as well as continuing frustration for many of the people involved. Underlying the development of modern, postmodern, and contemporary art has been a continuous battle of those from groups long excluded from intellectual work to insist that

their perspectives are indispensable in the shaping of a more equitable and realistic common culture.

Inclusion of more diverse participants in arts practice has accompanied and deepened the development of a more critical, a more contested culture. Contemporary art presents the contradictions of the contemporary world with a directness that would have surprised most modernist painters, many of whom strove to create an algebra for the translation of individual into intersubjective experience that could be shared in a manner that put apparently contradictory sensations into harmony with each other. Contemporary art has largely abandoned all ideas of harmony and resolution. The work is often difficult to absorb and grasp given the specialized practices and discourses that have developed around the construction and reception of aesthetic objects. Even if contemporary art has become more inclusive and, to that degree, consistent with the nation's ostensible democratic ideals, the practice of art has grown more complex and professionalized, more subject to formal constraints governing what work is shown and how it is discussed. Art is, and perhaps should remain, a discipline that works with forms, objects, processes, and ideas that are often difficult for the uninitiated to comprehend. In compensation, the alienation from routine ways of discussing well-known problems *may* stimulate an entirely new way of looking at a topic once a viewer has overcome the challenge of the unfamiliar. There are no guarantees, and indeed most work probably fails, but that is the gamble that both artist and public take. The question for society has been whether anybody can be initiated who is willing to make the effort.

The relationship of art to its potential publics remains a complicated question in a society where education has become a central foundation of privilege and power. The ability of a discipline to function as a social force rests on the ability of its practitioners to assert the autonomy of their work from the judgment of those external to the field. Work cannot be overly accessible if its justification is to expose and challenge conventional ways of perceiving and feeling. Estrangement generates a particular creative approach that requires unusual levels of critical judgment to absorb intelligently. Curators and critics have become the first, and to some degree, core public for contemporary art precisely because their training and work experience help them evaluate new work and determine what should be brought to the attention of other, less involved publics. They occupy a position comparable to peer reviewers in the sciences. Their judgments have practical effects for what is shown and discussed, as well as what is bought, but given the large number of organizations involved in exhibiting and interpreting contemporary art, the opinions curators and critics form are in no way homogeneous.

Despite the impossibility of a unanimous opinion on almost any question, the intensity of debate and discussion underscores the important role of expertise in the current configuration of contemporary art.

Artists and others who think that an artwork could, or ought to, communicate directly with a broader public must confront the paucity of support available for alternative practices. In that sense, they find themselves in a position comparable to their predecessors in provincial places like California before the boom in the visual arts of the 1960s. Improvisatory strategies developed for a cultural environment that assumed value lay elsewhere remain relevant to contemporary practice, even if the "elsewhere" whose authority must be confronted has shifted to structures that are inherent to the professional standards that, in principle, protect and expand the ability of all artists to work as freely and as deeply as they can. Aesthetic autonomy has been a precondition for being able to make statements about the contemporary world that are not already predetermined by political ideology. Yet by the same token, if free expression is a necessary precondition for any artist to make an original contribution, every generation of emergent artists confronts an inherent, existential challenge of learning how to break away from the institutional requirements particular to their own historical moment without losing the intellectual autonomy that makes what they do potentially interesting to many, many others looking for alternative ways of feeling that can replace complex, often intractable realities with experiences powerful enough to put ideas back into play.

Notes

Introduction

Note to epigraphs: Edward Kienholz, "Los Angeles Art Community: Group Portrait, Edward Kienholz," interview by Lawrence Weschler, Oral History Program, University of California, Los Angeles, 1976, 330. Fred Martin to Herschel Chipp, November (no year), Fred Martin Papers, Archives of American Art, Smithsonian Institution.

1. Fred Martin, "Art and Power, Esthetics and History, and the August Exhibitions at the San Francisco Museum of Art," *Artforum* 2 (October 1963), 47–48, followed by exchange between George D. Culler and Martin, 48–49. Page numbers for quotations will be cited parenthetically in the text.

2. Richard Cándida Smith, *Utopia and Dissent: Art, Poetry, and Politics in California* (Berkeley: University of California Press, 1995).

3. Martin Heidegger, "Die Zeit des Weltbildes," in Martin Heidegger, *Holzwege* (Frankfurt: V. Klostermann, 1950), 69–104; on the modern turn toward subjectivity, 98.

4. Immanuel Kant, *Political Writings*, trans. H. B. Nisbet (Cambridge: Cambridge University Press, 1991), 54.

5. Georg Wilhelm Friedrich Hegel, *The Philosophy of Right*, trans. T. M. Knox (Oxford: Oxford University Press, 1967), 286.

6. Following the suggestion of Roland Barthes, I do not assume that representation ever implied mimesis of an actually existing reality. Representation takes place whenever "a subject (author, reader, spectator, or observer) directed his *gaze* toward a horizon . . . [and] projects fragments in order to describe them" (Roland Barthes, "Diderot, Brecht, Eisenstein," in *The Responsibility of Forms: Critical Essays on Music, Art, and Representation*, trans. Richard Howard [New York: Hill and Wang, 1985], 90).

7. William James, *Principles of Psychology* (Cambridge, Mass.: Harvard University Press, 1982), 221.

8. James, *Principles of Psychology*, 277.

9. For more on this point and the pleasures that interaction with those whose rationality is initially incommensurable with one's own brings, see Jean-Luc Nancy, *The Birth to Presence*, trans. Brian Holmes (Stanford, Calif.: Stanford University Press, 1993), 222, and Maurice Merleau-Ponty, *The Primacy of Perception and Other Essays in Phenomenological Psychology, the Philosophy of Art, History, and Politics*, ed., James E. Edie (Evanston, Ill.: Northwestern University Press, 1964), 12–19, 117–118.

10. On the centrality of the ability to replicate innovations, understood

equally as a formal and as a social institutional concept, see George Kubler, *The Shape of Time: Remarks on the History of Things* (New Haven, Conn.: Yale University Press, 1962).

11. Wlad Godzich, "Religion, the State and Post(al) Modernism," afterword to Samuel Weber, *Institution and Interpretation* (Minneapolis: University of Minnesota Press, 1987), 163.

12. Kubler, *The Shape of Time*, 8. See also related critiques of the "author" in Roland Barthes, "The Death of the Author," in *Image, Music, Text*, trans. Stephen Heath (New York: Hill and Wang, 1977); Michel Foucault, "What Is an Author?" *Screen* 20, no. 1 (Spring 1979): 13–33; Adam Richardson, "The Death of the Designer," *Design Issues* 9, no. 2 (Fall 1993): 34–43; and *Theories of Authorship*, ed. J. Caughie (London: Routledge and Kegan Paul, 1981).

13. Ludwig Wittgenstein, *Philosophical Investigations*, trans. G. E. M. Anscombe (Oxford: Blackwell, 1967), §43.

14. Rush Rhees, *Wittgenstein and the Possibility of Discourse* (Cambridge: Cambridge University Press, 1998), 138.

15. In the opening of his State of the State speech, 9 January 2007, Governor Arnold Schwarzenegger declared, "I believe that together not only can we lead California into the future . . . we can show the nation and the world how to get there. We can do this because we have the economic strength, we have the population and the technological force of a nation-state. We are the modern equivalent of the ancient city states of Athens and Sparta. California has the ideas of Athens and the power of Sparta. As you know, California, if a nation, would be the sixth largest economy in the world. But it goes so much beyond that. According to *The Economist* magazine, California is home to three of the top six universities in the world. California has more Nobel Laureates, more scientists, more engineers, more researchers, more high-Tech companies than any other state. We are responsible for one of every four U.S. patents. We account for one of every five U.S. technology jobs. We attract almost half of all U.S. venture capital, which funds the ideas and industries of the future. California leads the nation in biotechnology. We lead the nation in nanotechnology. We lead the nation in medical technology. We lead the nation in information technology. And we will soon be recognized as the leader in clean technology." (Text on-line at <http://gov.ca.gov/press-release/5089/>.) The boosterist rhetoric Schwarzenegger employed is commonplace for the state's political and economic elites, both Republican and Democratic.

16. Attendance figures for the San Francisco Museum of Modern Art courtesy of the Library and Special Collections at the museum. My thanks to Barbara Rominski, the head of the library, for her help with my questions. Rominski has cautioned that figures prior to 1990 remain unreliable indicators of actual museum attendance given the lack of independent verification.

17. Attendance cited in Madeleine Grynsztejn, "(Y)Our Entanglements: Olafur Eliasson, the Museum, and Consumer Culture," in *Take Your Time: Olafur Eliasson*, ed. Madeleine Grynsztejn (San Francisco: San Francisco Museum of Modern Art, 2007), 11.

Chapter 1. The Case for Modern Art as a Distinct Form of Knowledge

1. Later published as Hippolyte Taine, *Philosophie de l'Art*, 2nd ed. (Paris: Librairie Germer Baillière, 1872), 68.

2. Michel Bréal, "The Latent Concepts of Language," in *The Beginnings of*

Semantics: Essays, Lectures, and Reviews, trans. George Wolf (Stanford, Calif.: Stanford University Press, 1991), 83–84. On Bréal, see George Wolf, "Translator's Introduction: The Emergence of the Concept of Semantics," in *The Beginnings of Semantics,* 3–17; Hans Aarsleff, *From Locke to Saussure: Essays on the Study of Language and Intellectual History* (Minneapolis: University of Minnesota Press, 1982); and Brigitte Nerlich, *Change in Language: Whitney, Bréal, and Wegener* (New York: Routledge, 1990). See also Paul Ricœur, *The Rule of Metaphor: Multidisciplinary Studies of the Creation of Meaning in Language,* trans. Robert Czerny (Toronto: University of Toronto Press, 1977), 44.

3. For the importance of this method to impressionist work, see Steven Z. Levine, *Monet and His Critics* (New York: Garland, 1976), 103.

4. Paul Signac identifies this difference in *De Delacroix au néo-impressionnisme* (1899; repr. Paris: Hermann, 1964), 70.

5. Charles F. Stuckey, *Monet: Water Lilies* (New York: Hugh Lauter Levin, 1988), 19–21.

6. On Clemenceau, see Gregor Dallas, *At the Heart of a Tiger: Clemenceau and His World* (New York: Carroll and Graf, 1993); David Robin Watson, *Georges Clemenceau: A Political Biography* (New York: David McKay, 1974); Wythe Williams, *The Tiger of France: Conversations with Clemenceau* (New York: Duell, Sloan, and Pearce, 1949); and Georges Lecomte, *Georges Clemenceau: The Tiger of France,* trans. Donald Clive Stuart (New York: D. Appleton, 1919).

7. Georges Clemenceau, *Claude Monet* (Paris: Librairie Plon, 1928), 11.

8. Clemenceau, *Claude Monet,* 19–20. Linda Nochlin places Monet's painting of his dead wife in a genre of mid-nineteenth-century paintings that presented dead bodies with detailed observation of the state of the corpse instead of sentiment. Monet's painting is distinguished by the close relationship of the subject to the painter, which may account for the intensity of the brushwork. Monet, in any event, was less concerned with the physicality of the body than with the light and color effects occurring before his eyes on the skin of a person who has just died. See Linda Nochlin, *Realism* (Harmondsworth: Penguin Books, 1971), 63.

9. Clemenceau, *Claude Monet,* 7, 9.

10. Clemenceau, *Claude Monet,* 19–20.

11. Clemenceau, *Claude Monet,* 36. Clemenceau followed nineteenth-century conceptions in stating that emotions are responses to underlying vibrations, the phenomenal forms of which take shape in visual, auditory, or other sensory stimuli.

12. Clemenceau, *Claude Monet,* 20.

13. Clemenceau, *Claude Monet,* 80.

14. See Daniel Wildenstein, *Claude Monet: Biographie et Catalogue Raisonné* (Lausanne: Bibliothèque des Arts, 1974), for a complete edition of Monet's correspondance in relation to his paintings and background interpretation.

15. Clemenceau, *Claude Monet,* 111, 116.

16. This particular marker was also significant to Paul Cézanne's reputation and is a factor in Gustave Kahnweiler's advice to Picasso and Braque that they strictly refuse to theorize verbally about their cubist paintings or engage in disputations with other painters over the functions of art.

17. Clemenceau quoted in Dallas, *At the Heart of a Tiger,* 452; full text in Georges Clemenceau, *Discours de guerre* (Paris: Librairie Plon, 1934), 157–182.

18. Clemenceau, *Claude Monet,* 115.

19. On Taine, see François Aulard, *Taine, historien de la révolution française* (Paris: A. Colin, 1928), Thomas H. Goetz, *Taine and the Fine Arts* (Madrid: Playor, 1973), and John Morley, *Biographical Studies* (London: Macmillan, 1923)

20. Taine, *Philosophie de l'Art*, 19, 23–24, 26.

21. American translation by John Durand, 41 (*Philosophy of Art*, New York: Holt and Williams, 1871). In the French original: "il regarde les choses elles-même, il les étudie minutieusement et anxieusement" (26).

22. Taine, *Philosophie de l'Art*, 27–28.

23. Taine's characterization of French classicism was overstated and developed in full in the first volume of his later book *Les Origines de la France contemporaine* (Paris: Hachette, 1876), in which he asserted, "There is nothing alive in the eighteenth century" (258). His contemporaries were well aware that his view completely ignored the revolutionary changes in literary expression that Rousseau and Diderot, among others, had effected.

24. Hippolyte Taine, *De l'Intelligence* (Paris: Librairie Germer Baillière, 1869), 23, 35–37, 73; published in English in a translation by T. D. Haye as *On Intelligence* (New York: Holt & Williams, 1872).

25. Taine, *Philosophie de l'Art*, 60–61.

26. The reforms are discussed in detail in Albert Boime, "The Teaching Reforms of 1863 and the Origins of Modernism in France," *Art Quarterly*, n.s., 1 (1977), 1–39. In *The Academy and French Painting in the Nineteenth Century* (London: Phaidon, 1971), Boime outlines in greater detail the continuities linking academic and independent painting in the second half of the century.

27. Taine, *Philosophie de l'Art*, 42–43.

28. Taine, *Philosophie de l'Art*, 51.

29. Taine, *Philosophie de l'Art*, 154.

30. Taine, *Philosophie de l'Art*, 155–156.

31. Taine specifically praised the unity of nation and crown that he claimed had been achieved by the parliamentary monarchy of Louis-Philippe and consolidated through Napoleon III's restoration of the French Empire in his coup d'état of 1851. The revolution of 1789 was not celebrated nationally until 1879, when the leaders of the Third Republic turned to the first revolution to validate their regime.

32. Taine, *Philosophie de l'Art*, 158–161.

33. See John House, *Monet: Nature into Art* (New Haven, Conn.: Yale University Press, 1986), 220, and Steven Z. Levine, "The 'Instant' of Criticism and Monet's Critical Instant," *Arts Magazine* 55 (March 1981), 114–121.

34. Octave Mirbeau, *Claude Monet* (Paris: Galerie Georges Petit, 1889), 11–12, 14–15.

35. This aspect of Clemenceau's thought is explored in Dallas, *At the Heart of a Tiger*, 194.

36. Clemenceau, *Claude Monet*, 53–54, 79.

37. My thinking on this issue has been influenced by Samuel Weber, *Institution and Interpretation* (Minneapolis: University of Minnesota Press, 1987).

Chapter 2. Modern Art in a Provincial Nation

1. Paul Signac to Henri-Edmond Cross, undated but ca. 1896, in Signac Papers, Department of Special Collections, Getty Research Institute for the History of Art and the Humanities. See also Richard Cándida Smith, *Mallarmé's Children: Symbolism and the Renewal of Experience* (Berkeley: University of California Press, 1999), 202–251, for a more extended discussion of U.S.-French cultural interaction at this time.

2. See T. J. Clark, *The Painting of Modern Life: Paris in the Art of Manet and His Followers* (New York: Alfred A. Knopf, 1985).

3. On the division of the impressionists into two camps, one focusing on landscape and the other exploring the urban scene, see John Rewald, *History of Impressionism* (New York: Museum of Modern Art, 1973), chaps. 12–13, and Joel Isaacson, *The Crisis of Impressionism, 1878–1882* (Ann Arbor: University of Michigan Museum of Art, 1979).

4. See C. Wright Mills, "Diagnosis of Our Moral Uneasiness" and "The Unity of Work and Leisure," in *People, Power, Politics: The Collected Essays of C. Wright Mills* (New York: Oxford University Press, 1963), 330–338, 347–352, for analyses of the dilemmas the concept of leisure posed in the United States in the mid-twentieth century.

5. Boston Art Students Association, *Art Studies in Paris* (Boston, 1887).

6. See, for example, "The American Student at the Beaux-Arts," *The Century* 23 (1882), 259–272, for a discussion of Beaux-Arts training methods and the value of its techniques for American subjects; for a later discussion suggesting it was time for communities in the United States to establish their own art schools combining French science and U.S. vigor, see "Shall Our Young Men Study in Paris?" *The Arena* 13 (1895), 131–134.

7. E. Boyd Smith's journals are located in the E. Boyd Smith Papers, Archives of American Art, Smithsonian Institution. All quotations are from this collection.

8. The work of Puvis de Chavannes was particularly important for Smith and may be among the work he viewed at the Palais Luxembourg. He was also particularly fond of the work of Toulouse-Lautrec, which he would have seen in independent galleries. See "About E. Boyd Smith" (Brooklyn Public Library), online at http://www.brooklynpubliclibrary.org/hunt/smith.html.

9. "Many Fine Pictures," *Kansas City Times*, 11 December 1888, p. 1.

10. Lorser Feitelson, "Tape-Recorded Interview with Mr. Lorser Feitelson, May 12, 1964," interview by Betty Lochrie Hoag, Archives of American Art, Smithsonian Institution, 3.

11. Clay Spohn, "Tape-Recorded Interview with Clay Spohn at His Studio in Grand Street, New York City," interview by Paul Cummings, 1976, Archives of American Art, Smithsonian Institution, 21.

12. Malcolm Bradbury and James McFarlane, "The Name and Nature of Modernism," in *Modernism 1890–1930*, ed. Malcolm Bradbury and James McFarlane (London: Penguin Books, 1976), 38.

13. Catalogue, Los Angeles Modern Art Society, Second Annual Exhibition, 5–30 March 1918, foreword.

14. David Hollinger, "The Knower and the Artificer," *American Quarterly* 39 (1987), 37.

15. On the Society of Six, see Nancy Boas, *Society of Six: California Colorists* (Berkeley: University of California Press, 1997).

16. On light and space, see Melinda Wortz, *California Perceptions: Light and Space* (Fullerton: California State University, Fullerton, Art Gallery, 1979); Paul J. Karlstrom and Susan Ehrlich, *Turning the Tide: Early Los Angeles Modernists 1920–1956* (Santa Barbara, Calif.: Santa Barbara Museum of Art, 1990); on Beatrice Wood, Theosophy, and the use of light-altering glazes, see Garth Clark, *Gilded Vessel: The Lustrous Life and Art of Beatrice Wood* (Brighton, England: Guild, 2001).

17. David Joseph Singal, "Towards a Definition of American Modernism," *American Quarterly* 39 (1987), 8.

18. Brief expositions of modernism as a cultural system can be found in Bradbury and McFarlane, "The Name and Nature of Modernism," 20–49; and Bruce Robbins, "Modernism in History, Modernism in Power," in *Modernism Reconsidered*, ed. Robert Kiely (Cambridge, Mass.: MIT Press, 1983), 231–239.

19. In 1926 Einstein wrote Max Born, "Quantum mechanics is certainly imposing. But an inner voice tells me that it is not yet the real thing. The theory says a lot, but does not really bring us any closer to the secret of the 'old one.' I, at any rate, am convinced that He does not throw dice." Einstein's observation has frequently been paraphrased as "God does not play dice" or "God does not play dice with the universe." Max Born and Albert Einstein, *The Born-Einstein Letters: Friendship, Politics, and Physics in Uncertain Times*, trans. Irene Born (New York: Macmillan, 2005), 88.

20. Raymond Williams, *The Politics of Modernism: Against the New Conformists* (London: Verso, 1989), 38. See also Williams, "Base and Superstructure in Marxist Cultural Theory," *New Left Review* 82 (November–December 1973), 3–16.

21. "Vorticist Manifesto," *Blast* no. 1 (20 June 1914), 1–20; Ezra Pound, "Vorticism," *Fortnightly Review* 96, no. 573 (June 1914), 461–471.

22. William Carlos Williams posed his idea that a poem is a machine for words against a conception of poems as statements of preexisting ideas and values waiting to be expressed. The words Williams deployed in a poem were to generate sensations striving to become ideas. In the process, the *act* of poetry was a process of discovery revealing the lessons of experience hidden within the body. See Williams, *The Great American Novel* (1923; repr. Copenhagen: Green Integer, 2003), 5–11.

23. Diary entry by Macdonald-Wright's student Mabel Alvarez for 2 May 1928, Mabel Alvarez Papers, Archives of American Art, Smithsonian Institution. Macdonald-Wright's ideas stem from the late nineteenth-century theories of Charles Henry, a French psychological experimenter and writer on aesthetics who influenced Seurat, Signac, and other postimpressionist painters. For a discussion of Henry and his influence on French painters, see Cándida Smith, *Mallarmé's Children*, 134–138, 202–204.

24. Arthur Millier, "Postsurrealism or Subjective Classicism: A Means to a Genuinely Contemporary Art," in Ferdinand Perret Papers, Notebooks on California Artists, Lorser Feitelson file, roll 3856, Archives of American Art, Smithsonian Institution. On the postsurrealists see Richard Cándida Smith, *Utopia and Dissent: Art, Poetry, and Politics in California* (Berkeley: University of California Press, 1995), 9–31.

25. Wolfgang Paalen, "The New Image," *Dyn*, no. 1 (April–May 1942), 7–8.

26. Paalen, "The New Images," 9.

27. Paalen, "The New Images," 13, 15.

28. T. Jackson Lears, *No Place of Grace: Antimodernism and the Transformation of American Culture, 1880–1920* (New York: Pantheon Books, 1981).

29. Diary entry for 10 December 1918, Alvarez Papers.

30. Diary entry for 18 March [1919?], Alvarez Papers.

31. Diary entry for 8 June 1919, Alvarez Papers.

32. In 1916 Ezra Pound proposed a distinction between perceptual and cognitive art that influenced poets and critics of the interwar period. Writing on the sculptor Henri Gaudier-Brzeska, Pound argued that artists who focus on the act of perception operate as receivers of impressions, from which they derive meaning. Such artists accept the external world as the dominant reality and see the

human being as a product of circumstances. The artist who focuses on cognitive process directs "a certain fluid force against circumstance, as *conceiving* instead of merely reflecting and observing." External reality was a jumble of meaningless events until an intelligent mind imposed order through the creation of images. See *Gaudier-Brzeska: A Memoir* (1916; repr. New York: New Directions, 1970), 89–90.

33. Diary entry for 2 May 1928, Alvarez Papers.

34. Biographical data on Sabato "Sam" Rodia (see n. 4 in Chapter 7 for use of "Simon Rodia") are based on David Johnston, "Towering Indifference," *Los Angeles Times*, Calendar section, 14 August 1984; Jules Langsner, "Sam of Watts: Three Bizarre Towers built by S. Rodilla," *Arts and Architecture* 68 (July 1951), 23–25; *Simon Rodia's Towers in Watts*, exh. cat. (Los Angeles County Museum of Art, 1962); Calvin Trillin, "Reporter at Large: Watts Towers, Los Angeles, 'I Know I Want to Do Something,'" *New Yorker*, 41 (29 May 1965), 72+; "The Watts Towers," pamphlet published by the Committee for Simon Rodia's Towers in Watts, Los Angeles, ca. 1960; and Leon Whiteson, *The Watts Towers of Los Angeles* (Oakville, Ontario: Mosaic Press, 1989). See also Edward Landler and Brad Byer, *I Build the Tower* (film produced by Brad Byer and Bench Movies, 2006).

35. Quoted in *Simon Rodia's Towers in Watts*, 11.

36. Langsner, "Sam of Watts," 25.

37. William C. Seitz, *The Art of Assemblage* (New York: Museum of Modern Art, 1961), 6.

38. Peter Bürger, *Theory of the Avant-Garde*, trans. Michael Shaw (Minneapolis: University of Minnesota Press, 1984), 72.

39. Bürger, *Theory of the Avant-Garde*, 77–78.

40. See Jürgen Wissmann, "Collagen oder die Integration von Realität im Kunstwerk," in *Immanente Ästhetik: Ästhetische Reflexion* (Munich: Wilhelm Fink Verlag, 1966), 327–360, on the distinction between organic and constructed work in the development of modernism.

41. Ernesto De Martino, *Mondo popolare e magia in Lucania* (Rome: Matera, 1975), 39.

42. This summary is drawn from De Martino's *Mondo popolare*, particularly the first chapter, "Intorno a una storia del mondo popolare subalterno," and his *La fine del mondo: Contributo all'analisi delle apocalissi culturali* (Turin: Giulio Einauldi, 1977), 212–282.

43. De Martino, *Mondo popolare*, 136.

44. "Being," translated from the Italian word *esserci*, the word Italians use to translate the German philosophical term *Dasein*, often untranslated in English or translated as "Being-there." *Esserci* refers to a being conscious of itself as a subject, whose most fundamental nature involves awareness that it has a relationship to Being, that is everything else that has or can exist. The quotations are from Ernesto De Martino, *Il Mondo magico* (Turin: Giulio Einauldi, 1948), 145.

45. Nathaniel Hawthorne, *The House of Seven Gables* (New York: Airmont, 1963), 209.

46. Perry Anderson, "Modernity and Revolution," *New Left Review* 144 (March–April 1984), 96–113.

47. Letter to Helen Lundeberg, 11 December 1947, Lorser Feitelson and Helen Lundeberg Papers, Archives of American Art, Smithsonian Institution, rolls 1103–1104.

Chapter 3. Modern Art and California's Progressive Legacies

1. John Aubrey Douglass, *The California Idea and American Higher Education: 1850 to the 1960 Master Plan* (Stanford: Stanford University Press, 2000), 1–11.

2. Douglass, *The California Idea*, 81–113; see also Clark Kerr, *The Gold and the Blue: A Personal Memoir of the University of California, 1949–1967*, vol. 2: *Political Turmoil* (Berkeley: University of California Press, 2003), 4–10, 17–22.

3. Howard Singerman, *Art Subjects: Making Artists in the American University* (Berkeley: University of California Press, 1999), 12–16, 19–22.

4. *The Centennial Record of the University of California*, ed. Verne A. Stadtman (Berkeley: University of California Printing Department, 1968), 79; Stephen C. Pepper, "Art and Philosophy at the University of California, 1919–1962," interview by Suzanne Riess, 1961 and 1962, Regional Oral History Office, Bancroft Library, University of California, Berkeley, 163–172.

5. Pepper, "Art and Philosophy," 252. For comparative assessments of the Berkeley studio art program in relation to other approaches to art education after World War II, see Robert Goldwater, "The Teaching of Art in the Colleges of the United States," *College Art Journal* 2 (1943), 3–31; Committee on Art in Higher Education, "A Statement on the Practice of Art Courses," *College Art Journal* 4 (1944), 33–38; John Alford, "Art, Science, and the Humanities in the College Curriculum, I: The Scope of the Problem," *College Art Journal* 5 (1946), 162–179; Committee on Art in Higher Education, "The Practice of Art in a Liberal Education," *College Art Journal* 6 (1946), 91–97; Philip R. Adams, "The Fine Arts in Liberal Education," *College Art Journal* 7 (1948), 184–190; Stefan Hirsch, "An Appraisal of Contemporary Art Education," *College Art Journal* 10 (1950), 150–156; Ernest Ziegfeld, *Art in the College Program of General Education* (New York: Bureau of Publications, Teachers College, Columbia University, 1953); David Manzella, "The Teaching of Art in the Colleges of the United States," *College Art Journal* 15 (1956), 241–251; Mary Jean File, *A Critical Analysis of Current Concepts of Art in American Higher Education* (Washington, D.C.: Catholic University of America Press, 1958); Guy Albert Hubbard, "The Development of Visual Arts Programs in the Curriculums of American Colleges and Universities" (Ph.D. diss., School of Education, Stanford University, 1962); Andrew C. Ritchie, *The Visual Arts in Higher Education* (New York: College Art Association of America, 1966); Arthur D. Efland, *A History of Art Education: Intellectual and Social Currents in Teaching the Visual Arts* (New York: Teachers College Press, 1990).

6. Progression of the course synthesized from class notes for Art 2A in Worth Ryder Papers, Bancroft Library, University of California, Berkeley. Lecture and observation notes related to the class were collected together but not organized by term. See also Ryder, "Dynamics of Picture Surface," notes for Art 173, 12 August 1938, Worth Ryder Papers.

7. Worth Ryder, "On Conventions and a Symbolic Art" [undated], in Worth Ryder Papers.

8. Worth Ryder, "Lecture on Cubism," undated, lecture 14 for Art 173, Worth Ryder Papers.

9. Worth Ryder, "To a Class of Students in Drawing," Art 2A, spring 1946, Worth Ryder Papers.

10. Worth Ryder, notes for spring 1948 course, Worth Ryder Papers.

11. Charlotte Streifer Rubinstein, *American Women Artists* (Boston: Avon, 1982), 216; San Francisco Museum of Modern Art, untitled brochure prepared for an exhibition of work by Margaret Peterson, 1973; Rick Therrien, *Beyond the*

Sun: A Portrait of Margaret Peterson (National Film Board of Canada, 1988). The summary of Peterson's views is also based on interviews conducted in summer 2000 by the author with former Peterson students Mary Murchio, Eleanor Anderson, Ruth Illg, Colin Graham, and her friend Professor Emeritus of Biology Howard Bern. For examples of Peterson's work, see http://aggv.bc.ca/mansion-madness/artist_m_peterson_klukwan.html and http://aggv.bc.ca/mansion-madness/artist_m_peterson_stormgods.html.

12. Pat Adams, interview by author in her home at Bennington, Vermont, 23–25 March 2004, in author's possession.

13. Fred Martin, "Art and History—About Education," *Artweek* 23 (9 July 1992), 3+; interviews by author with Fred Martin (14 and 21 September 2006) and Sonya Rapoport (26 June and 4 October 2006) for the Department of Art Alumni Oral History Project, Regional Oral History Office, Bancroft Library, University of California, Berkeley; Adams interview. For examples of student color exercises created for Peterson, see videotape excerpt from the author's interview with Rapoport, 4 October 2006, for the Department of Art Alumni Oral History Project, on-line at http://bancroft.berkeley.edu/ROHO.

14. Jay DeFeo, untitled interview by Paul J. Karlstrom, 1976, Archives of American Art, Smithsonian Institution, 3, 14–17; on-line at http://www.aaa.si.edu/collections/oralhistories/oralhistory/defeo 75.htm. See also interviews by author with Fred Martin and Sonya Rapoport for the Department of Art Alumni Oral History Project.

15. Jay DeFeo, lecture to students, at Mills College, part 1, 2 December 1986, videotape in archives of the Estate of Jay DeFeo, Berkeley, Calif.; Jay DeFeo, interview by Sidra Stich, 19 August 1988, tape 2A, side 2, and 23 September 1988, tape 4A, side 2, untranscribed tape recordings in archives of the Estate of Jay DeFeo.

16. Susan Landauer, "Searching for Selfhood: Women Artists of Northern California," in *Independent Spirits: Women Painters of the American West, 1890–1945*, ed. Patricia Trenton (Berkeley: University of California Press, 1995), 10–11.

17. Lena Wiltz Emery to Jay DeFeo, undated letter ca. early 1950s, in Jay DeFeo Papers, Bancroft Library.

18. See Pat Adams Papers, Archives of American Art, Smithsonian Institution; Adams interview. Fred Martin's art teacher at Alameda High School in Alameda, a small East Bay town near Oakland, also encouraged his inclination to be an artist, helping him overcome his fear of disappointing his parents and their expectations that he would major in the sciences; it would be incorrect to identify this network as exclusively gender-defined in its orientation (Martin interview.

19. See Richard Cándida Smith, *Utopia and Dissent: Art, Poetry, and Politics in California* (Berkeley: University of California Press, 1995), 3–31, and Chapter 2 of this book, for more discussion of this theme as it pertained to the developing art scene in the 1930s and the 1910s, respectively.

20. On Dow's place in U.S. art education, see Singerman, *Art Subjects*, 109–112.

21. Annita Delano, "Southwest Artist and Educator," interview by James V. Mink, 1971, Oral History Program, University of California, Los Angeles, 54.

22. Delano, "Southwest Artist and Educator," 122

23. Delano, "Southwest Artist and Educator," 91–95, 200–215, 229, 283–311.

24. Episode recounted in Pat Adams journals, 5 February 1987, Adams Papers.

25. Lena Wiltz Emery to Jay DeFeo, 27 July 1965, DeFeo Papers.

26. Dorothy De Feo to Jay DeFeo, 2 October 1979, DeFeo Papers.

27. Photographs from high school excursions that DeFeo saved are in the DeFeo Papers.

28. For a photograph of DeFeo wearing clothes that she designed while a student at Berkeley, see http://www.jaydefeo.org/contacts.html.

29. For examples see Rebecca Solnit, *Secret Exhibitions: Six California Artists of the Cold War Era* (San Francisco: City Lights Books, 1990), or Stephanie Barron, Sherrie Bernstein, and Ilene Susan Fort, *Made in California: Art, Image, and Identity, 1900–2000* (Berkeley: University of California Press, 2000).

30. Kerr, *The Gold and the Blue*, 4.

31. Clark Kerr, *The Uses of the University* (Cambridge, Mass.: Harvard University Press, 1963).

32. Cándida Smith, *Utopia and Dissent*, 269–298.

33. Vicki Reed, "Kitchen Odds and Ends Unite in Artistic 'Florals,'" *San Jose Mercury-News*, 2 February 1966; in Jay DeFeo Papers, Box 13:9, Mary Murphy: Clippings, 1966–1979, n.d.

Chapter 4. From an Era of Grand Ambitions

1. Fred Martin quoted in Seymour Howard, John Natsoulas, and Robert Duncan, *The Beat Generation Galleries and Beyond* (Davis, Calif.: John Natsoulas Press, 1996), 2.

2. Jay DeFeo, interview by Sidra Stich, 23 September 1988, tape 4A, side 2, untranscribed, Estate of Jay DeFeo, Berkeley, Calif.

3. Pat Adams recalled that DeFeo discussed Jung "all the time" when she was in Florence and in New York, with particular emphasis on the integration of the personality achieved through symbols (Pat Adams, interview by author, 23 March 2004, at her home in Bennington, Vermont), in author's possession. For DeFeo's statements on Jung, see Jay DeFeo, interview by Sidra Stich, 19 August 1988, tape 2A, side 2.

4. "Interview with Jay De Feo—Conducted by Paul J. Karlstrom, at the Artist's home in Larkspur, California, June 3, 1975," Archives of American Art, Smithsonian Institution, online at http://www.aaa.si.edu/collections/oralhistories/transcripts/defeo 75.htm.

5. Alfred Frankenstein, "Bruce Conner Exhibit—Magic in Disorder," *San Francisco Chronicle*, undated clipping, ca. 1959 or 1960, in Jay DeFeo Papers, Bancroft Library, University of California, Berkeley.

6. Jay DeFeo to Pat Adams, 12 December 1951; undated letter mailed from London [winter 1952]; Pat Adams Papers, in possession of artist.

7. Suzanne Kotz, ed., *Jean Fautrier 1898–1964* (New Haven: Yale University Press, 2002); David Ebony, "Jean Fautrier: Rapturous Texture," *Art in America* (September 2003), 94–97, 135; *Jean Fautrier* (Paris: Musée d'Art Moderne de la Ville de Paris, 1964). Thierry de Duve asks, "Why is it . . . that Fautrier had to wait until Schnabel had succeeded in making something out of the exhaustion of American painting à la Pollock to be a plausible candidate for rediscovery" (Thierry de Duve, *Kant After Duchamp* [Cambridge, Mass.: MIT Press, 1996], 44). "Fautrier was wonderful!" Pat Adams exclaimed and confirmed that he had been a subject of discussion in earlier days among young artists, but she could not recall any specific content of their conversations (Adams interview).

8. See Guido Bala, *Modern Italian Painting from Futurism to the Present Day*

(New York: Praeger, 1958), and *From the Abstract to the Possible* (New York: Wittenborn, 1960); Jean Paulhan, *L'Art informel* (Paris: Gallimard, 1962); Maurizio Calvesi, *Alberto Burri* (New York: Harry Abrams, 1971); Victoria Combalia Dizeus, *Tàpies* (New York: Rizzoli, 1990); Carla Shulz-Hoffmann, *Lucio Fontana* (Munich: Prestel, 1983); Michel Tapié, *Morphologie autre* (Turin: Pozzo, 1960).

9. Michel Tapié, *Un Art autre: Où il s'agit de nouveaux dévidages du réel* (Paris: Gabriel-Giraud, 1952), n.p.

10. While traveling in Spain, DeFeo went to a bullfight in Seville. Her letter home to her mother at the time has a lighthearted tone, though later in life when she talked about seeing the event, she spoke of it as both exciting and disturbing. See Jay DeFeo to Mary Murphy, 30 April 1952, Jay DeFeo Papers.

11. In a discussion on DeFeo at the San Francisco Museum of Modern Art, Cory Keller, photography curator at the museum, noted that the etymological meaning of "Veronica" is from the Greek *vera ikon*, "true image," a reference to the "true image" of Christ's face imprinted on the veil.

12. Jay DeFeo to J. Patrick Lannan, Sr., 1959, quoted in *Modern and Contemporary Art: The Lannan Collection at the Art Institute of Chicago* (Chicago: Art Institute of Chicago, 1999), 18.

13. Quote from Carl G. Jung, "Psychological Commentary on *The Tibetan Book of the Dead*," in Jung, *Psyche and Symbol: A Selection from the Writings of C. G. Jung*, ed. Violet S. de Laszlo (Garden City, N.Y.: Anchor Books, 1958), a paperback selection of Jung's work that Hedrick recalled he and DeFeo owned and read out loud to each other (Wally Hedrick, interview by author, 29 June 2002, at Hedrick's home in Bodega, Calif., in author's possession), 299–300; color coding on p. 297. Summary synthesized from this chapter as well as "Five Chapters from *Aion: Contributions to the Symbolism of the Self*," "The Phenomenology of the Spirit in Fairy Tales," "Foreword to the *I Ching* or *Book of Changes*," "Two Chapters from *The Interpretation of Nature and the Psyche*," and "Commentary on *The Secret of the Golden Flower*."

14. Martin Heidegger, "The Origin of the Work of Art," trans. Albert Hofstadter, in *Poetry, Language, Thought* (New York: Harper and Row, 1971), 59.

15. Hedrick interview.

16. Martin Heidegger, "Building Dwelling Thinking," in *Poetry, Language, Thought*, 143–162; quote on 149. See also "The Thing," 172–174, 181, in *Poetry, Language, Thought*.

17. This summary of what contemporary artists and museum curators might learn from Heidegger comes from Fred Martin, "Art and Power, Esthetics and History, and the August Exhibitions at the San Francisco Museum of Art," *Artforum* 2 (October 1963), 48.

18. Martin Heidegger, "Hölderlin and the Essence of Poetry," trans. D. Scott, in *Existence and Being* (Chicago: Regnery, 1949), 49.

19. See Martin, "Art and Power," 47–48, for a discussion of the relation of "objects" and "things" within the practice of art.

20. Robert Duncan, "From the H.D. Book, Part II, Chapter 5," *Sagetrieb* 4 (1985), 41.

21. Duncan, "From the H.D. Book, Part II, Chapter 5," 41–42, 46.

22. Robert Duncan, "Often I Am Permitted To Return to a Meadow," in *Opening of the Field* (New York: New Directions, 1960), 7.

23. DeFeo, interview by Stich, 19 August 1988, tape 2A, side 2; part 1: 16 September 1988, tape 4A, side 1; 9 October 1988, tape 6A, side 2.

24. Heidegger, "The Origin of the Work of Art," 63.

25. Jay DeFeo to Pat Adams, handwritten on printed gallery announcement for DeFeo's show at the Dilexi Gallery, 6 July 6–1 August 1959. *The Eyes* was the image chosen for the announcement. In Adams Papers in possession of artist, to be donated to the Archives of American Art.

26. Martin Heidegger, "What Are Poets For?" in *Poetry, Language, Thought*, 89–142; quote on 133–134.

27. Jay DeFeo, statement quoted in "New Talent, U.S.A.: Painting," *Art in America* 49 (Spring 1961), 30.

28. DeFeo thought that most contemporary painting had dissolved into "formal nothingness" because artists had given insufficient attention to the field (DeFeo, interview by Stich, 9 October 1988, tape 6A, side 1).

29. Niccolo Caldararo, "Conserving *The Rose*," in *Jay DeFeo and The Rose*, ed. Jane Green and Leah Levy (Berkeley: University of California Press, 2003), 111–125.

30. Caldararo, "Conserving *The Rose*," 123.

31. Clinton Hill, interview by author, at Hill's home in New York City, 25 January 2002, in author's possession.

32. Jay DeFeo to J. Patrick Lannan, Sr., 1959, in the possession of the Estate of Jay DeFeo. Quoted in Green and Levy, *Jay DeFeo and The Rose*, 157.

33. Anonymous handwritten poem in Michael McClure Papers, Bancroft Library.

34. On Vajrayana symbolism, see Shashi Bhushan Dasgupta, *An Introduction to Tantric Buddhism* (Calcutta: University of Calcutta Press, 1950); Herbert V. Guenther, *The Tantric View of Life* (Berkeley, Calif.: Shambhala, 1973); Marie-Thérèse de Mallmann, *Introduction à l'iconographie du tantrisme bouddhique* (Paris: Librairie Maison-Neuve, 1975); Robert Sailley, *Le bouddhisme "tantrique" indo-tibetain, ou, "Véhicule de diamant"* (Sisteron: Presence, 1980); Teja Narayana Misra, *Impact of Tantra on Religion and Art* (New Delhi: D. K. Printworld, 1997); Teja Narayana Misra, *Buddhist Tantra and Buddhist Art* (New Delhi: D. K. Printworld, 2000); *Embodying Wisdom: Art, Text, and Interpretation in the History of Esoteric Buddhism*, ed. Rob Linrothe and Henrik H. Sørensen (Copenhagen: Seminar for Buddhist Studies, 2001).

35. Jay DeFeo, diary entry, ca. 26 July 1975, Estate of Jay DeFeo.

36. C. G. Jung, *Psychology and Alchemy*, trans. R. F. C. Hull (Princeton: Princeton University Press, 1953), 246.

37. Quoted in Bruce Glaser, "Questions to Stella and Judd," *Art News* 65 (September 1966), 58–59.

38. Ludwig Wittgenstein, *Tractatus Logico-Philosophicus*, §4.1212.

39. Wittgenstein, *Tractatus Logico-Philosophicus*, §2.161.

40. Jung, *Psychology and Alchemy*, 246.

Chapter 5. Becoming Postmodern

1. Many books have been written on postmodernism. For overviews, widely diverging in interpretations, see *Postmodernism: A Reader*, ed. Thomas Docherty (London: Harvester Wheatsheaf, 1993); Perry Anderson, *The Origins of Postmodernity* (New York: Verso, 1998); Christopher Butler, *Postmodernism: A Very Short Introduction* (Oxford: Oxford University Press, 2002); Steven Connor, *Postmodernist Culture* (Oxford: Blackwell, 1989); Ibn Hassan, *The Postmodern Turn* (Columbus: Ohio State University Press, 1987); Charles Jencks, *What Is Postmodernism?* (New York: Academy, 1996). For a useful collection of writings on the transition from

"modern" to "contemporary" art, see *Theories and Documents of Contemporary Art*, ed. Kristine Stiles and Peter Selz (Berkeley: University of California Press, 1996).

2. Hal Foster, "Introduction," *The Anti-Aesthetic: Essays on Postmodern Culture*, ed. Hal Foster (New York: New Press, 1998), xvi.

3. Wally Hedrick, untitled statement for exhibition at California School of Fine Arts, 1956, Wally Hedrick Papers, Archives of American Art, Smithsonian Institution.

4. Wally Hedrick, "Hedrick Interview, Session 2," interview by Paul Karlstrom, June 1974, Archives of American Art, Smithsonian Institution, 4–5.

5. Hedrick, untitled statement. Hedrick's toilet is recounted in Don De Feo, interview by author at his office in Orange, California, 23 July 1999, in author's possession.

6. Hedrick, untitled statement.

7. Hedrick, untitled statement.

8. Quoted in Jerry Adams, "A Drip-Blob Scene: A Metal Tree from a Lot of Junk," *San Francisco Examiner*, 3 December 1961. Name usage follows the original text.

9. The distinction I make between Hedrick's emphasis on prefiguration and DeFeo's on refiguration relates to Paul Ricœur's analysis of the three levels of mimesis (prefiguration, configuration, and refiguration) developed in *Time and Narrative*, trans. Kathleen McLaughlin and David Pellauer (Chicago: University of Chicago Press, 1984), vol. 1, chapter 3.

10. For discussion of New York's cooperative galleries, see Dore Ashton in *New York, Culture Capital of the World, 1940–1965*, ed. Leonard Wallock (New York: Rizzoli, 1982), p. 147.

11. Wally Hedrick, "Oral History Interview with Wally Hedrick at His Home, San Geronimo, California, June 10, 1974. Interviewer: Paul Karlstrom," 22–23; online at http://www.aaa.si.edu/collections/oralhistories/transcripts/hedric74.htm.

12. Bruce Nixon, "The 6 Gallery," in Seymour Howard, John Natsoulas, and Robert Duncan, *The Beat Generation Galleries and Beyond* (Davis, Calif.: John Natsoulas Press, 1996), 83.

13. Alfred Frankenstein, "Lively Arts: '6'—Informal Gallery with More than Visual Arts," *San Francisco Chronicle*, 17 November 1954. Chronology of Six Gallery events in Howard, Natsoulas, and Duncan, *The Beat Generation Galleries*, 201–204.

14. Some remember the piano event as occurring at the party for the closing of the gallery in 1957, but accounts vary, and it may well have been earlier. Bruce Nixon places it either November 1956 or December 1957 (Nixon, "The 6 Gallery," 88). The chronology prepared for *The Beat Generation Galleries* dates the piano destruction event as 1 December 1957, and names Leonard Hull, Barney Guggle, Ed Taylor, and Joe Dunn as the performers who destroyed the piano as part of a dada poetry event.

15. "JoAnn Low and Ron Loewinsohn—May 29, 1999—Rooftop at San Francisco Art Institute," in Mary Kerr, "Swinging in the Shadows, interviews conducted by Mary Kerr," 3; transcripts at Bancroft Library, University of California, Berkeley.

16. Hedrick, "Oral History Interview with Wally Hedrick at His Home," 30–31.

17. Nixon, "The 6 Gallery," 91.

18. ruth weiss: "Jay DeFeo had these kind of parties . . . that would just go

on. They were fantastic. And then we'd all just disappear into our own spaces and really work" ("ruth weiss—5/31/97—Albion," in Kerr, "Swinging in the Shadows," 6).

19. Mark Van Proyen, "An Interview with Wally Hedrick," *Expo-See* no. 16 (Summer 1985), n.p.

20. According to *The New Grove Dictionary of Jazz*, ed. Barry Kernfeld (London: Macmillan Press, 1988), funk was a synonym for soul jazz, a form of hard bop developed in the mid-1950s that was characterized by simple melodic themes modeled on the speaking characteristics of black preachers in sanctified churches. Harmonic progressions and riffs often emphasized structures associated with black church music (2:480). Horace Silver's 1953 *Opus de Funk* was an early recording in this style. Other jazz proponents of funk were Art Blakey, Cannonball Adderley, Jimmy Smith, and occasionally Miles Davis, J. J. Johnson, Sonny Rollins, and Art Farmer (1:138).

21. Hedrick, "Oral History Interview with Wally Hedrick at His Home," 31–33, 37. See Peter Selz, *Funk and Assemblage Art* (Berkeley, Calif.: Berkeley Art Museum, 1974), for a contrasting definition of funk. Most funk artists have strongly disagreed with Selz's interpretations. See "Panel Discussion on Funk," untranscribed tape recording, November 1974, Berkeley, Calif., Archives of American Art, Smithsonian Institution, for a discussion by artists involved in an exhibit organized by Selz of their disagreements with Selz.

22. Jay DeFeo, "Interview with Jay De Feo—Conducted by Paul J. Karlstrom, at the Artist's home in Larkspur, California, June 3, 1975," Archives of American Art, Smithsonian Institution, on-line at http://www.aaa.si.edu/collections/oral histories/transcripts/defeo 75.htm.

23. William C. Seitz, *The Art of Assemblage* (New York: Museum of Modern Art, 1961), 6.

24. On the relation of assemblage to consumer society see Jürgen Wissmann, "Collagen oder die Integration von Realität im Kunstwerk," in *Immanente Ästhetik: Ästhetische Reflexion* (Munich: Wilhelm Fink Verlag, 1966), 327–60.

25. On assemblage in California see *19 SIXTIES: A Cultural Awakening Reevaluated, 1965–1975*, ed. Lizzetta LeFalle-Collins (Los Angeles: California Afro-American Museum, 1989); Samella Lewis, *Art: African-American* (New York: Harcourt Brace Jovanovich, 1978), 169–177, 231; Sandra Leonard Starr, *Lost and Found in California: Four Decades of Assemblage Art* (Santa Monica, Calif.: James Corcoran Gallery, Shoshana Wayne Gallery, Pence Gallery, 1988); Elena Siff, *Southern California Assemblage: Past and Present* (Santa Barbara, Calif.: Santa Barbara Contemporary Arts Forum, 1986); Marie de Alcuaz, *Ceci n'est pas le surréalisme, California: Idioms of Surrealism* (Los Angeles: Fisher Gallery, University of Southern California, 1984); Susan Ehrlich, *Pacific Dreams: Currents of Surrealism and Fantasy in California Art, 1934–1957* (Los Angeles: Armand Hammer Museum of Art and Cultural Center, University of California, Los Angeles, 1995); Anne Ayres, *Forty Years of California Assemblage* (Los Angeles: Wight Art Gallery, University of California, Los Angeles, 1989); Andrew Clark Hodges, "Junk Sculpture: What Does It Mean?" *Artforum* 1, no. 5 (October 1962), 34–36; Donald Factor, "Assemblage," *Artforum* 2, no. 12 (Summer 1964), 38–41; Julius Stephen Kassovic, "Junk and Its Transformations," *Report from the Center for Folk Art and Contemporary Crafts* 3 (1983); Richard Cándida Smith, "Exquisite Corpse: The Sense of the Past in Oral Histories with California Artists," *Oral History Review* 17, no. 1 (Spring 1989), 1–38.

26. Richard Diebenkorn, "Richard Diebenkorn Oral History Interview Con-

ducted by Susan Larsen for the Archives of American Art, Smithsonian Institution, 1985 May 1, 2 & 7 and 1987 December 15," online at http://www.aaa.si.edu/collections/oralhistories/transcripts/dieben85.htm#Diebenkorn1.

27. Edward Kienholz, "Los Angeles Art Community: Group Portrait, Edward Kienholz," interview by Lawrence Weschler, 1976, Oral History Program, University of California, Los Angeles, 109.

28. Kienholz, "Los Angeles Art Community," 215–216.

29. Kienholz "Los Angeles Art Community," 113.

30. Elizabeth M. Polley, review, "Invention and Tradition in Contemporary Sculpture, San Francisco Art Institute," *Artforum* 1, no. 7 (December 1962), 62.

31. Richard Diebenkorn, interview by Sandra Leonard Starr, 1987, James Corcoran Gallery, Santa Monica, Calif., n.p.

32. Fred Martin, "The Birth of the Thing," typescript in Fred Martin Papers, Archives of American Art, Smithsonian Institution, 9–10.

33. Martin Heidegger, "The Thing," trans. Albert Hofstadter, in *Poetry, Language, Thought* (New York: Harper and Row, 1971), 163–186.

34. Norman Bryson, *Vision and Painting: The Logic of the Gaze* (New Haven, Conn.: Yale University Press, 1983), 92.

35. Gerald Nordland has described his having to pay a courtesy visit to Clement Greenberg in the 1960s when planning a show on color-field painting for the Washington Gallery of Modern Art. Greenberg's approval was required to secure loans of work from galleries. Greenberg reviewed the concept of the show, suggested modifications, and insisted on selecting the major works exhibited by two of the artists, works that reflected Greenberg's conception of the important trends developing in abstract painting at the time. Nordland accepted the terms as the show would not have taken place otherwise. See Gerald Nordland, interview by Lisa Rubens, 12 April 2007, San Francisco Museum of Modern Art Seventy-Fifth Anniversary Oral History Project (Regional Oral History Office, University of California, Berkeley), 18–19, online at http://bancroft.berkeley.edu/ROHO.

36. See Michael Davidson, *The San Francisco Renaissance: Poetics and Community at Mid-Century* (New York: Cambridge University Press, 1989); Lewis Ellingham, *Poet Be Like God: Jack Spicer and the San Francisco Renaissance* (Hanover, N.H.: University Press of New England, 1988); Warren G. French, *The San Francisco Poetry Renaissance, 1955–1960* (Boston: Twayne, 1991).

37. In 1962, Philip Leider complained that the Eighty-second Annual of the San Francisco Art Institute had excluded artists working in hard-edge abstraction and pop art. He warned that the California School of Fine Arts legacy had turned into an orthodoxy intolerant of other approaches to art. The jurors for this exhibit invited Joan Brown, Bruce Conner, Jay DeFeo, Manuel Neri, Deborah Remington, and William Wiley to participate outside of competition ("Reviews: San Francisco," *Artforum* 1, no. 5 [October 1962], 40). John Coplans compared the relatively narrow focus on the legacy of what he acknowledged as a great past with the more open, fluid situation in Los Angeles. He predicted that Los Angeles would quickly surpass San Francisco as the most important city for art on the West Coast because no stylistic orthodoxy had established itself in southern California. "Sophistication, variety, and openness" characterized the Los Angeles scene ("The Art in the Exhibitions," *Artforum* 1, no 12 [Summer 1963], 23–25, quote on 24).

38. Beverly Pabst to Six Gallery members, December 1957. In Wally Hedrick Papers.

39. See Dorothy C. Miller, *Sixteen Americans* (New York: Museum of Modern Art, 1959), 9.

40. Wally Hedrick, interview by author at Hedrick's home in Bodega, California, 29 June 2002, in author's possession.

41. Stuart Preston, "Art: 'Sixteen Americans,'" *New York Times*, 16 December 1959, p. 50. Available online from ProQuest Historical Newspapers at http://proquest.umi.com/pqdweb?index = 0&did = 88914023&SrchMode = 1&sid = 1&Fmt = 10&VInst = PROD&VType = PQD&RQT = 309&VName = HNP&TS = 12 34558809&clientId = 1566.

42. Stuart Preston, "The Shape of Things to Come?" *New York Times*, 20 December 1959, p. X11.

43. Canaday's published comments on "Sixteen Americans" were made in John Canaday, "Evolution of a Public," *New York Times*, 31 January 1960, p. X17, and "It Talks Good," *New York Times*, 6 March 1960, p. X13. Canaday's letter to Dorothy Miller, 21 December 1959, is in the Dorothy Miller Archives at the Museum of Modern Art.

44. Sidney Tillim, "Month in Review," *Arts* 34 (February 1960), 52–53, quotation on 53.

45. Robert M. Coates, "The 'Beat' Beat in Art," *New Yorker* 35 (2 January 1960), 60–61, quotation on 61; Thomas B. Hess, "U.S. Art: Notes from 1960," *Art News* 26 (January 1960), 24–29; Emily Genauer, "Art in Review," *New York Herald Tribune*, 20 December 1959. See also Lynn Zelevansky, "Dorothy Miller's 'Americans,' 1942–63," in *The Museum of Modern Art at Mid-Century: At Home and Abroad*, ed. John Szarkowski and John Elderfield (New York: Museum of Modern Art, 1994), 74–96; and Bill Berkson, "Without *The Rose*: DeFeo in *Sixteen Americans*," in *Jay DeFeo and The Rose*, ed. Jane Green and Leah Levy (Berkeley, Calif.: University of California Press, 2003), 43–54.

46. On Miller, see Lindsay Pollock, "Mama MoMA," *NewYork Metro*, http://newyorkmetro.com/nymetro/arts/features/n_9461. This article includes citations of other reviews of "Sixteen Americans" and quotes from Canaday's letter to Miller when the show opened. The lectures scheduled at the Museum of Modern Art during the "Sixteen Americans" exhibition focused on the work of Stella and Johns, suggesting the priorities of the museum curators for educating the public. On Miller and Barr's enthusiasm for Johns, see Kirk Varnedoe, *Jasper Johns: A Retrospective* (New York: Museum of Modern Art, 1996), 128; and Fred Orton, *Figuring Jasper Johns* (London: Reaktion Books, 1994), 124.

47. Lucy Lippard, "Translating *The Rose*," in *Jay DeFeo and The Rose*, 55–64, quotations on 55; Sol LeWitt, *Sol LeWitt: A Retrospective* (New Haven, Conn.: Yale University Press, 2000), 26; Robert Ryman, quoted in Vittorio Colaizi, "How It Works: Stroke, Music, and Minimalism in Robert Ryman's Early Paintings," *American Art* 21 (2007), 28–49; see also Michael Fried, *Three American Painters: Kenneth Noland, Jules Olitski, Frank Stella* (Cambridge, Mass.: Fogg Museum, 1965), 43–44.

48. Thomas Albright, "Reestablishing Contact Esthetic with the 'Beat,'" *San Francisco Chronicle*, 30 September 1979, World magazine, 41 + .

49. David Sylvester, "Jasper Johns," in *Interviews with American Artists* (New Haven, Conn.: Yale University Press, 2001), 151; Jasper Johns, *Jasper Johns: Writings, Sketchbook Notes, Interviews* (New York: Museum of Modern Art, 1996), 82.

50. The controversial status of *Target with Plaster Casts* was reaffirmed in 1960 when the jury selecting work for the Jewish Museum's annual exhibition asked Johns to remove the work from the show. The same year, the painting went to

Paris for an exhibition of "erotic" surrealist work. See Jeffrey Weiss, *Jasper Johns: An Allegory of Painting, 1955–1965* (Washington, D.C.: National Gallery of Art, 2007), 16–21, for a history of early responses to the painting. Art historians and critics have read the combination of a target with male genitals as, in the words of David Hopkins, "imagery [that] may dramatize the insecurity of gay identity at a time when homosexuality was virulently proscribed, mobilizing metaphors of sexual 'outing' and 'closeting' or invoking social 'targeting,' as symbolized by the fragmented body parts" (David Hopkins, *After Modern Art, 1945–2000* [Oxford: Oxford University Press, 2000], 55). However, as Hopkins acknowledges, the "reticence" of the piece resists interpretation, perhaps thereby promoting a variety of readings in an effort to decode the puzzle. Given the popularity of openly homosexual writers like Tennessee Williams, James Baldwin, or Truman Capote, the conclusion that homosexuality was "virulently proscribed" in the 1950s needs more careful consideration, at least in analysis of how sexual orientation signified within the arts and letters.

51. Miller, *Sixteen Americans*, 76.

52. Ad Reinhardt, "Twelve Rules for a New Academy," *Art News* (May 1957), 37–38, 56.

53. Quoted in Bruce Glaser, "Questions to Stella and Judd," *Art News* 65 (September 1966), 58–59. On the effect of Stella's work on debates within the art world at the end of the 1950s and the beginning of the 1960s, see Fried, *Three American Painters*; William Rubin, *Frank Stella* (New York: Museum of Modern Art, 1970); Robert Rosenblum, *Frank Stella* (Harmondsworth, England: Penguin, 1971); and Harry Cooper, *Frank Stella 1958* (New Haven, Conn.: Yale University Press, 2006). Jasper Johns's artist statement for the "Sixteen Americans" catalogue asserted that he was not interested in seeing since "at every point in nature there is something to see." Instead, his interest lay in the "changing focus of the eye" as it moved across the many possibilities for vision that both nature and art provided (Miller, *Sixteen Americans*, 22).

54. Frank Stella, "Pratt Institute Lecture," in *Art in Theory, 1900–1990: An Anthology of Changing Ideas*, ed. Charles Harrison and Paul Wood (Oxford: Blackwell, 1992), 805–806.

55. Miller, *Sixteen Americans*, 13, 8.

56. The ideas referenced here are derived from Wittgenstein's distinction made in his *Tractatus Logico-Philosophicus*, § 4.1212. Through the 1960s, as artists grappled with the implications of doing intellectual work that had neither representational nor philosophical content, a variety of positions appeared in artist statements and magazine articles. Among the most influential was Joseph Kosuth's "Art After Philosophy," published in *Studio International* in 1969 (178 [1969], 134–137, 160–161, 212–213; reprinted in Harrison and Wood, *Art in Theory*, 840–847). Kosuth argued that modern art had never represented thought processes nor had there been a question of visual organization or surface effects. The best work had triggered new ways of thinking. The modern artist who had understood this most clearly had been Marcel Duchamp, whose ready-mades, in particular, had provided art with its own, autonomous conceptual foundations independent of all other intellectual or practical activities. Duchamp's work offered neither myths nor sensual pleasure, but nonetheless used materials to provoke an experience that could not be explained away referentially. The ideas that the piece provoked had to emerge through the viewer grappling with the experience.

57. Exchanges with George W. Staempfli are mentioned in Jay DeFeo's

undated letters to Nell Sinton in the Sinton Papers, Archives of American Art, Smithsonian Institution. Sinton briefly discusses Staempfli's interest in DeFeo in Nell Sinton, "An Adventurous Spirit: The Life of a California Artist," oral history interview by Suzanne B. Riess, 1961 and 1962, Regional Oral History Office, Bancroft Library, University of California, Berkeley, 185. Irving Blum, who bought the Ferus Gallery from Walter Hopps and Edward Kienholz in 1962, also decided to drop DeFeo as one of the artists showing at the Ferus. He liked her work, but he was unsure that he would be able to work with her to develop a salable body of work. See Irving Blum, "At the Ferus Gallery: Oral History Transcript," interview by Joann Phillips in 1976 and 1978 and by Lawrence Weschler in 1979, Oral History Program, University of California, Los Angeles.

58. Quoted phrase from Adams, "A Drip-Blob Scene."

59. Griselda Pollock has explored the distinctive ways in which Jackson Pollock and Helen Frankenthaler were photographed at work during the 1950s in her essay "Killing Men and Dying Women: A Woman's Touch in the Cold Zone of American Painting in the 1950s," in *Avant-Gardes and Partisans Reviewed*, ed. Fred Orton and Griselda Pollock (Manchester: Manchester University Press, 1996), 219–294. Pollock stresses the presentation of Jackson Pollock as an unrestrained sexual force, an image she links to images of Marilyn Monroe. To the degree that DeFeo allowed herself to be understood as a female heir to Pollock, as a woman with an ambition as grand as his, the conventions surrounding media presentations of "artistic genius" required her being sexualized and her actual work being subordinated to images of her body actively struggling with recalcitrant materials to reveal hidden images and meanings. Frankenthaler, on the other hand, was presented as more methodical and fluid, quietly spreading her paint across the canvas. Pollock interprets these photographs as capturing a positive image of female creativity that was unusual for a time when women artists to the degree that they were acknowledged in the press were inevitably presented as sexual beings rather than as working artists.

60. On the kabbalistic meaning of this photograph, see Robert Berg, "Jay DeFeo: The Transcendental Rose," *American Art* (Fall 1998), 68–77.

61. See my discussion of the retreat from public view that several California artists, including DeFeo and Berman, made in the 1960s in Richard Cándida Smith, *Utopia and Dissent: Art, Poetry, and Politics in California* (Berkeley: University of California Press, 1995), 172–211.

62. Thomas Albright, "Just One Single Rose—A Glorious Anachronism," originally published in the *San Francisco Chronicle*, 11 April 1969, reprinted in Thomas Albright, *On Art and Artists: Essays by Thomas Albright* (San Francisco: Chronicle Books, 1989), 68–69.

63. William Hackman, "Seven Artists in Search of a Place To Hang," *California Magazine* 11 (November 1986), 88–95, 108.

64. Robert Irwin, "Los Angeles Art Community: Group Portrait, Robert Irwin," interview by Lawrence Weschler, 1975 and 1976, Oral History Program, University of California, Los Angeles, 25–29, quotations on 26, 27, 28.

65. On Bell's cubes see Maurice Tuchman and Jane Livingston, *A Report on the Art and Technology Program of the Los Angeles County Museum of Art, 1967–1971* (Los Angeles: Los Angeles County Museum of Art, 1971); Jan Butterfield, "Context: Light and Space as Art," *LAICA Journal* 32 (Spring 1982), 57–61; Michele D. De Angelus, "Visually Haptic Space: The Twentieth-Century Luminism of Irwin and Bell," in *Art in Los Angeles: Seventeen Artists in the Sixties*, ed. Maurice Tuchman (Los Angeles: Los Angeles County Museum of Art, 1981); Larry Stuart

Bell, "Tape Recorded Interview with Larry Bell, Taos, New Mexico," interview by Michele De Angelus, 1980, Archives of American Art, Smithsonian Institution, 18–19.

66. On artist involvement in the antiwar movement, see Cándida Smith, *Utopia and Dissent*, 357–362, 407–432; Francis Frascina, *Art, Politics and Dissent: Aspects of the Art Left in Sixties America* (Manchester: Manchester University Press, 1999); and Peter Selz, *Art of Engagement* (Berkeley: University of California Press, 2006).

67. Susan C. Larsen, "Los Angeles Painting in the Sixties: A Tradition in Transition," in *Art in Los Angeles*, ed. Maurice Tuchman, 21.

68. In an interview, Bengston said that he knew painting sergeant stripes would a great idea "because it stopped [Robert Irwin] from talking" when he first heard about it. See William Turner, "An Interview with Henry Hopkins and Billy Al Bengston," in *Sunshine & Noir* (New York: William Turner Gallery, 1999).

69. Peter Plagens, *Sunshine Muse: Contemporary Art on the West Coast* (New York: Praeger, 1974), 117–138; Larsen, "Los Angeles Painting." See also Lucy R. Lippard, *Six Years: The Dematerialization of the Art Object from 1966 to 1972* (New York: Praeger, 1973), for a discussion of a sea change in aesthetic values emerging at the end of the 1960s.

70. Peter Plagens, "What Is to Be Learned?" *LAICA Journal* 40 (Fall 1984), 83.

71. Bell, "Tape Recorded Interview with Larry Bell, Taos, New Mexico," 17–18.

72. Bell, "Tape Recorded Interview," 17, 91.

73. Johns, *Jasper Johns*, 31.

74. Bell, "Tape Recorded Interview," 77–78.

75. On the relation of Judy Chicago's *Dinner Party* to contending trends within California art in the 1960s and 1970s, see Laura Meyer, "From Finish Fetish to Feminism: Judy Chicago's *Dinner Party* in California Art History," in *Sexual Politics: Judy Chicago's* Dinner Party *in Feminist Art History*, ed. Amelia Jones (Berkeley: University of California Press, 1996), 46–74.

76. See Jay DeFeo, "Jay DeFeo Interview, Session 2," interview by Paul Karlstrom, 1974, Archives of American Art, Smithsonian Institution, 27, for why she supported civil rights protection for women but rejected any form of gender-based art.

77. Jay DeFeo to James Kelly, 16 March 1982, DeFeo Papers, Bancroft Library.

78. Jay DeFeo, interview by Sidra Stich, 23 September 1988, tape 5A, side 1; see also 19 August 1988, tape 2A, side 2), and 23 September 1988, tape 4A, side 2.

79. DeFeo, lecture to students, at Mills College, part 2, 4 December 1986, videotape in archives of the Estate of Jay DeFeo.

80. Thomas Albright, "Strong Works by a Powerful Artist," originally published in the *San Francisco Chronicle*, 7 February 1980, reprinted in Albright, *On Art and Artists*, 70–71.

Chapter 6. California Assemblage

1. Percentages from National Income Accounts, Survey of Current Business, United States Department of Commerce, 1974. Cited in Dick Netzer, *The Subsi-*

dized Muse: Public Support for the Arts in the United States (Cambridge: Cambridge University Press, 1978), 10–11.

2. Economic developments in the arts since the 1970s drawn from Gary O. Larson, *American Canvas: An Arts Legacy for Our Communities* (Washington, D.C.: National Endowment for the Arts, 1997); Joseph Wesley Zeigler, *Arts in Crisis: The National Endowment for the Arts Versus America* (Pennington, N.J.: A Capella Books, 1994), 59–89, 156–161; Julia Low, *States Arts Agencies, 1965–2003: Whose Interests to Serve?* (Santa Monica, Calif.: RAND Corporation, 2004); and Jerry Henderson, *The State and the Politics of Culture: A Critical Analysis of the National Endowment for the Arts* (Lanham, Md.: University Press of America, 2005). See also Michael Kammen, *Visual Shock: A History of Art Controversies in American Culture* (New York: Knopf, 2006), chaps. 8 and 9. The changing relation of trustees, curators, and artists is also a major theme discussed in an oral history project documenting the Pasadena Art Museum, organized by the Oral History Program, University of California, Los Angeles, conducted in the late 1980s and early 1990s, as well as in an ongoing oral history project on the San Francisco Museum of Modern Art, organized jointly by the museum and the Regional Oral History Office, Bancroft Library, University of California, Berkeley.

3. The economic situation of the arts continues to generate studies attempting to assess cost structures and public benefits. See, for example, Kevin F. McCarthy, Elizabeth H. Ondaatje, and Laura Zakaras, *Gifts of the Muse: Reframing the Debate About the Benefits of the Arts* (Santa Monica, Calif.: RAND Corporation, 2005); Graeme Evans, *Cultural Renaissance: An Urban Renaissance* (New York: Routledge, 2001); *ArtsREACH: Strengthening Communities Through the Arts, Alabama, Arkansas, Delaware, Idaho, Indiana, Iowa, Kansas, Mississippi, Montana, Nebraska, Nevada, North Dakota, Oklahoma, Rhode Island, South Carolina, South Dakota, Tennessee, Utah, West Virginia, Wyoming* (Washington, D.C.: National Endowment for the Arts, 2001); David T. Schwartz, *Art, Education, and the Democratic Commitment: A Defense of State Support for the Arts* (Dordrecht: Kluwer, 2000); Arthur C. Brooks, *Arts, Markets, and Governments: A Study in Cultural Policy Analysis* (Santa Monica, Calif.: RAND Corporation, 1998); *America's Commitment to Culture: Government and the Arts,* ed. Kevin V. Mulcahy and Margaret Jane Wyszomirski (Boulder, Colo.: Westview Press, 1995); J. Mark Davidson Schuster, *Supporting the Arts: An International Comparative Study, Canada, Federal Republic of Germany, France, Italy, Great Britain, Netherlands, Sweden, United States* (Washington, D.C.: National Endowment for the Arts, 1985); *The Arts and Public Policy in the United States,* ed. W. McNeil Lowry (Englewood Cliffs, N.J.: Prentice-Hall, 1984).

4. See Peter Selz, *Funk* (Berkeley, Calif.: University Art Museum, 1967) for a chronology of assemblage exhibits in California, as well as "Panel Discussion on Funk," untranscribed tape recording, November 1974, Berkeley, Calif., Archives of American Art, Smithsonian Institution, for a discussion by artists involved in Selz's exhibit (see Chapter 5, n. 22). On "Museum of Unknown or Little Known Objects," see Richard Cándida Smith, *Utopia and Dissent: Art, Poetry, and Politics in California* (Berkeley: University of California Press, 1995), 110–113.

5. Gordon Wagner, "California Assemblage Art: Gordon Wagner," interview by Richard Cándida Smith, 1986 and 1987, Oral History Program, University of California, Los Angeles, 163.

6. Bruce Conner, "Tape-Recorded Interview with Bruce Conner," interview by Paul J. Karlstrom, 1974, Archives of American Art, Smithsonian Institution, 8–9, 14.

7. Andrew Clark Hodges, "Junk Sculpture: What Does It Mean?" *Artforum* 1, no. 5 (October 1962), 34.

8. Donald Factor, "Edward Kienholz," *Artforum* 2, no. 2 (August 1963), 24–25.

9. John Coplans, "The Art in the Exhibitions," *Artforum* 1, no. 12 (June 1963), 23–25; Constance Perkins, "Reviews: Collage Artists in California, Pasadena Art Museum," *Artforum* 1, no. 3 (August 1962), 9. See Coplans, "Sculpture in California," *Artforum* 2, no. 2 (August 1963), 3–6. *Artforum*, established in 1962 to express the particular viewpoint of art in the western United States, went through three distinct critical phases in its assessment of assemblage. From vol. 1, no. 1 (July 1962), to vol. 2, no. 2 (August 1963), criticism on assemblage, largely by Philip Leider, John Coplans, and Arthur Secunda, emphasized connections to ongoing developments in Europe. In part this may have been due to Secunda's influence as the individual who put the magazine together. Secunda strongly believed that there were no independent, regional developments in art. All artistic creativity springs from response to other works of art (conversation by author with Secunda, November 1988). After Secunda left the magazine, Coplans, Leider, and Donald Factor began to argue that California assemblage was completely independent of neodada and, like abstract expressionism, a uniquely U.S. development by artists unconcerned with European art concepts. With vol. 3, no. 6 (1965), Philip Leider became the sole writer on assemblage. He focused on the links between assemblage and pop art, the movement that he considered to be the primary field for avant-garde development. Once a strong proponent of assemblage, he began to write disparagingly of the work. A common thread to this development was the magazine's commitment—prior to 1971 with its sudden relocation from California to New York—to the proposition that West Coast art had something unique to contribute to American and international art. The editors saw their magazine as a bully pulpit from which they could build support for contemporary art produced on the West Coast among institutions and collectors. The shifting evaluation of assemblage occurred in a context both of changes in personalities and an assessment of what was most likely to advance the cause of the regional art movement. After 1965, the magazine became a proponent of the "cool school," the elegant, technologically sophisticated work of Robert Irwin, Larry Bell, Craig Kauffman, Ed Ruscha, and others, as a style of art particularly meaningful in the California context because it built upon the impetus begun by pop artists in New York but corrected the "dismal failure" of pop art (see Leider, "The Cool School," *Artforum* 2, no. 12 [Summer 1964], 47–52).

10. Wagner, "California Assemblage Art: Gordon Wagner," 164–165.

11. This argument relates to but inverts some of the implications in Roland Barthes's discussion of the power of connotation in modern myth to overpower denotative presence. See Roland Barthes, *Mythologiques* (Paris: Éditions du Seuil, 1957), 193–247.

12. On these two episodes see Cándida Smith, *Utopia and Dissent*, 225–227, 231, 294–295, 308, 318–319, 324–327.

13. "Respect for the Flag," *Pasadena Independent,* 26 June 1962, p. 12; Jan Butterfield, "George Herms: Magician and Logician," *Artweek* 6 (22 February 1975), 3. See also interviews with Walter Hopps and John Coplans in *Pasadena Art Museum* series, Oral History Program, University of California, Los Angeles.

14. "Respect for the Flag."

15. Leo Steinberg, "Other Criteria," in *Other Criteria: Confrontations with Twentieth-Century Art* (Oxford: Oxford University Press, 1972), 88.

16. On *The Bed*, see James Leggio, "Robert Rauschenberg's *Bed* and the Sym-

bolism of the Body," in *Essays on Assemblage* (New York: Museum of Modern Art, 1992), 10; Helen Molesworth, "Before *Bed*," *October* 63 (Winter 1993), 68–82; Leo Steinberg, *Encounters with Rauschenberg* (Chicago: University of Chicago Press, 2000), 45–51; Kathryn Boyer, "Robert Rauschenberg and the American Postwar Political and Social Scene," *Konsthistorisk Tidskrift/Journal of Art History* 76 (2007), 92–106.

17. Steinberg, "Other Criteria," 88.

18. Conner, "Tape-Recorded Interview," 25–26.

19. For more on Wagner, see Richard Cándida Smith, "Exquisite Corpse: The Sense of the Past in Oral History Interviews with California Artists," *Oral History Review* 17 (Spring 1989), 1–38. Wagner's stereotyping of contemporary Mexico as a "timeless" and "primitive" refuge was a common theme in beat and bohemian work of the post–World War II era, including Jack Kerouac's *On the Road*.

20. See Alonzo Davis, "African American Artists of Los Angeles: Alonzo Davis," interview by Karen Mason, 1990, Oral History Program, University of California, Los Angeles, for a discussion of the Brockman Gallery's exhibitions by one of the owners of the gallery. Noah Purifoy also discussed his shows at the Brockman in Noah Purifoy, "African American Artists of Los Angeles: Noah Purifoy," interview by Karen Mason, 1989, Oral History Program, University of California, Los Angeles.

21. John Outterbridge, "African American Artists of Los Angeles: John Outterbridge," interview by Richard Cándida Smith, 1989–1992, Oral History Program, University of California, Los Angeles, 578; interview on-line at http://content.cdlib.org/xtf/view?docId=hb229006xm&doc.view=frames&chunk.id=0&toc.depth=1&toc.id=0&brand=oac.

22. Ibid. In 1987 Lizzetta LeFalle-Collins curated an exhibition of home and garden decorations in the Los Angeles black community for the California Afro-American Museum. See Lizzetta LeFalle-Collins, *Home and Yard: Black Folk Life Expressions in Los Angeles* (Los Angeles: California Afro-American Museum, 1987).

23. Outterbridge quoted in Lizzetta LeFalle-Collins, ed., *19 SIXTIES: A Cultural Awakening Re-evaluated, 1965–1975* (Los Angeles: California Afro-American Museum, 1989), 19–23.

24. Outterbridge, "African American Artists of Los Angeles: John Outterbridge," 172, 561–562.

25. Outterbridge, "African American Artists of Los Angeles: John Outterbridge," 223–224.

26. Outterbridge, "African American Artists of Los Angeles: John Outterbridge," 174, 558–572, quotations on 572 and 565; LeFalle-Collins, *19 SIXTIES*, 19–23.

27. See Cecil Fergerson, "African-American Artists of Los Angeles: Cecil Fergerson," interview by Karen Anne Mason, 1996, Oral History Program, University of California, Los Angeles.

28. The paucity of outlets for African American art underscores the importance of those individuals and corporations, like the Golden State Mutual Insurance Company, a black-owned firm headquartered in Los Angeles, who set out to develop comprehensive collections in the field. They provided affirmation that the work possessed long-term value.

29. An attempt to analyze Warhol's work in terms of his family background can be found in Raymond M. Herbenick, *Andy Warhol's Religious and Ethnic Roots:*

The Carpatho-Rusyn Influence on His Art (Lewiston, N.Y.: Edwin Mellen Press, 1997).

30. *Belief Versus Theory in Black American Literary Criticism*, ed. Joe Weixlmann and Chester J. Fontenot (Greenwood, Fla.: Penkeville, 1986), 221. Houston A. Baker, Jr., has proposed that black intellectuals turned to folk culture and its strengths to counter the inequalities they faced as writers, artists, or musicians in white-dominated institutions, but they remained fundamentally outsiders within the black community (*Modernism and the Harlem Renaissance* [Chicago: University of Chicago Press, 1987], 93–95). What Baker defined as the "blues aesthetic" expressed a cultural predisposition to "improvise resiliently with opportunities that arise," while accepting that life is "unrelentingly hard and unjust but allows for the possibility of fruitful achievement" (*Blues, Ideology, and Afro-American Literature: A Vernacular Theory* [Chicago: University of Chicao Press, 1984] 18).

31. For a comprehensive survey of Saar's career, see Jane H. Carpenter with Betye Saar, *Betye Saar* (San Francisco: Pomegranate, 2003); and Jane H. Carpenter, "Conjure Woman: Betye Saar and Rituals of Transformation, 1960–1990" (Ph.D. diss., Department of History of Art, University of Michigan, 2002). See also Betye Saar, "African American Artists of Los Angeles: Betye Saar," interview by Karen Mason, 1989, Oral History Program, University of California, Los Angeles; M. J. Hewitt, "Betye Saar: An Interview," *International Review of African American Art* 10, no. 2 (1992), 7–23.

32. Betye Saar, "Unfinished Business: The Return of Aunt Jemima," in *Betye Saar: Workers and Warriors, the Return of Aunt Jemima* (New York: Michael Rosenfeld Gallery, 1998), 3.

33. On the historical interpretation of the Sambo and other stereotypes of African Americans, see Joseph Boskin, *Sambo: The Rise and Demise of an American Jester* (New York: Oxford University Press, 1986); Kenneth W. Goings, *Mammy and Uncle Mose: Black Collectibles and American Stereotyping* (Bloomington: Indiana University Press, 1994); Marilyn Kern-Foxworth, *Aunt Jemima, Uncle Ben, and Rastus: Blacks in Advertising, Yesterday, Today, and Tomorrow* (Westport, Conn.: Greenwood Press, 1994); Jo-Ann Morgan, "Mammy the Huckster: Selling the Old South for the New Century," *American Art* 9 (Spring 1995), 87–109; Patricia A. Turner, *Ceramic Uncles and Celluloid Mammies: Black Images and Their Influences on Culture* (New York: Anchor Books, 1994); Jackie Young, *Black Collectibles: Mammy and Her Friends* (West Chester, Pa.: Schiffer, 1988).

34. Carpenter with Saar, *Betye Saar*, 46.

35. On the Woman's Building, see Terry Wolverton, *Insurgent Muse: Life and Art at the Woman's Building* (San Francisco: City Lights, 2002).

Chapter 7. Learning from the Watts Towers

1. For an interpretation of the Watts Towers in relation to the modern avant-garde arts movements, see Chapter 2. See also Sarah Schrank, "Picturing the Watts Towers: The Art and Politics of an Urban Landmark," in *Reading California: Art, Image, and Identity, 1900–2000*, ed. Stephanie Barron, Sheri Bernstein, and Ilene Susan Fort (Berkeley: University of California Press, 2000), 373–386.

2. Jane H. Carpenter with Betye Saar, *Betye Saar* (San Francisco: Pomegranate, 2003), 2.

3. Carpenter with Saar, *Betye Saar*, 4.

4. The name Simon came from a 1937 *Los Angeles Times* article that incor-

rectly reported Rodia's first name as Simon instead of either his given name Sabato or Sam, the nickname he used in most situations.

5. See "Watts Towers Study," State of California Department of Parks and Recreation, Division of Beaches and Parks, Sacramento, June 1965.

6. David Johnston, "Towering Indifference," *Los Angeles Times*, 14 August 1984, Calendar section, p. 34.

7. Noah Purifoy, "African American Art in Los Angeles: Noah Purifoy," interview by Karen Mason, 1989, Oral History Program, University of California, Los Angeles, 15.

8. Purifoy, "African American Art in Los Angeles: Noah Purifoy," 15.

9. Purifoy, "African American Art in Los Angeles: Noah Purifoy," 16–17.

10. Purifoy discussed his reading of Freud in Noah Purifoy, interview by author at Purifoy's home in Joshua Tree, Calif., 11 December 1998, 21–24, 41–42, 48–49 (transcript in progress at Regional Oral History Office, Bancroft Library, University of California, Berkeley, to be posted on-line at http://bancroft.berkeley.edu). See Sigmund Freud, *A General Introduction to Psychoanalysis* (New York: Pocket Books, 1953), 304–306, 374, 416, 432.

11. For Purifoy's discussion of Husserl and Heidegger, see Purifoy, "African American Art in Los Angeles: Noah Purifoy," 23–27, and Purifoy, interview by author, 11 December 1998, 3–5, 39. See Martin Heidegger, *Poetry, Language, Thought,* trans. Albert Hofstadter (New York: Harper and Row, 1971), and especially, "Hölderlin and the Essence of Poetry," trans. D. Scott, in *Existence and Being* (Chicago: Regnery, 1949); Edmund Husserl, *Ideas: General Introduction to Pure Phenomenology,* trans. W. R. Boyce Gibson (New York: Colliers Macmillan, 1962).

12. Purifoy, interview by author, 11 December 1998, 12–15.

13. Noah Purifoy as told to Ted Michel, "The Art of Communication as a Creative Act," in *Junk Art: Sixty-Six Signs of Neon* (Los Angeles: Sixty-six Signs of Neon, 1966), 7.

14. This is Purifoy's account of his admission, told in the interviews conducted by Karen Mason and the author. There are no records remaining of the admissions process for 1952, nor of Mrs. Chouinard's decision-making process. Robert Perine's history of the Chouinard Art Institute confirms that Purifoy was the first African American student at the school; see Robert Perine, *Chouinard, an Art Vision Betrayed: The Story of the Chouinard Art Institute, 1921–1972* (Encinitas: Artra, 1985).

15. Purifoy, "African American Art in Los Angeles: Noah Purifoy," 32.

16. Purifoy, "African American Art in Los Angeles: Noah Purifoy," 161.

17. John Outterbridge, "African American Art in Los Angeles: John Outterbridge," interview by Richard Cándida Smith, 1989–1992, Oral History Program, University of California, Los Angeles, 154.

18. Purifoy, "African American Art in Los Angeles: Noah Purifoy," 40, 44–45.

19. Purifoy, "African American Art in Los Angeles: Noah Purifoy," 87.

20. See Richard Cándida Smith, "Junk into Art: Noah Purifoy's Assemblage of Experience," in *Noah Purifoy: Outside and in the Open,* ed. Lizzetta LeFalle-Collins (Los Angeles: California Afro-American Museum Foundation, 1997), 63–86.

21. Purifoy, "African American Art in Los Angeles: Noah Purifoy," 49.

22. Compare with Viktor Shklovsky: "Art exists that one may recover the sensation of life; it exists to make one feel things, to make the stone *stony*—art removes objects from automatism of perception" (Shklovsky, "Art as Tech-

nique," in *Russian Formalist Criticism: Four Essays,* ed. Lee T. Lemon and Marion J. Reis [Lincoln: University of Nebraska Press, 1965], 12). It follows from this position that using real objects as art indicates a sense of alienation from the most tangible aspects of human society. Everyday objects had to be renewed in an idealized and purposeless form to be felt once again.

23. Purifoy, "African American Art in Los Angeles: Noah Purifoy," 65.

24. Purifoy, interview by author, 8 December 2002, tape 4, untranscribed, in author's possession.

25. For a discussion of the distinction between manual and cognitive knowledge, see David Rothenberg, *Hand's End: Technology and the Limits of Nature* (Berkeley: University of California Press, 1993), 4–6. Susanne K. Langer presented an earlier and influential, although somewhat differently argued, version of this distinction in Susanne K. Langer, *Philosophy in a New Key: A Study in the Symbolism of Reason, Rite, and Art* (Cambridge, Mass.: Harvard University Press, 1942)—see particularly 266–294—and *Feeling and Form: A Theory of Art* (New York: Scribner, 1953). Purifoy had read and valued Langer's approach to art as a form of practical knowledge.

26. Purifoy, interview by author, 11 December 1998, 4–6.

27. Purifoy, "African American Art in Los Angeles: Noah Purifoy," 69.

28. The catalogue for the show, *Junk Art: Sixty-Six Signs of Neon,* has been reprinted by the California African American Museum in Los Angeles.

29. Christopher Knight, "Art Review: An Overlooked Journey," *Los Angeles Times,* 8 February 1997, section F, p. 10.

30. Purifoy, interview by author, 11 December 1998, 4–5.

31. Purifoy, interview by author, 11 December 1998, 7.

32. Purifoy, interview by author, 11 December 1998, 5, 6–9.

33. Purifoy, interview by author, 11 December 1998, 11–14.

34. The new council came into being at a time when the number of people professionally involved in the arts was doubling. According to the state Employment Development Department (EDD), less than 100,000 individuals worked in arts-related positions in 1970, while by 1980 the figure had climbed to over 200,000 (California Arts Council, *Annual Report for 1979/80 and 1980/81* [Sacramento: California Arts Council, 1981], p. 7). EDD figures broke down to 35,123 painters and sculptors; 30,366 designers; 26,892 musicians and composers; 21,583 public relations specialists (a questionable category to include with the arts); 14,133 photographers; 9,015 authors; 5,699 actors; 2,858 dancers; 2,800 radio and television announcers. On the transformation of the Arts Council under Governor Brown, see Lou Rosing, "Update on California's Art Council," *New Art Examiner* 4 (May 1977), 5.

35. Richard Piper, W. Dwaine Greer, and Ruth N. Zwissler, *California Arts Council Alternatives in Education Program: An Evaluation Study of Nine Project Sites* (Sacramento: California Arts Council, 1979).

36. For a summary of the goals with evaluation of how effectively they were met, see Piper, Greer, and Zwissler, *California Arts Council Alternatives,* 15–20.

37. California Arts Council, *Report to the Governor and to the Legislature* (Sacramento: California Arts Council, 1976), 36, 61; Purifoy, interview by author, 11 December 1998, 9–13.

38. California Arts Council, *Annual Report,* 7. Not all participating institutions were listed in the council's reports, but the following breakdown indicates the types of community organizations that accepted council-funded artists in 1980–81: children's art workshops, five; adult art workshops, nine; city and

county recreation departments, seven; city and county arts commissions, ten; ethnic cultural centers, nineteen; neighborhood community centers, twelve; museums, three; theater groups, ten; music groups, two; dance group, one; colleges and universities, four; primary and secondary schools, fifty-four; public library, one; children's welfare programs, two; senior citizen centers, four; churches, three; Native American tribe, one; environmental group, one; bookstore, one; food program, one; halfway house, one; drug counseling program, two; women's organizations, two; nonprofit corporations, four; art gallery, one; juvenile delinquency program, one; prisons, four; county jail, one; hospital, one.

39. California Arts Council, *A Summary of Artists-in-Education Summer Workshop/Conference* (Sacramento: California Arts Council, 1977), 3.

40. On the political successes of the California Arts Council in broadening its programs, see Dorothy A. Kupcha, "How the Arts Council Shed the 'Weirdo' Image," *California Journal* 10 (1979), 318–320. See also public correspondence files, California Arts Council, 1967–1978 and 1984–2003, California State Archives, Sacramento, accessions 84–131 and 2004–089, and National Research Center for the Arts, Inc., *Californians and the Arts: Public Attitudes Toward and Participation in the Arts and Culture in the State of California* (Sacramento: California Arts Council, 1981).

41. Purifoy, interview by author, 11 December 1998, 9.

42. California Arts Council, *A Summary*, 5.

43. Purifoy, interview by author, 11 December 1998, 13–19.

44. California Arts Council, *A Summary*, 6.

45. Purifoy, "African American Art in Los Angeles: Noah Purifoy," 137.

46. I have drawn biographical information primarily from personal conversations with Purifoy conducted since I first met him in 1989, augmented by talks with Debbie Brewer, Alonzo Davis, John Outterbridge, and Sue Welsh, as well as the transcripts of the oral history interview with Purifoy conducted by Karen Mason in 1989. All direct quotes are from this interview; the quotation here can be found on 166.

47. Christopher Isherwood, "Los Angeles," *Horizon* no. 93–94 (October 1947), 147.

48. Noah Purifoy, interview by author, 26 April 2001, untranscribed, in author's possession.

49. Jill Moniz, "Accession Proposal Form: *Review 54/Outhouse*," 14 February 2008, prepared for Collections Resolutions meeting 21 March 2008, California African American Museum, Los Angeles, pp. 14–15.

50. See Tanabe Hajime, *Philosophy as Metanoetics* (Berkeley: University of California Press, 1986), 1–7.

51. Purifoy, "African American Art in Los Angeles: Noah Purifoy," 119.

52. Purifoy, "African American Art in Los Angeles: Noah Purifoy," 49.

53. Purifoy, interview by author, 11 December 1998, 49–52, 56.

Chapter 8. Contemporary Art Along the U.S.-Mexican Border

1. For a summary of approaches and analysis of how effectively new programs support alternative artist-community relations, see *Critical Issues Facing the Arts in California: A Working Paper from the James Irvine Foundation* (San Francisco: James Irvine Foundation, 2006).

2. On the Nortec Collective, see José Manuel Valenzuela Arce, *El Paso del Nortec: This Is Tijuana* (Mexico City: Trilce Ediciones, 2004).

3. Important discussions of the borderlands concept in relation to the cultural politics of the U.S.-Mexican border can be found in Alfred Arteaga, ed., *An Other Tongue: Nation and Identity in the Linguistic Borderlands* (Durham: Duke University Press, 1994); *Criticism in the Borderlands: Studies in Chicano Literature, Culture, and Ideology*, ed. Héctor Calderón and José David Saldívar (Durham: Duke University Press, 1991); Teddy Cruz and Anne Boddington, eds., *Architecture of the Borderlands* (London: Academy Editions, 1999); Philip J. Ethington, "Towards a 'Borderland School' for American Urban Ethnic Studies," *American Quarterly* 48 (1996), 344–353; Claire F. Fox, "The Portable Border: Site-Specificity, Art, and the U.S.-Mexico Frontier," *Social Text* 41 (1994), 61–82; Guillermo Gómez-Peña, "Border Culture: A Process of Negotiation Toward Utopia," *La Línea Quebrada* 1 (1986), 1–6; Guillermo Gómez-Peña, "Border Culture and Deterritorialization," *La Línea Quebrada* 2 (1987), 1–10; Carl Gutiérrez-Jones, *Rethinking the Borderlands: Between Chicano Culture and Legal Discourse* (Berkeley: University of California Press, 1995); Lawrence A. Herzog, *Where North Meets South: Cities, Space, and Politics on the U.S.-Mexico Border* (Austin: University of Texas Press, 1990); Vicki Ruiz and Susan Tiano, eds., *Women on the U.S.-Mexico Border: Responses to Change* (Boston: Allen and Unwin, 1987); José David Saldívar, *Border Matters: Remapping American Cultural Studies* (Berkeley: University of California Press, 1997); Chela Sandoval, "U.S. Third World Feminism: The Theory and Method of Oppositional Consciousness in the Postmodern World," *Genders* 10 (1991), 1–24. In *The Militarization of the U.S.-Mexico Border, 1978–1992: Low-Intensity Conflict Doctrine Comes Home* (Austin, Tex.: Center for Mexican American Studies, 1996), Timothy J. Dunn presents an invaluable history of U.S. policy toward the border.

4. George Yúdice, *The Expediency of Culture: Uses of Culture in the Global Era* (Durham: Duke University Press, 2003), 255, 302–307.

5. Lynda Forsha, introduction, *in-Site 94: A Binational Exhibition of Installation and Site-Specific Art/Una Exposición binacional de arte-instalación en sitios específicos*, ed. Sally Yard (San Diego: Installation Gallery, 1994), 8. For a history of the in-Site programs by Michael Krichman and Carmen Cuenca, see http://www.insite 2000.org.

6. "Acerca de nostros: History," Centro Cultural de Tijuana web site, online at http://www.cecut.gob.mx/.

7. See Yúdice, *The Expediency of Culture*, 309–311, for a discussion of funding for in-Site activities.

8. On the Border Arts Workshop, see David Avalos, "A Wag Dogging a Tale," in *La Frontera/The Border: Art About the Mexico/United States Experience*, ed. Kathryn Kanjo (San Diego: Centro Cultural La Raza and the Museum of Contemporary Art of San Diego, 1993); María Eraña, "From a Border of Canyons and Sand," in Kanjo, *La Frontera/The Border*; Claire F. Fox, *The Fence and the River: Culture and Politics at the U.S.-Mexico Border* (Minneapolis: University of Minnesota Press, 1999); Guillermo Gómez-Peña, "The Artist as Criminal," *Drama Review* 40 (1997), 112–118; Madeline Grynsztejn, "La Frontera/The Border," in Kanjo, *La Frontera/The Border*; Tomás Ybarra-Frausto, "Rasquachismo: A Chicano Sensibility," in *Chicano Art: Resistance and Affirmation, 1965–1985*, ed. Richard Griswold del Castillo (Los Angeles: Wight Gallery, University of California, Los Angeles, 1991).

9. See Robert L. Pincus, "In-Site 05 More InSiteful: Transborder Exhibition Aims to Redefine Relationship between Art and Public," *San Diego Union-Tribune*, 21 August 2005, online at http://www.signonsandiego.com/uniontrib/20050821/news_lz1a20insite.html.

10. Leah Ollman, "Losing Ground: Public Art at the Border," *Art in America* 89, no. 5 (May 2001), 68. Reviews of earlier in-Site exhibitions in *Art in America* also tended to view the work shown as overly reliant on the political context of the border. In 1995, Michael Duncan noted that the work could not compete for sheer physical effect with the actual border fence and was hard-pressed to be more than "set design" for ideologies on the border (Michael Duncan, "Straddling the Great Divide: The Neighboring Border Cities of San Diego and Tijuana Recently Presented an Ambitious Joint Exhibition of Installation Art," *Art in America* 83, no. 4 (March 1995), 51.

11. Kate Bonansinga, "False Borders: Conversation with Marcos Ramírez ERRE," *Sculpture* 25, no. 9 (2006), 20–27. See also Jo-Anne Berelowitz, "The Spaces of Home in Chicano and Latino Representations of the San Diego–Tijuana Borderlands (1968–2002)," *Environment and Planning D: Society and Space* 23 (2005), 323–350.

12. Federico Campbell, *Tijuanenses* (Mexico City: Joaquín Mortiz, 1989), translated into English as *Tijuana: Stories on the Border,* trans. Debra A. Castillo (Berkeley: University of California Press, 1995); Federico Campbell, *Transpeninsular* (Mexico City: Joaquín Mortiz, 2000); Gabriel Trujillo Muñoz, *Espantapájaros* (Mexico City: Lectorum, 1999); *Visual Arts on the U.S./Mexican Border—Artes plasticas en la frontera Mexico/Estados Unidos,* ed. Harry Polkinhorn (Calexico: Binational Press, 1991); *Open Signs: Language and Society on the U.S.-Mexico Border—Signos abiertos: lenguaje y sociedad en la frontera Mexico-Estados Unidos,* ed. Harry Polkinhorn, Rogelio Reyes, and Gabriel Trujillo Muñoz (Calexico: Binational Press, 1993); *The Flight of the Eagle: Poetry on the U.S.-Mexico Border,* ed. Harry Polkinhorn, Rogelio Reyes, and Gabriel Trujillo Muñoz (Calexico: Binational Press, 1993); *Bodies beyond Borders: Dance on the U.S.-Mexico Border—Cuerpos mas allá de las fronteras—La danza en la frontera Mexico-E.U.A.,* ed. Harry Polkinhorn, Gabriel Trujillo Muñoz, and Rogelio Reyes (Calexico: Binational Press, 1994); Harry Polkinhorn, Gabriel Trujillo Muñoz, and Rogelio Reyes. eds., *Border Lives: Personal Essay on the U.S.-Mexico Border* (Calexico: Binational Press, 1995); *Across the Line/Al otro lado: The Poetry of Baja California,* ed. Harry Polkinhorn and Mark Weiss (San Diego: Junction Press, 2002).

13. Information on Daniel Joseph Martínez's personal history and summaries of his perspectives are drawn from my audiotaped interview with him, 16 and 17 February 2001, at his studio in Los Angeles, California. Six hours of interview were recorded; all of the interview remains untranscribed and are in the author's possession.

14. Martínez interview, tape 4, side 1.

15. Martínez interview, tape 4, side 1.

16. Martínez interview, tape 4, side 1. See also Daniel J. Martínez, *The Things You See When You Don't Have a Grenade!* (Santa Monica, Calif.: Smart Art Press, 1996), 54–56; Chon A. Noriega, "On Museum Row: Aesthetics and the Politics of Exhibition," *Daedalus* 128 (1999), 57–81; Victor Zamudio-Taylor, "The Castle Is Burning," essay included in Martínez, *The Things You See,* 105–107.

17. Martínez interview, tape 1, side 1.

18. See Walter Benjamin, "The Story-Teller," in *Illuminations,* trans. Harry Zohn (New York: Schocken, 1969), 83–110; see especially sections 5 and 8.

19. Martínez interview, tape 1, side 1.

20. Martínez interview, tape 1, side 1.

21. Nancy Mirabal has noted that Martínez's use of "third space" parallels Emma Pérez's description of "decolonial" spaces as providing a place for a

"third logic" that is neither reaction nor emerging simply as a response to power. In a decolonial space, groups that have been marginal develop strategies for controlling the publics addressed, as well as the contexts for reception and interpretation of the statements and actions that the group makes. See in particular Emma Pérez, *The Decolonial Imaginary: Writing Chicanas into History* (Bloomington: Indiana University Press, 1999). The term "third space" is a key concept in the work of Homi K. Bhabha, who wrote in 1994: "The intervention of the third space of enunciation, which makes the structure of meaning and reference an ambivalent process, destroys this mirror of representation in which cultural knowledge is customarily revealed as an integrated, open, expanding code. Such an intervention quite properly challenges our sense of the historical identity of culture as a homogenizing, unifying force, authenticated by an originary past, kept alive in the national tradition of the people," from Homi K. Bhabha, *The Location of Culture* (New York: Routledge, 1994), 37. Bhabha also described the "third space" as a "cultural space" where "incommensurable differences" "peculiar to borderline existences" are open to negotiation (218).

22. The response has not yet converted him into a fauve with all the privileges and honorifics that connection might carry in an art world resting proudly upon its avant-garde patrimony.

23. Martínez, *The Things You See*, 96–98.

24. David Levi Strauss has noted how Josef Beuys provided Martínez with a model for acting socially as an artist rather than creating more discourse. See David Levi Strauss, "Between Dog and Wolf," in *Between Dog and Wolf: Essays on Art and Politics* (Brooklyn, N.Y.: Autonomedia, 1999), 133–134.

25. For a historical survey of this conflict in U.S. arts policy, see Michael Kammen, "Culture and the State in America," *Journal of American History* (1996), 791–814.

26. Martínez interview, tape 1, side 2.

27. Robert E. Park, "Human Migration and the Marginal Man," *American Journal of Sociology* 33 (1928), 881–893.

28. Robert E. Park, "Cultural Conflict and the Marginal Man," in Robert E. Park, *Race and Culture* (Glencoe, Ill.: Free Press, 1950), 376.

29. Manuel Gamio discussed these ideas in his proposal for reforming Mexican education advanced in 1926 while he was living in exile in the United States. See Manuel Gamio, *Aspects of Mexican Civilization: The Indian Basis of Mexican Civilization* (Chicago: University of Chicago Press, 1926), 129–154. After he returned home, Gamio served as one of the architects of the new educational system that the revolutionary government developed. See Ángeles González Gamio, *Manuel Gamio: Una Lucha sin final* (Mexico City: Universidad Nacional Autónoma de México, 1987), 79–159.

30. See Nestor García Canclini, *Hybrid Cultures: Strategies for Entering and Leaving Modernity* (Minneapolis: University of Minnesota Press, 1995), 100, for a discussion of the "public" as a concept.

31. Tamayo, interview by author, 29 and 30 April 2001, at various locations in Mexicali, Baja California, including his studio space at the Universidad Autónoma de Baja California, all untranscribed, tape 4, in author's possession.

32. Tamayo interview, tape 2.

33. Tamayo interview, tape 2.

34. Marco Antonio Vilchis, interview by author, facultad de arquitectura, Universidad Autónoma de Baja California, 30 April 2001, twenty minutes untranscribed, in author's possession.

35. Tamayo interview, tape 5.

36. Tamayo interview, tape 5.

37. Daniel J. Martínez, artist statement in *Cola 2000: Individual Artist Fellowships* (Los Angeles: City of Los Angeles Cultural Affairs Department, 2000), 3.

Conclusion

Note to epigraph: Manfredo Tafuri, *The Sphere and the Labyrinth: Avant-Gardes and Architecture from Piranesi to the 1970s* (Cambridge, Mass.: MIT Press, 1987), 2.

1. *Artweek: West Coast Art News* provides the most complete listing of art exhibits in the San Francisco Bay Area.

2. On juxtaposition as a method that inevitably devalues work done in a group, place, or culture with lesser social or cultural prestige, see Wolfgang Iser, "Coda to the Discussion," in *The Translatability of Cultures: Figurations of the Space Between,* ed. Sanford Budick and Wolfgang Iser (Stanford, Calif.: Stanford University Press, 1996), 299.

3. Maura Reilly has reviewed a broad range of evidence for the structural inequality still facing women artists and curators at the beginning of the twenty-first century in "Introduction: Toward Transnational Feminisms," in *Global Feminisms: New Directions in Contemporary Art,* ed. Maura Reilly and Linda Nochlin (London: Merrell, 2007), 17–24.

Index

Acknowledgments

A book that has gestated as long as this one has involved so many discussions on points both big and little that it is impossible to thank everybody who has helped me along the way. Conversations with Michael Frisch, Gordon Wagner, Katherine P. Smith, Paul J. Karlstrom, Paul Thompson, Luisa Passerini, Aurelia Brooks, Sue Welsh, Ed Ruscha, Lizzetta LeFalle-Collins, Ana Mauad, Leah Levy, Michael Dear, Gustavo Leclerc, Héctor Lucero, Ramón Tamayo, Mónica González, Luis Ituarte, Nancy Mirabal, and Forrest Robinson have helped me clarify one or more critical points. To each of them I remain deeply in debt for illuminating the path at different moments of what proved a longer journey than I initially imagined. More recent conversations with curatorial and conservation staff at the Museum of Modern Art in San Francisco have been critical in helping me see more clearly the broad range of perspectives within a modern-contemporary art museum and the real difficulties of the many choices museum leaders and staff must make as they acquire work and develop exhibitions.

Two people were particularly important in the development of my thinking about the relation of centers and peripheries in modern cultural life. While working at the University of California, Los Angeles, Oral History Program in the 1980s, I organized a series of interviews with African American artists in southern California. Having learned about Noah Purifoy's work as an assemblage artist and as founding director of the Watts Towers Arts Center, I invited Purifoy to participate in an interview that Karen Anne Mason conducted with great skill and patience. In the course of the project, Noah and I became friends. I served as the first president of the foundation established to preserve his desert sculpture park in Joshua Tree, California, and to promote his vision of art's potential within society. I shared the vision that motivated him, and in many ways, this book is a continuation of the conversations we had over the last fifteen years of his life.

I have dedicated this book to the memory of Eric Monkkonen. Eric, a professor of history at the University of California, Los Angeles, chaired

my dissertation committee. Until his death in 2005, we remained friends and colleagues discussing every topic under the sun. Given that he was a historian of nineteenth-century homicide, our work would seem to be very far removed in topic and temperament, yet as everyone who knew Eric can testify, he was a perceptive reader, able to couch his criticisms in a wry humor that all his friends will miss. Eric understood, better than anybody I have known, that California society, for all its mystique and glamour, has been a particularly successful version of the types of places where most people in the United States have lived during the past 160 years. He insisted that cultural and intellectual life in the state was therefore an excellent starting point for exploring the cultural shifts in U.S. life of the last century.

Chapter 4 appeared in similar form in "Postwar Modern Art and California's Progressive Legacies," *Rethinking History* 11 (2007), 103–124, as part of a special issue on California. Other sections of the book began as essays published in *Betye Saar: Extending the Frozen Moment*, ed. Sean Ulmer (Berkeley: University of California Press, 2005); *Postborder City: Cultural Spaces of Bajalta California*, ed. Michael Dear and Gustavo Leclerc (New York: Routledge, 2003); *Art and the Performance of Memory: Sounds and Gestures of Recollection*, ed. Richard Cándida Smith (London: Routledge, 2002); *Noah Purifoy: Outside and in the Open*, ed. Lizzetta LeFalle-Collins (Los Angeles: California African American Museum, 1997); *On the Edge of America: Modernist Art in California*, ed. Paul J. Karlstrom (Berkeley: University of California Press, 1996); the *Oral History Review* 17 (Spring 1989); and *Assemblage: Poetry and Narration* (Palos Verdes, Calif.: Palos Verdes Art Center, 1988). The material has been reworked significantly and in many cases my interpretive framework moved in radically different directions as the larger framing arguments developed. I am indebted to the editors for their support and enthusiasm.

Robert Lockhart of the University of Pennsylvania Press and Casey Blake Nelson, the editor of the series in which this study appears, proved to be the ideal engaged, critical readers that most authors hope to find. I was fortunate to receive their perceptive suggestions as the book was taking its final shape. Robert Milks, the copy editor, and Noreen O'Connor-Abel, the production editor, helped me make the book a better read. Ashley Nelson and Maura Krause from the University of Pennsylvania Press had the arduous task of securing illustrations. Despite the difficulties some images involved, they maintained a reassuring confidence that all problems could be solved.